DAN NORTH

PERFORMING ILLUSIONS

Cinema, Special Effects and the Virtual Actor

 WALLFLOWER PRESS LONDON & NEW YORK

First published in Great Britain in 2008 by
Wallfower Press
6 Market Place, London W1W 8aF
www.wallfowerpress.co.uk

a catalogue record for this book is available from the British Library.

ISBn 978-1-905674-53-4 (pbk)
ISBn 978-1-905674-54-1 (hbk)

Book design by Elsa Mathern

Printed in India

PERFORMING ILLUSIONS

CONTENTS

ACKNOWLEDGEMENTS

This work could not have been completed without the assistance of innumerable friends, family members, colleagues, students and random strangers.

I am fortunate enough to work and teach in an exceptionally nurturing environment, and this line of employment would be deeply dull and difficult without my film-studying partners Helen Hanson, Joe Kember, James Lyons and Steve Neale. Their friendship and unstinting support cannot be understated. The School of Arts, Languages and Literatures at the University of Exeter has for a long time provided me with a base for operations, and the collegiate safety net is held up by too names to mention, but I could start by thanking Helen Vassallo, Jason Hall, Paul Young, Julia Copus, Melissa James, Becky Munford, Chi-Yun Shin, Stacy Gillis, Andrew Shail, John Plunkett, Susan Hayward, Will Higbee, Song Hwee Lim and my friends in the North, Dan Cambridge, Tom Sykes, Martin 'Lewy' Lewis, Nicholas Stewart, Stephanie Cambridge and Laura Todd: apologies to any of the above who have ever had to suffer my failure to give a succinct answer to the simple question 'what is your book about?'

Yoram Allon, Ian Cooper and Jacqueline Downs at Wallflower Press have helped to pull a proper book out of my notes and ramblings.

The Bill Douglas Centre at the University of Exeter has been a source of inspiration and information from the start. Its collections played an integral part in directing my research, and I am indebted to the staff for making it accessible and enjoyable, particularly Hester Higton, Michelle Allen, Phil Wickham and Jessica Gardner.

Tuesday Kirsten has made the final stages of this project far more fresh and excited than writing an index has any right to be.

Special thanks are due to Duncan Petrie, who talked me into and pulled me through postgraduate study from start to finish. His relentless encouragement gave me confidence whenever I was subdued by self-doubt or lack of motivation, and the early years of research would have been a drab, humourless affair without him. Isabella Ho was tirelessly tolerant of me during the solipsistic troughs that tend to accompany the writing process. Mark Whalan has been a vital friend, landlord, tour guide and intellectual pace-setter throughout my period of research and writing.

My parents and siblings have never questioned my choice of career: that may be the greatest achievement of all.

If I have forgotten or excluded anyone from this list, then I'm sure that's not the last mistake that will be found within these pages, but I take full responsibility for each and every one of them.

INTRODUCTION

What good is sleight of hand if you cannot see the hand? (Klein 2004: 89)

In the closing moments of Peter Jackson's *King Kong* (2005), the latest in a cascade of remakes and rip-offs of the 1933 film, the mortally-wounded giant ape shares a tender moment with Ann Darrow (Naomi Watts) at the top of the Empire State Building. The New York City backdrop recedes to focus on their misty-eyed final caress. They appear to be lit by the same sunrise, ruffled by the same breeze. This moment of trans-photographic contact, with a live actress reaching out to touch a computer-generated co-star, challenges the

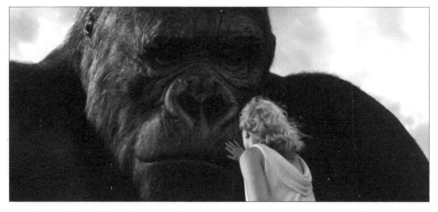

Ann Darrow (Naomi Watts) shares a final moment with a computer-generated Kong

spectator to spot the join between the two worlds. Even as the shot asks us to accept that the two figures share the same narrative space, and thus that their spatial proximity can convey an empathetic bond, at another level we are invited to marvel at a complex technical achievement, and challenged to locate discrepancies in the illusion. Instances such as this, which one might consider spectacles of comparison, when composited elements drawn from discrete and diverse sources share the frame, are the defining units of the kinds of special effects which will be discussed in this book.

Performing Illusions is an attempt to inspect the development of filmed illusions in order to show how they influence or interfere with the spectator's reception of visual information. Its thesis is simple: within every film in which special effects play a significant part lies the theme of illusionism. Whatever other stories they may tell, these films are also *about* special effects and techniques of visualisation. They are *about* the relationship between the real and its technological mediation. By compositing pro-filmic (broadly speaking, those which are physically present at the point of principal photography) and synthetic elements (those which are manufactured separately) within the same frame, they construct a spectacular dialectic between them; the effect is characterised not by the absolute undetectability of the mechanisms behind it, but by the interdependence of those elements. This calls into question a widespread impression that the development of special effects has been driven by a series of incremental improvements and modifications moving towards a capacity for absolute simulation and imperceptible illusion.

The emergent protagonist of this story will be the synthespian, or virtual actor, an anthropomorphic embodiment of imaging technologies performing the ultimate feat of mimicry by supplanting human forms with digital imitations. Through its enactment of an enfleshed persona, the synthespian personifies the popular myth that the aim of special effects is immaculate imitation; what could be more demonstrative of the imminent achievement of such a goal than an artificial human that can pass for real in the eyes of human spectators? Asked by online trade journal *VFXWorld* to extrapolate some predictions on the future of visual effects from current trends, Kim Libreri, then visual effects supervisor of ESC Entertainment, begins with the assertion that 'we will build a better virtual human' (2004: 1). Barbara Creed has speculated that 'in the future, living actors may compete with digital images for the major roles in the latest blockbuster or romantic comedy' (2000: 80). Artificial Intelligence researcher Ray Kurzweil has claimed that virtual personalities (like the ones he himself is attempting to market) will be 'a ubiquitous phenomenon' by 2010 (quoted in James 2002: 53). 'Virtual human designer' Peter Plantec be-

lieves that this kind of 'digital character acting' will presently produce autonomous virtual actors capable of emoting (assisted by sophisticated software) according to the demands of the script (2005: 1). Back in 1991, Geoffrey de Valois, head of Digital Vision Entertainment envisaged that within the next few years his company would be 'able to create computer-generated actors who will look so real, you won't be able to tell the difference between them and human actors' (quoted in Killheffer 1991: 53). This oft-cited 'Holy Grail' of digital animation bears the promise that there will one day be a simulation of a human being so indistinguishable from its flesh-and-blood co-stars that it will be able to perform alongside them without being recognised as a special effect.

The process of critiquing the proclaimed trajectory of special effects towards this quasi-mythical endpoint will require a broader consideration of how such effects operate, including the definition of some principles of illusionism which can help us to account for aesthetic continuities between effects regardless of the mechanisms deployed in their creation. The primordial locus of this type of trickery lies in the magic theatre of nineteenth-century Europe and America, where the drive to standardise magic performances and thus render them suitable for the popular stage led magicians to devise conventions of space, movement and embodiment which would lay the groundwork for the early cinema period and its appropriation of these pre-prepared tropes of illusion. The first chapter sets out this historical moment and the illusory practices it introduced. Subsequent sections examine some selected case studies from later periods which uphold some of the preoccupations of the magic theatre even as the technologies of filmed spectacle undergo dramatic developments. From early trick films and stop-motion animation, through science fictional imaginings of alien invasion and space exploration in the 1950s, via the adaptation by Hollywood special effects artists to the digital age, to the latest experiments with digital performance, this book aims to accentuate the continuities in a creative domain where teleological accounts of incremental improvements seem so obviously persuasive; in adopting a broadly chronological structure, I do not want to endorse a stance of technological determinism where special effects evolve towards a zenith of perfection. Rather, I hope to present changes in techniques as active engagements with past as well as present cultural forms and techniques. These changes occur in response to the specific contexts in which they are necessitated either by the competences and preoccupations of particular artists or by the properties of the available equipment – they do not emerge as pre-determined steps towards a long-term goal.

The production of a special effect denotes the use of a technique specifically designed to alter, enhance or create an element of the diegesis. These techniques are essentially disruptive – they upset the notion that everything within the frame is evidence of an event occurring before the camera. Such disruptions can be seen in the coloured gunsmoke and safe-cracking explosives in some hand-painted prints of the otherwise monochrome *The Great Train Robbery* (Edwin S. Porter, 1903), the impossible cityscapes of Fritz Lang's *Metropolis* (1927) or in the destruction by fire of a miniature model representing the world's tallest skyscraper in *The Towering Inferno* (John Guillermin/Irwin Allen, 1974). In these spectacular moments, the spectator is challenged to perceive the joins between composited elements: all special effects leave vestigial traces of their means of production, and it is these traces which aid the spectator in their detection. If the discrepancies between the real and its simulation are too jarringly pronounced, we dismiss them as 'bad' special effects, those which have reminded us too forcibly that Superman is not really flying or that the Titanic is just a glorified bath toy bobbing in a pond on the studio backlot. But the illusion is *never* perfect. There is always a dynamic friction between the special effect and the filmic space it infiltrates, and the spectator can always be activated to seek and detect the evidence of their co-existence within the film frame. This type of analytical viewing might not be carried out consciously, but is a more instinctive part of assimilating visual information and making sense of its various components in relation to one another.

Recent developments in computer graphics suggest that these seeming dysfunctions of the illusory effect will eventually be erased by detailed computer graphics that can replicate the properties of scale and texture needed to blend the illusion imperceptibly with the real. Certainly, in the tricks of early films, the evidences of mechanical agency are more pronounced. In a stop-motion substitution in a film by Georges Méliès or R. W. Paul and Walter R. Booth, for example, the camera has been stopped and the *mise-en-scène* adjusted before filming is continued. Whether it is a slight discrepancy of continuity which signals the edit or simply a tiny difference in camera position, the source of the effect can be detected on inspection (a privilege granted by repeat viewings). Of course, it can also be spotted by acknowledging the instant at which an impossible event occurs, when the integrity of the image is subverted by a magical transformation or disappearance. Double exposures are equally simple to discern in most contexts. The entrance of a ghost or other transparent figure might signal that the film has been exposed twice upon different subjects. Early blue screen techniques are recognisable by a pronounced black line that appears around the superimposed subject.[1] Special effects can be perceived by

their mechanical idiosyncrasies or deficiencies, by inadequacies of their man-ufacture, or by simple acknowledgement of impossibility (we know that the actor Christopher Reeve cannot fly, so we assume that it is trick photography which makes his Superman, in Richard Donner's film of that name, appear to defy gravity), but these are not truly *failings* of the technology or the techni-cians. Rather, they are points of access for the spectator's critical engagement with the film on a technical level.

Proper use of terminology would dictate that 'special effects' refers to those which are produced on the set before the cameras, while 'visual effects' usu-ally describes those which are created or added to the image in post-produc-tion. Credits may also list 'special photographic effects', which refer to matte work, in-camera compositing shots or artificially composed shots. It would be impossible to respond in a single text to the full range of techniques which comprise the categories of special and visual effects. My use of the term 'spe-cial effects' is one which encompasses all those techniques which can be em-ployed, whether on the set (pyrotechnics, make-up), in-camera (glass shots) or post-production (Computer-Generated Imagery (CGI), process work) to create the impression of an inactuality within the image. More specific terms will be used to describe particular techniques. There is a distinction to be drawn between the types of ostentatious spectacle which will preoccupy most of this book, and what might be termed 'invisible effects' (See Skweres 2004). Examples can include the digitised scourging in *The Passion of the Christ* (Mel Gibson, 2004), where the visceral effect of violent torture, rendered mostly through use of prosthetic make-up is accentuated by digital effects that move the depiction of flayed flesh beyond what might safely be practiced on set. Given that Gibson's film was designed as a religious experience as much as an entertainment spectacle, the special effects should, ideally, go unnoticed by spectators, allowing them to stay immersed in an empathetic relationship with Christ's torment. It is impossible to gauge the individual responses of the film's viewers, but it can be noted that the effect of the violence in *The Passion of the Christ* is deliberately enhanced through its technologised differentia-tion from other depictions of body horror across a range of other film texts. Thus, I would argue, even when the effect is not engineered as a self-reflexive spectacle, the spectator must, perhaps unconsciously, perceive it in relation to a shared knowledge of cinematic possibilities.

Films might contain more truly invisible moments such as the removal of a Kabbalah bracelet from Ashton Kutcher's wrist in *Guess Who?* (Kevin Rod-ney Sullivan, 2005), the digital deletion of a microphone wire from Woody Allen's shirt in his otherwise FX-free *Manhattan Murder Mystery* (Woody

Allen, 1994), or the addition of wisps of computer-generated mist emanating from the mouths of actors in *Titanic* (James Cameron, 1997) to give the impression that they are floundering in icy waters. These use technologies of digital imaging to 'fix' images rather than to enhance their effects. The Visual Effects Society (VES) distinguishes between the two types of effects with its 23 awards for various kinds of achievement, even in films which might not be effects-driven (see Skweres 2004: 2). This is, within the industry at least, an attempt to maintain the recognition (and thus the visibility) of invisible effects. The distinctions between these two approaches to effects (they could be seen as associated only in the sense that the same equipment is used to achieve them) show up how deliberately certain types of spectacular display will be pushed to the fore for spectatorial inspection and consumption, while other types, similarly deserving of admiration for their intricacy and skill, are relegated to a rather more lowly status.

Without repeatedly referring back to this analytical model in the subsequent case studies, it will be argued that a filmic special effect can be broken down into three categories of spectacle: *diegetic, intertextual/comparative* and *speculative*. It portrays a fictional event occurring within the self-contained narrative space of the film (*diegetic*): to re-use the example that opened this book, we might cite the dying moments of an outsized ape at the pinnacle of a skyscraper in *King Kong*. Secondly, the effect invites comparison with other portrayals of similar story events (*intertextual/comparative*), either in the earlier versions of the same story of which Jackson's film is a remake, or in the broader sub-genre of the monster movie. Finally, it suggests the eventuality of even more astonishing illusions using the same technology (*speculative*) – witnessing the digital incarnation of Kong through motion capture and animation does not mark the completion of a technological project, but checks off a latest development, which past form tells us will be surpassed in a forthcoming attraction. Now, by understanding spectacle as a retrospective glance back at 'inferior' antecedents coupled with a speculative nod to the future, it might seem as though this description of special effects incorporates exactly the kind of teleological model of progress that I have been trying to avoid thus far. But I hope to have described a spectatorial position that is in constant flux – because this viewpoint is situated in context rather than in isolation, the spectator is not merely passive in receiving the visual impact of an effect, but active in making sense of it as a technical accomplishment (as opposed to an incomprehensible, overwhelmingly 'magical' conjuration).

The aim here is to examine and connect the key areas of interest in what has been a mistreated and misunderstood field in film studies. It is the conten-

tion of this book that, rather than being seen as little more than an exercise in technical intemperance, or a mesmeric bid for the spectator's undivided attention, the special effects film can be more productively located within debates about filmic reality, technologies of visualisation, and the ontology of the image. According to Scott Bukatman:

> Neither participating in the satisfactory *telos* of cinematic narrative nor fully inscribed by the terms of an alternative avant-garde, special effects are doubly compromised. Because of the tremendous capital investment involved, special effects are primarily associated with mainstream American cinema, and thus inevitably function as a sign of the commodity rather than the author or artwork. (1993: 13)

Much of the published material on special effects has so far fallen into one of three categories: the first group is based around discussions of the effects of a particular technical development such as matte painting, stop-motion animation or CGI;[2] the second group includes 'exposés' of supposed trade secrets, often aimed at fans of particular films or film genres;[3] the last group are the general historical studies, which normally begin with tributes to the films of Georges Méliès (a convenient father figure for the founding of a culture of cinematic illusion) and end with reference to the latest Hollywood blockbuster.[4] All of these serve a purpose and meet a need, but the centrality of special effects in popular cinema has often escaped the attention of academic film studies. It might be considered a blessed mercy if the worst excesses of (for example) Lacanian psychoanalysis have not been unleashed upon *Tron* (Steven Lisberger, 1982), like a theoretical sledgehammer deployed to crack a textual nut, but surely a trick is being missed if we neglect to study the aesthetic and semic contributions which special effects make. In the general editor's introduction to *Spectacular Narratives* (King 2000), Jeffrey Richards applauds author Geoff King's analysis of the Hollywood blockbuster at the end of the twentieth century, stating that:

> Thanks to King, we can now see that there is much more to the Hollywood spectacle than just special effects, and we can begin to view these films in the light of fundamental cultural and ideological debates. (Richards 2000: vii)

There is a suggestion by Richards that the presence of special effects presents an obstacle to rational criticism, and that it is only by sidestepping such anti-

cerebral showcasing that the true significance of the films in question can be realised. Blockbuster films might otherwise seem, in Brooks Landon's phrase, like 'dogs wagged by the tail of special effects' (1992: 41). This is not an uncommon view. Paul Willemen has claimed that mainstream cinema's ultimate aim is the annihilation of the viewer's critical faculties by overwhelming the senses with high volume and the use of special effects as a kind of hypnosis (2000: 7; see also Grindon 1994). Sensory immersion, and the quest for pristine, audiovisual high fidelity could be viewed as a way of achieving greater clarity of image and sound in order to engage the viewer more thoroughly in the narrative, but there is great resistance by many theorists and cultural critics to the idea of a forceful manipulation of the audience. Academic discourse, says Bukatman, 'mistrusts the pleasures of illusion, dismissed as illusions of pleasure' (2003: xiii). This resistance is tied to a long-standing suspicion of new media technologies and their supposedly narcotic effect on the mass audience. Geoff King has suggested that a taste for subtlety, and the antipodal *dis*taste for detonative spectacle may be a socially defined, class-based construct that prejudicially maligns those kinds of instantly gratifying modes of entertainment most likely to appeal to those from 'lower-class backgrounds' (2002: 198–9). After all, as Robert Baird puts it, 'one does not need specialised training or art appreciation classes to comprehend or enjoy blockbusters' (1998: 97); big budget Hollywood films are not inherently shallow, but they express intelligences distinct from those which flatter academic interest in 'hermeneutical puzzle solving' (ibid.). That a film like *Jurassic Park* (Steven Spielberg, 1993) indulges kinaesthetic more than intellectual pleasures is probably a fair description, but this book hopes to demonstrate that it is not a necessary side effect of special effects that they disconnect the film from any interpretative commitments.

Another factor in scholarly resistance to special effects may lie in the status of technical ostentation as a signifier of manufacture, industry, production lines and collective artistry, undermining film's status as an autonomous or auteurist art. Hollywood cinema is often mistrusted as a purveyor of crowd-pleasing, anti-intellectual entertainment, recycling the narrative formulae most likely to satisfy and least likely to offend the aggregated sensibilities of its imagined target audience. Robert Phillip Kolker, in a study of contemporary international (that is, non-American) cinema, uses mainstream Hollywood product as the monolithic antithesis of the relatively sovereign working conditions enjoyed by European or Asian filmmakers. His definition of its commitment to audience pacification can be shown as a typical example of a prevailing view of populist filmed entertainment:

Since the early teens, when it began organising itself to reach the widest possible audience, American film began to adopt a number of conventions in content and form that it has repeated, albeit with many variations, to the present day, always proclaiming that these conventions fulfilled audience desires. But in fact popular film does not so much fulfil or reflect the desires of its audience as create them through a complicated ideological process in which cultural and social attitudes are enhanced, given form and reinforced in a circuit of exchange between the producers and consumers of cultural artefacts. (1983: 6–7).

Kolker is positing the Hollywood mainstream as a form of cinema which encourages the passive assent of the viewer to whatever ideological standpoint may be forced upon them by a film, and which does not reflect or observe social situations so much as it influences them by its own rendition of the world. Moreover, Kolker is citing the form of *realism* offered by Hollywood cinema as a key characteristic in his comparative study of world cinemas. The thought-control to which he alludes is informed by a Brechtian suspicion of manipulative or emotional representation. To quote one of Bertolt Brecht's direct definitions of how he hoped 'realism' could come to be expressed:

Discovering the causal complexes of society/unmasking the prevailing views of things as the view of those who rule it/writing from the standpoint of the class which offers the broadest solutions for the pressing difficulties in which human society is caught/emphasising the element of development/making possible the concrete, and making possible abstraction from it. (1974: 50)

Brecht hoped that by distancing the audience from the art (in his case theatre) the viewer could be urged to confront and question the nature of its construction, to realise that the content and meaning of any work is, to a degree, dictated by its form. By making that form readily perceptible, as Brecht sought to do, the stealth of its influence could be subverted. Brecht's didacticism was as concerned with the nature of art as it was with socio-political education, but special effects, as this study will show, *do* provide the required formal disruptions that create a distance between text and spectator, even if they do not do so in the service of the same revolutionary goals that Brecht had in mind.

In Guy Debord's phrase, the spectacle is 'the opposite of dialogue' (1983: paragraph 18) a way of stalling communicative processes in order to emphasise sensory thrill, just as Willemen saw the Hollywood blockbuster as a force for thought annihilation, dazzling and deafening with spectacle and noise.

Christian Metz, on the other hand, seeing the apparently simulacrous nature of the film image as one of its defining properties, gives a sense that the realism of the image energises some responses in the viewer, rather than having a numbing effect by nature of its proximity to ordinary observation: 'A fairly convincing reproduction causes the phenomena of affective and perceptual participation to be awakened in the spectator, which, in turn, give reality to the copy' (1974: 7). Debord takes a Marxist stance on spectacle that may have had some influence on Willemen, stating that in capitalist societies, 'all of life presents itself as an immense accumulation of *spectacles*. Everything that was directly lived has moved away into a representation' (1983: paragraph 1; emphasis in original). Under this definition, the spectacle is 'the image of the ruling economy', and it 'aims at nothing other than itself' (1983: paragraph 14). Theodor Adorno (1991) has argued similarly that admiration for cinematic spectacle triggers an awed deference to industrial power (see also Adorno and Horkheimer 1986). Jean-Louis Comolli similarly argues that a society is '*driven by representation*. If the social machine manufactures representations, it also manufactures *itself* from representations – the latter operative at once as means, matter and condition of sociality' (1980: 121; emphasis in original). More recently, Richard Allen has suggested that standardisation of production and marketing methods, presumably in contrast to avant-garde principles, 'coincided with or facilitated the drive to create an illusion of reality which requires standardised presentation in order to induce absorption into the illusion rather than have one's attention called to the illusion-creating process' (1995: 32).

The spectacle thus demands an attitude which 'in principle is passive acceptance which in fact it already obtained by its manner of appearing without reply, by its monopoly of appearance' (Debord 1983: paragraph 12). For Debord, visual culture has superseded the other senses to dominate representation. The confusion of the real with the image is a phenomenon much criticised by Marxist ideas of visual culture, but also something for which special effects technicians claim proudly to have been aiming for many years. They might express hope that their effects will be indistinguishable from the real, but what they are actually seeking is a new, idealised simulation that is absolute *representation*, when the illusion is a perfect fit for the diegetic space into which it is placed.

We should not need to produce justification for the study of spectacular forms as culturally productive. Built into their denigration is a condescending presumption of a correct function for cinema, and a miscalculation of the viewer's ability to discriminate – there should be nothing wrong with a

desire to view amazing pretences onscreen, especially once we demonstrate that these images are semiotically rich or formally complex. Either way, value judgements on the types of films in which special effects are most frequently to be found should not impede the rigours of our inquiries into their nature. Michele Pierson's excellent study of special effects and the enthusiasts they attract should stand as a valuable riposte to the suggestion that visual spectacle solicits no contemplative or nuanced engagement from its consumers. She argues that 'cultures of connoisseurship and fandom cultivate an attentional complex in which it not only becomes important to "pay attention" at the movies but also to attend to discussion and evaluation after the fact' (2002: 72). This might simply mean a flock of nerds arguing over the weapons capabilities of the X-Wing Fighter, but it might also remind us that the discourses surrounding the technologies involved in film production are a legitimate entry point for experiencing those films, especially if the films in question are thematically concerned with the impact of new technologies.

If, as noted above, spectacle is scorned because it seems to require little or no cultural knowledge for its full enjoyment, the first step in countering that view might be to think about how special effects operate intertextually. Barbara Klinger has noted the prevalence of what she terms 'digressions', ranging from 'generic or narrative intertexts that school the spectator in dramatic conventions, to a host of promotional forms ... that arm the spectator with background information' (1989: 4). A digression, as Klinger understands it, can be any kind of paratextual information that inflects the spectator's understanding of any filmic situation. With the rapid increase in the sales of films on DVD for home viewing, it is clear that a great deal of supplementary detail is packaged along with the film itself in the form of 'making of...' documentaries, behind-the-scenes featurettes, audio commentaries, scene dissections and other 'backstage' documents. These might be presented as 'bonus' or 'added value' adornments, but they can augment and articulate the film experience in quite sophisticated ways. The tortuous, interweaving journeys that form the narrative threads of Peter Jackson's *Lord of the Rings* trilogy (2001, 2002, 2003) are compounded by the presentation of the films on DVD. The theatrical versions of the films ran for a total length of 558 minutes, while the extended DVD editions clocked up 682 minutes and a cumulative total of some seventy hours of extra material. This network of detail turns the viewing experience into a complex weave of information about the film's production, mythology and history, bolstering the scale and status of the trilogy through sheer force of agglomerated imagery. The film text is therefore not sealed up between opening titles and end credits, but branches out in multiple directions.

'Digressions' are not a new phenomenon – the English-language pro-gramme for the first demonstrations of the Lumière brothers' Cinématogra-phe camera/projector in Britain (1896) feature an explanation of the princi-ples of persistence of vision (reprinted in Ceram 1965: 182), and cinemagoers in 1958 may have seen a trailer for Nathan Juran's *The 7th Voyage of Sinbad* in which the narrator explains, over behind-the-scenes footage, the 'Dyna-mation' process used by Ray Harryhausen for compositing live actors with animated models.

Visual illusions have always depended upon a kind of doublethink on the part of the spectator – we *need* to recognise the illusion as such before we can engage with it meaningfully at a semiological level. Angela Ndalianis charac-terises this as an amalgam of the rational and the irrational, which is 'expe-rienced as the ambivalent tension that tugs at the spectator: the oscillation between emotion and reason – between the sensory and the logical' (2000: 260). Ndalianis also locates this dual function in magic shows which 'gener-ated an affective response of awe and wonder from the audience so as to stress a more scientific concern with unveiling these fantastic and magical illusions as scientifically constructed and false' (2000: 261). What will be explored in more detail are the specific ways in which the multi-focal viewing practices of spectators, who are simultaneously accepting fabrications as narrative devices and decoding them as artificial contrivances, are mediated by filmmakers. The film's author(s) can enjoy the same mediating role as the stage magician, and this emphasis on mediation is a crucial one, since it warns us that an oscilla-tory spectatorial position might not necessarily be a democratic or liberated one.

When we see, onscreen, an impossible event happening in 'photorealis-tic' CGI, we are invited into the fantasy that it has actually been recorded photographically, and thus that it has taken place in the real world. This per-formance of 'photographicness' (simulated motion blur, camera movement and so on) is as much a part of the illusory strategy as is the simulation of flesh and form on computer-generated bodies. It mobilises a set of expectations of spatio-temporal continuity that we attach to photography, while effacing the subversive and liberated forms of animation to which CGI might otherwise be attached. In this sense, perhaps animation is merely pretending to be a part of mainstream cinema, sneaking back in to acceptance by disguising itself as pho-tography, following its banishment to the realms of children's entertainment in the early decades of the twentieth century. Primarily, though, this means that the spectator is, even unconsciously, active in reconciling the actuality (for example, an animatronic dinosaur puppet) with the appearance (a liv-

ing, breathing dinosaur). The filmmakers endeavour to aid this reconciliation through a range of presentational strategies that hide the mechanical origins of the effect, ranging from the simplistic (avoidance of close-ups, low lighting) to the more subtle (fast cutting, slow motion/sound effects to reinforce the creature's supposed scale and weight). It is this dynamic relationship between the spectator and the filmmaker which is the primary concern of this book, for this is the nature of illusionism – an interplay between the practitioner and the recipient, the former testing out the latter's knowledge of other deceptions, adapting each trick to circumvent the viewer's ever-expanding awareness of the means and mechanisms behind the illusion. Though there may never be a state of perfect illusionism, whereby the simulation is absolutely impercep-tible, this does not mean that its pursuit is a fruitless quest, since it is the dia-logic quality of illusory practice that characterises it. For this reason, the first chapter will be dedicated principally to a discussion of nineteenth-century magic theatre, and the establishment of such performative codes; the template for illusionism laid down by Victorian magicians is still a relevant means to conceptualise the way in which visual illusions are delivered and received.

In reference to attempts to simulate human forms, Robin Baker has ar-gued that 'if reality could be conquered (and what is more real than a person?) the supremacy of the synthetic over the real would be established' (1993: 42). Presumably, such a conquest could only occur when the spectator is unable to discern the pro-filmic action from the post-produced fabrication. The ul-timate purpose of special effects is not one of simple deception (that is, the subterfuge of passing off an illusion as real) but of mediated ostentation. This contradicts Noël Burch's definition of an Institutional Mode of Representa-tion, the bourgeois imagining of a perfect simulacrum of the real world, with the effacement of all indicators of the means of production prompting specta-tors to accept constructed images as transparently realistic (see Burch 1990). As Robert Stam and Toby Miller have remarked, capital-intensive special ef-fects production aims not at undetectable illusion, but is instead dedicated to 'fetishising innovation and difference, pointing out the fallacy in mimesis to the audience as part of its product differentiation' (2000: 97). An effect which so closely resembles its real-world referent that it disappears from view is one which renders itself obsolete. To serve its purpose, the effect must announce its presence, and film has developed a code of practice for addressing the audi-ence with reassurances that what they are seeing is not real, but an expensive simulation. Jean-Louis Comolli has summarised this position in relation to the nature of the image, but it is easy to see how the principle can be applied to special effects:

The spectacle, and cinema itself, despite all the *reality effects* it may produce, always gives itself away *for what it is* to the spectators. There is no spectator other than one *aware* of the spectacle, even if (provisionally) allowing him or herself to be taken in by the fictioning machine, deluded by the simulacrum: it is precisely *for that* that he or she came. The certainty that we always have, in our heart of hearts, that the spectacle is not life, that the film is not reality, that the actor is not the character and that if we are present as spectators, it is because we know we are dealing with a semblance, this certainty must be capable of being doubted ... We want to be fooled, while still knowing a little that we are so being. (1980: 139; emphasis in original)

Comolli talks of how spectators become complicit in an illusion by allowing themselves to deny the non-existence of what they know to be fictional spectacle (see 1980: 140).

Barry Salt, a film historian and apparently a believer in scientific determinism (admitting little in the way of cultural theory into the path of his analyses) has described the medium of film as 'a more faithful or less faithful reproduction of audio-visual reality', evolving through trial and error towards ever more complex and accurate simulation (1983: 35).[5] Salt suggests a spectrum of realism, with absolute simulation (exemplified by stereoscopic vision engulfing the spectator) and single shot, unstaged action at one end and abstract, synthetic cinema at the other:

All films can be considered to lie on a spectrum between these two extremes, with a greater or lesser degree of distortion (or transformation) of reality being introduced in various ways: by making cuts between shots rather than running the camera continuously, using zooms and camera movements within shots, shooting in black and white rather than colour, using various degrees of non-natural sound, filming acted events, and so obviously on. (Ibid.)

Here we see a quantifiable version of realism, with certain cinematic effects and actions delegated a value in terms of its detriment or addition to the overall realism of a film.

Rudolf Arnheim saw film as offering a 'partial illusion', and little more:

Up to a certain degree it gives the impression of real life ... By the absence of colours, of three-dimensional depth, by being sharply limited by the margins on the screen, and so forth, film is most satisfactorily denuded of its realism.

It is always at one and the same time a flat picture postcard and the scene of a living action. (1958: 31)

By introducing the concept of a partial illusion, Arnheim may be sitting on the fence in the film/realism debate, refusing to compare film directly to either simulacrum or reality, but instead searching for a middle ground. It may turn out to be the most productive way to view this debate, as precisely a dynamic between illusion and realism. It is the constant interplay between the perception of film's illusory capabilities and of its glancing resemblance to reality that provides its most distinctive effects.

André Bazin's conception of realism has been highly influential, and centres on a division he perceived between formalist allegiances to montage and other 'markers of mediation', and those who sought to preserve the integrity of the subject in space and time (see Stam 2000: 224). A filmmaker could either *construct* meaning through the juxtaposition of images, or could aim to leave intact a meaning that might be emerging unaided from the subject. His theoretical position was, according to Kolker, 'grounded in the belief that film could create images spatially and temporally faithful to the fullness and richness of the world' (1983: 16). Bazin saw cinema as essentially realistic, 'a recreation of the world in its own image, an image unburdened by the freedom of interpretation of the artist or the irreversibility of time', and celebrated those of its characteristics which link it directly to 'real' experience: sound, colour, depth of field (1967: 21). These are the imitations of human senses that were lacking in the earliest films, with their flat, mute, monochrome world. Bazin also suggested that cinema would have achieved its ultimate goal of convincing verisimilitude if it had not been constrained by the indolence of technological progress:

> If cinema in its cradle lacked all the attributes of the cinema to come, it was with reluctance and because its fairy guardians were unable to provide them however much they would have liked to. (1967: 68)

Poetic though it is, Bazin's description matches a simplistic and determinist assessment of cinema history, but what he touches upon here is the fact that mainstream cinema is required to exploit the most advanced science available, which is, more often than not, used to render objects in a realistic manner. He implies concomitantly that early filmmakers were biding their time while science produced the necessary means for more realistic representations.

Bazin also saw realism as rising naturally out of specific techniques and apparatus. Summarising film as a 'synthetic art', Vladimir Nilsen made a simi-

lar connection between techniques, such as colour and stereoscopy, which advance cinematic processes towards a 'complete technique … thus enriching the resources available for achieving the creative tasks of cinema art' (1959: 11–12). However, even Bazin acknowledged that film's quest for perfect realism was a rhetorical one, and that 'reality must inevitably elude it at some point. Undoubtedly an improved technique, skilfully applied, may narrow the holes of the net, but one is compelled to choose between one kind of reality and another' (1971: 29).

There is no 'ultimate goal' for cinema, no point at which it can appear so realistic that it becomes a perfect simulacrum. If it were to become totally 'real', it would cease to hold fascination as an *illusion* of reality. Apart from the fact that Bazin's hypothesised 'total cinema' neglects social influences on the development of film technology (as Jeanne Thomas Allen has put it: 'Bazin characterises film as a neutral technology, a passive recording mechanism which evolves towards self-effacement by quintessentially matching human perception and experience' (1980: 26)), it also conforms to what Comolli has identified as an 'ideological heritage' of cinema – the synecdochic focus on the camera as the primary mediator between the referent and its image (1980: 128). Technologies which facilitate replications of human senses (widescreen's mimicry of a greater field of vision, stereo sound's multi-directional articulation of sonic 'spatiality', and the perceived visual democracy of deep focus photography) suggest to Bazin a continuous perspective that attempts to diminish the opportunities for the objective or formalist interruptions of the film's director, editor or cinematographer. His 'total cinema' is a wish for a nexus of image technologies where, as Scott Bukatman suggests, 'all the senses are engaged by a perfect simulacrum of reality which denies its own technological origins' (1993: 239). Although Bazin ultimately saw this apotheosis of the image as an unattainable goal, there is a residual implication that future developments would be able to further a quest for sensory imitation until there was a possibility of an unmediated view through a camera. The key role played by special effects in cinematic constructions acts as a disruption of this myth of continuity. The superimposition of several photographic elements in a single image, the temporal dislocations of stop-action substitutions and stop motion animation, the digital erasure of physical objects which were present during principal photography – all of these techniques subvert the indexical integrity that the image may have possessed at the point of recording. Crucially, these are not techniques that aim to preserve an impression of integral imagery, and their presence is not intended to pass unnoticed – special effects are dependent upon a constant collusion between realistic representation and

the acknowledgement that an illusion is being displayed. As Richard Maltby has explained:

> The goal of realism is an illusion. Art cannot 'show things as they really are', because the 'real' in realism is understood to be exactly that which is unmediated by representation. Since it is outside representation, the 'real' cannot be represented: representations can be only more or less inadequate imitations or substitutions for it. Precisely because it remains an absolute, untarnished by the compromises of representation, the 'real' retains a tremendous power as a point of reference to be invoked in the rhetoric of criticism. (2003: 233)

Bazin valued what he saw as realistic cinematic technologies because they allow the viewer to be active rather than passive, to engage several senses simultaneously, but it would surely be a passive viewer who was so fully immersed in the diegesis that the forgery became the truth. It is the very activity of the viewer which prompts discernment between the onscreen illusions and the film's meaning as a work of fictitious art, a constant questioning of the material being proffered by the filmmaker. The virtual actor is the anthropomorphisation of the Bazinian myth of total cinema, accruing an inexorable series of improvements with the stated aim of eventually manufacturing an illusion of the real that will simulate its subject perfectly.

Realism, representation and the digital age

Until the arrival of computer-generated special effects, all trick shots involved the photography of solid objects, whose appearance and visible properties could then be transformed using various photographic processes. A film of an object bears both an iconic and an indexical relation to the object itself, being a duplication of that object *and* a separate entity formed as a result of light rays reflected from its surface, through a lens and onto a strip of celluloid. To produce a digital representation of an object, whether or not it has a real-world referent, is to remove the element of *indexicality*, the direct relationship between the image and its source; Laura Mulvey has described this altered relationship as a 'crisis of the photographic sign as index' (2006: 18). The computer-generated object is a creation whose physical presence bears no resemblance to what it signifies – it is merely a quantity of data in a microchip – but when transferred to its imagistic form, it can be rendered with such photographic verisimilitude that it can *appear to be* an index of its referent. The upheavals that the proliferation of digital images has caused come from

the incompatibility of these theoretical definitions when applied to a techno-logical medium. There is no inherent realism in the image, and digitalisation did not make this the case, but forced its recognition, instilling a distrust of the image, which one now recognises as unstable, a potential liar. This distrust is obsessively indulged in the form of image manipulation and erasure, photore-alistic simulacra and illusions that embrace this power to deceive by contextu-alising its capacities within the safe borders of spectacular entertainment.

As Comolli puts it, the act of filming something separates it from real life:

> The most analogical representation of the world is still not, is never, its re-duplication. Analogical repetition is a false repetition, staggered, disphased, deferred and different; but it produces *effects* of repetition and analogy which imply the disavowal (or the repression) of these differences and which thus make of the *desire* for identity, identification, recognition, of the desire for the *same*, one of the principal driving forces of analogical figuration. In other words the spectator, the ideological and social subject, and not just the tech-nical apparatus, is the operator of the analogical mechanism. (1980: 138; em-phasis in original)

Semiotic studies of cinema have attempted to expand upon the idea of film as a language in broad Saussurean terms, the image being a signifier imprinted directly from its object onto the film itself, fragmented into fractions of a sec-ond though it may be. Roland Barthes suggests that photography is uniquely imbued with the power to capture a realistic image, being the most literal way to translate a picture of the world to an indexical referent. He contends that 'the photograph possesses an evidential force, and that its testimony bears not on the object but on time. From a phenomenological viewpoint, in the Photograph, the power of authentication exceeds the power of representation' (1982: 88). Objects in a photograph are therefore not coded, but directly relat-ed to their referent, but the idea of a direct reproduction of the real becomes increasingly deficient when applied to moving pictures. The placement of the camera, the selection of atmospheric and temporal conditions all immediately affect the nature of the image taken, and special effects and post-production work operate in the gaps between recording and reception, subverting the in-dexical relationship between object and image by proffering an arsenal of tools for altering the pictures. The moving picture is always mediated, and how-ever much a filmmaker tries to remove the evidence of aesthetic or technical choices, they are always present, awaiting detection and interpretation. Surely the study of cinema must begin from a foundation that assumes this simple

fact – that film's claim to essential realistic properties is as erroneous as that of any other medium, if not more so, due to the capacity for deception which is concomitant with its status as a truthful device. There is an indexical relationship between King Kong's knee-high puppet and the image of King Kong, but it does not follow from this that the camera has actually filmed a giant ape.

Paul Willemen has decried 'the waning of the indexical dimension of the image and the consequent changes in its relation to the subjectivity … which animates and supports the publication of images' (2000: 5). His antipathy towards the digital image is based on the ease with which it can be manipulated to generate new meanings. Willemen fears an onset of anti-intellectualism brought about by the delegation of mental labour to computers, with representations becoming 'mediated through keyboard commands and clicks of mice' (2000: 17). His response to new technology is typical of an attitude presented by Martin Heidegger in 1954, who claimed that technology does not liberate its user, but merely prescribes a limited set of new possible courses of action (see Heidegger 1977). It is a common fear amongst technophobes that something vaguely understood as humanity is lost when one completes functions using a machine, but the personal computer's CPU (central processing unit), with its superhuman powers of calculation and output has heightened this impression of encroaching mechanical proliferation.

Brian Winston has seen digitalisation as a displacement of the essential integrity of the photographic image, since 'absolute indetectability, for the first time, is undermining the mimetic power of all photographic processes' (1995: 6). Winston is concerned in this case with a reassessment of filmed reality in the form of John Grierson's documentary aesthetic, and refers to something called a 'scitex', a process of digitally retouching a photograph, similar in principle and effect to airbrushing. The existence of this capability makes it harder to trust the picture from which one seeks the truth, but what it might usefully bring to light (instead of being an opportunity to deceive the viewer wherever possible) is how untrustworthy the image has always been, always selected to back up a particular ideology or to illustrate the viewpoint of a news report. It is the credence lent to the photographic image (with its dubious mantra 'the camera never lies'), which gives it its illustrative capacity at a level superior to artists' drawings. The photograph suggests the eye of a witness present at an event and viewing it firsthand, but the same photograph may be selected from hundreds, even thousands taken at the scene. Any innovation that downgrades the credibility of the image can be seen as contributing to a healthy culture of inquiry as to its veracity. The proliferation of digital effects in fantastic, mainstream entertainment makes such a contribution in that it makes associations

between digital technology and disbelief, and the accompanying extratextual information which shows how such effects are achieved consolidates the skills of a spectator equipped to analyse the image.

Rather than explaining cinema as a fully cultural phenomenon, Bazin tries to attribute an absolute 'newness' to film, defining and examining its origins as a photographic form with an indexical relationship to its referent. The lapse of the indexical in the digital age would indicate that Bazin was mistaken, that cinema's cultural identity is more enduring than its technical make-up, and thus that its base material, be it digital or photochemical, is not relevant to the spectator. Yet, we have forms of realism that cling to the photographic as real, which simulate the photographic qualities of the medium. In such instances, mainstream cinema is maintaining Bazinian aesthetic ideals.

Special effects technicians have learned that an impression of greater realism can be given by simulating practical flaws inherent in photographic processes. For instance, the computer-generated dinosaurs in *Jurassic Park* appear to be more credibly present because artificial motion blur has been added to several shots to suggest that their speed was too great to be captured precisely on film. The only reason this device adds realism is that the viewer has come to expect certain photographic properties to be visible in the films they watch – it is not a reference to the relationship between the human eye and the object, but a mimicry of the relations between object, camera and eye. There is a paradox here in the way that the digital replaces the indexical but imitates those properties of the photographic image which signal its indexicality – the photographic idiosyncrasies which remind us of the photochemical reactions required to record on celluloid.

Perceptual realism

Metz finds one of the most vital issues in cinema studies in the '*impression of reality* experienced by the spectator' (1974: 4). Films can be 'very convincing' in the effects they present to the audience. Metz attributes much of the massive popularity of cinema to the appeal of 'a presence and of a proximity that strikes the masses and fills the movie theatres' (1974: 4–5). The spectator feels the presence of the camera, the operator and perhaps the crew; we have an intangible awareness that we are occupying the space where the crew is standing on the set. Watching a film is closer to the act of viewing the outside world than is say, looking at a painting or reading a book. There is less interpretative work for the spectator to perform. A film exists in time and perspectivally simulated space.

Metz finds tactility to be important in the experience of filmic simulations of reality:

> Movement is insubstantial. We see it, but it cannot be touched, which is why it cannot encompass two degrees of phenomenal reality, the 'real' and the copy. Very often we experience the representation of objects as *reproductions* by implicit reference to tactility, the supreme arbiter of 'reality' – the 'real' being ineluctably confused with the tangible: There, on the screen, is a large tree, faithfully reproduced on film, but, if we were to reach forward to grasp it, our hands would close on an empty play of light and shadow, not on the rough bark by which we usually recognise a tree. It is often the criterion of touch, that of 'materiality', confusedly present in our mind, that divides the world into objects and copies. (1974: 8–9; emphasis in original)

The tactile nature of an image comes to the fore in special effects. The CG character, during its creation, is passed through several basic stages of development towards its most 'realistic' final version – first plotted as a series of co-ordinates in a virtually three-dimensional space within the computer's memory (itself translating binary information into pictorial representations which can be understood by the operator), then given motion and choreographed actions, before being fully rendered with textured coatings. These textural simulations provide the fetishism of reality in CGI – playing on the Metzian idea that touch is the 'supreme arbiter' of reality, the variety of extreme or heightened textures on display (dinosaur skin, metallic sheens, fur, moisture, ice) teases the viewer with the possibility of touching these objects.

Stephen Prince has argued that CGI exhibits 'perceptual realism', acknowledging that a fantastic object or character can be imbued with characteristics that render it more acceptable to the viewer's perception of it as an indexical referent. He observes that the dinosaurs of *Jurassic Park* were 'images which have no basis in any photographable reality but which nevertheless seemed realistic' (1996: 28). 'Perceptual realism' breaks from conventional discussions of filmic realism, which have tended to focus on the camera's ability to capture life as it is, as opposed to its capacity to make the unreal seem actual, or its capacity to reorder the footage to create an authorised, persuasive viewpoint. Prince sought to provoke a re-thinking of conceptions of filmic realism which hinged upon indexicality as the arbiter of presence:

> A perceptually realistic image is one which structurally corresponds to human audiovisual experience of three-dimensional space. Perceptually real-

istic images correspond to this experience because filmmakers build them to do so. Such images display a nested hierarchy of cues which organise the display of light, colour, texture, movement, and sound in ways that correspond with the viewer's own understanding of these phenomena in daily life. Perceptual realism, therefore, designates a relationship between the image or film and the spectator, and it can encompass both unreal images and those which are referentially realistic. Because of this, unreal images may be referentially fictional but perceptually realistic. (1996: 32)

In effect, then, CGI is aiming to match the viewer's expectation of how an object or creature will behave in a given situation, with a visualised depiction of one possible outcome. The viewer is given cues as to what to expect. To continue using *Jurassic Park* as an example, its dinosaurs are digital renditions of creatures we have seen in books and documentaries as artists' impressions based on fossil information and a mixture of archaeological and speculative data. The viewer knows roughly how to expect large animals to move – the digitial animators from Industrial Light and Magic took excursions to zoos in order to study the movements of animals and to match versions and amalgamations of those movements to their dinosaur characters in order that they might be seen to be moving in a manner which corresponds to viewer expectations. By aligning the animation with scientific study and real-life observation, it is able to gain credibility as perceptually realistic, even without an indexical relationship between the image and its referent.

In this sense, it seems obvious that perceptual realism does not bind the technology to an aesthetic or thematic realism and, consequently, that it makes no pretence of being the tool of truthful representation. The sheer number of impossible creatures and landscapes conjured through CGI is evidence that its illusory capacities are not being employed in the service of anti-indexical representations so much as they are used to depict things which have no real-world referent. Not only does *Jurassic Park* assume that the audience is fully aware that dinosaurs do not exist in the real world, but it also thematises their very non-existence in a narrative about their technologised re-creation. The perceptually realistic techniques applied to the digital rendering of the dinosaurs (motion blur, textured skin) are a considered impersonation of indexicality which exploits those very photochemical idiosyncrasies which gave the photographic image its claim to verity. The technical trammels which caused us to associate particular apparatus with unmediated presence can now be simulated, not for the purposes of absolute deception, but in order to lay bare the fraudulent endowment of inherent belief in the image and the technologies

behind it. Bazin saw the camera as essentially honest because it is a mechanical device, with no politics, ideology or bias. Its mechanical nature prevents it from intervening between image and referent. Special effects *are* those interventions, subverting the integrity of the image's relation to its referent, which break down the blind trust that the viewer has been conditioned to place in the film, and, by extension, all visual media. A photographic image will no longer be trusted as being a 'certificate of presence', and will even be shown to have barely ever possessed such properties of truth (Barthes 1982: 87).

Umberto Eco has claimed that the aim of simulacra is to abolish the referent by substituting for it a sign that will be taken for the real thing, hence the drive towards perfect reproductions, particularly in historical recreations, which aim to 'assume the aspect of a reincarnation' (1986: 7). Eco sees the entertainment industry as producing signs which look so much like their referents that 'when there is a sign it seems there isn't one, and when there isn't a sign we believe that there is. The condition of pleasure is that something be faked' (1986: 52). In the face of this attempt at sign/referent interchangeability (and we should remember that its total achievement is not possible), Eco also urges a utopian conception of spectatorship whereby all viewers become vigorously interpretive in seeking the codes between the source and its reception (1986: 142). Special effects, with their inherent desire to give the game away and announce their synthetic make-up, are the guiding beacons to viewers seeking these codes in cinema.

CHAPTER 1
The Magic Theatre

These audiences come with no reverence, as the audiences of fifty years ago, impressed in most instances with the superstition that the performer relies upon supernatural aid. For the most part they are as intelligent as he, and know as well that his seemingly contrary effects are produced from perfectly direct and natural causes. Their mission is to detect his methods or to find amusement and wonder in his cleverness. (Herrmann 1892: 208)

The earliest phase of cinematic production and exhibition has been referred to by Nico de Klerk as a 'novelty period', during which the technical possibilities of the filmmaking apparatus were attractive to audiences, particularly due to 'the verisimilitude of its representations' (1999: 5). The Cinématographe offered what Stephen Heath has called 'machine interest', a chance to observe the workings of the apparatus in processing images, rather than simple access to documentary footage of everyday life (1980: 1; see also Williams 1983 and Cartwright 1998: 200–1). Responses to early film were not focused purely on the amazing *resemblances* which the equipment could conjure, but also on the 'novelty and strangeness' of those images (Grieveson & Krämer 2004: 1). Audiences were not responding to the *reflection* of real life onscreen as much as they were enjoying its *transplantation* into two-dimensional forms. The inherent transparency of visual effects, their dependence on the spectator's complicity in the illusion, has been a crucial component in their construction

since the earliest days of cinema. These characteristics can be attributed in part to the influence of practical conventions from the magic theatre of the nineteenth century. Science and magic were two disciplines that offered different ways to receive information about technological innovation, and this chapter seeks to investigate the connections between early cinema, the culture surrounding magic theatre, and the audiences they shared in common.

The aim of this chapter is to show that the aesthetics of illusionism were central to the formation of early cinematic style and technique, and provided audiences with a template for the reception of mechanical novelties such as the Cinématographe, the film camera/projector first demonstrated publicly by Auguste and Louis Lumière in 1895.[1] The Cinématographe was not merely a scientific tool that was later purloined for the purposes of artifice by a coterie of fantasists. Nor was it a frivolous conjuring trick but rather a combination of both, negotiating the same interactions between science and entertainment that had come to characterise the magic theatre of the nineteenth century. As Michael Chanan states, film was always 'an art of both realism and illusion, veracity and deception, transparency and trickery' (1996: 117). It never demanded unquestioning credence from its audience, and nor were its spectacles reliant upon the naiveté of audiences, despite scattered claims of a few credulous unsophisticates fleeing from the approach of the Lumières' train.[2] Chanan also notes that the veneer of authenticity that was attached to photography was matched by 'the seeds of a greater and more intense fabrication' (1996: 119). In other words, while the photograph was initially perceived as 'a guarantor of a new realm of visual certainty', it bore simultaneously the potential for subversions of such spectatorial faith via its capacity for granting illusory images access to its cachet of verity and thus setting off a perceptual incertitude about the constitution of images (Gunning 1995: 42). It will be argued in this chapter that inquisitive, critically engaged and discerning responses to the new media technologies were fostered in part by the promotion of access to 'inside' information, the 'backstage' information that equipped spectators with a grounding in the formal and mechanical properties of the apparatus and gave them the critical tools to compare, contrast and distinguish between the various filmic practices with which they were presented. The English-language programme for the first Cinématographe shows in Britain features an explanation of the scientific principles of persistence of vision, furnishing viewers with technical information, and linking the new machine to the optical toys which preceded it, as if to contextualise the apparatus not as an eruptive invention but as a continuation of extant visual cultures (see Ceram 1965: 182).

Crucial to this study of the interactions between magic and early cinema will be Georges Méliès (1861–1938), so often the starting point for histories of cinematic illusion and science fiction. Sean Cubitt has referred to the elevated status of Méliès' work as 'the canonical origin of special effects movies, of the appropriation of mechanical perception for the purposes of fantasy' (1999: 119). Méliès is often just a convenient father figure whose selected works can be framed as precursors of modern science fiction and fantasy (see, for example, La Valley 1985). This view actually tends to single him out as some sort of prophet, an early adopter too forward-thinking to be influenced by the conventions of his age. It extracts Méliès from pre-cinematic culture as if to position him as a kindred spirit of George Lucas, rather than as, in Laura Mulvey's words, 'the family relation between' magic and cinema (2006: 34).

By situating Méliès as a liminal figure negotiating the processes of adapting the conventions of stage magic for the screen, we can see how early trick films bear the patina of theatricality and promote the same spectatorial modes as the Victorian magic shows which inspired him. While the aim here is to provide a way of understanding how spectators engaged with magic tricks of the stage and screen, it is also hoped that a template for such engagement that will carry through to subsequent chapters can be set up, suggesting a way of reading special effects as spectacular moments which demand the complicity of the viewer in the illusion.

It is not the aim to suggest that magicians were necessarily concerned with the edification of their spectators, but that the institutionalisation of magic as a technical, formalised set of entertainment conventions fostered a kind of spectatorship that was prototypical of the viewing practices which can be seen as prevalent in special effects films of later years. Theatricalised magic moved beyond sensory spectacles of scale and magnificence towards the kind of visual conundrum that hinted that somewhere in the stage-view could be detected traces of mechanical apparatus, wires or mirrors, all hidden in plain sight. Even if the performer's skill was sufficient to conceal these traces completely, the creation of the search is the significant point here. Managing the doubts, expectations and perceptions of the viewer is the task of all the techniques that regulate the viewer's knowledge of an illusion.

Victorian magic theatre

Integral to the commercial viability of magic theatre in the nineteenth century was the dilution of its associations with the occult and with timorous superstition. In the seventeenth century in particular, alchemy, astrology, conjuring

and witchcraft were widely practiced, but they were to become less tolerated in the subsequent century. As Stuart A. Vyse remarks, 'this waning influence of the supernatural occurred at a time of rapid scientific and technological development. The magical arts were severely threatened by advances in the natural sciences, such as [Robert] Boyle's descriptions of the behaviour of gases and Newton's theory of gravitation' (1997: 13). Pascal, Bernoulli and other European mathematicians gave people theories of probability 'that provided alternative explanations for misfortune and helped to objectify the interpretation of everyday events', while improvements in communications meant that communities were less isolated and were allowed freer access to information and knowledge (ibid.). In *Religion and the Decline of Magic*, Keith Thomas argues that magic was not decaying simply because of technological advances that replaced faith in the supernatural, but rather that magic was dissolved by a change in the popular psyche, by 'the emergence of a new faith in the potentialities of human initiative' (1971: 661). Most importantly, at least for the sake of this argument, the rising prominence of conjuring as a theatrical art form demonstrates the taming of illusionistic practices, the reduction of occultism to a thematic trace element (as opposed to a *raison d'être*), and the alignment of magic with standardised, mechanised practice.

Roberta McGrath has located the period 1795–1895 as 'a bridge between an old world and a new' as natural magic emerged as 'a precursor to science fiction' and entertainment converged with education (1996: 13–14). The Royal Polytechnic Institution Gallery of Sciences, opened on 6 August 1838, was a place where (mostly middle class) members of the public could go to see demonstrations of the latest technological wonders, whether they were new forms of automata, steam engines or other mechanical devices. It was 'a microcosm of commerce and manufacture' which 'drew no distinction between art and science, amusement and instruction' (McGrath 1996: 18). There were two theatres on the premises, one used for lectures and parlour conjuring, the other given over to optical entertainments, the most popular of which were magic lantern shows by entertainers such as Henry Langdon Childe.

By reducing the magic trick to a series of disguised scientific mechanisms and announcing their knowledge of its workings, the Victorians could stress their sophistication while indulging their own fascination with the occult, the magical and the superstitious within a respectable, rational environment. Simon During refers to this contradistinct art form as 'secular magic', differentiated from earlier formulations by the fact that it 'stakes no serious claim to contact with the supernatural' (2002: 1). While the themes of magic performance were suffused with ethereality, phantasmagorical characterisations and

impossible powers, the theatrical trappings legitimised interest in such unsavoury subject matter. As one anonymous commentator, dubbing himself 'an amateur', noted in 1882:

> In olden days, devotees of the black art incurred the risk of being burned as wizards or ducked as witches, according to their kind, male and female, and of receiving other unpleasant tokens of popular disfavour. In our own times, its professors make a very good thing out of it; and the public, so far from wreaking vengeance on them in life or limb, will rush to a 'magical entertainment' with greater eagerness than to almost any other minor form of amusement. (1882: 800)

London's Egyptian Hall (opened in 1812) had initially housed the London Museum of Natural History, where sensational exhibits such as Napoleon's carriage, captured at the battle of Waterloo (1816), conjoined twins Chang and Eng (1829) and the world's largest electromagnet (1846) were displayed (see Bacon 1902). In 1846, an exhibition of 'the missing link' (later unmasked as a costumed actor) added another popular point of entry to the evolutionary debate, indicating how science and spectacle could be interconnected. It catered for all kinds of entertainment until John Nevil Maskelyne and George A. Cooke took over (on 1 April 1873) and turned it into a specialist magic theatre, employing magicians such as David Devant, Charles Bertram, Buatier de Kolta and Charles Morritt. Maskelyne espoused virulent opposition to the practice of Spiritualism, an antinomy that may have stemmed from his conviction that it was descended from the deceptions of ancient rulers who 'raised their secret rites above the comprehension of the masses, and bound them in the irresistible thraldom of superstition' (1878: 87). The placement of such illusions in the context of popular, 'safe' entertainment divorced magic from its history as the tool of fearful despots, but also allowed the audience a sense of superiority over 'primitive' peoples, the sense that this was an essentially modern pastime for which previous generations had been unprepared. As Maskelyne reassures us, 'modern investigation and learning have stripped the pagan rites of the supernatural cloak, and these priests stand before mankind as tricksters, clever and unscrupulous jugglers' (1878: 88). Ancient uses of natural magic depended on 'knowledge of optical laws and appliances, with which the majority of people are not acquainted' (1878: 90). An emphasis on disclosure, on revealing the 'tricks of the trade' is one way to fend off charges of mysticism and to keep up a discourse about the self-reflexivity and technological awareness that is essential for the spectator's reception of a spe-

cial effect. Of course, this principled stance may in itself have been a sort of posturing: spiritualists and conjurors were using many of the same tricks for their effects, and were both cashing in on swathes of public interest in the supernatural. If the supernatural provided a common *theme* for both types of performance, the contexts in which those performances were given could demonstrate crucial distinctions.

In Victorian magic shows, the application of scientific knowledge to fantastic entertainment indulged spectators' fascination with innovation and modernity – 'chemistry, electricity, optics, pneumatics, and most of the ologies' were used in the production of 'magical entertainment' (Anon. 1882: 803). Designating science as 'magic which actually works', Simon During posits the two as 'intimate enemies', though their relationship may be mutually supportive rather than explicitly antagonistic (2002: 20). Magic theatres were showcases for new inventions, where they could be displayed in entertaining contexts – the shock of the new would be palliated by the theatrical atmosphere and turned into a pretext for amusement. Edwin A. Dawes has commented that conjuring was a favourite method used by scientists to 'sugar-coat the educative pill' during demonstrations (1979: 8).

Scientific demonstrations were more easily communicable to the audience within entertainment contexts, particularly the magic show, though Henri Robin, a Dutch magician and owner of the Théâtre Robin in Paris from 1862–69, discovered that a balance had to be struck between science and showmanship while performing at London's Egyptian Hall. At one show he included a monologue about the logistics of lighting the whole of London with electricity, to a disappointed audience, who demanded that future shows replace the lecture with more from Robin's repertoire of vanishing acts (see Lamb 1976: 35). It was clear that there could be distinct fora for scientific lectures presented entertainingly, and entertainment with a scientific theme, and it is in this capacity of mediation between education and amusement that cinema was turned from a tool or scientific instrument, as it may have been used by Eadweard Muybridge or Étienne-Jules Marey, into a popular entertainment attraction. As an anonymous writer for *All the Year Round* noted, science 'fulfils the pretensions of Magic; it is Magic grown modest' (1861: 562).

The exemplary events which will serve as a link between magic as the cultural or scientific phenomenon described above and its position as a popular form of entertainment are the 'quasi-political' mission to Algeria undertaken by Jean-Eugène Robert-Houdin, France's most celebrated magician, and the discrediting of the Davenport Brothers spiritualist act by Maskelyne and Cooke. Erik Barnouw, in his book *The Magician and the Cinema*, remarks that

in the nineteenth century, 'the magician made it his business to stay a step or two ahead of public understanding of science', (1981: 11) and Robert-Houdin demonstrated this when he was sent to Algeria in 1856 to perform in front of crowds whom the French government considered dangerously close to an uprising, 'stirred to a rebellious state by wonder-performing holy men' (ibid.). If Algerian magicians were proclaiming the 'magical' power and strength of the nation's people, the French colonists saw fit to use the same device by sending in one of their own magic men to prove that the foreign rulers had even greater supernatural force on their side. Robert-Houdin's finale incorporated the 'light and heavy chest', a trick that had been a staple of his act since 1845. It saw the strongest members of the audience unable to lift an iron box which the magician himself had no trouble raising – it clung to the stage inseparably once Robert-Houdin activated an electromagnet concealed beneath the floor. Another trick applied agonising electric shocks to 'volunteers' (the entire audience had been *ordered* to attend, on the authority of the country's French diplomatic governor) challenged to pit their strength against the conjuror's powers. This aggressive deployment of electromagnetic spectacle was reportedly successful in convincing the 'primitives' that the colonialists were 'their superiors in everything' (Robert-Houdin 1859: 373).

Robert-Houdin is often credited with initiating a new wave of respectability and refinement amongst magicians, most notably in his donning of a top hat and tails as opposed to the more usual robe and pointed hat. He was 'a gentleman whose finer art was concealed by simplicity' (Jenks 1901: 520). Most importantly, Robert-Houdin redefined the role of the magician as that of a mediator between the mechanics and the execution of an illusion by proclaiming himself as their inventor and operator; he did not brand himself as a sorcerer materialising matter from nowhere, but as a sophisticated practitioner of a scientific mode of entertainment.

In his rather self-aggrandising memoirs, Robert-Houdin discussed what he believed to have been his 'complete regeneration in the art of conjuring', claiming that:

> I wished to offer new experiments divested of all charlatanism, and possessing no other resources than those offered by skilful manipulation, and the influence of illusions. (1859: 236)

Was he really so open and generous with his magical gifts and secrets? His Algerian mission might be seen as a rather extreme example of absolute deceit as a gesture of superiority over uninitiated spectators, attempting in the

process to define the colonial rulers by their correlative sophistication to their subjects. As Robert-Houdin put it in his memoirs:

> These false prophets and holy Marabouts, who are no more sorcerers than I am, and indeed even less so, still contrive to influence the fanaticism of their co-religionists by tricks as primitive as are the spectators before whom they are performed. (1859: 372)

At his own magic theatre, the Théâtre Robert-Houdin in Paris, which saw its first performance by its proprietor on 3 July 1845, Robert-Houdin would exploit both the public's awareness of scientific innovations, and their ignorance of those same innovations' practical applications. One of his earliest tricks was to anaesthetise his six-year-old son on stage using ether, which was becoming commonly and controversially used as a medical anaesthetic during the 1840s. He would then perform a basic levitation illusion with the boy, proclaiming that the ether had made him lighter than air (see Lamb 1976: 34). Some audience members may have feared for the boy's safety due to the uncertain effects of the gas, but he was simply drinking coloured water. By exploiting current scientific debates, Robert-Houdin had tapped into a public fear and reframed an old and oft-repeated trick (levitation) within a modern context, offering a 'logical' solution to the mystery, which might distract the audience from the mechanical apparatus which actually enabled it.

Particularly in ethnographic social anthropology, magic tends to be rendered synonymous with superstition and used to connote the primitive beliefs of peoples isolated from Western rationalism. Sir James George Frazer's *The Golden Bough*, first published in 1890, but more famously re-issued from 1906 to 1915 as a 12-volume study of magic, myth and religion, investigated shared beliefs from around the world. Frazer differentiated between the primitive, who can engage with homeopathic or contagious principles but does not understand the science behind them, and the scientists and physicians of Western communities who apply the same principles within a nexus of knowledge that has enabled them to profess a complete comprehension of how the effect is achieved. An article on 'Magic and Science' from Charles Dickens' weekly journal *All the Year Round*, remarked that 'what to the cultivated mind seems a physical impossibility, to the uncultivated seems as probable as anything else' (Anon. 1861: 562). In other words, if the audience was cultured and intelligent, it would enjoy the magic tricks without needing to believe that they were real. Being taken in by a trick was a sign of untrained ignorance.

The second emblematic event was Maskelyne and Cooke's exposure through imitation of the Davenport Brothers' spiritualist act. Ira Irastus (1839–1911) and William Henry Harrison Davenport (1841–1877) were professed spiritualists from Buffalo, New York who attracted popular attention with an act that saw them tied and handcuffed in a large wooden cabinet, along with a guitar, a trumpet, a tambourine, a set of bells and a violin. Moments after the cabinet was closed, the instruments would be heard, and the bells would ring. When the cabinet was opened for inspection, the brothers were still bound hand and foot. They began performing this act in the 1850s and continued until William's death, though Ira reproduced it on a farewell tour with the conjuror Professor J. F. Day in 1879.

On 7 March 1865, the brothers performed at Cheltenham Town Hall, to an astonished full house. In attendance was John Nevil Maskelyne, who immediately discerned the trick and set about producing a reproduction. On 19 August of the same year, he and Cooke performed the same illusion at the same venue, calling for the spiritualists to be discredited (see Jenness 1967: 23). Maskelyne was an illusionist and anti-spiritualist, but also an inventor, holding more than forty patents for items such as a cash register (1869), a typewriter (1889) and a film projector (1896), and a coin-operated lock used on public lavatories from the 1890s to the 1950s (see Anthony 2001: 85–6). His exposure, with Cooke, of the Davenport Brothers, was a significant boost to his career.

Despite the exposition of the trick, and with the brothers refusing to admit that they had been discovered, the controversy gathered momentum. Maskelyne's interventions were refuted, and there were riots at Davenport shows in Liverpool, Huddersfield, Leeds and Paris in 1864 amidst claims of blasphemy in the brothers' performances (see Fitzsimons 1980: 74). Maskelyne's particular objections to mediumship lay partly in some anti-Christian declarations made at the conference of the National Association of Spiritualists in 1873, but also in its appropriation of ancient conjuring tricks. The Davenport Brothers restaged escapological feats, while other mediums used mind reading tricks, confederacy or apparatus to achieve spiritual effects. The recourse to such tools was only to be considered immoral if it was not advertised as an illusion. A conflict of interests lay in the way tricks should be presented, how they should be packaged for popular consumption. In his 1875 book *Modern Spiritualism*, Maskelyne condemned spiritualists who claimed links to Indian Fakirs in order to add an ancient credibility to their acts (he is even billed on the title page as 'Illusionist and Anti-Spiritualist', in case his position on the matter might otherwise have seemed ambiguous). He seemed to be trying to

urge a new conception of magic as self-conscious, self-reflexive – a modern and technologically-aware art distinct from its superstitious history. Spiritualism was not just strong competition to illusionism in the pursuit of audiences – the common origins in conjuring made it a professional embarrassment.

The Davenport Brothers never openly proclaimed their own supernatural abilities, but nor did they deny them. They were accompanied on tour, and introduced onstage by a Unitarian minister known as Dr Ferguson, who was firmly convinced of their veracity and whose sponsorship doubtless inspired credence in many viewers. They were subjected to scrutiny, and the controversy around their act only served to increase its popularity once it was established as a talking point. It is impossible to know what proportion of the audience was convinced by the show, or what proportion was merely relishing the excitement of witnessing the spectacle of a supernatural fiction.[3]

Ira Davenport disclosed the secrets of the Brothers' act to Harry Houdini at a private meeting in July 1910. The brothers had been escapologists, who could remove their hands from the bindings, play the instruments, and occasionally insert their hands through gaps in the cabinet, claiming that they had summoned hands belonging to spirits of the dead. It was a basic trick dressed up in the guise of Spiritualism. Houdini expressed distaste (cynics might call it professional jealousy) for such deception. Davenport admitted that the religious context of the act had made it seem more believable, and that the brothers did not reveal the secret because they did not believe that escapology alone was sufficient to arouse audience interest (see Fitzsimons 1980: 80–1).

It was this level of exploitative pretence which Maskelyne and Cooke would continue to refute, and they set the tone for the flourishing of secular magic, removing the suggestion of supernatural forces from their act – the paranormal became a *theme* of their work (as it was with almost all magic performance), without being part of its professed methodology. Many spiritualists looked to mechanical apparatus for evidence to back up the claims of contact with the deceased. Since séances themselves took place in 'complete, Stygian darkness' (Price 1905: 109), their effects were not susceptible to photography; nevertheless, many mediums used so-called spirit photographs as evidence of their abilities. A pamphlet from 1909 records the beginning of the spiritualist age as 1848, when the first (accidental) spirit photographs began to appear, offering, by virtue of their objective mechanism, 'irrefragible proof' of the existence of spirits (see Morse 1909: 4). William Marriott had noted that these were instead accreditable to 'the clumsiness of an incompetent photographer', but they marked a point upon which Spiritualism could be differentiated from other religions through its association with scientific apparatus (c.1890: 162).

The perceived incorruptibility of photography provided spiritualists with the physical evidence whose prior absence had frustrated their efforts to be taken seriously. The first example of the deliberate production of spirit photographs is attributed to William Mumler of Boston, 5 October 1861. Mumler had been attempting a psychic self-portrait (sometimes called a 'dorchagraph'), for which photographic images were imprinted onto a plate using only the power of thought (see Nickell 2005: 192), and claimed that an image of his dead cousin had appeared on the plate. He went into business producing similar effects for paying customers; when he was brought up on fraud charges at the Tombs Police Court, New York, in 1869, it was the testimonies of his clients, including an endorsement from the wife of Abraham Lincoln, which saw him acquitted (see Gettings 1978: 23–5). The use of spirit photographs as evidence of supernatural ability exploited the photograph's status as an instrument of 'true' documentation, but also undermined that status by creating objective representations of demonstrably false phenomena.

While spiritualistic performers were attempting to 'scientise' their art by claiming it to be a verifiable, logical application of newly discovered principles, magicians were 'magicalising' scientific mechanisms and making physical actualities appear to be more spectacular. The status of the magician as an artistic performer would increase markedly during the nineteenth century with more rational considerations of magic as an art form. Superstition and dread, fuelled by ignorance and religion, gradually dissipated, and magicians realised that they could increase their renown by facilitating their further dissolution. Distancing themselves from any of the paganistic connotations of their chosen profession was the best way to improve the status of magic performers, and they embraced science and mechanics, the major components of modernity, thus siding with the kind of rationalism which had depleted the influence of the Church during the Age of Enlightenment.

Distancing his shows from Spiritualism, Maskelyne knew that the tricks were the same whether performed by medium or conjuror. As T. Hanson Lewis put it, Maskelyne was 'fighting trickery with weapons forged at the same smithy' (1985: 75). In 1891, Maskelyne published an exposure of 'The Magnetic Lady', a performer professing superhuman magnetic abilities. He said his aim was to counteract what he called the 'twaddling incoherency' of members of the medical profession trying to explain biologically what Maskelyne knew was a simple deployment of stage props. But he states:

> Had this thing been put before us as a trick pure and simple, I should be the last to say a word in explanation of the *modus operandi*. No right-thinking

man would interfere with another's efforts to gain an honest living. But when we are told that a person exercises abnormal powers born with the individual, it becomes our duty to sift the matter to the bottom. (C.1891: 3)

In this sense, we can see clearly how Maskelyne and Cooke's exposure of these performers brands them as apostates of the magic community – the term charlatanry does not, in this context, differentiate between real and fake performers, but points out those who refuse to conform to an ostensible code of conduct. This code is not built around the *protection* of secrets, but around the mode of their performance, and the way in which the spectator is incited to view and to appreciate the art of that performance. Maskelyne notes that mediums and illusionists are performing tricks from the same repertoires, but that 'the conjurors perform [them] so much better!' (1875: 181), while mediums trot out 'stale' tricks 'like old rams dressed up lamb fashion' (1875: 179).

In an article of 1880, Maskelyne noted what he saw as a 'new school of conjurors' inspired by Robert-Houdin, who responded to the specificities of the theatre stage with an increased use of mechanical apparatus, often within the simple staging of a drawing room scene. There was a similar shift in the types of costume commonly worn, from robes decorated with runes or hieroglyphs, or from a capacious apron for storing props (known as a *gibicière*) to evening wear. The 'Poole' jacket advocated by Maskelyne appears to offer no hiding places, but in actuality its capacity is, he says, 'rivalled only by the omnivorous poke of the Pantomime clown' (1880: 151). The stage thus appears to be less loaded with otherworldly potential, and magic is aligned with the sophisticated application of technique.

This drive towards a kind of standardisation, consolidating the fitness of magic for residency in respectable theatrical settings, includes the controlled removal of layers of mystique and the fostering of connoisseurship. Devant's 'Mascot Moth' illusion, which he sometimes referred to as his greatest trick, saw the disappearance of a moth-garbed female assistant, and was first performed in 1905 at St. George's Hall, following the closure of the Egyptian Hall. The new theatre environment encouraged him to re-imagine old tricks. This trick's achievement is notable for the way in which it plays upon audience expectations of how it will occur. At the climax of a short play, the moth lady stands onstage and folds her wings around her body, concealing her face. When Devant moves to touch her, her body dematerialises, disappearing in a rapid upward motion and shrinking away to nothing 'as quickly as an electric light goes out when the switch is turned' (Devant quoted in Steinmeyer 2004: 191).

As Devant described in his book *Secrets of My Magic*, but also in an article for the less specialised *Windsor Magazine* a few years later (1935: 125), while the assistant's body disappeared through a trapdoor in the stage floor, the moth-lady outfit retained its shape (very much like the Buatier de Kolta vanishing lady) but the outfit itself was collapsed and dragged through a tube protruding from the stage and concealed by the positioning of Devant's body. Spectators might have thought they had seen a disappearance before, but Devant altered it crucially. This subversion of expectation, the embellishment of a well-known type of illusion, is a prime example of a dialogic relationship between performer and spectator.

Amongst the most popular illusions of this time were those which dismembered, disappeared or distorted human bodies. As early as 1867, Randolphe H. Pigott pointed out that the 'decapitation' illusion demonstrated at the Polytechnic was over 1000 years old, described in Reginald Scot's *Discoverie of Witchcraft* (1584) and dating back to 876 AD where it was an enactment of the beheading of John the Baptist. By appealing to the heritage of the illusion, Pigott assures us that this observation will 'not diminish the interest of any future visit to the Polytechnic to think that it is of immense antiquity' (1867: 675).

Colonel Stodare's Sphinx illusion, premiered at the Egyptian Hall in 1865 showed a disembodied living head atop a table, using mirrors to suggest that the space below the table is empty. The thauma illusion, as described by Henri Garenne amongst others, seemed to show a woman bisected and perched on a swing from the waist up. Her body was actually behind the swing and blacked out, her head perched on a fake bust – a painful position to hold. Bright lights shone outwards at the viewer to frustrate attempts to peer into the darkened areas of this space. Such spatial distortions ran contrary to, perhaps even reacted against, the staging norms of theatrical drama of the period.

Over the course of the nineteenth century, theatres in England and France moved towards a predominant aesthetic of pictorialism, in response to audience demands for realism. Michael R. Booth records that spectators complained about 'the sheer *theatricality* of production techniques', such as the presence of scene-shifting technicians onstage or visible joins in sets (1991: 75; emphasis in original). Conventional sets became more three-dimensional, but retreated behind the proscenium arch. Intervals lengthened to allow for extensive scene changes, and 'carpenter's scenes' were devised in which actors performed at the very front of the stage to allow further set-ups behind the curtain. Improved (and strengthened) lighting techniques allowed for this retreat from the footlights:

When this happened [an actor] was no longer performing well in front of a pictorial background of wings and backshutters but integrated within a scenic unit, a part of a pictorial composition in three dimensions as well as of a dramatic event. (Booth 1981: 11)

Roy Strong has suggested that the development of stage pictorialism stems from the sixteenth century's increased use of 'indoor spectacles where visual effects can be more easily controlled, where the eyes of the spectator can be almost forced to look at things in a certain way' (1973: 73). Nicholas Vardac has argued that the emergence of cinema is the end result of this development, and that aesthetic preferences for mimetic realism prefigure cinema's delivery upon the promise of increased verisimilitude once stagecraft could advance no further in that direction (1987: xviii). As he suggests, 'the stage constantly endeavoured to create artificially what constituted the very essence of the cinema: pictures in motion' (1987: 19). To Vardac, cinema was the fulfilment of a cultural consensus that things should be depicted realistically onstage, and that cinema's realism lay, at least in part, in its ability to elide all of the cumbersome mechanics of stage spectacle with stop-action edits and instant scene changes – rather than being distinctively cinematic then, these techniques were improved versions of theatrical practice.

If we can see a dominant theatrical aesthetic of pictorialism in the nineteenth century spectacular theatre, then we can see the magic theatre as, in many cases, a grotesque extension of this, as the transformation of the stage performance into a space which has some of the same physical properties of the pictorial stage – that is, the body, and other seemingly solid objects become insubstantial, imagistic. By performing 'impossibilities', stage magicians could defy theatrical codes of verisimilitude, but at the same time their situation within the theatrical space became dependent upon those codes in order to provide a model from which to deviate.

Magic is full of distortions of the everyday. Maskelyne describes the use of boxes and containers which appear to be less spacious than they are, or how blocking out parts of the stage can skew the perspective which the audience has – objects are also designed to fold away into smaller shapes until they are to be made visible on the stage (1880: 152). If standard staging was aiming to synthesise a sense of verisimilitude, then the magic stage was a place where that expectation of integral space was subverted by a great dynamic potential and spatial elasticity, where objects and bodies might at any moment transmogrify, vanish or appear.

Within the respectable confines of the theatre enclosure, magic tricks

would not only take advantage of the greater ability to hide and utilise large apparatus, but would also respond to the new frontal viewing position imposed on spectators, presenting a stage image that was necessarily flattened, viewable only from certain angles. Indeed, the use of mirrors, black velvet backdrops and concealed props necessitated the reinforcement of this fixed viewpoint for such illusions of perspective to take effect.

An examination of the language used in programme notes at some magic shows of the early cinema period is revealing. A companion to 'Maskelyne and Cooke's Mysteries' from around the first years of the twentieth century shows that the programme was worded so as to deflect expectations of supernatural activity and to invite the audience to marvel at a mechanical or scientific achievement:

> Mr David Devant will present a series of magical problems selected from his repertoire of original experiments in prestidigitation, concluding with his wonderful electric hand shadows.[4]

The use of the word 'problems' prompts the audience to search for solutions, to divine how the trick is performed. The prominent reference to Devant's skill as a shadowgrapher highlights his manual dexterity – this was an entertaining portion of the show free from any sinister connotations, in which Devant would punctuate a story with pictures made by manipulating his hands to cast shadows on a screen. The 'electric' of the title merely refers to the fact that he was using electric light to assist him in casting the shadows. Later in the same programme, one of John Nevil Maskelyne's sketches (a magic trick would frequently be framed by a narrative vignette), is thus introduced:

> Maskelyne's amusing and sensational sketch, entitled 'Elixir Vitae', in which a man's head is apparently removed from his body. The illusions are so ingeniously arranged that they are exceedingly amusing, and in no way repulsive.[5]

This note is crucial. Not only does it reassure us that the head is only 'apparently' removed (there is no actual decapitation or accompanying gore), but also that the ingenuity makes the spectacle funny rather than grotesque.

Another programme from 1896 lists other items from a Maskelyne and Cooke show at the Egyptian Hall:

> Original magic problems by Mr David Devant, including his latest mystery, 'The Phoenix', the mechanism of which has been devised and constructed

by Mr Nevil Maskelyne. Mr Devant will conclude with a New and Original Stage Illusion, 'The Birth of Flora', a marvellous and beautiful development from a small square of silk, examined by the audience, and suspended in mid-air. The absence of elaborate apparatus renders this illusion most effective and inexplicable.[6]

Again the spectator is given sufficient information so that they have an idea of what to expect, and can concentrate their faculties on discerning how precisely the illusion is achieved, without obliterating the enjoyment of the spectacle being presented. Just as a modern film viewer will try to 'see the join' between the 'real' footage and a superimposition, without losing sight of the spectacle or the story, so magic theatre audiences were encouraged to spot the moment of sleight-of-hand or other deception.

Devant's famous 'Spirit Wife' act featured the magician in his parlour (recreated on the stage), mourning the death of his wife, only for her to appear, translucent and ghostly, on the stage at his side. An article in *The Strand*, published at the time of the trick's first performances at the Egyptian Hall, revealed its mechanism with the magician's full approval. It was a recreation of the famous Pepper's Ghost illusion, where the translucent figure is projected onto a glass plate at the front of the stage from her actual position below the stage (see Anon. 1897).

John Henry Pepper was, from 1848 to 1872, the Polytechnic Institution's chief lecturer and analytical chemist, attracting huge audiences to his demonstrations of magnetic, electric, pneumatic and astronomical principles. The original idea for the ghost illusion came from a retired civil engineer named Henry Dircks at an engineering conference in Leeds sometime in 1858. Requiring the construction of a customised theatre, the design would have been expensive to implement. Pepper found Dircks' explanation of it 'somewhat vague and unsatisfactory' (1996: 1), and made alterations to the proposal based on his knowledge of theatrical exhibition requirements. A patent for a viable design was placed in both of their names as no.326, 5 February 1863. By placing a large pane of glass at an angle across the front of the stage, an apparition could be conjured by reflecting the light cast onto a performer from a lantern below the stage onto a mirror and directing it onto the glass. The audience would see the performers on stage, alongside a pellucid figure, and meticulous rehearsal could give the impression that the natural and the supernatural were interacting with one another.

The preoccupation with ghosts and spectres in lantern projections, especially the phantasmagoria, is not only an exploitation of tremulous spectators'

superstitions – the ghostly motif represents a comparison of the image with a spirit, both of them being intangible manifestations whose ethereality is one of their defining characteristics – there is a thematic correlation between the depiction of spirits and the projection of light rays to form an image. In 1863, Pepper's Ghost was first exhibited at the Regent Street (or Royal) Polytechnic.

This device prefigures one of the quintessential principles of filmic special effects, namely the photographic superimposition of 'unreal' elements into the frame, beginning with ghosts and other apparitions (something which was already popular in spirit photography – see Gettings (1978), with the caveat that the author accepts the veracity of some spirit photographs) and later the animated simulacra of prehistoric animal species or aliens from outer space, for example. The juxtaposition of 'real' and illusory elements requires the spectator to make sense of their co-existence, in order to construct the scene as a fictional event (that is, to understand the transparency of the 'ghost' as a quality that marks it out as distinct from the human figure). In the process, the viewer makes comparisons of the relative qualities of each component of the illusion, and assesses the interactions between them (see Steinmeyer 2004: 22–43).

Pepper's first show was given privately to 'literary and scientific friends' (1996: 3) in December 1862, but since he had not yet taken out a provisional patent at this point, he deferred the explanation of its workings; Pepper himself claimed that he wanted to include an explanation of the illusion as part of an accompanying talk, but sought only to deter 'duffers' from presenting inferior versions of the illusion (1996: 46; see also Dircks' own account from 1864).[7]

In Devant's 'Spirit Wife' illusion, the trick is incorporated into a short narrative, or at least a tableau of grief, but the most distinctive aspect of this popular spectacle is the way it prompts interaction between the projected image and the theatrical space. Using a conjuror's sleight-of-hand, Devant apparently intensified this frisson of ethereal contact by seeming to take a flower from the ghost. *The Strand* justifies the exposure of Devant's centre-piece trick with the publicity-friendly proviso that 'the popular Egyptian Hall entertainer has so many strings to his bow that he won't miss this one; possibly, indeed, the show may be the more popular hereafter' (Anon. 1897: 780). It is unlikely that many readers were not already familiar with the illusion, whose 'secret' had been published many times since its first public performance in 1863. Revealing how a trick was done did not destroy or diminish the spectacular effect of its performance, but instead held it up for comparison with other performances of similar illusions. Granted inside information, and able to make comparative assessments of several magicians' renditions of the same trick, the interested spectator could acquire an appreciation of the art of magic which went be-

yond the immediate marvels of the illusion itself. Desmond Ryan noted as early as 1868 that even the most modern tricks 'are now familiar, and many who have seen them are not so completely imposed upon as not to entertain a suspicion how they are accomplished. Of feats of dexterity in the conjuring line, exhibited in public, which offer to the adult spectator no possibility of solution, I do not know one' (1868: 577).

Dozens of books and articles were published, exposés of tricks which told readers in great detail how a trick was achieved. *The Boy's Own Paper* serialised 'The Young Wizard' by the conjuror known as Professor Hoffmann, from November 1885 to August 1886, and published a similar serialisation of 'The ABC of Conjuring' by an anonymous Professor of Legerdemain. Hoffmann, a pseudonym of amateur conjuror Angelo Lewis, published nine editions of his *Modern Magic*, after the first edition sold out within seven weeks of publication in 1876 (see Knight 1896: 362–4). In 1894, the monthly magazine *Suggestion* was first published, featuring sceptical articles on psychic and spiritualistic phenomena.

All of these explicatory texts doubled as promotional material for magic theatre, and their diagrammatic, step-by-step formats aligned the tricks with scientific experiments, in which a series of stages could be followed to the expected conclusion – in this case a disappearance or a transformation. In short, anyone who had access to books and journals (and was able to read them), could assuage their curiosity as to how magic tricks were performed. From 1802, they could consult the *British Encyclopaedia*, where the entry on *legerdemain* was an exhaustive explanation of many tricks including 'cups and balls', 'card tricks', memory magic and mind reading. This alignment of magic with popular science rather than the occult even enabled the Religious Tract Society of London to publish their own book, *Magic, Pretended Miracles and Remarkable Natural Phenomena* (c.1860), offering explanations of natural magic as well as practical feats of conjuring – by attributing such phenomena and mechanical deceptions to human, but divinely approved, agency, the Tract could give credit, indirectly, to God, for performances which might once have been branded as heresy. To be fair, the exposure of magic methods was not a nineteenth-century innovation. John Melton's *Astrologaster* (1620) announces itself on its title page as 'the Arraignment of Artlesse Astrologers, and Fortune-tellers that cheat many ignorant people'. Henry Dean's *Hocus Pocus*, first published around 1720, was a compendium of magic tricks, lantern techniques and conjuring acts, mainly sleight-of-hand and coin and card work. The last page of the book is a full-page advertisement for Dean's London shop, which supplied all of the tools required to perform the tricks described in the

text, along with the reminder that 'there is not a Trick that any Juggler in the World can shew thee, but thou shalt be able to conceive after what manner it is perform'd' (1727: 132). In the nineteenth century, what changed was the extent to which magicians were prepared to trumpet the prosaic origins of their art and to demythologise their craft. This did not just protect consumers from confidence tricks and fraudsters; it also empowered them as spectators. Rather than stemming curiosity, a certain amount of this background detail was considered by magicians to be essential in attracting audiences who were literate in the magic arts and could therefore tell a great performer from a poor one. This is not to say that no spectators were duped or confounded, but rather that the standardisation of magic practice encouraged a response from its viewer which included rational reflection along with the customary amazement, creating a dynamic collision between rational methods and fantastic appearances.

In *Magic in Theory*, Peter Lamont and Richard Wiseman explore the interactions between magician and spectator, suggesting not only that the spectator, having witnessed an illusion, will try to reconstruct events in order to understand how the effect was achieved, but also that the magician may try to 'actively influence the reconstruction process' (2005: xi). This strikes me as an excellent summation of the process whereby the performer mediates reception, applying misdirection to delay the correct deduction of the trick's exact solution (one might know that a levitated assistant is suspended on wires, even as one struggles to see them). But the spectator is not unarmed during this process. She might possess knowledge of prior instances of similar effects and other performers, for instance, or secrets of illusion gleaned from published exposés. The exchange between stage and audience is bi-directional and provocative, rather than doctrinaire and stultifying.

In his autobiography, *My Magic Life*, David Devant stresses the importance of rehearsed performance in staging a magic act. He would practise his patter to help himself to confidently engage the audience without being distracted from the intricate sleight-of-hand upon which he was concentrating. He even offers advice regarding lighting and atmospheric effects:

> I would impress upon any conjuror producing a show the importance of a good colour scheme and the wisdom of avoiding ugly contrasts ... The wrong colour scheme can ruin a show. (1931: 21)[8]

Showmanship was of prime importance to Devant, and in one of his instructional guides, he stresses that 'many people have the erroneous idea that if

they know how a trick is done they are quite capable of presenting it to an audience' (1915: 9), later adding that,

> the presentation of the trick is everything; the little secret round which the performance has been woven is comparatively unimportant ... [A] conjuring performance cannot be properly and thoroughly appreciated by anyone who does not know something about the art ... When a member of an audience knows that secret he ceases to be curious about it, and so devotes his whole attention to the way in which the conjuror presents his little fairy story. (1931: 101)[9]

Elsewhere he breaks magic down into seven basic areas, claiming that there are really only seven kinds of trick which are then presented in manners limited only by the imagination of the performer.[11] Perhaps more succinctly, Henry Ridgely Evans has quoted Robert-Houdin as having reduced magic to five areas of possibility:

1. Feats of dexterity: the hands and tongue being the only means used for the production of these illusions.

2. Experiments in natural magic: experiments devised from the sciences, and which are worked in combination with feats of dexterity, the combined result constituting 'conjuring tricks'.

3. Mental conjuring: a control acquired over the will of the spectator; secret thought read by an ingenious system of diagnosis, and sometimes compelled to take a particular direction by certain subtle artifices.

4. Pretended mesmerism: imitation of mesmeric phenomena, second-sight, clairvoyance, divination, trance, catalepsy.

5. Mediumship: spiritualism or pretended evocation of spirits, table-turning, rapping and writing, mysterious cabinets etc. (Quoted in Hopkins 1977: 2)

Even in the first edition of 1487, Heinrich Kramer's *Malleus Maleficarum* was denoting seven categorisations of which all magic tricks were a variation. Since there are so few forms of magic trick, the skill, as professed emphatically by Devant, lies in the presentation, in the artist's ability to captivate the audience with a miniature narrative that traces, for instance, an object's selec-

tion, presentation, disappearance and reappearance – a progressive narrative framework is an essential part of the trick, a way of hooking the audience, entertaining them while subtly evading their faculties of discernment.

Devant was aware that the audience were constantly trying to discern the secrets of his tricks, so his dialogue and gestures were vital tools in distracting their eyes from whatever prestidigitation he did not want them to see. Another article claiming to offer instruction in magic performance advises amateurs that:

> There isn't anything superhuman about modern magic, and as the intelligent portion of your spectators know this, they will be unceasingly on the look out for the *modus operandi*, and if they do not know what to expect, they are less likely to discover the means by which you accomplish a mysterious result. (Skinner 1892: 5)

As Charles Carter commented, patter and performance were crucial to the magician's art since 'that is all magic is – appearance, words' (1903: 6).

Positive response from the audience was reliant upon the performer's ability to deceive the eye as well as the mind and it was the efforts of magicians to eliminate the influence of the occult that equipped spectators with the ability to question the nature of the image and the mechanisms behind their creation when the first film shows began to appear on the theatrical circuit. A mass of published material exposed the mechanisms behind popular illusions to stimulate interest in performances and to empower the spectators with the inside knowledge which would allow them to focus on their presentation and to distinguish between a great artiste and a poor one.[11] There is most probably an element of disingenuity on the part of the magicians who allow access to their secrets – they may be giving out false solutions to their tricks, or only revealing half of the story. We should not conclude that magicians wanted everybody to know how every trick was done, but rather that they hoped to nurture a multi-faceted appreciation of their art by superintending the ways in which it was perceived, and by setting forth tricks as visual problems to be re-solved by the viewer. By emphasising diction, costume and simplified staging, these performers are inevitably aiding magicians to mask their tricks behind a veneer of quotidian respectability, but they are also appealing to the high regard attached to 'legitimate' theatre. These attempts to contain and regulate the art of magic, to institute a proper way to do it, might seem like the best way to ossify it, but the effect was to subvert some notions of theatrical space and embodiment.

Also crucial to the development of magic theatre was the equipment that was purpose-built for the achievement of illusions. The repetitive use of devices manufactured specifically for a particular trick was beneficial to the standardisation necessary for the establishment of both magic theatre and trick films. The spectator's focus of attention then moves from the mechanism itself to its placement within a particular staging or narrative, once more inviting comparative assessments of style and presentation.

By the late nineteenth century, the word illusionist had come to be used instead of conjuror, to connote the use of large apparatus in a trick, but also to stress the spectatorial subjectivity on which the illusion was dependent (see Everett 1902: 142). The distinction puts the emphasis on the way in which the spectator perceived the trick, as opposed to what the magician actually *does*. Mechanical tricks were a direct way of creating a distinction between spiritualists, who were receiving ridicule and exposure in the press. Subsequently, many magicians were jumping on technological bandwagons as if to create a further distinction from the ancient and often deceitful history of the art. The ultimate scientific addition to the magician's arsenal became animated pictures; the Cinématographe was both a technical marvel and a vessel of narratival content, thus sharing some characteristics of those magic shows which built their mechanical displays into themed or narrativised performances.

Magic and early cinema

The spectre of magic has always existed somewhere within the body of the scientific. Vivian Sobchack has defined magic as 'the term born from our collective lack of knowledge about something which works anyway' (1993: 58).[12] Michael Punt has located a 'professionalisation' of science from around the middle of the nineteenth century, during which time, scientists exerted greater control over scientific discourse and apparatus, reducing the interested but unqualified general public (such as those patronising the Royal Polytechnic) to the status of consumers, as opposed to participants. For the working classes, Punt argues, resistance to this exclusion could come in the form of 'flippant and subversive' uses of scientific spectacle, perhaps in the arena of the technologised magic performance and later, in the commandeering of the Cinématographe's scientific pedigree for 'frivolous pleasure' (2000b: 74).

Magic shows and magicians were crucial components in the establishment of a cinematic industry and art. At the first public showing on 28 December 1895 of the Cinématographe at the Grand Café, 14 Boulevard des Capucines (a short walk away from the Théâtre Robert-Houdin), the majority of the in-

vited guests came from the entertainment industry, rather than from scientific fields (see Ezra 2000: 1). Georges Méliès was present,[13] as were Émile and Vincent Isola, two magicians from Algeria who had been impressed by Robert-Houdin's politically motivated performances there, and who had established their own Théâtre Isola in Paris in 1892; clearly, they did not match Robert-Houdin's characterisation of their countrymen as credulous primitives, having spotted a commercial opportunity where they were supposed to have been awed by a fearsome foe. Their Isolatograph projector (probably based on one of the imitation Kinetoscopes made by R. W. Paul) was being used to show films less than a week after Méliès showed moving pictures at the Robert-Houdin (4 April 1896, showing Edison's Kinetoscope films).[14]

The first demonstration of the Cinématographe in the UK was overseen not by the Lumière brothers, but by one of their associates, Félicien Trewey, a highly-renowned magician and shadowgrapher, who appeared in several Lumière films in 1895, including *Assiettes Tournantes* (*Spinning Plates*), *Chapeaux à transformations* (*Transformation by Hats*) and *Partie d'écarté* (*Card Game*), and who had assisted at Cinématographe shows in Lyons (see Hunningher 1995: 45). Trewey's shows began with a press screening in the Great Hall of Regent Street's Polytechnic Institution, on 20 February 1896, the same day that R. W. Paul was showing his Theatrograph at Finsbury Technical College.

Having witnessed one of the first of Trewey's Polytechnic shows, David Devant tried to buy the machine, but it was not for sale (the Lumières did not sell the Cinématographe until 1897), and Devant could not afford the £100 per week rental fee to include it in his act. The Polytechnic demonstrations were aimed at theatre managers, and the Empire, Leicester Square, acquired the London rights to the Cinématographe. Devant could not convince Maskelyne, then director of London's Egyptian Hall, to invest in the invention and include film shows on the playbill. Maskelyne predicted that moving pictures would be a short-lived attraction.

Devant turned to R. W. Paul, who had invited him to a Theatrograph show, and the pair made a deal. Devant purchased, for £100, one Theatrograph for himself (first exhibited at the Egyptian Hall, 19 March 1896), and was to receive commission for selling others to his friends in the business (see Armes 1978: 21). Of course, once film shows became an essential component in a magician's repertoire, Devant had no trouble selling two machines to Georges Méliès and one to the American illusionist Carl Hertz.[15]

Devant and Paul worked together on several short films, including *The Egg-Laying Man* (1896), a 15-metre record of a popular stage illusion,[16] *Devant's*

Hand Shadows (1896), a record of his famous skill as a shadowgrapher, and *The Mysterious Rabbit* (1896), shot on the roof of London's Alhambra Theatre and used in a Filoscope flipbook.

There are two kinds of filmed magic – the first being when a trick is filmed, recording and replicating a magician's act as it would be seen on a stage, and the second requiring the use of in-camera effects to produce a photographic illusion. Those tricks which featured no camera tricks, but records of performances, such as *Mr. Maskelyne Spinning Plates and Basins* (1896) and *The Egg-Laying Man* (R. W. Paul, 1896) enabled a magician to promote his act on the fashionable new medium, but also to record a definitive rendition of a trick in the best light and from the optimum angle. There would be no troublesome punters towards the side of the stage who could see the rabbit squirming in the lining of the jacket or the vase hidden behind the back. Although theatrical magic performances were given in three-dimensional space, seating would ideally be arranged so that most spectators faced the stage directly, since many illusions were only fully apparent when viewed head-on. On film, a magician could give a performance visible from a single, prescribed angle. Ironically, this subtracted the element of interactivity and spontaneity from the performance, leaving the magician upstaged by the filmic apparatus and unable to respond to the audience. In the theatre, audiences may have known they were being tricked, but at least they had a chance to look for the hidden wires, the trapdoor or the card up the sleeve. David Devant in particular would encourage the audience to call out where they thought he had hidden a rabbit or a coin. If they guessed right, he might have to shift its secret location.

Films of magic tricks meant that the act could be presented to wider, larger audiences and (in theory) preserved indefinitely. However, the ease of diffusing filmed entertainments slowly depleted the demand for live performance, and many magicians were gradually forced out of business by the technology which, as scientifically/technically-minded artists, they had been amongst the first to embrace. Even the most famous performer of all was not protected from this mechanical rival; it was Harry Houdini's ability to escape from chains and locks in full view of an audience which made his act worth incorporating in films. He starred in several features,[17] all of which were crime adventure thrillers in which the plot frequently contrived to have Houdini's character captured and chained, thus allowing the spectacle of his escape.

Despite Houdini's fierce self-promotion, and the proven success of his stage act, his film career was a failure. The Houdini Motion Picture Corporation lost over half a million dollars by 1924, and Houdini retired from films. There is perhaps something ultimately pointless about filmed magicians. Camera

tricks such as double exposures, stop motion and invisible edits can eradicate the need for any genuine human feats on the part of the performer.[18] There was no need for 'star' magicians on film, since this manipulable format could allow anybody the appearance of magical ability. When, towards the end of 1897, the Lumières finally began to sell the Cinématographe to interested buyers, perhaps compelled to do so by the number of imitators who were flooding the market, one of the first buyers was Leopoldo Fregoli, an Italian impersonator, prestidigitator and character performer. He featured the machine in his magic acts and, using techniques such as reversal and match cuts could appear, in films such as Méliès' *L'Homme-Protée* (*Lightning Change Artist*, 1899), to be performing a rapid succession of characters, with instantaneous costume changes, without needing to disappear momentarily behind the scenes (see Herbert & McKernan 1996: 53). The filmed image of a magician was *not* a supplementary virtual rendering – it was an upstaging alter ego, a mechanised conjuror that could repeat a performance with absolute precision every time. How could Fregoli compete with his photographic avatar, a quicker quick-change artiste than he could ever hope to be himself?

It is easy to view early film as an undeveloped ancestor of contemporary motion picture art, as an incomplete trial run for the Bazinian total cinema. Silence, black and white film stock, fixed camera position and a lack of montage could be seen as presenting a form of cinema defined by the technology which was *not* exploited in its manufacture, as the skeleton of the talking, walking colour films of today. However, the earliest cinema can be more constructively examined as the culmination of decades of experimentation in visual and cultural entertainment, a pinnacle of achievement in science rather than simply a base from which classical film would inevitably grow. Thanks to the ongoing resonances of the 1978 International Federation of Film Archives (FIAF) conference in Brighton, which 'mounted a first assault on the evolutionary master narrative written by previous generations of film scholars,' early cinema need not be examined as a set of 'primitive precursors of the fully developed and superior classical Hollywood cinema' (Pearson 1996: 154), but can instead be situated within an array of interdependent mass cultural forms, emerging as 'a combinatoire of existing and innovative elements ... a hybrid medium which only gradually coalesced into something more or less distinct as cinema' (Abel 2005: xxix). It can also be used to show how some aspects of cinema, including the illusionism of trick effects, have retained some of the characteristics which they absorbed or inherited from other media, including magic theatre.

Discourses around early cinema focus extensively on ontological questions surrounding the relationship between the image and the real, and on the dy-

namic relationship between narrative and spectacle. Tom Gunning's influential theory of what he terms the 'cinema of attractions', argued that filmed entertainment from 1895 to 1907 was not driven by narrative, but provided a technological spectacle – the machine which made the pictures move was the primary source of fascination rather than the themes and stories represented by the pictures themselves. Overturning primitivist conceptualisations of early cinema as only a rudimentary trial run for classical narrative cinema, he describes how the first films functioned to engage the spectator without recourse to story-telling:

> Rather than being an involvement with narrative action or empathy with character psychology, the cinema of attractions solicits a highly conscious awareness of the film image engaging the viewer's curiosity. The spectator does not get lost in a fictional world and its drama, but remains aware of the act of looking, the excitement of curiosity and its fulfilment. (1995: 121)

Any sequence of events, however narrow in scope or brief in duration (the baby eats breakfast, the workers leave the factory, the train arrives at the station), constitutes a progression, and thus a narrative. According to Stephen Heath, frame space can be constructed as narrative space, since there is an inherent narrative component contained in every movement within the frame, and since 'it is narrative significance that at any moment sets the space of the frame to be followed and "read"' (1976: 76). Gunning notes, however, that narrative time is not simply a linear progression, but 'the gathering of successive moments into a pattern, a trajectory, a sense. Attractions ... do not build up incidents into the configuration with which a story makes its individual moments cohere. In effect, attractions have one basic temporality, that of the alternation of presence/absence that is embodied in the act of display' (2000: 44). Still photography, dioramas and magic lantern slides had already imagined means of presenting a story linked by a narrator or visual continuities such as recurring characters and situations.[19] Thus, rather than being necessarily connected by the imperatives of narrative progression, moments of ostentatious display might be linked thematically, iconographically or conceptually, that is, linked by their content or the mechanics of their formal construction. The Cinématographe was the machine that explicitly demonstrated a mechanism for capturing a glimpse of a moment beginning with the activation of the camera and (usually) ending with the exhaustion of the reel's length. In this light, the film camera appears to be a scientific tool for gathering, preserving and analysing fragments of time and space, even if they

are ordered by the subjective eye of the camera, itself at the mercy of an operator. Roberta McGrath suggests that from the eighteenth century, objectivity was equated with a lack of the signs of manufacture, and that photography was the apex of the association of truth with apparently unmediated representation:

> The invention of photography marked the realisation of such a philosophical ideal in the age of mass production. Its trick was to conceal the signs of manufacture and thus for the first time to abolish the distinction between a natural and a manufactured world, between real and fake. From the moment of their invention photographs were passed off as portions of nature. Placed on the threshold between an old natural magical world and a newly emergent manufactured universe, the technologies of photography and film represented a dream of the simulacral: the copy without an original; the sign without a referent; ultimately a signifier severed from its signified. (1996: 16–17)

As is evident from spirit photography and the sceptical inquiry/outright derision aimed at it from various quarters, it is the trick effect, the deviation from norms of plausibility, which subverts the automatic connection of photography to truth claims, either by foregrounding the traces of manufacture with prominent artifice, or by raising doubts about the veracity of a scene. Michael Chanan cites a late nineteenth-century article entitled 'Photographic Lies', published in *The Harmsworth Magazine*, declaring that the proliferation of trick photographs had rendered the medium 'absolutely inadmissible as evidence of anything' (quoted in Chanan 1996: 119). It is the presence of special effects which reinscribes images with the signs of manufacture, mediation and therefore artifice, even as they appear to have been constructed in such a way as to belie the presence of mediating influences and manufactural remainders.

Early cinema has been dichotomised to imagine a distinction between the fantastic capabilities of the earliest films and documentary-based, non-narrative observational filming. The Lumière brothers have often been used to emblematise the latter, while Georges Méliès is portrayed as the inventor of the former, but the distinctions between them are not so clear, and what can be demonstrated is that a major aspect of cinema's fascination lay in its synthesis of photographic verisimilitude and fantastic, transformative effects, a dual identity which requires no such binary distinction in order to be historicised.

The Lumière brothers, narrative and inherent realism

Marshall Deutelbaum (1979) has argued against primitivist readings of Lumière films, and the suggestion that the films were simply the result of random pointing and shooting. Gerald Mast charges them with amateurism, comparing their work to '"home movies"– unedited scenery, family activity, or posed action' (1971: 36). Arthur Lenning referred to the brothers themselves as 'entrepreneurs and technicians rather than artists', and attributes to them the establishment of 'the documentary aspect of cinema, the recording of unadjusted, unarranged, untampered reality' (1969: 14). Heath also defines the Lumière brothers (classifying them alongside Thomas Edison) as 'exploiters and businessmen, developers rather than inventors' (1980: 6) as if to suggest either that their authorship of a film is somehow less significant, or that it is unsurprising that they focus on functional, rather than fantastic, filmmaking.

The Lumières' filmstrips were 17 metres long (16 metres in the prototype), 35 millimetres wide and able to hold up to nine hundred photographic images in succession. This meant that films lasted for approximately fifty seconds, denying the viewer the necessary time for deep narrative immersion, but rather than stifling creativity, this strict technical frame of possibility encouraged variety and experimentation while circumscribing many of the films' formal properties.

Barry Salt maintains that, because the earliest film cameras had no separate viewfinder, and the framing had to be done by opening the back of the camera and lining up the framespace, 'it was largely guesswork as to exactly what was in the frame and what was not, unless the limits of the frame were marked on the set' (1983: 41). It can be argued on the contrary that this need to get the camera in a suitable position would create a greater awareness of a need to position the camera in such a way as to take in the necessary view, and, by extension, would give rise to a desire to order the frame by arranging and controlling what passes before the lens. Patterns of composition and subject emerge in any study of the Lumières' films. Street scenes could provide multitudinous lines of movement, the outdoor locations suggesting boundless offscreen space. Rather than shooting their subjects head on (and therefore perhaps most objectively), they would often use diagonal perspective set-ups, with vanishing points at one side of the frame. The diagonal configurations reveal through their repetition a compositional strategy that emphasises movement from foreground to background, and thus changes in scale and movement through space (and the temporal factor which accompanies such actions) become primary points of interest. In *The Stonecarvers Horses* (1896),

the animals parade diagonally past the camera, entering and exiting the off-screen space within the duration of the film allotted by the camera's capacity. The famous *L'Arrivée d'un train à La Ciotat* (*Arrival of a Train* at *La Ciotat*, 1895) is also a demonstration of this, with the front of the train moving out of the left hand side of the frame and the alighting passengers crossing the platform in front of the camera.

Often, the Lumière films demonstrate their awareness, even their exploitation, of the time constraints imposed by the early film technologies. *Premiers pas de bébé* (*Baby's First Steps*, 1897) shows an infant walking from the background to the foreground, where her toy is lying on the pavement. As the toddler teeters and sways on her short mission, the suspense soon builds as to whether or not she will reach the toy. Will she navigate the short journey without straying out of the frame? The presence of a nanny to guide her, and the boundaries of the pathway ensure that her steps are controlled; the mixture of precarious unpredictability and regulatory demarcations characterises the containments which the act of filming imposes upon seemingly quotidian events. Since the Cinématographe films of this time were of a standard length, the time limit for the action arranged within these temporal borders provides the film with a small-scale suspense story that requires contemplation and comprehension of film form for its full effect.

A prime example of a film which experiments with the capabilities of the apparatus is the Lumières' *Démolition d'un Mur* (*Demolition of a Wall*, 1896), for which Louis filmed his brother Auguste assisting in the demolition of a wall in the grounds of their factory. This contains a miniature narrative – the men have a goal (to knock down the wall) – and there is suspense provided by the wall's initial resistance to the blows from several sledgehammers. The wall falls, and the men have achieved their aim. A simple story with a beginning and an end, encasing a moment of time which holds particular interest due to the fact that an action begins and ends within its span.

What makes *Démolition d'un Mur* a particularly interesting compound of actuality and artifice is that this is one of the films which the Lumières would screen twice at their shows – the second time in reverse, spectacularising at the point of projection the temporal manipulations which film was well-placed to explore during recording. This newly palindromic structure, restoring the film to its starting point, permits a striking mastery of images. It links the simple narrative explicitly to the technology that makes it comprehensible. By playing the film backwards, the operator demands that the viewer recognise that the effect is a technical one – it is not a fantastic depiction of a self-healing wall, but a reconfiguration of the scene that has just been shown, an oppor-

tunity to examine human movement from the vantage point of an impossible time frame, demonstrating cinema's capacity for toying with representations of chronology.

Other Lumière films displayed experimentation with perspective, deep focus, special effects and action. *Le Squelette joyeux* (*The Happy Skeleton*, c.1897) features a skeleton marionette dancing against a black background, reminiscent of moving skeletons in the Phantasmagoria. It is a striking departure from the location shoots in the Paris streets that constituted most of the earliest Lumière shorts. Firstly, it creates the illusion of an impossible reality, and secondly, it is shot on a studio set, probably a theatre stage; it is proof that the brothers had recognised the illusory entertainment capabilities of the medium as well as the representational advantages of moving photography.[20] It seems they knew that the Cinématographe was not an objective scientific instrument, but a device for transforming and defamiliarising all that passed before its lens.

Georges Méliès and magic cinema

The first Cinématographe shows demonstrated that a machine now existed for creating moving photographs of the human body, and its incorporation as part of magic acts and spectacular shows meant that it would have to do to the body what magicians had been pretending to do for decades – that is, to pull it apart and fragment it, to make it disappear or to transform it. This could be done with static objects in conjuring tricks, but the greatest attractions in magic theatre were those where the human body was made to transcend its earthly limitations. The filmed body was imbued with these powers of transcendence and indestructibility. As *Démolition d'un Mur* demonstrated, film could appear to restore what it had just destroyed, and could repeat that trick of destruction/restoration incessantly. It could act upon the body to remaster its movements as the raw material of a technical illusion, thus delineating the cinematic body as at once expressive, articulate and recognisably human, and, simultaneously insubstantial and malleable; the cinematic body incarnates the paradox of cinema – its simultaneous presence and absence, its intangible, fleeting ghostliness and its inviolable permanence.

Georges Méliès, a magician credited as producer and director of over 500 films[21] between 1896 and 1913, about a third of which have survived, is the starting point of most extant histories of special effects. While such chronologies are right to consider him important, his work is usually portrayed as amusingly primitive in the way it antecedes later excursions into fantasy

spaces.[22] John Brosnan is particularly unequivocal about the inadmissibility of pre-cinematic illusions, commencing his history by stating that 'the beginning of the story of special effects is to be found at the beginning of the film industry itself' (1974: 15); Méliès is almost dismissed as a repetitive novelty act who failed to 'grow up' with the burgeoning film industry (see Brosnan 1974: 15–19). Sean Cubitt has referred to the elevated status of Méliès' work as 'the canonical origin of special effects movies, of the appropriation of mechanical perception for the purposes of fantasy' (1999: 119). It was Méliès in particular who innovated in-camera techniques such as multiple-exposures (already commonplace in still photography), dissolves, fades and wipes to exploit the technical possibilities of the cinematographic equipment and produce visual effects which rendered physical impossibilities on screen. But he, along with other magicians who moved into filmmaking, can also be seen as the founders of the kinds of spatio-temporal strategies employed and subverted by early trick films.

Siegfried Kracauer believed that since film, like photography, is equipped for recording reality directly, it 'gravitates toward it' (1997: 98). In other words, filmmakers make actualities because that is what the medium is good for. Kracauer falls for the Lumière/Méliès dichotomy when he lists them as 'Lumière, a strict realist, and Méliès, who gave free rein to his artistic imagination. The films they made embody, so to speak, thesis and antithesis in a Hegelian sense' (1997: 99). A key part of this dichotomy lies in the belief that, while the Lumières could be seen as scientific inventors failing to spot the fantastic entertainment potential of the cinematic medium, Méliès was cinema's forward thinker.[23] Kracauer asserts that Lumière films such as *Repas de Bébé* (*Feeding the Baby*, 1895) and *Partie d'Écarté* (*Card Game*, 1895) 'testify to the amateur photographer's delight in family idylls and genre scenes … Méliès' tremendous success would seem to indicate that he catered to demands left unsatisfied by Lumière's photographic realism' (1997: 99–101). Kracauer thinks Méliès' tricks and innovations were all theatrical, rather than cinematic, as evidenced by the fact that he never thought to move the camera, since 'the stationary camera perpetuated the spectator's relation to the stage' (1997: 102). The amount of process work he did, necessitating the absolute immobility of the camera to avoid variations between exposures, surely has something to do with this, but it also hints that he was aiming to urge comparisons between theatrical presentation and filmic construction by mimicking the fixed perspective of a theatregoer's viewpoint – he is not sticking indolently to what he knows by making films about magic, but actively engaging with the distinct properties of each medium; Simon During even calls his films 'a memory theatre of ear-

lier show business" (2002: 171) and they explore the specificities of film and stage performance via the tropes and tricks which connect them.

The first film in which Méliès incorporated a trick shot was *L'Escamotage d'une Dame au Théâtre Robert-Houdin* (*The Lady Vanishes*, 1896), ostensibly a record of the popular 'vanishing lady' illusion.[24] In the most common method, created by Buatier de Kolta, the magician placed a newspaper on the stage, upon which an (invariably female) assistant would sit in a chair. The conjuror would then place a drape over her, and seconds later remove it to reveal that the woman had disappeared without rupturing the newspaper. Assorted magicians incorporated the trick in their repertoire, each performance differentiated by the speed with which they could perform it, and the skill with which they could conceal what was really happening. In the de Kolta method, the newspaper that supposedly vouches for the integrity of the space is actually a rubber sheet, split to allow the assistant to escape through it into a trap-door, while a wire frame holds her shape beneath the drape to give the impression that she is seated there until the magician pulls it away.

In his filmed version of the trick, Méliès uses a *temporal* trap-door, halting the camera and removing his assistant, Jeanne D'Alcy, before restarting the film. This is a stop-motion or stop-action substitution, one of the staples of Méliès' filmic repertoire. Since it depends on splicing the film after shooting in order to elide the moment of substitution as seamlessly as possible (rather than relying on the precise moment of stopping and starting the camera), it could be seen as an early form of editing, though it offers not a new image but the same one slightly or radically transformed. To the eye not keen enough to spot the join, it seems that D'Alcy's disappearance is exceptionally quick, but having created the likeness of a familiar trick, Méliès confounds expectation by instantaneously bringing her back in skeletal form. The aim of this device seems to both re-enact and to mechanise a familiar illusion in order to foreground the special capacities of the medium, setting up a comparison of theatrical and filmic space. The film does not therefore record passively or quicken the performance, but transforms it.

Méliès developed his film technique as a way of using the mechanical potential of the camera for its own effects, and for displaying his own body as another form of spectacle, his filmic avatar equipped with a new arsenal of illusions (see Abel 2000: 64). He could manipulate what the viewer saw, and preclude the need for smokescreens and curtains. While the Lumière brothers sent camera operators all over the world to record views of exotic locations, Méliès was simulating his excursions indoors in purpose-built studio sets, exerting a magician's mastery of the space within the proscenium/frame.

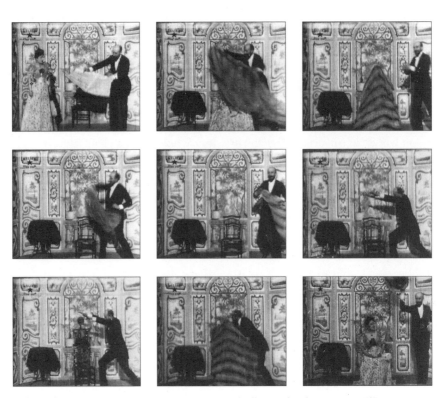

Georges Méliès adapts the famous Vanishing Lady illusion for the screen in *L'Escamotage d'une Dame au Théâtre Robert-Houdin* **(1896)**

Méliès may have discovered the advantages of shooting in an indoor studio when he was forced to accommodate the pedantic whims of the opera singer Paulus, who had asked to be filmed in one of his leading roles in order to promote his career (the silence of the film seemed not to be a concern). Paulus refused to suffer the indignity of being filmed outdoors in full make-up and costume, so Méliès shot the film indoors with available light and a painted backdrop. He began constructing a studio at Montreuil (in the grounds of the family home) late in 1896, finishing it in May of the following year (in 1905, he built a second studio next to this one). It was later expanded, but began as 17 metres long, 7 metres wide and 6 metres high at its tallest points, roughly the same dimensions as the stage area in which he performed at the Robert-Houdin (see Ezra 2000: 14; Barsacq 1985: 12). The walls and ceiling were glass, and Méliès relied on natural light, at the mercy of daylight shooting schedules and whims of weather. By 1899, the studio was fitted with thin cotton cloths that could be stretched below the roof to diffuse the direct sunlight when it was particularly bright outside. Salt points out that this style of shadowless, over-

all lighting would later become an industry standard for about a decade, but Méliès was initially the only filmmaker using it – everyone else had to shoot outdoors in direct sunlight (1983: 40). This studio facility was equipped with trapdoors and moving panels to enable the easy conjuring and disappearances of performers. Barsacq notes that the studio had 'a stage with a below-stage area and a rigging loft', just like a theatrical stage (1976: 5). It had all the capstans, winches and pulleys of the theatrical space in which he usually worked, purpose-built for staging fantasy sequences and mechanical effects. These occult places facilitated the manipulation of the framespace from offscreen. The camera was positioned as if at the back of the theatre, and 'cords or wooden laths connecting the foot of the camera with the edges of the set marked off a visual field out of which the actors could not step' (Barsacq 1976: 6). For certain films, such as *L'Homme Mouche* (*The Human Fly*, 1902), a camera was raised and aimed straight down onto the stage, so that characters could appear to be running up vertical walls.

The restrictions and repetitions enforced by shooting hundreds of scenes within the same confined space show how a distinctive style and *mise-en-scène* quickly emerged in Méliès' work. The repetitions of a particular trick (to make full use of the equipment designed specifically for that effect) invited comparisons between each instance of the same effect, and effectively derealised the sensation of the trick and encouraged a critical appreciation of the technical artistry involved. This is not to say that his films are not torrentially inventive, but that the invention stems from the imaginative recycling of a set of motifs and devices.

A talk given by Méliès in 1906 was aimed at viewers curious about how certain special effects were produced, a curiosity which the director considered 'very justifiable and natural in intelligent people who always seek to know the explanations behind what they are looking at' (1988: 36). He defines four types of cinematographic views; natural views, scientific views, views of composed subjects and transformations – he is most renowned for the latter two categories. He says he invented the principle of stop-motion effects when the camera jammed as he was photographing a street scene at Place de l'Opéra in Paris (this was the third time he had shot a view of this part of the city) (see 1988: 44). The projected image showed the passers-by changing position in an instant. However, even if it is true that Méliès discovered the process independently (the story may be entirely apocryphal), it had been used by Alfred Clark in a Kinetoscope film for the Edison Company, *The Execution of Mary Queen of Scots*, one of several films which staged traditional waxwork tableaux (see Christie 1994: 114), filmed on 28 August 1895 at the Edison studio in

New Jersey, which may include the first ever cut in cinema history (see Salt 1996: 171).[25] When the executioner's axe was raised, the camera was stopped and the actress playing Mary was replaced with a dummy before filming was resumed to record the decapitation. Méliès' accidental noticing of the effect (that is, he did not devise it in order to solve a problem in representing a physical impossibility) pointed towards its opportunities for transformation ('I suddenly saw an omnibus changed into a hearse and men into women')[26] rather than the erasure of a transition as seen in Clarke's film. The glitch in the camera that had provoked the accidental stop-motion effect at Place de l'Opéra embodied the principles of filmed illusion, but was only visible as a trick and not as a technical fault when resituated within a narrative that establishes it as a picturing of a magical event.[27]

In an echo of David Devant's revelatory proclamations about the need for knowledgeable spectators, Méliès remarks that a trick effect 'allows the supernatural, the imaginary, even the impossible to be rendered visually and produces truly artistic tableaux that provide a veritable pleasure *for those who understand that all branches of art contribute to their realisation*' (1988: 45; emphasis added). If he hopes that the magician's artistry might be appreciated, it is not just because he seeks to commemorate the endeavours of technicians, but because he sees such engagement with the performance as an essential part of the comprehension and digestion of the work as a whole. It is a way of differentiating between the technical error and the narratively significant, of acknowledging the deliberateness of the manipulation.

Frank Kessler defines trick films against the presumption of a 'cinematic specificity' lying in the camera's capacity for 'reproducing visible reality.' A trick, on these terms, is 'any kind of intervention which manipulates the exact rendition of the visual impression that an actual scene would provide to an eye-witness' (2005: 643). In a film such as *Escamotage d'une Dame au Théâtre Robert-Houdin*, or any other which foregrounds the magician, Kessler argues that 'both the fixed framing and the frontality are in fact essential to the functioning of the tricks, since their effect rests upon the illusion of a temporal continuity that is enhanced by the unchanging spatial arrangement' (2005: 644). I agree, but would stress that this interruption of spatio-temporal continuity is as much directed at a perceived *theatrical* norm as it is directed at the kinds of integral space attributed to Lumière films. The manipulation of theatrical space and human bodies performed by Méliès' Vanishing Lady or by *Le Mélomane* (*The Melomaniac*, 1903) is a continuation of spatially subversive practices of the magic theatre as much as it is a disturbance of notions of photographic objectivity. Gunning asserts that, rather than imitating theatrical

Through the careful application of multiple exposures, Méliès replicates his own head to provide notation on a musical stave in *Le Mélomane* (1903)

presentation, *Le Mélomane*, in which Méliès repeatedly throws his own head onto a giant musical stave, exhorting the audience to sing along with the notation, proffers a distinct conceptualisation of space:

> This space is defined as a surface bearing the imprint of several images that create an ambiguous area of often contradictory orientations. This is evident in *Le Mélomane* as the painted backdrop of power lines against a night sky becomes transformed into the flat space of musical notation. The head-notes embody this double nature, appearing both as notes on a page and as grimacing faces. (1983: 358)

While it is certainly true that such spaces, recurring in many of Méliès' films, become double-images, they depend upon a play with theatrical conventions for their effects – each ambiguity and transformation stems from a deviation from the conventions of theatrical presentation, and the effect comes largely from the discrepancy between the two.

In a 1926 issue of *Ciné-Journal*, Méliès protested that his films could not be attributed to the transposition of conjuring effects, since the prefabrication of the former was fundamentally opposed to the liveness of the latter, but he does often seem to be remediating his stage illusions, with witty embellishments. Katherine Singer Kovács has discussed the influence of the 'féerie', an operatic or balletic genre featuring magical fairy tales, on Méliès' cinematic work, arguing that a fixation on transformation and fantastic dismemberment was evident in this earlier theatrical form, which was at its peak of popularity on the French stage in the 1850s. Scenic transformations could be effected by fades/dissolves using different images painted onto either side of a translucent screen (1983: 248). In the féerie *Les Pilules du Diable*, the villain is trapped in an exploding train, at which point his body falls from the sky in pieces, which

are then reassembled, restoring him to life. This was a common stage illusion incorporated into an extended narrative, and as with the decapitations at the Egyptian Hall, 'these scenes were never alarming. In all féeries the victims of violent action are immune to serious disability' (1983: 249; see also Abel 2000: 66).

The influence of pre-cinematic forms on Méliès cannot be denied, but what is perhaps crucial to note is the way in which he indulges the capacities of the cinematic apparatus, remarking upon its distinct properties as well as its connections to other media. As Linda Williams has claimed, one of the pleasures of cinema is derived from 'the discrepancy between the perceived illusion of presence created by the image and the actual absence of the object replaced by the image' (1986: 522), and Méliès indulges this pleasure relentlessly. In a repetitious frenzy, he controverts the integrity of theatrical space with instantaneous transformations, notable not only because they are cinematically specific, but also because they require no apparatus, staging, trapdoors or pyrotechnics.

Williams notes that from its earliest uses, the cinematic apparatus has offered 'an image of the body *as mechanism* that is in many ways a reflection of the mechanical nature of the medium itself' (1986: 508; emphasis in original). *Le Mélomane* thematises both the insubstantiality of cinematic bodies *and* the contingent relationship to theatricality. In those films where Méliès replicates (*Un Homme de têtes* (*The Four Troublesome Heads*, 1898)), dismembers (*Dislocations Mystérieuses* (*Extraordinary Illusions*, 1901)) or detonates (*L'Homme à la tête en Caoutchouc* (*The Man with the Rubber Head*, 1901)) himself, his body is irrepressively vital – whatever destructions are visited upon it, it always reappears intact, either in a new form in the same film or in the next film from the Star Film catalogue. It is not being suggested here that the bodily transformations and mutations performed onstage by magicians are proto-cinematic effects, but more that they are cultural preoccupations which most easily survive the process of remediation from theatrical presentation to recording on film.

Méliès is only the most prominent maker of trick films, his infiltration of the genre a logical development of his abiding preoccupation with illusionism. The British producer and director Cecil M. Hepworth (1874–1953) is noted for his contributions to the establishment of a British film industry with his Hepworth Manufacturing Company, established in 1899. He was also a designer of photographic equipment, but one of his earliest filmmaking achievements was *How it Feels to be Run Over* (1900), an exercise in subjectivity which promises the audience a sensory simulation of something they would

never seek out or enjoy in real life – being knocked down and run over by a motor car (see Christie 1994: 21). The film is a single static shot situated in the middle of a country road. A horse and cart approaches the camera, but then passes safely to the right of it. Then a recklessly-driven motor car speeds towards the camera/spectator, with the driver (played by Hepworth himself) and passenger (May Clark) gesticulating wildly. Finally the car appears to run into the lens and the film ends with a blackout and the somewhat cryptic caption: 'Oh, mother will be pleased.'

How it Feels to be Run Over is a simple concept executed efficiently: there is no time for extensive exposition or character development. Ian Christie comments that 'almost all the early films that feature motor cars show them as dangerous and destructive' (1994: 21). Death by motor car was a genuine modern fear – notice that the seemingly innocuous horse and cart offers no threat to the viewer because the driver is in control, while the motor vehicle is operated by careless, jaunting aristocrats. Within the sensory shock there is a social comment, and the special effect is employed for realising the impossible view that is instant death by machine. However, this is also a tamed shock, drawing attention to the distance of the image from reality – the forced subjectivity (the spectator cannot evade the approaching vehicle) demonstrates how the camera could record views without bodily danger to the audience. Cinema was 'the safe, the passive, the vicarious technology' (ibid.).

Hepworth incorporated a trick effect with the theme of automotive destruction in *Explosion of a Motor Car* (1900), in which a car appears to explode spontaneously thanks to a stop-motion substitution – the film is spliced to elide the point at which the vehicle is replaced by its pre-demolished replacement. A passing policeman inspects the scene, at which point the occupants of the car rain down in a shower of dummy limbs; the bloodless dismemberments, and the bobby's casual note-taking as he catalogues the dispersed body parts ensure that this is a comic departure from reality rather than a gruesome simulation. The trick enables the filmmaker to select sections from pro-filmic scenes to create a new apparent reality, but the edit is a disturbance of the temporal unity that is the hallmark of the actuality film.

R. W. Paul (1869–1943) was another innovator of the conventions of the trick film, as well as being a crucial figure in the diffusion of motion picture technology. While the Lumière brothers were still guarding their Cinématographe from imitation and refusing to sell it, Paul had identified a market ripe for exploitation and produced his Theatrograph in order to take advantage of the imminent rush of demand for moving pictures. Edison had neglected to patent his Kinetoscope in the UK, and, along with photographer Birt Acres,

Paul produced an imitation of the Edison device which could project images onto a screen.[28] The Edison Kinetograph was used to make films for the Kinetoscope, and run at 46 frames per second, but after 1898 it could be used for normal films for projection at 16fps (see Salt 1983: 41). Although its intermittent mechanism was not reversible, R.W. Paul's version of it was, as was the version Méliès commissioned from him. This enabled the retraction of the film to produce a precise double exposure. Edison's machine had not predicted such a requirement.

Following the construction of a studio in Muswell Hill, North London, in 1899, Paul made many trick films, but also continued shooting outdoors to expand the compositional possibilities of his work and to combine what he had learned of special effects with his experience of location shooting. One example of this, again involving a road accident, is *The Automobile Accident* (1903), in which a drunken man collapses onto his back and falls asleep in the road. A motorised taxi-cab approaches and drives over the man's legs, severing them cleanly. Unperturbed, a doctor steps from the cab and reattaches the legs, whose owner gets to his newly-restored feet, shakes the doctor's hand and continues happily on his way.

The effect of the severing of limbs was achieved, once again, through a substitution. At the point where the cab arrives immediately before the drunk's legs, the camera is stopped, and an amputee wearing dummy legs substitutes the lead actor in the frame. When the camera restarts and the car continues on its path, it is these prosthetic limbs which are cut off by the oncoming wheels.

By shooting on location, and particularly on a road, Paul adopts the posture of actuality, the drunk perhaps signalling a message of temperance. The accident itself is therefore designed to be more surprising than it would have been in a studio, the domain of trick effects and theatricality. As mentioned in connection with the similarly themed Hepworth film, car accidents were an increasingly frequent occurrence, and therefore an acceptable subject for an actuality film. However, these implied realisms are undercut by the surrealistic ease with which the wounded man is restored to full health. The audience is not invited to accept the realism of the scene, but finally to wonder at how the trick effect was produced. The impossibility, played for comic value, leaves no doubt that a trick was being presented, so that, as in the description of Maskelyne's dismemberments above, the amusing scene is 'in no way repulsive'. There is ultimately no pretence, no claim that the camera has captured anything other than a staged event. The initial posture of actuality, subverted in the instant of the stop-motion cut and followed by a fantasy sequence, undermines the truth-bearing qualities of the moving image and satirises the

viewer's faith in images which are presented in the guise of actuality. These 'car crash' films all play upon notions of perceived realism and the ability of trick effects to subvert the spatio-temporal unity of the filmic space. They also represent instances in which trick effects are used to portray everyday events, rather than being compartmentalised within the fantasy genres where such spectacles might be more readily expected.

R. W. Paul also used double exposures in his productions. Made with his regular collaborator Walter R. Booth (himself a former stage magician), *Cheese Mites/Lilliputians in a London Restaurant* (1901) features miniature men that appear on a traveller's dining table. For the double exposure, the diner and his table were shot from a distance of 15 feet, then the 'Lilliputians' were shot with a camera with a long-focus lens against a black background, the camera being situated about 150 feet from these actors. Frederick A. Talbot has given an account of this shoot, describing the facilities which Paul had set up in his studio:

> The camera was mounted upon a special trolley, which could be moved forwards and backwards in relation to the stage over a pair of rails similar to a railway track. The closer the camera was to the stage the larger were the figures. (1912: 201)

What Talbot is describing is a purpose-built facility designed for the production of a particular effect, in this case the double exposure of 'normal'-sized actors and apparently miniaturised performers. Talbot also notes that when reversal of films became popular, and filmmakers started shooting sequences backwards, they were initially faced with practical problems (1912: 216–7). To run a film in reverse through the camera, the operator would have to crank the machine backwards, an awkward action leading to variable cranking speeds. One solution was to invert the camera on the tripod, but, as Talbot attests, some cameras were later fitted with a second driving spindle precisely for the purpose of facilitating reversal effects. This suggests just how frequently these and other effects were put to use in trick films. In fact, there was quite a small repertoire of effects that was reapplied in various narrative contexts. Repeats of the same trick enable the audience to make comparative assessments of the effectiveness of each individual example of its use, and also subordinate the reactions associated with novelty and surprise to those best suited to appreciations of the artistry involved.

An early film which manipulates the recording apparatus to present a subjective time frame is Jean Durand's *Onésime horloger* (*Onésime, Clockmaker*),

produced for Gaumont in 1912. This places it outside the era which Gunning defined as 'cinema of attractions' (ending around 1907), but it stands as a transitional film in which a novelty aspect of the apparatus is used as the basis for a simple narrative. The plot concerns a man named Onésime who tampers with the regulator of Paris's central clock, thus speeding up time so that he can receive his inheritance sooner.[29] After the establishment of this narrative device the rest of the film consists of a series of set-pieces, all shot with an undercranked camera (an effect which would have been well known to camera operators who had ever practised keeping a rhythm with the crank (see Chanan 1996: 120)) to give the impression of increased speed. Thus, the experience of a fast-forward world (*the narrative*) is working in perfect concert with the equipment which records and displays it (*the attraction*).

Rather than precipitating the slapstick chaos which is normally made to seem comedically-enhanced by speeding up the film, Onésime's prank makes the city more efficient, 'more beautiful' as an inter-title tells us. Commuting on public transport becomes less time-consuming, court cases are settled swiftly, children pass through adolescence to adulthood with no time for the turbulence of youth to cause upset to the rest of the populace. Especially interesting is the scene in which a group of builders construct a brick wall in a matter of seconds, the bricks flying into their hands from offscreen. Close inspection reveals that the scene was filmed in reverse, with the bricks being removed and thrown off-camera by the cast, but the speed of the film makes the trick difficult to fathom at first. One optical effect is used to cover the evidence of another.

Most importantly, Durand's film skilfully combines social comment with a striking visual effect. Vitagraph's *Liquid Electricity; or, The Inventor's Galvanic Fluid* (1907) also used deliberate undercranking in its tale of a scientist whose galvanic fluid causes bursts of energy and speed in those upon which it is sprayed, but *Onésime Horloger*'s satirical commentary on the inefficiency of modern society is inextricably linked to its technique, in contrast to *Liquid Electricity*'s foregrounded comic spectacle.[30] It allows film technology to transform what it records into an 'improved' reality.

At the end of his famous essay on the 'Cinema of Attractions' Tom Gunning refers to modern special effects (presumably of the kind which will occupy later discussions in this book) as 'tamed attractions', (1990: 61) stationed at various points throughout the narrative rather than providing the primary reason for a spectator to continue watching – Brewster and Jacobs liken these embedded monstrative moments to 'plums in a pudding' (1997: 18). Gunning infers that, as cinema became narrative-driven and feature length, spectacular

interruptions were integral points of audience address and solicitation, but not a film's *raison d'être*. Thus, the idea of self-contained trick films gave way to an entirely different type of cinema. Kessler also describes how trick effects became 'narrative devices', assisting in the verisimilar presentation of narrative events rather than proffering fantastic and eruptive moments of monstration (see Abel 2005: 644).

However, in films like *Onésime Horloger*, the special effect could gain some status as a necessary and meaningful component of film production rather than as mere adornment. It is the narrative which links the spectacular effects together and provides a motive for arranging them in a particular sequence, but those special effects (the accelerated action) are integral to the thematic coherence of that narrative. In subsequent chapters, it will be shown how special effects were to assume a new role not as interruptions to narrative flow, but also as thematically consistent elements within the narrative vessel. This is comparable to the way in which the nineteenth-century stage magician found that tricks alone had to be encased within a coherent scenario to re-present familiar effects in a new context which could be considered to be expertly authored and therefore artistically creditable. The template for narrative/spectacle interactions established on the magic stage will inform the understanding and explication in this book of how filmmakers were to resolve the same potential conflict into a harmonious interplay.

The next chapter will discuss the beginnings of stop-motion animation, a point at which the fantastic capacities of the cinematographic apparatus would be exploited more extensively. If the stop-action substitutions of Méliès and his fellow illusionists were dissolving the perception of film as an expression of a continuous, inviolably truthful space, the introduction of animated motion of still objects would take this concept further.

CHAPTER 2
Rituals of Incarnation

Stop-motion animation is a process in which a model, usually a scale miniature, is photographed a single frame at a time and moved incrementally between each exposure. As its name suggests (though it has also been called stop-frame, stop-action or dimensional animation), its achievement hinges on a paradox; it requires the stasis of the object in front of the camera in order to build up an illusion of continuous movement from a series of still images.

Studied application of the technique enables a character to move in a mimetically realistic manner, but the nature of its construction lends it a level of anti-realism, of aberrancy lent by its occupation of a spatio-temporal environment separate from that of the viewer. It preserves the textural or anthropomorphic attributes of a model or puppet, but renders the resulting figure distinctly 'othered', sometimes uncanny. Thus, the technique is particularly suited to depictions of the monstrous, the imaginary or the impossible.

The points of interest in this chapter are the way in which this form of animation quickly becomes used for pseudo-realistic motion studies of prehistoric animals, as opposed to purely fantastical beasts, and how special effects become a component of narrative film. *King Kong* (Merian C. Cooper/Ernest B. Schoedsack, 1933) can be seen as an exemplary special effects film of the early sound era. All of the tropes which have recurred ever since are in place by the time this film reaches the screen – a narratively centralised special effect (Kong himself) whose singular nature not only forms the basis for the

diegetic story, but also supports a meta-narrative *about* spectacular display (the quest of the narrative is to retrieve Kong from a remote island and place him on display on a Broadway stage), and the juxtaposition of an animated character, live human actors and miniature sets within the same frame. By superimposing animated characters within the live-action frame, the emphasis is placed upon a *comparison* between the real (synecdochically represented by human actors) and the fabricated, placing the two forms in competition for the spectatorial gaze and combining filmic elements from different sources. In those scenes where Kong shares the frame with Fay Wray, for instance, their proximity within a shot functions as a narratival act (we comprehend a dynamic tension between the two characters) at the same time as it designates one of them as distinctly monstrous through markers of artifice, giving Kong an otherworldly *separateness*. The impossibility of the image and the discrepancies of scale and mannerism between Kong and Wray compel the spectator to inspect the frame for disjunctures that reveal the joins between composited elements, even as the narrative presumes acceptance of their unity.

Discussions of the first film screenings stressed that the moving pictures were being produced by deluging the viewer with a rapid succession of still pictures, as if to demonstrate the scientific (and mechanically-implemented) principle of persistence of vision, or at least to upstage the static limits of the photographic medium of the time (see Gunning 2001: 3). Some Lumière shows (including the first public show at the Grand Café in 1895) began with a still image on the screen which would suddenly be made to move, allowing the paused image to take on 'life' and drawing attention to the still photograph's usual inability to do so. It was like a conjuring trick, transforming the familiar still photograph into something powerfully fresh and vital.

Assuming for illustrative purposes that there is some truth to his story, Georges Méliès harnessed the technical error which had left a jump in the film at Place de l'Opéra and utilised it for maximum effect under controlled circumstances. His substitutional match-cuts reflect the end of the magic theatre's ownership of certain tricks – the film camera's sleight-of-hand lay in the invisible, atemporal spaces between edits. As filmmakers sought to compile sequences of discrete shots into the comprehensible order demanded by continuity editing, Méliès was trying to make those edits disappear, with his precisely timed match-cuts serving to elide the disruption they might cause. Stop-motion animation works on the frame-by-frame principle that is integral to the creation of moving pictures, and which was the domain of optical toys such as the zoetrope, the phenakistiscope and the praxinoscope even before it was a photographic process.[1]

James Stuart Blackton and Albert E. Smith claim to have invented stop-motion animation inadvertently while making a trick film on the roof of the Morse Building in New York in 1898. While they were making the stop-action substitutions, steam was rising in the background, and when the film was projected, the steam seemed to have a crudely animated, jerky motion (see Crafton 1982: 20–1). They applied the technique to moving objects in *A Visit to the Spiritualist* and *The Humpty Dumpty Circus*, neither of which survives today.

Segundo de Chomón (1871–1929) told a similar story of inadvertent discovery. While filming title cards for a film in 1902, he was under-cranking the camera to obtain a high contrast image, and a fly that had been crawling around unnoticed on the card appeared to be moving erratically when the film was projected. His film *El Hotel Electrico* was made in 1905 but not released in the US until 1908, after other animators had aroused audience interest in the effects, but Chomón had applied the principle of frame-by-frame animation to clay models (as opposed to solid objects) by late 1906, for his film *Sculpteur Moderne*. Edwin Porter spent 56 hours animating a minute's footage of moving stuffed toys for *The Teddy Bears* (1907). James Stuart Blackton made *The Haunted Hotel* in 1907 (it was photographed by Albert E. Smith, and released in the US in March), in which objects and furniture were seen to move around of their own accord by application of stop-motion techniques. The 'haunted house motif' provided a space in which supernatural events could take place, setting up a narrative frame around the animation techniques that justified their presence. Since 'the length of the animated sequences gave the audience sufficient time to ponder the trick', the diegetic characters' struggle to explain impossible events could be made an equal partner with the spectator's attempts to divine the mechanisms of the illusion (Crafton 1982: 18).[2] This kind of 'object' animation did not develop independently of two-dimensional, 'cartoon' animation, but the two forms did take divergent paths to meet different commercial and aesthetic demands.

Winsor McCay and 'Gertie'

Without wanting to force comparisons other than as a point of interest, we can see how the authored work of an animator and the performance of a magician might be paralleled, especially in terms of giving life to static objects, if we accept that enjoyment of early cartoons was dependent upon, in Donald Crafton's words, 'vicarious participation in the ritual of incarnation' (1982: 12). These illusory arts may be built around a creatively empowered progenitor

and seen as a kind of technical performance even as they serve up portions of narrative and character display. Believing that animation had been a neglected field of study, and prompted by the paradoxical characterisation of animation as both alive and dead, Alan Cholodenko aimed to resituate discussion of the genre 'between the animists, who believed that the world was alive with spirit or material substance, that all that moved was alive, and the mechanists, who believed that motion was obedient to physical laws and necessitated no presumption of organic or spiritual vivifying agency' (1991: 16). Animation is thus tied to the idea of granting motion, and therefore agency, to immobile machinery long before King Kong took a swing at any dinosaurs.

The cartoonist Winsor McCay (1867–1934) made his contribution to representations of dinosaurs on film, but his creation, *Gertie the Dinosaur* (1914), was less of a fearsome beast than a petulant pet. Charles Solomon has suggested that McCay designed the character in a caricatured manner to ensure that it could not be mistaken for a real creature or for trick photography – some viewers had mistaken his films of *Little Nemo* (1911) and *How a Mosquito Operates* (1912) for live-action trick photography, thus neglecting to appreciate his handcrafted work (see 1994: 17).

Gertie was made up of thousands of drawings, meticulously designed and timed so that McCay could interact onstage with the onscreen character, instructing Gertie to perform tricks for the audience, throwing her a pumpkin (which she would appear to catch) and finally appearing to climb on her back and ride away into the distance. He achieved this finale by stepping behind the screen, at which point, if the timing was accurate, he would seem to transform into his cartoon avatar and enter his own drawing. Crafton has claimed that the early decades of animation were characterised by the endowment of the artist with special attributes and abilities, a distinct authorial presence:

> Part of the animation game consisted of developing mythologies that gave the animator some sort of special status. Usually these were very flattering, for he was pictured as (or implied to be) a demigod, a purveyor of life itself. (1982: 12)

McCay's literal insertion of his own image, along with the title card's introduction of him as 'the inventor of the animated picture', illustrates this dramatically. McCay is also placing *himself* in direct juxtaposition with his animated drawings in order to provoke a spectacular dialectic between the organic and synthetic characters. Such a move would surely enhance the apparent vitality of his drawings by making Gertie appear 'live' and interactive. After his

employer, William Randolph Hearst, placed restrictions on the quantity of his live performances, this show was hardly performed by McCay himself outside New York. Consequently, prints of the film were made for distribution with a live-action framing narrative, shot by J. Stuart Blackton, in which McCay observes a brontosaurus skeleton in a museum and bets his companions 'that he can make the Dinosaurus live again by a series of hand-drawn cartoons'. In actuality, McCay had been approached by the American Historical Society for such a purpose, but in the film it is presented as a bet amongst friends. This sequence is an exaggerated piece of documentary, with studio hands bringing huge boxes labelled 'DRAWING PAPER' and kegs of ink into McCay's studio.[3] Though non-naturalistic, it is indicative of his working methods, suggesting the solitude of the process and also demonstrating the device that he had constructed for reviewing his work, based on a Mutoscope, enabling him to flip through a sequence of drawings held in a rotating mechanism. Using what he called his 'split system', in which the course of a moving object would be plotted in advance as start-, mid- and end-points before filling in the interstitial drawings which created the impression of continuous motion, McCay could achieve a high level of control over how a cartoon would develop (there was no equivalent procedure in puppet animation, for instance, where entire sequences have to be shot in linear sequence).

The onscreen claim of 10,000 separate pictures used to make *Gertie* is surely an exaggeration – Karl F. Cohen (2002) calculates that, since the animated portions of the film comprise no more than four minutes of screen time, there are more likely to have been around 5000 frames of Gertie. Just as Emile Cohl had to do when he made his first animated film, *Fantasmagorie* in 1908, all of the backgrounds in *Gertie the Dinosaur* were redrawn in every frame – this was before the use of cels (acetate strips which could be used to place the individual frames of a character's motions onto a fixed background). Cohl was also the first to combine animation and live action, by means of a matte process, in *Clair de Lune Espagnol* (March 1909), in which a jilted matador fights a cartoon moon in the sky above him. In the case of *Gertie the Dinosaur*, the backgrounds were traced from McCay's master drawing by John Fitzsimmons, whose contribution is not noted in the framing narrative – McCay is always presented as a lone artist, avoiding the equation of animation with industrial process that would later become so pronounced. Part of the Disney process in the late 1920s and beyond involved making the animators anonymous under the catch-all Disney banner, but McCay was working at a time when the authorship of a cartoon was vitally important, as was the attribution of enormous amounts of careful work to a single cartoonist. McCay's

films feature cycled drawings, sequences repeated to save the time that would have been spent on repeating certain actions. For instance, in *How a Mosquito Operates*, when the insect's victim scratches the back of his neck, moving his hand back and forth across it, McCay simply drew the action once and rephotographed it several times. In early cel animation, the walk cycle was a way of cutting down the amount of labour required to complete a cartoon sequence. Felix the Cat's distinctive walk cycle, usually accompanied by the self-reflexive theme tune 'Felix Kept on Walking', enabled Pat Sullivan and Otto Mesmer to re-use the cels of Felix to create repetitive scenes which made him immediately recognisable to audiences and a familiar icon of predictable gait. As Donald Crafton puts it, the special attraction of the Felix cartoons 'arose not from the clever gags (although they were very important), but primarily from the consistency and individuality of the character' (1982: 25.) Certain of Winsor McCay's drawn sequences in *Gertie the Dinosaur* and *How a Mosquito Operates* are repeated cycles of drawings. These repetitious temporal manipulations (possibly throwbacks to the palindromically structured actions seen in zoetrope strips and phenakistiscope disks) were performed in the service of crystallising the recognisable motive characteristics of a cartoon figure.

McCay would later spend three years working on *The Sinking of the Lusitania*; released 20 July 1918, long after the tragedy of 7 May 1915, *Lusitania* could be seen as a call-to-arms, but the long process of animation made it unsuitable for use as a topical art form. The opening live-action sequence shows McCay researching the events and settling down to begin work. Emphasis on the facts of production gives the film an extra emotional dimension. The attention to detail is tacitly equated with historical accuracy, an attempt to give the film a level of veracity which would not normally be attributable to a cartoon film, and which would later become almost non-existent as the Hollywood industry forced animation to preserve a tenacious connection with simplistic family entertainment.

Kristin Thompson has argued that animation was contained within the format of the family film or programme filler to suppress the subversive potential which accompanied its freedom from codes of realism and resemblance. Cel animation, in which cartoon characters are animated on celluloid sheets against fixed backgrounds, was patented by Earl Hurd and John Randolph Bray in 1915, and in subsequent years the process of making cartoons became divided into specialised tasks, around the same time that Hollywood was becoming industrialised as a production-line system (see 1980: 107–8; see also Ward 2000). Thompson argues that Hollywood tamed animation's disruptive aspects to make it compatible with classical cinema as a whole. Crafton agrees

that animation was given a degraded status in the 1920s since it undermined 'the highbrow reputation that intellectuals and critics were self-consciously ascribing to the cinema' (1982: 3), and Kenneth Tynan located a more specific culprit when he complained that 'Walt Disney's accidental domination of the cartoon scene has made it impossible for us to think of it except in terms of clothed speaking animals and birds going through motions designed to entertain the nursery' (2002: 100).

In the 1920s, cartoons were usually a part of motion picture programmes, not main attractions in their own right, so animated figures were pegged as interludes between the serious adventures of flesh and blood actors, and since 'comedy so easily permitted the stylisation thought "natural" to the animated film, an ideological view of cartoons as comic developed' (Thompson 1980: 110). Live-action films retained a certain prestige considered inherent to their photographic nature, while animation was trivialised and remained a technical novelty restricted largely to anthropomorphised animals.

Mainstream cartoons were thus forced to conform to certain codes of practice, remaining anti-realistic in their representational strategies – think of the ways in which even the earliest cartoon characters such as Little Nemo, Koko the Klown and Felix the Cat defy patterns of physical logic and solidity – but avoiding avant-garde or subversive applications of the medium. Disney animators were schooled in a series of standardised techniques which comprised a house-style, but due to the studio's pre-eminence in the industry, the same codes of practice became 'the fundamental principles of animation' (Thomas & Johnston 1981: 47). Chief among these was the formula for *squash and stretch*, which governed the amount of compression and expansion which should be displayed by objects in motion. Observing moving bodies reveals how forms alter slightly in shape while in progress, and if real-world physical laws stand as the default setting for the depiction of movement, then the extent to which animators are permitted to elongate those rules represents a point beyond which the body becomes surreal. This allocation of boundaries to the potentially limitless animated character reflects a cautious conventionalisation imposed upon mainstream animation.

As we shall see in the exemplary work of Willis O'Brien, the use of stop-motion animation would develop according to expectations of realistic presentation, despite its potential for subversive or surrealist applications. Model-work was endowed with a degree of technical prestige due to its alignment with motion studies and scientific plausibility. McCay's work is as valuable to cinematic art as is that of O'Brien, but it was three-dimensional model animation which enabled the direct juxtaposition of the real and the synthetic within

the same diegetic space. It might seem an odd choice to include cartoons in a discussion of special effects, since their generic separation from live-action features would suggest that illusory techniques are their very nature rather than a spectacular component, but they seem to find a common fascination in scrutinising motion and vitalising objects.

Animating the extinct – Willis O'Brien

Born in California, 2 March 1886, Willis O'Brien worked on a cattle ranch, a chicken farm and at a rodeo, before becoming an architect's clerk and a sports cartoonist for the *San Francisco Daily News*. This mixture of vocations, combining practical experience with animals and artistic imitations of movement, equipped him for the task of stop-motion animation, which he practised in an 80-second test reel shot with the assistance of a newsreel cameraman (see Rovin 1977: 7–8). Impressed by the test, Herman Webber, a San Francisco filmmaker and exhibitor gave O'Brien a $5000 budget to make a five-minute short, which took him five months to complete. The film was *The Dinosaur and the Missing Link* (1915), marking the beginning of his fascination with prehistoric animals – he recognised early on the power of recreating dinosaurs rather than wholly fantastic species. O'Brien had trouble finding an outlet for his work; narrative-driven drama and vehicles for human stars were the priorities of cinema exhibitors at the time. After more than a year of unsuccessful attempts to find a distributor, Thomas Edison purchased it (for $525 – $1 per foot) for exhibition as part of a larger programme from his Conquest Pictures Company, first shown 30 May 1917 (see Goldner & Turner 1975: 43; Rovin 1977: 11). Retitled *The Dinosaur and the Baboon*, it was released separately on 11 August 1917.

While waiting for the release of his first film, O'Brien made *The Birth of a Flivver* (1916), in which animated cavemen invent the wheel before deeming it impractical and discarding it. Edison contracted him to one of his small production units based at his Decatur Street studios in the Bronx, New York. For $500 each, O'Brien was to produce eight short films. As well as *R.F.D. 10,000 B.C.*, which was released shortly after *The Dinosaur and the Baboon*, O'Brien made a series called *Mickey's Naughty Nightmares* (aka *Nippy's Nightmares*) combining stop-motion models with live actors by intercutting between them (no composite shots were used). Before completion, the programme of shorts was phased out when the Supreme Court ordered the dismantling of the monopolistic practices conducted by the Motion Picture Patents Company. Exhibitors had begun to concentrate more on entertainment features than on

shorts, and Edison cut back some of his operations, setting O'Brien to work on educational films. Unlike his previous, caricatured characters, these shorts drew upon palaeontological evidence to show scientifically informed approximations of dinosaur forms and movement.[4] He studied zoo animals as well as professional (human) wrestlers to help him to endow his models with realistic movements and to simulate the effects of gravity on bodies (see Elsaesser 2000: 24).

This body of work, along with the subsequent feature films on which O'Brien designed and implemented extensive animation effects, can be placed within the context of decades of fascination with, and artistic representation of, the prehistoric world – Noël Carroll contends that 'there could be no fiction of the prehistoric world variety until the scientific conception of it had taken root' (1998: 121). The cultural preoccupation with dinosaurs must have begun no earlier than 1780, when the first significant, identifiable fossil of a prehistoric creature was unearthed, in a gravel pit in Pietersberg, Holland. Examining the fossil in Paris in 1794, Georges Cuvier found that it confirmed his theory that creatures now extinct had previously inhabited the world. His scientific approach was influential on the burgeoning science of geology, or 'undergroundology' as it was sometimes called, but there were those who still clung to a desire to reconcile the new discoveries with Biblical accounts of Creation. William Buckland, Oxford University's Reader in Mineralogy, found himself under great pressure 'to satisfy the urgent need to find geological evidence that would corroborate the Scriptures, such as a biblical flood' (see Cadbury 2001: 62). Decades later, these beasts would be termed 'dinosaurs' after Sir Richard Owen classified them as 'Dinosauria' in 1841, a term which means 'terrifying lizards', forever branding the creatures as figures of fear (see Gillette & Lockley 1989: 11).

The dinosaur represents a unique configuration of the monstrous, being both a creature which has never, *will* never be seen, but which can also be proven to have existed. It relies upon techniques of representation to retain a place in history as anything other than a mythical beast; fossil evidence has been instrumental in reconstructing the dinosaur in the popular imagination, but these crushed and deformed skeletal shapes required artists' impressions of their living forms to consolidate an accepted visualisation. The rise of studies of prehistory based on fossil evidence of dinosaur skeletons coincided in the nineteenth century with a gradual depletion of superstitious explanations of natural phenomena surrounding the era, and the popularisation of evolutionary theories spearheaded by the publication of Charles Darwin's *The Origin of Species* in 1859. The full title, *The Origin of Species by Means of Natural*

Selection or The Preservation of Favoured Races in the Struggle for Life, articulated a recurrent motif in so many depictions of prehistoric life – that dinosaurs were constantly locked in violent competition ('nature, red in tooth and claw', as Tennyson's *In Memoriam* (1850) put it). Such visions of accelerated evolutionary progression (the 'survival of the fittest' being imagined as an immediate battleground scenario rather than as change over time) represent a conceptualisation of Darwinism which mixes science and spectacular, pugilistic entertainment. The combat of these gargantua is more thrilling and visually opportune than the protracted process of selective breeding.

It is notable what a prominent role the dinosaur has played in the development of special effects, and particularly in animation – the dinosaur's proven existence, along with the lack of a definitive visual representation provided inspiration to many artists.[5] O'Brien's work is probably the most influential in establishing the conventional image of dinosaurs. If this chapter focuses mainly on the creation of animated creatures, fantastic or otherwise, it is also important to note the contribution made by innovations in what I shall term *virtual set design* – the practise of simulating a space in which action can appear to be taking place, either by photographically compositing actors in miniature sets, or by blending those actors with background 'plates' photographed separately. This search for various ways to give the appearance that characters are inhabiting and moving within simulated spaces has been the backdrop to the history of special effects, and continues the earliest filmmakers' attempts to control the frame, to fictionalise film by artificially arranging, as fully as possible, the view which is presented to the spectator. Raymond Fielding sees all matting and compositing processes as technical solutions to practical problems, connected by their attempts to reduce the complexities, expenses and inconveniences of location shooting, but it can be demonstrated that they can also make an aesthetic contribution to a film (1965: 11).

Barry Salt records Norman O. Dawn as the first to use a glass shot in still photography in 1905 (see 1983: 159). His employer at the Thorp Engraving Co. in Los Angeles, Max Handsleigh, had shown him how to enhance the appearance of a building by placing a sheet of glass in front of it and painting the adjustments directly onto the glass. He also used the technique in *Missions of California* (1907), allowing partially-built sets to be 'completed' by painting extensions onto glass. In 1911 he modified this process to create the *glass matte shot*, in which a sheet of glass is set up in front of the camera and a matte of black paint applied to it to cover unwanted parts of the frame. This is then filmed (along with several feet of test footage from which the glass painter will then work) and developed. A paused frame from the film can then

be projected onto an artist's easel. The painter paints the sections to be placed in the matted area, and blacks out the areas of the original film. The painting can then be filmed as a second exposure with both elements combined in the same frame (see Salt 1983: 160). This process required meticulous planning to ensure that the 'real' and the painted elements were integrated with minimal evidence of the seams on display. It could be used to place actors in virtual locations or to place painted ceilings on roofless sets.

'Hall's background process' was an extension of the glass-shot technique, but using a cut-out plywood background instead of a sheet of glass. The wooden shape would act as a mask for the scene involving actors performing many metres away from the camera to lend an impression of great scale to the composited elements (see Low 1971: 246). Paramount held the exclusive American rights to the use of this process, and the minor variations in similar processes were forced by copyright restrictions requiring each studio to develop their own distinct method of compositing, rather than by an urge to standardise the 'most realistic' process. In the period 1907–13, some special effects that had previously been used only in trick films were first used regularly in 'substantial dramatic films' (Salt 1983: 130). These include composite photography using mattes and counter-mattes with part of the frame blocked off in each exposure, which can be seen in Italian epics such as *Cabiria* (Giovanni Pastrone, 1914). Any slightly unsteady movement of the film in the camera gate would reveal the appearance of a black line between the two separately exposed parts of the frame.

The first uses of travelling mattes date back to the early 1920s, following Frank Williams' patenting of the first successful technique in 1918 (see Field 2002).[6] The Williams process involved shooting the foreground action against a highly illuminated white background, and from the negative of this a high contrast film was taken to produce a moving black silhouette on clear film. This was then combined in an optical printer with the negative of the background plate, followed by a second pass to place the original foreground action in the scene (Salt 1983: 206).[7] The Williams Process was used by John P. Fulton to astonishing effect in *The Invisible Man* (James Whale, 1933), in which the technique used to simulate background spaces becomes a foregrounded spectacle; to create the effect of 'empty' clothing walking around, Claude Rains (though he may have been replaced by a stand-in at times) was covered in black velvet before being dressed in the clothing of the character, then filmed against a black velvet background to capture the foreground matte which could then be composited with the background scenery. Various practical effects (hidden wires and pulleys) were then used to manipulate props on

set when the character was totally unseen. The franchise was enormously successful for Universal, spawning several sequels[8] that continued to indulge the fascinating sight of everyday activities performed by an unseen actor (lighting and smoking a cigarette, for example).

The Dunning Process was patented in 1928, a travelling matte technique that eased some of the troubles of the Williams Process (see Salt 1983: 234). Otherwise known as the Dunning-Pomeroy self-matting process in acknowledgement of the input of Roy J. Pomeroy, this was a complex matting technique which proved prohibitively awkward and ultimately incompatible with colour cinematography, though it was used for certain shots in two films by W. S Van Dyke: *Trader Horn* (1930) and *Tarzan the Ape Man* (1932).[9] From about 1930 both travelling matte processes were abandoned in favour of back projection, an in-camera effect achieved live on the set with the concomitant reduction in costs and time schedules required. The earliest back projections had to be on small, ground glass screens (hence the frequent use of the process to show the back windows of moving cars), until the introduction of a new cellulose screen material and improved optics in the projectors enabling the use of much larger screens in 1932 (see Salt 1983: 269–71).

German filmmakers, and UFA studios in particular, were committed to epic productions and the extensive use of optical and mechanical effects to invoke fantasy worlds – Paul Wegener had, in 1916, envisaged a future of 'synthetic cinema', where all elements of the frame would be constructed and controlled artificially (quoted in Rickitt 2000: 19). The career of Eugen Schüfftan (aka Eugene Shuftan, 1893–1977) saw him working as cinematographer on 61 films between 1930 and 1966 in his native Germany, in France and in Hollywood, but his credit as special effects director on Fritz Lang's *Metropolis* (1927) is the one for which he is best remembered, utilising to the full the 'Schüfftan process' of shot composition which he had pioneered for use on Lang's *Die Nibelungen* (1924), released in two parts, as *Siegfried* and *Kriemhilds Rache*, two months apart. Using a dual-lensed camera capable of exposing two focused images onto a single filmstrip, the process could combine miniature models and live actors in one composite shot without the need for multiple exposures or extra laboratory work. This matte-shot technique involved scraping off an area of the tain on the back of a mirror and filming through this new window, while a painted backdrop or miniature scenery could be reflected in the mirror and thus composited in camera and on the set. The Moloch machine envisioned by Freder, the Cathedral's interiors and several street scenes were completed using the process (see Elsaesser 2000: 25). It was invaluable in enabling Lang to show his human characters dwarfed by a brobdingnagian in-

Kong fights a dinosaur opponent: miniature stop-motion models (A, B) face off in a miniature jungle set augmented with glass-painted foliage (C) in the immediate foreground, and painted backdrops (D) to add depth, while an animated miniature model of Fay Wray (E) looks on helplessly from a tree

dustrialised world, and it was also used on Alfred Hitchcock's *The Ring* (1927), *Blackmail* (1929) and *Rich and Strange* (1932), as well as in *Things to Come* (William Cameron Menzies, 1936).

The unreal spaces seen in a film like *King Kong* provide an environment in which special effects can be placed and manipulated with ease, further condensing the production process and containing it, first within a studio, then within miniature sets or in front of back-projection screens.[10] All of *King Kong*'s animation sequences use large back projection screens along with fixed matte techniques and a very few brief Dunning Process shots (such as the scene where a group of sailors on a raft are attacked by a brontosaurus). In some shots of the jungles on Skull Island, studio sets are augmented by glass shots and hanging miniatures. This variety of illusory modes lends an other-worldly sense to the island, and it is in this environment that human actors and animated models are made to apparently co-exist. The monstrous figure (or other special effect) is regularly placed in seeming proximity to live hu-man beings (as opposed to clay models of human subjects), usually so that the former can imperil the latter. The effect of this is to place the two in compara-tive situations, to invite the spectator to examine the motile characteristics of each and to measure the quality of the visual effect next to the yardstick of the human being. By comparing the monster to the human in such a direct man-ner, these compositions can literalise the otherness of such creatures. Ludwig Wittgenstein once described the photographic image as 'a situation in logical space, the existence and non-existence of states of affairs', and these 'states' posit the image 'against reality like a measure' (1981: 8–10). So, just as the im-age is always correlated with the real, so the component parts of a composite image are correlated with each other. This concept of comparison will become a more pronounced point of discussion in the later examination of synthespi-

ans, but at the time of *King Kong* and other films centred on the threat from gargantuan creatures, it is already a key tactic in drawing the attention of the spectator towards the locomotive characteristics of an animated specimen.

Released several years before *King Kong, The Lost World* is the film that first demonstrated how O'Brien's animation techniques could be integrated with a narrative, serving as spectacular adornments to a romantic emprise. The film (released in 1925) is based on the novel (published in 1912) by Sir Arthur Conan Doyle (1859–1930), a writer who had achieved success with the adventures of his fictional detective Sherlock Holmes, but who also wrote travel books and spiritualist studies prior to this adventure based around a South American plateau which has preserved specimens of prehistoric life, including dinosaurs, in a state of suspended evolution.[11] A prologue was made for the film which included footage of Doyle inspecting the craft of O'Brien in his workshop and thus showcasing the technical artistry (and revealing, immediately before their presentation, the means of their achievement) and indicating the approval of their literary originator. This footage has been lost since the film's initial release – the only surviving portion is a brief filmed portrait of the author as if offering a personal appearance to endorse the film adaptation.

Ed Malone, a London reporter, hopes that his mission to document a rescue attempt in South America, with the implied danger of mythical monsters, will provide sufficient evidence to Gladys, his intended fiancée, that he is the agent of his own destiny and a worthy suitor. Once on the plateau and amongst the beasts, which have proved themselves to be real, he falls in love with Paula White, a young woman who hopes the mission will save her father, who was stranded on the plateau. The love triangle has a somewhat Darwinian tinge to it, with Ed selecting the mate who is best suited to the environment in which he is contained. Ed's reasoning for his swift transference of affections is that he and Paula are thoroughly segregated from the obligations of the modern world. John Roxton, the adventurous hunter selected by scientist and expedition leader Professor Challenger for his experience and daring, is clearly attracted to Paula, but concedes defeat to the younger, more procreatively suitable Malone.

The dinosaurs, and their plateau, thus represent a utopian escape, an evolutionary pile-up where man and dinosaur end up co-existing free from the nuisances of modernity, urbanisation and technology. Doyle's satirical target may have been the destructive effects of colonialist interference in balanced eco-systems (what could be more balanced than a land which has retained an evolutionary status for tens of millions of years, sustained by its resistence to

modernisation?), and the humans in this film, despite their frequent expressions of such fears, are not directly threatened by the dinosaurs. It is only a catastrophic, indiscriminately destructive volcanic eruption which forces the flight of both species and leads to one brontosaurus (a change from the book's pterodactyl) being captured and unleashed in London, raging against its unwonted environs. Unable to settle in the city it brings violence and aggression until it falls through Tower Bridge, a human confection that mirrors the makeshift tree bridge which gave the humans access to the plateau in South America. Adapting quickly to the more familiar scene of the River Thames, the dinosaur swims off towards an uncertain future in the sea (though drowning would seem like the most likely outcome).

The Lost World emphasises the opposite 'spatial zones' occupied by the human and animal characters. The dinosaurs provide a backdrop to the human drama, in particular the romantic dilemma, at the centre of the film. They are catalysts for action, and have no contact with the human characters until the climactic brontosaurus rampage, during which shots of actual contact are achieved not with the animated models but with a life-sized model head, foot and tail. Cutaways from the humans to the dinosaurs are usually sudden and disjunctive. Separate lighting arrangements illuminate them and, obviously, they occupy separate sets. Those shots in which they are composited together are achieved using a combination of glass shots and travelling or static mattes. The matte techniques developed for the film by Ralph Hamerass (one of First National's contracted special effects technicians and a glass-shot specialist) and Fred Jackman enabled them to insert, photographically, human actors into the miniature dinosaur sets or model dinosaurs onto the full-size sets. The latter arrangement does not occur until the climactic rampage in London, with the beast invading the human space both diegetically and technically.

First National had been sceptical about the film's reliance on model animation, unsure that it could be integrated with dramatic, narrative and human elements fluidly, and insisted that Marion Fairfax's screenplay be made secure by retaining a structure that would be coherent and entertaining should there have been a need to abandon the animation and leave out the dinosaurs. Although it is difficult to imagine how the film would have been received had it not delivered any sightings of the promised monsters, it is still evident that the screenplay further serves to segregate the human and dinosauric elements – the actions of the monsters never affect the humans irreversibly. They are separated by narrative, by studio concerns and by the technological limitations preventing actual physical contact between human actors and miniature models.

O'Brien worked almost entirely alone while animating the dinosaur models. Only during the stampede caused by an erupting volcano did he have assistance from other animators, working with up to fifty creature models on a set 75 feet wide.[12] Most of the sets were approximately 3ft x 6ft, designed by Hamerass, with trees fitted with metal leaves to prevent their disturbance by the hands of the animator.[13] Fifty dinosaur models were designed by art student Marcel Delgado (who would work with O'Brien again on the designs for *King Kong*), based on the speculative drawings of Charles Knight from the Museum of Natural History. The armatures of the models contained balloon bladders that could be slowly inflated and deflated to simulate the creatures' breathing; this adds a second layer of artifice by pointing to a vitalising force, within the model, that cannot be attributed at first sight to the handiwork of an animator.

Stop-motion animation urges the viewer to seek evidence of the presence of the artist, whether through a close inspection of the indentations of an animator's fingers in the clay of the model, or a futile search for glimpses of his hand between the frames. Norman McLaren has suggested that what happens *between* frames is more important than what is *on* each frame. Animation is thus 'the art of manipulating the invisible interstices that lie between frames' (quoted in Diprose & Vasseleu 146: 146). Out-takes from *The Lost World* show that O'Brien, animating at speed, would sometimes appear in the frame for a split-second, mistakenly caught on camera between model movements. Even if we are always aware that the dinosaurs are miniature models, it is only through examination of the vestigial traces of the artist that we can discern their exact scale and gain a glimpse at the interstitial spaces in which the art of special effects is performed. It is a compelling act of concealment, making the puppeteer invisible.

The eighth wonder of the world

After the success of *The Lost World*, O'Brien was keen to explore other uses for his famous techniques. A film about Atlantis was shut down after three months of pre-production in collaboration with Ralph Hamerass, and the pair then proposed a film of Frankenstein in 1929, using a live actor for close-ups and a stop-motion creature performing super-human feats of strength in long shots. It received no interest from Hollywood studios. *Creation* was to have reunited O'Brien with Harry O. Hoyt, but was shut down in 1931 despite the completion of a year of animation tests and pre-production work on sets and design (see Rovin 1997: 23). Stop-motion animation was also proving to be a

much slower process for a sound film, since it ran at 24fps instead of the 16 or 20-frame standards in which O'Brien had previously worked.

Studio executive Merian C. Cooper (1893–1973)[14] had planned to use live gorillas and miniature sets for a monster movie he was developing, until he came across RKO's 'Production 601', provisionally titled *Creation*.[15] The plot, apparently lifted from *The Lost World*, concerned a submarine crew marooned on an island populated by surviving prehistoric animals. The project had been cancelled when it became too expensive to shoot, but Cooper decided to utilise *Creation*'s miniature sets and props for *King Kong*, as well as adopting the stop-motion animation process which had been proposed by '601''s special effects supervisors Willis O'Brien, and Marcel Delgado.[16] This is also where the idea for the inclusion of other prehistoric species came from – O'Brien had planned a variety of monster attractions for *Creation*.

O'Brien used a technique called 'miniature process projection' for scenes shot for *Creation* by cinematographer Karl Brown. All the scenes of natural catastrophe (including a mountain rising out of the sea and a tornado, which was achieved by creating a vortex in a water tank and pouring in negrosin, a black powdered dye soluble only in alcohol, to give the funnel definition) were lost when the film was halted due to objections from studio stockholders. The film had consumed $300,000 in production costs before principal photography was fully underway, and O'Brien had already animated a menagerie of models, comprising a family of triceratops, an ape, a jaguar, a kinkajou (sometimes called a 'honey bear') and a human figure (see Turner 1982: 1084). A version of the scene where Kong shakes the ship's crew from a tree trunk into a ravine was filmed to show to the studio executives (the sets and props were already built for Production 601), in the hope of convincing them that *Kong* would be a viable proposition. The animation was sufficiently impressive to secure the funding for the whole production.

The models for *King Kong* , approximately 18 inches high, were made of cotton and foam rubber over metal skeletons with ball-and-socket joints, and the fur was made from rabbit skins. The stop-motion models constituted almost all of the animals' physical characterisations, although a life-sized bust, hand and foot of Kong were built for some shots. The giant head-and-shoulders model, hardly used in the film, came to be of more use in publicity drives – Sid Grauman placed it outside his Chinese Theater in Los Angeles when he screened the film on 24 March 1933.

Some of the written material contained in an original Radio Pictures programme commemorating the release of *King Kong*[17] provides insight into the industrial concerns of the special effects input. While the programme makes

no mention of stop-motion animation or the actual size of the Kong models, it speaks of the film's previously unparalleled dedication to the realism of its depictions. Expert showman Merian C. Cooper described the monsters displayed in the film as: 'Mammalian and reptile ancients so true to known facts that today they form the most scientifically valuable collection of palaeontology in the world.'[18] The endeavour to achieve realistic, that is, historically/empirically accurate dinosauric representations is tempered by boasts of how astonishing a sight the realistic achievements are. If we are to be amazed, we must be aware of the research and the preparation and the craft that has gone into creating a source of amazement. After all, how can the quality of depictions of creatures nobody has ever seen be measured if not through its situation within the parameters of current scientific knowledge?

On the other hand, Jean Boullet compared O'Brien's deliberate use of 'conscious poetic improbabilities' to that of Jules Verne, remarking that 'Willis O'Brien never aimed at realism; he only sought the impact of the fantastic' (1976: 108). There is thus a curious mix of verisimilitude and exaggerated spectacle that characterises this kind of special effects work. Kong, for instance, is modelled upon a real gorilla, but is fully characterised – he does not move naturally, but his actions are instead meticulously directed. He has meaning only when in motion – if the character were to stop moving, he would immediately become all too obvious as an inert puppet. As a result, he is in constant motion, and O'Brien always finds reasons to move his fingers, facial expressions or limbs. It is this 'busy' nature of animated creatures that is demonstrative of their distance from realist principles. It may simply be the case that a model animator feels obliged to move the character slightly between every exposed frame rather than pacing the motions realistically, thus resulting in a character which moves restlessly, since its artist must constantly imbue it with the very capacity which is its primary characteristic as a source of technological spectacle – movement. David Allen has remarked on how the need for special effects shots contributed to this hyperreal aspect ('the deficiencies of miniature background projection meant that no real jungle could be projected behind the puppet characters' (1976: 186)), but Noël Carroll tries to reclaim these same deficiencies as a virtue of the style of filmmaking:

> Despite Willis O'Brien's skill, the space of many of the shots sporting battling, back-projected behemoths in the background and tiny humans in the foreground seems curiously disjunct. The monsters inhabit tangibly different spatial zones than the humans. They appear, at times, like visions, imbued with an aura of irreality, which, in the long run, works in Kong's favour as

yet another dimension of dream-likeness ... The visible unnaturalness of the monsters does not make them any less persuasive. Rather, it accents their otherness, a more appropriate effect for this type of film than a smoother, flowing naturalism would offer. When the cinematic seams show in *King Kong*, they fortuitously fit the overall expressive scheme of the film. (1998: 135–6)

The detectible composition of separate elements does not create a view of a single, coherent image, but a cluster of distinct components dialogically combined. Carroll is making an important point by acknowledging the ways in which the particular style of a film's special effects, when given technological and artistic coherence, can provide meaning. For instance, the primary authorial role of Willis O'Brien in the production of the stop-motion creatures gives them continuity and a uniform set of motional characteristics. It would have been ridiculous and incoherent to have a stop-motion puppet fighting a hand puppet or marionette. Kong is primarily disjunct in those shots where the stop-motion miniature is intercut with views of the enormous model that was built for facial close-ups. This artistic quality is more important in establishing a relationship between the spectator and the animated character than is any verisimilar aspect.

King Kong is an extension of *The Lost World* in several respects. When the arrival of sound on film rendered the relatively recent (and still popular) spectacles of Hoyt's film a little passé, domestic prints and the export negative were destroyed in anticipation of a 'talkie' remake, and the work passed into obscurity, consigned prematurely to the status of historical landmark which it still occupies, rather than preserved as a modern triumph of special effects artistry. It was assumed that a sound remake would be presently forthcoming, and so it was with O'Brien's *Creation*, a largely technical exercise which merged with the adventurous narrative sensibilities of Cooper and Schoedsack to form the basis of *King Kong*.

In *King Kong*, the giant ape is emotionally and physically altered by his contact with the humans, the city, and the modern world, with which he compulsively interacts. His destructive spree in New York is a vengeful assault on the decadent city that imprisoned him for the sake of its selfish questing for colonialist pleasures and exotic entertainments with no thought for the conquered subject. Both of these films criticise the hubristic arrogance of explorers (and, by extension, exploitative entertainment promoters), but *King Kong* is emphatic in permitting empathetic readings of its creature's plight.

The film is open to many interpretations, and as Fatimah Tobing Rony has stated, it has been variously seen as 'dream, capitalist fairy tale, imperial-

ist metaphor, allegory of the unconscious, and repressed spectacle for racial taboos' (2000: 242). William Troy's review, first published at the time of the film's release, sees *King Kong* as 'the sign of an inflated decadence', and stresses that its hyperbole and magnitude indulges America's 'sometimes childish, sometimes magnificent passion for scale' (1972: 104), an observation which might become ironic considering that those spectacles of scale are achieved using miniatures. Noël Carroll posits *King Kong* as a metaphor for the Great Depression, comparing it to musicals such as *42nd Street* (Lloyd Bacon, 1933) and *Gold Diggers of 1933* (Mervyn LeRoy, 1933), in which the production of a lavish stage show was a cathartic goal for all concerned, in order to bring prosperity and happiness (see 1998: 126). Similarly, Kong is captured for his value as an entertainment attraction, promising riches and fame for his captors. Andrew Bergman includes it in a list of films such as *State Fair* (Henry King, 1933), *The Stranger's Return* (King Vidor, 1933) and *Our Daily Bread* (King Vidor, 1934) which contain 'implicit or explicit celebration of rural life' at a time when twelve million Americans were unemployed, the New Deal was granting homes to the jobless, and the 'Back-to-the-Earth' movement was arguing for a return to a sustainable agrarian existence (1991: 70). X. J. Kennedy finds another Depression allegory in the character of Ann Darrow, who is 'magic-carpeted out of the National Recovery Act', and sees in Kong himself a beast who furiously smashes up the Depression-era setting of the grim Manhattan shown at the start of the film, and to where he has been relocated from his jungle kingdom (1972: 106). Kong dies when he topples from the spire of the Empire State Building, enduring symbol of modernity and one of the last skyscrapers to be built in the period of frenzied building in the New York of the 1920s (though in 1933 it was still half-empty), which ended with the Great Crash. Kennedy goes on to suggest another reading which might be taken by 'Negro audiences', in which Kong could be seen as a satirical vision of racial injustice, being the story of 'a huge black free spirit whom all the hardworking white policemen are out to kill' (1972: 109; see also Snead (1994) for a discussion of the racial themes of *King Kong*). He could also represent 'the impulses of the unrestrained libido', and the oneiric qualities inherent in the animation effects link the psychoanalytic implications of such iconography succinctly enough to facilitate such interpretations (see Dale 1976: 121). R. C. Dale believes that *King Kong* 'manages to bypass the critical, censorious level of the viewer's consciousness and to secure his suspension of disbelief with what appears to be great ease', and the vividness with which the film is able to present its illusions helps it to 'succeed in dreaming for us' (1976: 117).

What is obvious is that Kong accommodates many different 'dreams' – if not quite an empty signifier, he is at least a capacious one. Claude Ollier suggests that the first design of the giant ape was posed atop the Empire State Building, and thus that the story might have been reverse-engineered to create 'absolutely ineluctible lines of causality' leading up to that defining moment' (1972: 111). The plot therefore consists of simple binaries (male/female, human/non-human, civilised/savage, jungle/city) culminating in a vertiginous zenith of conflict combining them all. The threat posed by Kong escalates from the individual (Ann, his sacrificial victim) to the group (her team of rescuers) to the village (the besieged island natives) to the city (New York) and perhaps finally to the nation, represented by the scrambling of air power to unseat the monster from his perch atop a monument to national pride. This simple narrative structure, with its clear structures of causal development and binarised thematics, acts as a framework for the film's spectacular pleasures, with set-piece confrontations punctuating the storyline and positing those binaries as points of physical confrontation. It is also a deeply self-reflexive film, repeatedly using image and dialogue to draw attention to its own status as a work of illusory narrative fiction, to lay bare the mechanisms driving the plot forward. If, conceptually, *King Kong* is a premise for showcasing the special effects of Willis O'Brien (a giant ape, subtracted from its natural habitat, finally runs amok in New York and wreaks widespread destruction before being destroyed), the narrative framing devices become more vital as a result. The beast is not revealed to the audience until forty minutes into the film, almost at the halfway point. Until then, the story concerns the efforts of a filmmaking explorer, Carl Denham (Robert Armstrong), to capture on film a giant ape of which he has heard stories. He enlists the help of Ann Darrow (Fay Wray), an aspiring actress who agrees to go on the expedition to Skull Island, where Denham believes he will find Kong. Like Dziga Vertov's *Chelovek s Kinoapparatom* (*The Man With a Movie Camera*, 1929), which begins with an audience awaiting a performance and ends with the cans of film being delivered to the theatre so that this diegetic audience can begin watching the film that we have just seen being made, *King Kong* repeatedly references its own manufacture.

In respect of this, Carroll notes that *King Kong* displays 'the hysterical cadences and hyperbole of Hollywood advertising', and refers to it as 'a swaggering, arrogant film that spends much of its time telling us how great it is' (1998: 129–30). Denham declaims repeatedly about how marvellous and revolutionary his film will be, which reflects back onto the film in which he is a fictional character. *King Kong* is by no means unique in its desire to draw attention to the mechanisms of its own production, but the extent of its reflexivity certain-

ly gives it a strong sense of irony with its self-contained analyses not only of its own production but also of its own publicity. It is this narrational strategy, which creates a space for unalloyed spectacle and justification for astonished gazing.

The result of this self-reflexivity is that the viewer is constantly reminded of her position as spectator, as a part of an audience in a theatre. The paradox is that this happens in a film that invites her to indulge in visions of the fantastic. The dreamlike qualities of the film, documented by so many critics (see below), work alongside devices of alienation which serve to jostle the viewer between suspension of disbelief and the stark reality that one is in a theatre. While the ethnographer's claim is to bring the distant views closer to the audiences at home, one of the actual effects is to create a reminder of distance and difference. Hence the fascination in ethnography with tribal customs, showing how other races deal with familiar situations (eating, sheltering, getting married) in ways that seem strange to external observers. *Kong*'s spectacle is similarly derived from reminding the audience of its distance from actual experience, and parallels the ape's exotic attraction with the techno-exoticism of his visualisation.

Special effects, (un)realism and the Uncanny

As mentioned above, one of the recurring motifs in depictions of dinosaurs was an aggressive, inter-species struggle for survival in an accelerated Darwinian selection process that could represent leaps of evolution in a few confrontations over food and territory. In *King Kong*, the ape fights and defeats giant lizards, but is later felled by Man, who uses advanced machines and weapons to reinforce his evolutionary advantages. Kong is then removed from his habitat to be displayed in New York as a public entertainment. Cooper and Schoedsack thus provide a discourse, which would include their own ethnographic works, about the transformative effects of 'capturing' the beast, literally and figuratively.

By the time O'Brien and Marcel Delgado came to produce what they hoped would be perceived as a definitive rendition of the prehistoric world, the sparring beasts were a device they could use naturally, to show off their skills at integrating several models and special effects sequences, and also to express this microcosmic vision of Darwinian natural selection. If the discovery of dinosaur fossils proved the world to be millions of years older than had been previously believed, and that humankind had not always been the dominant species appointed by a creative deity to rule the planet, the dinosaur became

an awesome symbol of Man's subservience to nature, a warning against hubris and scientific arrogance. The trend for archaeological digs in search of further fossils is reflected in films which seek to provide photographic records of dinosaurs which complement the scientific data so far gathered. *The Lost World* and *King Kong* can both be counted in this category, and are therefore seen as thematising attempts to represent the prehistoric world and create images of it for public consumption.

Willis O'Brien took it upon himself to give his own account of how the *King Kong* miniature effects were produced, in order to counteract the misinformation that he saw as clouding the publicity for the film. He saw that several publications were speculating on the precise details of the special effects, and hoped that by removing some of the elements of mystery, audiences could become more fully engaged with the characters and situations that those effects represented:

> Miniatures and so-called trick shots are not a medium used to fool the public, but rather a means of obtaining a better or otherwise impossible angle to further the completeness of the story and are used as the only possible solution to get the desired effect ... I believe the public has come to realise and appreciate the true creative ability required in the conception and execution of these shots so as to obtain the maximum in artistic and realistic effects. (1976: 184)

Just as David Devant claimed that the spectator's awareness of the artifice on display would foster greater appreciation of the artistry behind it, so O'Brien suggested that his audiences needed to see his work as displays of applied technique as well as narrative events. Extending this viewpoint is the Surrealist writer Jean Lévy, who appreciates the film not for its function as a contrived spectacular entertainment, 'a grandiose fairground attraction', but for its 'involuntary liberation of elements in themselves heavy with oneiric power, with strangeness, and with the horrible' (1988: 137). Lévy is attributing dream-like qualities to the look of the film, particularly those images conjured using special effects, shifting discussion away from qualitative assessments of how 'realistic' those effects might be:

> I think the inept laughter of the public is only a defence mechanism to force itself to think that this is only a mechanical toy and, having succeeded in this, to escape the feeling of *unheimlich*, of disquieting strangeness, that we cherish and cultivate, for our part, so carefully, and which nothing brings to life as readily, and rightly so, as being in the company of automata. (1988: 139)

Here, it is the very mechanistic nature of the Kong model, including the jerki-ness that might be classified as a failing of the technique, which makes it a fearful sight. It is Kong's resemblance to a machine pretending to be an ape that is unsettling, as opposed to the realistic depiction of a mythical beast. Even if contemporary viewers could not describe precisely what it was about Kong's movement that was not 'quite right', the absence of motion blur may explain much of the effect. Since Kong was photographed in stasis at all times, he does not bear the photographic evidence of ever having moved – that is, his movement is never blurred, as it is in photographs of fast-moving objects in motion (see Flynn 1995a and 1995b). In his biography of O'Brien, Steve Archer notes that he would sometimes animate 'in twos', exposing two frames each time a model was moved, or left models static for even longer if they were not performing important actions. This saved time on production, but made the movement of the figures seem even more jittery (1993: 9).

The unrealistic (perhaps even deliberately *anti*-realistic) motile aspects of stop-motion characters need not therefore be dismissed as feeble forerunners of more 'sophisticated' effects. The attraction of the technique lies in its dis-tance from the real that renders it fascinating because of the oneiric sensation that is induced when a simulation stands in comparison with a real-world referent, creating a fragmented collage from discrete spatio-temporal units, what Ollier calls a 'doubtful space' indicative of 'nightmare worlds' (1972: 118–19). He notes that any flaws in the film's design, either in the compositing of elements shot separately or in the rendering of Kong's movement, 'far from destroying or enfeebling the credulity of the spectacle, are in accord rather with the presentation of a totally dreamlike state, a dream created by means of spatial illusion, optical displacement, and disruptions between individual shots and the overall continuity' (1972: 118). The spectacular qualities of *King Kong*'s animated creatures are not caused by a startling realism, but rather by the spectators' instinctive response to an uncanny image which has so far only existed in the imagination.

Sigmund Freud identified the Uncanny as a fear of something artificial which has transgressed a representational boundary to cause the viewer to momentarily question its artificiality. This 'special conceptual term' (2003: 123) relates to 'that species of the frightening that goes back to what was once well known and had long been familiar' (2003: 124). As Robyn Ferrell describes it, the Uncanny is 'expressly *not* an explicable, lucid, decipherable moment; it is anathema to intellectual confidence. It is bodily; you feel a chill, a shiver, you flinch' (1991: 131).

Unheimlich is the opposite of *heimlich* ('homely'), which might suggest that the Uncanny is the unknown, and thus frightening, but Freud argues instead that it stems from something that has deviated from its familiar state in certain vital properties. Ernst Jentsch, in an earlier paper on the Uncanny (1906) defined it as being embodied in 'doubt as to whether an apparently animate object really is alive and, conversely, whether a lifeless object might not perhaps be animate' (Jentsch quoted in Freud 2003: 135). For Freud, the Uncanny is the return of the repressed from its station in the unconscious, offering a case study to validate his psychoanalytic theory of the castration complex, but Jentsch's earlier definition is very apt in its characterisation of this eerie sensation caused by an intellectual uncertainty 'as to whether something is animate or inanimate, and whether the lifeless bears an excessive likeness to the living' (Freud 2003: 140–1). This could be something as literal as a statue coming to life to form a living simulacrum of its subject, or King Kong himself, an animated special effect imbued, once in motion, with an ability to interact with human actors and express his symbolic functions (racial stereotype, depression-era rage, primitivist discourse and so on). The moment of hesitation, the momentary co-existence of rational explanations and fantastic illusions is another key description of the nature of special effects.

The stop-motion animation techniques of Willis O'Brien did not evolve as a response to a new technological development or public fascination with a particular piece of apparatus, as did CGI in the age of computers, but rather they were the output of singular craftsmen, of whom O'Brien was the most renowned. He was the first person to win an Academy Award for special effects, for his work on *Mighty Joe Young* (Ernest Schoedsack, 1949), a follow-up to *King Kong* featuring a smaller, more overtly sympathetic ape.[19] O'Brien is credited as 'special effects supervisor' on the film, and one of his technicians was a young Ray Harryhausen, who actually performed most of the animation himself under O'Brien's tutelage.[20] The financial failure of this film compounded the reputation of stop-motion as expensive and time consuming, since it was the special effects budget that had significantly reduced profits. Harryhausen comments that the special effects involving stop-motion were so expensive that, even after winning the Academy Award, 'no one knocked on Willis O'Brien's door' (quoted in Pinteau 2004: 37). But even earlier, the enormous success of *King Kong*, critically and financially, had not caused a wave of similar films to be produced (apart from the hastily-concocted sequel, *Son of Kong*, Ernest Schoedsack, 1933), simply because there was no stop-motion department at any of the major studios which could be employed for such an enterprise, and the exercise itself was laborious and expensive. It therefore re-

Kong crosses a photographic
barrier to tease his captive:
the Kong model is animated
in front of live-action footage
matted in of Fay Wray
struggling in a full-scale hand
and forearm rig. A matte line
around the space in which she
performs is just visible

tains the characteristics given to it by O'Brien and emulated by Harryhausen,
leaving us with a legacy of a special effect that is strongly authored, formed
by the particular sensibilities of an artist rather than being at the mercy of the
idiosyncratic capabilities of a cinematographic mechanism. Norman M. Klein
has remarked upon student computer animators who told him of their admi-
ration for the grotesque, scratchy puppet animation of the Brothers Quay, and
their wish that their films could be similarly 'haunted … as an antidote to the
hygienic digital screen' (2000: 35).

As has been made clear, there are certain strategies at play in the produc-
tion of spectacular sequences involving stop-motion animation, almost all of
which are predicated upon the interplay that is co-ordinated between com-
posited elements. This is partly in the service of depicting narrative events,
but it also requires a parallel appreciation of the mechanics of the illusion. A
lengthy shot shows Kong tearing strips from Ann's dress, holding her in one
hand and curiously tickling her with one finger of the other. This is a moment

Animated miniature of Mighty
Joe Young tips over a cage
containing a rear-projected
lion, while live-action footage
of water flows across the
immediate foreground

Mighty Joe Young wins an easy tug-of-war with a group of strongmen: the rope held by the strongmen in the live-action footage is exactly matched to the rope that miniature Joe holds in his hands

of peril in the story (and an interesting piece of characterisation), but it also operates as a spectacular incident because the spectator knows that these two beings should not be able to *touch*. The thrill of connection between the two elements, fracturing their ontological separations, is a crucial aspect of special effects.

Similarly, in *Mighty Joe Young*, an early shot shows Joe tipping over a lion-cage; whatever this action means for Joe's characterisation (particularly his contempt for confinement), it means something entirely different at the spectacular level, once the spectator perceives that the animated ape appears to be rocking the cage of a creature that is clearly a real live beast, shot separately. Not all spectators would be technically cognisant enough to see through the trick immediately, but it is certainly true that the sequence has been constructed not simply to carry out narrational tasks, but to present something that spectators know to be technically difficult. The technical decisions which dictate how such an effects shot will look stem from attempts to mask the 'blend', the point at which the elements meet within the frame. There seems to be a presumed sense of Bazinian realism, whereby spatio-temporal continuity stands as evidence that the camera captured events objectively, and without manipulation. The techniques on show are all designed to give the impression that Joe and the lion were photographed at the same time from the same fixed position. The addition of live-action water flowing across the foreground adds another spatio-temporal zone to this complex composition.

Mighty Joe Young is littered with other examples of visual play with the boundaries between live action and animation. In an echo of Winsor McCay throwing a pumpkin to Gertie the Dinosaur, Jill (Terry Moore) throws a banana to her primate companion, and the key sequence in which Joe performs a tug-of-war against a team of strongmen is surely a conscious play with appar-

ent physical impact of composited elements upon one another. The creation of absolute realism in these instances is less a concern than the production of a dynamic frisson between the filmic and the animated.

CHAPTER 3
Invasion and Excursion

Stop-motion animation embodied certain key principles of special effects – the supply of apparent movement to an actually stationary character; a false impression of scale through the use of miniature sets and props to represent full-scale objects; the juxtaposition of the organic with the synthetic by matting, compositing and back projection to suggest that the live performer and the animated model are spatially co-existent. However, despite the enormous success of *King Kong*, stop-motion's great signature moment, the time-consuming and therefore expensive technique did not become widely used. The wantonly cutesy sequel, *Son of Kong* (Ernest B. Schoedsack, 1933) was produced in haste to capitalise on the immediate sensation of the original film, but Willis O'Brien had to rush the relatively small number of animation shots to meet scheduling demands. However wondrous the technique might have been, it was too specialised a skill for a studio to commit resources to, and it remained an occasional attraction rather than an industry standard.[1]

More common in Hollywood cinema of the 1930s was the use of 'background' effects, relegating special effects to a supporting role. The implementation of sound films as the standard format in the late 1920s, and the cumbersome equipment required for the conversion from silent film production and exhibition, forced filmmakers back into the confines of interior studios and necessitated the extensive use of miniature sets and virtual set design.[2] This shift was hastened by the practical difficulties accompanying the construction

of the kind of gargantuan sets used for *Intolerance* (D. W. Griffith, 1916) or *The Thief of Bagdad* (Raoul Walsh, 1924). Fred Niblo's *Ben-Hur* (1925), perhaps the costliest of all silent films, had used a full-scale reconstruction of Rome's Circus Maximus on location in Italy, but production difficulties, including a major fire on a full-scale ship (rumours persist of Italian extras drowning during this incident, shots of which survive in the final cut), disastrous weather conditions and an Italian labour dispute forced the completion of many shots using miniatures on rebuilt sets in California (see Thomas 2006; Rickitt 2000: 19). There was also a taste amongst audiences for urban crime dramas, musicals and talkie comedies that did not require the foregrounding of spectacular illusions. The tools of special effects, such as the optical printer[3] and the rear projection screen, were applied as supports to dramatic narrative cinema, the former used to provide transitional effects such as wipes and dissolves, and the latter for providing backdrops not just for fantastic locations, but also for dialogue scenes where the characters were, for instance, in a moving vehicle. The proliferation of such techniques was not in the service of fantastic display, but to add fluidity and variety to the cinematic lexicon, and this meant that even those films laying claim to realist intentions were encrusted with the iconography of special effects techniques – split screens, optically printed titles, rear projection and transitional devices. Raoul Walsh's *The Roaring Twenties* (1939), for instance, races through an account of America's prohibition era using a wide variety of these transition techniques to subdivide a montage of images and present them as a historical background to the film's narrative – the optical effects mark out these expository sequences as distinct from the classically-edited story action.

It is not to be suggested that artificially constructed visual spectacle dropped out of favour (lavish composite shots and model-work pervade or at least adorn *The Adventures of Robin Hood* (Michael Curtiz/William Keighley (1938), *Gone With the Wind* (Victor Fleming/George Cukor/Sam Wood, 1939), *The Robe* (Henry Koster, 1953) and *Vertigo* (Alfred Hitchcock, 1958), to name but a few), but it is the intention here to discuss some films whose use of special effects is intimately linked to their themes and meanings. By the 1950s, the burgeoning interest in the science fiction genre was requiring the extensive use of models and compositing. More specifically, special effects were being used to aid and shape the depiction of interplanetary travel by alien invaders and explorers from Earth.

According to Ken Hillis, 'SF has always been an ideological narrative or "discourse". Its visions and overt use of spatial metaphors in describing power relationships offer compelling glimpses into the popular "geographic imagina-

tion" and are part of the apparatus facilitating actual technology's social acceptance' (1999: 19). Patricia S. Warrick begins her account of the literary science fiction genre in Mary Shelley's *Frankenstein* (1818), continuing with H. G. Wells and Jules Verne, who imagined machines capable of transporting people on amazing journeys through time and space. Their narratives foregrounded the potentialities of technology, whether they represented fabulous opportunities for social improvement or more destructive possible scenarios (see 1980: 2). Other film genres, such as the musical or comedy, which dealt with technological issues, were able to mask any feelings of trepidation with humour or genre conventions, but J. P. Telotte believes that science fiction was 'almost too close to its subject, too marked by the same sort of tensions that typified modern culture, tensions that came with technology itself' resulting in 'a form simply unable to fully or satisfactorily accommodate the very values associated with its subject, to solve the problem of distance' (1999: 19). Evidently, science fiction is the mule for a massive burden in popular cultural discourse, and special effects can be shown to have a 'special relationship' with the genre that accords them a high level of representational importance. Beginning with the American science fiction cinema of the 1950s, this chapter provides a historical bridge between the early sound era discussed at the end of the last chapter and the later examination of digital effects; it also traces the development of a complex and intimate relationship between technology, its representation and special effects. Emergent in the course of this narrative will be the characterisation of the computer as a synecdoche for broader trends in technological discourse, leading to the anthropomorphisation of machines in the figure of the android, the cyborg and finally, in chapter five, the synthespian.

Low cost alien invasions

After World War Two,[4] science fiction films proliferated in America; Patrick Lucanio estimates that approximately 'five hundred features and shorts made between 1948 and 1962 could be broadly termed sci-fi' (1987:1). If the films in the previous chapter were connected by organic monsters rendered spectacular through the use of trick effects, the focus in this chapter shifts to a form of the monstrous that is represented by technological progress and an accompanying apprehension towards it, but the terrors evoked by technology are rarely abstract. According to Susan Sontag, technology, as opposed to human characters, is the primary focus of science fiction cinema. Machines and technical equipment hold the attention and drive the action: '*They* stand for different values, they are potent, they are what get destroyed, and they are the

indispensable tools for the repulse of the alien invaders or the repair of the damaged environment' (2001: 216; emphasis in original). Annette Kuhn adds that it is the spectacular use of the techniques of filmic illusions which forges a relationship between the cinematic and the scientific:

> Wherever cinema exhibits its own distinctive matters of expression – as it does with science fiction in displays of state-of-the-art special effects technologies – there is a considerable degree of self-reflexivity at work. Indeed, when such displays become a prominent attraction in their own right, they tend to eclipse narrative, plot and character. (1999: 5)

However tremulously they view the machinic infiltration of human environs, films such as *Metropolis* (Fritz Lang, 1927), *Things to Come* (William Cameron Menzies, 1936), *2001: A Space Odyssey* (Stanley Kubrick, 1968) and *Blade Runner* (Ridley Scott, 1982) retain a bedazzled, long-shot sense of awe at the splendour of those futurescapes. For the viewers of these films, the camera's wonderment at the sight of beautiful illusions, expertly crafted, acts as a proxy for their own awestruck gaze. Before discussing the films that deploy sophisticated mechanics to envisage a wondrous future of interplanetary travel, it is useful to digress in order to explore another important subset of 1950s science fiction cinema, and examine what happens when the promise of visual splendour is subverted by 'bad' special effects in cycles of low-budget 'B-movies'. Vivian Sobchack wonders if 1950s science fiction can be divided into 'big-budget optimism or low-budget pessimism' (1993: 229) and as a supplement to this definition, it will be argued here that low-budget alien invasion films of this period can be read as offering a reply to the militarily-orientated, politically conservative films on which the higher budgets were spent, such as the narratives of space exploration discussed in the second half of this chapter. These cheaper films, incapable of luxurious visual attractions, replace the respect for technology that is usually demanded by contemplations of its awe-inspiring spectacular surfaces, with a more direct articulation of its destructive potential.

The characterisation of alien invasion films of the 1950s as reactionary 'schlock' can be partly attributed to their association with crude special effects. Tacky, tentacled depictions of alien monstrosity have been seen as part of a general political naivety and vulgar exploitation of Cold War paranoia, but it can be argued that this same cheapness contributes to making meaning in many of these films. The science fiction genre depends upon the use of special effects to visualise and communicate themes of technology, and the upper

limit on what can be achieved onscreen with special effects represents the 'state of the art' – a technological plateau accessible only to filmmakers with a large budget at their disposal.

One critical view is that films about invaders from outer space, loaded with references to the dangers of contact with super-intelligent alien powers, hysterically forewarned of a communist threat to the American societal balance. Robin Wood argues that 'the political (McCarthyite) level of 50s science fiction films – the myth of Communism as total dehumanisation – accounts for the prevalence of this kind of monster in that period' (1986: 75). Perhaps the focal point of this view is *Invasion of the Body Snatchers* (Don Siegel, 1956), in which the occupants of a small American town are replaced one by one by visually exact but emotionally vacant doubles in a quiet and insidious alien takeover bid. It is not a stretch to locate in this film a metaphor for communist ideological infiltration.[5]

On the other hand, Terence Pettigrew has stressed that films of this period 'agonized about social control', presenting allegories for domestic authoritarianism in the form of betentacled invaders (1986: 65). In this interpretation, the real terrors of the alien invasion narrative involve the individual being reduced to the status of a mindless drone in the service of a technologically advanced totalitarian authority. The tool of this feared enslavement was mechanical, and technologically advanced, based on an image of technology as inextricably linked to social control projects consolidated during the Machine Age.

J. P. Telotte delineates the Machine Age as the years between World War One and the start of World War Two. He sees science fiction of this period as expressing tensions between film's search for transparent realism and a self-reflexivity about its own technology (see 1999: 2). For Telotte, the anxiety about machinery in science fiction is evidence of a cultural ambivalence towards it, one that runs counter to the institutional embrace of its potency and potential. It displays a strong trepidation about the displacement of the human body in the face of technological development. According to Telotte, spectacles in science fiction 'challenge an American cultural emphasis on the centrality of the individual' (1999: 98–9).

Patrick Lucanio (1987) has attempted a psychiatric evaluation of alien invasion narratives, presenting them as the cathartic playing out of possible outcomes in wars with other planets. Since the outcome is almost always a positive one for the Earthlings (*The Thing from Another World* (Christian Nyby/Howard Hawks [uncredited], 1951), *The War of the Worlds* (Byron Haskin, 1953), *Earth vs. the Flying Saucers* (Fred. F. Sears, 1956), *It Conquered the World* (Roger Corman, 1956)), these films can be seen as offering comfort and reassurance

to audiences suffering in a climate of social unease. Mark Jancovich sees the development of rationalised, 'scientific' industrial management, extrapolated from Fordist production line policies and the time-and-motion labour experiments of Frederick Winslow Taylor, as creating an insecure, paranoid population, who were 'increasingly critical of scientific-technical rationality, and authority in general' (1992: 83).[6] Thus, the systems which facilitate this erosion of individuality and promote conformity amongst the populace are equated with the alien invader, who is, almost without exception, portrayed as scientifically, technologically and militarily superior to humankind. The post-Fordist era was to see a steady increase in the popularity of science fiction and horror films as, Jancovich claims, a direct result of national insecurities. This is particularly evident in the plethora of films that imagined a hostile alien invasion of Earth, borrowing their hysterical tone and shrill politics from the tabloid conflagration that had been sparked by reports of flying saucers.

The flying saucer age began on 24 June 1947, when an American private pilot, Kenneth Arnold, reported seeing nine unidentified flying objects in formation over the Cascade Mountains in Washington State, and estimated their air speed as far too fast to be military craft of any description currently known. When relating to newspaper reporters that the objects flew like saucers skimming across water, the simile was misinterpreted as referring to the appearance of the craft, which Arnold described as winged and banana-shaped. The misquotation, attributed to Bill Besquette of the *East Oregonian* newspaper, was sufficiently evocative to provoke hundreds of sightings of 'flying saucers' or 'flying discs' across America. The phrase Unidentified Flying Object (UFO) was coined by Edward J. Ruppelt, who was in charge of the US Air Force's Project Bluebook, established in 1952 to investigate the phenomenon.

At 4.26pm, on 8 July 1947, an Associated Press bulletin announced that the army air forces in Roswell, New Mexico, had recovered a flying disc from a ranch in the area. There was frenzied speculation over the sketchy press release, until a Fort Worth army airfield weather officer announced that the object had been identified as a weather balloon. Many years later, this simple event would be the centrepiece of conspiracy theories about secret military bases housing captured alien vessels and the corpses of their occupants, but at the time of its reporting, Roswell was simply one of almost nine hundred UFO reports which appeared in the US media in July 1947. Deluged with fallen weather balloons, debris from aircraft or homemade junk brought to them by well-meaning/deluded/deceptive members of the public, the army and navy tried to clamp down on hoaxes for the sake of stemming the growing hysteria and conserving military time and resources.

At this stage, 'flying saucer' or 'flying disk' (*sic*) was not journalistic short-hand for 'alien spacecraft'. A Gallup poll from August 1947 showed that, although 90 per cent of Americans had heard of the phenomenon, 33 per cent had no interest, 29 per cent attributed it to imagination, mirages, or optical illusions, 15 per cent to sightings of a US secret weapon (compared to the 1 per cent who thought the 'secret weapon' was from a foreign military force), 10 per cent to hoaxes and 3 per cent to weather forecasting devices – hardly confirmation of a credulous nation fearing themselves to be on the brink of annihilation by tentacular moon-men.[7] The science fiction cinema of the 1950s might be seen as less an expression of paranoia or threatened intergalactic miscegenation than an engagement with popular culture and its representations of current events – its relation to the real, and to what we can safely perceive as the truth. The self-conscious use of special effects is a crucial component of cinematic activity that characterised the depictions of aliens in this period.

Tzvetan Todorov defines the fantastic as a conflict between the real and the imaginary, best exemplified by someone witnessing an event which cannot currently be explained by world experience (for example, a strange object in the sky):

> The person who experiences the event must opt for one of two possible solutions: either he is the victim of an illusion of the senses, of a product of the imagination – and laws of the world then remain what they are; or else the event has indeed taken place, it is an integral part of reality – but then this reality is controlled by laws unknown to us. (2000: 14)

The fantastic depends upon the creation of an uncertainty in the reader/viewer, a sense of ambiguity during which one must decide, perhaps unconsciously, whether one is witnessing a truth or an illusion:

> The fantastic occupies the duration of this uncertainty. Once we choose one answer or the other, we leave the fantastic for a neighbouring genre, the uncanny, or the marvellous. The fantastic is that hesitation experienced by a person who knows only the laws of nature, confronting an apparently supernatural event. (2000: 15)

Sustaining the moment of hesitation which houses the fantastic is the aim of special effects and its engagement of the viewer with visual stimuli, and combining cinematic techniques with real-world referents is an effective way

to achieve this. It requires ambiguity, and a totally convincing illusion (that is, one which is not recognised as illusory) would not have the same spectacular effect.

The fantastic lies in the viewer's wavering between the diegetic marvel of the character's view of something amazing, and the extratextual appreciation of the splendour of a special effect deftly executed. The occurrence of flying saucer sightings represents a real-world spectacle, sought but not found, provoking a moment of fantastic hesitation. Addressing the numerous reports of Unidentified Flying Objects, many of which have corresponding characteristics in various eyewitness reports, Carl Jung places such phenomena within the boundaries of myth and 'visionary rumour', his own phrase for describing a collective vision 'for whose dissemination nothing more is needed than popular curiosity and sensation-mongering' (1959: 2–3). Leaving aside Jung's quasi-mystic equation of the flying saucer with the mandala (a circular individuation symbol expressing 'order, deliverance, salvation and wholeness' (1959: 22–3)), I would suggest that the cycle of flying saucer movies saw commercial gold in the popular interest in the subject, and commandeered this symbol as a logo for the threat of mass destruction. Against the background of a set of mythical codes already laid out in the audience's collective imagination, political, social and satirical subtexts could be played out.

The pivotal text in the alien invasion movie canon is, for the purposes of this discussion, *Earth vs. the Flying Saucers*. The alien invaders in this film are occupants of a fleet of flying saucers and their mothership, the final survivors of a disintegrated solar system, come to enslave mankind and to plunder Earth's natural resources. Much of the story revolves around the heroic scientists' attempts to locate the aliens' weakness, since their spacecraft seem to be impregnable, their weaponry devastating. It is discovered that, inside their spacesuits, the extra-terrestrials are aged, atrophied humanoids kept alive by the machinery which enhances their senses and scaffolds their feeble muscles. Submission to this extra-terrestrial society would surely deliver a victory for cold scientific fundamentalism over flesh-and-blood human goodness.

Prior to this discovery, the plot follows what Lucanio has identified as the standard narrative passage of the 'Classical Alien Invasion text', which usually begins with an observer witnessing the alien invader's first appearance on Earth.[8] The observer is disbelieved and often ridiculed, while unexplained events are rationalised and attributed to natural causes. The observer struggles to prove the existence of the invader in the hope of neutralising its threat. The invader makes its presence known, often by attacking a highly populated area, and society has to turn to the observer-hero for help. The observer offers

a rational explanation for the invader's presence on Earth, and a plan is thereby formulated for its repulsion. A battle takes place, resulting in the destruction of the alien menace. Finally, 'humanity acknowledges that it has been arrogant in presuming upon its role in the cosmos' (Lucanio 1987: 26). One product of such formulaic structures is to shift the emphasis away from the plot and onto the particular ways in which a film shows those events occurring.

Earth vs. the Flying Saucers offers a particularly striking representation of the alien spacecraft in flight, thanks to the expert effects work of Ray Harryhausen. The advanced powers possessed by the alien technology are, analogically, those of the film image; through double exposures, the invaders can seem to obliterate (fade out) Earth's military hardware, or see inside their captives' brains; they can infiltrate the filmic space through their insertion into stock footage or with matting processes; Harryhausen's stop-motion effects enable the craft to spin while in flight, and the jerkiness of the technique lends the spaceships a distinct otherworldliness. Aptly, it emerges that the aliens can pause time at will, travelling and acting within the infinitesimal spaces between temporal units, so stop-motion is an appropriate method to reflect this manipulation of time and space, but what this visual clarity really performs is a subversion of Todorov's fantastic hesitation – we see the alien spacecraft so clearly (the stop-motion's lack of motion blur means that the machines are always in perfect focus) that there is no ambiguity about what is appearing.

UFO proselytes can offer an abundance of photographic attestations to support their claims, but none of it has yet proven to be evidentially secure. The images which *do* exist are out of focus, or depict ambiguous objects of indefinable scale. It is hopefully not too hubristic to dismiss these evidences as simple fakes, homespun special effects produced with miniature models, or misidentifications of natural phenomena or aircraft, leaving the credulous observer caught in the Todorovian hesitation that prevents them from attributing the images to earthly origins. The flying saucers of the alien invasion film disambiguate this popular myth.[9] Those hazy photographs of distant disc-shaped objects in the sky, barely discernible in the background of an amateur photograph, are rendered perspicuous and explicit, just as O'Brien's dinosaurs represent a (fictionalised) photographic capture of mythical bodies. Harryhausen's flying saucers are amongst the very few to achieve an effective illusion, conjuring a fearsome, weaponised alien technocracy, but their interpretation is complicated by the use of stock footage. It was not uncommon for films to save money by incorporating previously shot film. *Just Imagine* (David Butler, 1930),[10] for instance, donated some its special effects footage to several *Flash Gordon* serials and to *Buck Rogers* (Ford Beebe/Saul Goodkind, 1939, a

A flying saucer prepares to attack the stock footage in *Earth vs. the Flying Saucers* (1956)

12-episode serial). As the climactic battle swells towards the end of *Earth...*, the amount of stock footage increases and the 'real', represented by documentary newsreel footage, is in direct confrontation with the illusion. A saucer destroys a B-52 bomber, and the alien craft are superimposed onto footage of an actual B-52 exploding and crashing during a training manoeuvre. The hero is then seen running in front of rear-projected newsreel excerpts of forest fires. A mock newsreel montage shows stock footage of storms, volcanoes and earthquakes while a voice-over suggests that this devastation was wilfully caused by the invaders disturbing the surface of the sun. We can perhaps find in this sequence an admonition, albeit perhaps an accidental one, about how easily the meaning of a piece of film can be manipulated by its contextualisation, a subtle undermining of the credulity normally lent to items of actuality footage by their authoritative presentation. Aside from cutting the film's budget, the recourse to stock footage seems designed to pepper the film with borrowed markers of authenticity, yet what they end up doing is depleting the indexical power of the original images.

There is a distinctive, recurring satirical element to the way the flying saucer is viewed as a diminished threat, and this diminution of the fearful spectacle of the Other is particularly striking in the 1950s when so much of Hollywood cinema was devoted to spectacles which offered 'the large scale illusion of presence' in order to define itself in opposition to the experientially smaller facets of home viewing (King 2000: 33). The phrase Big Science was coined by American physicist Alvin Weinberg in the early 1960s to describe the 'gigantism' he felt had come to dominate science in the preceding decades

(see Hughes 2002: 11), and the presentation of the military/scientific estab-lishment as threatened by plastic toys carries with it a connoted rejection of such technological proliferation. Marina Benjamin has added that the flying saucer and its alien occupants became 'the public mascot around which peo-ple who reject Space Age rationalism can rally' (2003: 87).

As Vivian Sobchack has noted, 'what we wonder at today, we may laugh at tomorrow' (1976: 49), since, as Philip Hayward and Tana Wollen put it, 'our notions of the 'real' are changed by the 'realisms' which supersede each other to represent it' (1993: 2). While it is not uncommon for the outdated technolo-gies of older films to attract ridicule or affection in equal measure, it can be patronising to suggest that the oblivious naivety of the films themselves is their defining characteristic. The enormous amount of exploitation cinema which exists within and around the 1950s science fiction film is strong evidence that those films which are now retroactively considered as low-grade reactionary trash were presented self-consciously, even with a vein of self-parody. Films such as *Rocketship X-M* (Kurt Neumann, 1950), *Attack of the Crab Monsters* (Roger Corman, 1956), *Invasion of the Saucer Men* (Edward L. Cahn, 1957), *Attack of the 50-Foot Woman* (Nathan Hertz (aka Nathan Juran), 1958) and *The Atomic Submarine* (Spencer Gordon, 1959) are all low-budget attempts to capitalise on the fashion for hyperbole, aliens and technologised violence, but their crass opportunism can be read as a mischievous brand of non-con-formism, treating grave technological futurology with unpolished distaste. My argument is not necessarily that these films might deliberately set out to be subversive, but rather that, if we allow special effects to become markers of tone and meaning, they might facilitate such an interpretation.

American International Pictures (AIP) was a production and distribution company that began in 1955, expanded from American Releasing Corpora-tion (ARC), founded in the previous year, by James H. Nicholson and Samuel Z. Arkoff. Nicholson had been a cinema manager, and Arkoff a studio lawyer, and together they pooled just $3000 to start ARC. AIP began production of what would be termed 'B' pictures during the rise in the popularity of televi-sion, and as the major studios had been forced to stop production of 'B's in the wake of the anti-trust cases of the late 1940s. 1946 saw the first judgement handed down to prevent the monopolisation of the film industry by the verti-cally integrated Big Five studios, and the early 1950s saw the trough of a film industry recession (B-movie stalwarts Monogram and Republic were suffer-ing heavy losses), and AIP dared to enter the low-budget exploitation market at a time when studios were putting all their resources into their prestige pic-tures. The popularity of science fiction was also beginning to wane, so AIP's

tactic was not to target the fan-base of a particular genre, but to aim for the teen audience, which Arkoff and Nicholson agreed was not well-catered for by the majors.

Invasion of the Saucer Men is a particularly interesting entry in the AIP catalogue, and a telling contribution to the UFO story. Tagged by its opening title, with reckless disregard for factualism, as 'a true story of a flying saucer', it is narrated by lethargic barfly Artie Burns (Lyn Osborn), but the central characters are a teenage couple, Johnny Carter (Steven Terrell) and Jean Hayden (Gloria Castillo), who are planning to elope and get married against the wishes of their strait-laced parents. After 'making out' at Lover's Point, a spot seemingly very popular with local teenagers, Johnny and Jean see a flying saucer landing in the forest, but are disbelieved by the police ('Only one [flying saucer]? Nobody's got a right to brag these days unless they see at least six, and in different colours.'). When Johnny and Jean knock down and apparently kill one of the ufonauts in their car (its disembodied hand survives to roam spider-like around the scene), the aliens frame them by making it appear to the police that the youngsters have actually killed local boozehound Joe Grouens; in actual fact, the invaders have murdered Grouens by injecting him with a mystery liquid. Mistrusted and disbelieved at every turn, notably by the military commanders of the US Air Force, who are actually concealing their knowledge of the landing and hoping to destroy the evidence, Johnny and Jean set out to prove the existence of the aliens. The plot follows the generic formula laid out by Lucanio, replacing the heroic scientist with a bunch of 'crazy kids'. They discover that the injected fluid is alcohol, lethal only to those who have already consumed a considerable amount of it. That such an obviously authoritarian moral temperance is espoused must surely be an ironic gesture in the direction of the young drive-in crowd at which the film is aimed.

How might a study of special effects account for a film such as this? Why might it need to? Aside from the fact that the film bears a generic heritage linking it to wondrous spectacle and technical sophistication, it seems to me that its steadfast refusal to observe the genre's rules of decorum can serve as a useful corrective to the expectation that special effects must be state-of-the-art in order to contribute to a text's communicative operations. Seemingly assembled with very little care, *Invasion of the Saucer Men* might be a knowing compendium of genre clichés and parodically meagre production values. The cheapness of the special effects is a recurring joke in the AIP style of filmmaking, rather than shameful evidence of underbudgeting (see also *Voodoo Woman* (Edward L. Cahn, 1957), *The Undead* (Roger Corman, 1957), *The Brain Eaters* (Bruno VeSota, 1958), *Attack of the Giant Leeches* (Bernard L.

Kowalski, 1959), *The Angry Red Planet* (Ib Melchior, 1960)). Rather than aspiring to the production values of a major cinematic release on a reduced budget with fewer star performers, films such as this proudly display the limitations of their resources. While the invading saucermen are hidden for most of the film, when they eventually appear we see them fully and clearly. In a comic scene, one invader fights with a cow (not exactly the most formidable of Earth's defenders) – there is enough tight editing to give the impression of action being created by montage (the actor in the alien suit is not really fighting a cow, but images of each one attacking are juxtaposed and intercut with shots of a model cow's head), but the cutting is not so severe as to prevent the audience from clearly seeing the absurd, bulbous plastic head and tiny body of the alien. The effect is to hold up for ridicule the work of the special effects department, which cannot be dismissed as incompetence because it is deliberately makeshift. It is an anti-classical device shattering codes of realism and lambasting the credulity often lent to the popular myth of extra-terrestrial visitors. It is a refusal of attempts at credible illusion and, to risk an over-generous assessment, a (deliberate?) critique of the sombre and conservative orthodox view of technology as a powerful ally to be dutifully respected and assiduously applied. This is not just Sobchack's 'low-budget pessimism' – it is low-budget insubordination. To fully consider the textual operations of low-rent special effects would require a separate book and an exhaustive filmography of Hollywood's nether regions, but it is hoped that this excursus into the flying saucer movie can offer a brief reminder that the state of the art is not the whole story, before attention returns to the spectacular orthodoxies of cinema's space race.

The space exploration pseudo-documentary

While tales of alien invasion were finding their place as a staple of the B-movie circuit, several major productions were entertaining the possibility of a future lunar mission, and in the process espousing the value of the technologies denigrated by their low-budget imitators. In the 1950s, inspired by genuine rocket research and concerted efforts to reach and explore outer space, a few films offered predictions of what the space race might achieve, sometimes smuggling in militaristic propaganda. This visualisation of capital-intensive science stands in sharp contrast to the half-hearted attempts at astronautical engineering shown in the B-movies described above, and show up even more starkly the divisions between the high- and low-budget cinema of the time, the one aggrandising the military and scientific establishment with meticulously constructed effects held up for spectatorial contemplation, and the other be-

smirching the worth of the multi-billion dollar space program with depictions of the cosmos as a site of plastic toys wobbling through a worthless void.

Underpinning both discussions of the future of space exploration was the knowledge that, as rocket science progressed, one consequence would be the parallel development of missile systems, so that space exploration was tied technologically and iconographically to military power. Crucial to creditable renderings of spacecraft are the miniature models used to represent them, and the compositing techniques used to create the impression of flight. The skills required for such effects would have been honed at studio facilities with particular interest in war films during the 1940s, such as *Ships with Wings* (Sergei Nolbandov, 1941), *Mrs. Miniver* (William Wyler, 1942), *Air Force* (Howard Hawks, 1943) and *Thirty Seconds Over Tokyo* (Mervyn LeRoy, 1944), all of which rely on miniature models to represent ships and aircraft. In this way, depictions of spacecraft can be seen as connotatively linked to depictions of military machines, and the appropriate attention to detail in respecting the integrity of such vehicles can be read as either subversion or sustenance of their iconic power as a physical threat and a patriotic symbol.

Destination Moon (Irving Pichel, 1950) was based loosely on Robert A. Heinlein's novel *Rocketship Galileo* (1947), and Heinlein, along with Transylvanian rocket expert Hermann Oberth,[11] acted as technical adviser on the film. Mechanical effects were provided by Lee Zavitz (who won an Academy Award for his contribution) with background scenery and sets created by Chesley Bonestell (credited as 'technical adviser of astronomical art') and Ernst Fegté.[12] Another film, *Rocketship X-M* (Kurt Neumann, 1950) was actually the first Hollywood movie centred on a lunar expedition to be released theatrically, rushed into production to capitalise on the pre-publicity for *Destination Moon*. While *Destination Moon* cost $586,000, *Rocketship X-M* was budgeted at just $94,000 (see Brosnan 1991: 44). As such, it lacks the benefit of extended scientific research, and is more closely associated with space opera stories such as *Flash Gordon*. In Neumann's film, the moon rocket is diverted from its course and eventually lands on Mars (the change in atmosphere signalled by Neumann's decision to tint the film red for all sequences set on the surface of Mars, which were actually shot in Red Rock Canyon, Nevada), where the crew discover a race of beings who have survived an atomic holocaust which once destroyed the planet's super-intelligent inhabitants.

Destination Moon is a piece of barely disguised propaganda, an educational rallying cry for the importance of lunar missions, at a time when such excursions were still considered to be a distant fantasy. In seeking to assert the plausibility, as well as the military advantage, of space travel, the film aims

at a realistic approach. It does this via appeals to scientific realism which are encoded in its diligent attitude to design and special effects; the esteemed scientists named in the credits offer validation of its accuracy. Aside from a few inserts visible on a monitor inside the rocket, we never see the ship launched from Earth in *Destination Moon* – instead the camera focuses on the contorted faces of the astronauts, who become nauseous and disorientated by the first sensations of weightlessness. An attempt is being made at heightened realism by showing the unpleasant realities to be expected in the future of space flight – such realities as the after-effects of G-force or motion sickness on Flash Gordon were not in evidence. The illusion of weightlessness is created by suspending the actors from wires or positioning them on moving platforms with their feet out of shot. The design of the control room of the rocketship 'Luna' is a compromise between the requirements of authenticity and the necessity of photographic and aesthetic conditions; the panels in the consoles could be removed to allow the insertion of a camera or lighting rig (see Heinlein 1972).

To provide exposition and information to the audience in an early scene, potential investors in a lunar mission are shown a short film where the principles of space flight are explained by the cartoon character Woody Woodpecker (*Rocketship X-M*'s equivalent expository scene can only muster some chalkboard sketches) – the scene doubles as a promotional short for one of the studio's other entertainment franchises while making a sharp comment on the need to popularise scientific innovation to maintain uncritical public support and comprehension. When one private investor questions why the mission is necessary, General Feyer delivers the following speech:

> We are not the only ones who know the moon can be reached. We are not the only ones who are planning to go there. The race is on, and we'd better win it, because there is absolutely no way to stop an attack from outer space. The first country that can use the moon for the launching of missiles will control the Earth.

Thus is forged a bond between big business and big (military) science, resulting in the reactionary, paranoid representation of technology that has traditionally been attributed to the alien invasion film, and all of it mediated by a chuckling cartoon bird. The space exploration film shows technology as a way of claiming territories outside the Earth in order to present a display of might to other nations, and by inviting the contemplation of expertly rendered sequences of space travel, it tacitly accepts the value of militarily-enforced

scientific research. While planning to test a nuclear engine for the rocket, the mission team receive a letter from their governing body, declining the proposal to test on American soil, since: 'While it is admitted that no real danger of atomic explosion exists, belief in such danger does exist in the public mind.' This is probably the film's most insidious act – to blame public scepticism about the value and safety of rocket research for hindering its unchecked development. Such stubborn faith in the nuclear project stands in stark contradistinction to the torrent of irradiated mutant mayhem that was to be unleashed in low-budget exploitation films such as *Bride of the Atom* (Edward D. Wood, Jr, 1955), *The Creature With the Atom Brain* (Edward L. Cahn, 1955), *The Amazing Colossal Man* (Burt I. Gordon, 1957), *Attack of the Crab Monsters* (Roger Corman, 1957) and *The Cyclops* (Burt I. Gordon, 1957) (see also Newman 1999: 76–97).

Conquest of Space (Byron Haskin, 1954), inspired by the speculatively scientific book of the same name written by German émigré rocket scientist Willy Ley and illustrated by Chesley Bonestell (1949), is a self-professed 'story of tomorrow', and a pseudo-sequel to *Destination Moon*, set at a time when space travel is more commonplace and straightforward. Rather than being a story of heroic pioneers, more drama is gleaned from details of the emotional effects of such excursions on the temperaments of the men who do so (there are still no women in space at this point). A planned Moon mission is revealed to be an expedition to Mars in search of natural resources to solve Earth's energy needs. An attempt to sabotage the mission is made by its leader, General Merritt (Walter Brooke), ranting that exploring worlds beyond those provided by God must be a blasphemous transgression of some Edenic pact. In other words, the film's only stated objections to the destructive, colonialist thrust of the military industrial complex are put into the mouth of an unhinged fanatic, safeguarding the patriotic ideals of the expedition as admirable goals.

2001: A Space Odyssey was nurtured through a lengthy production alongside the research in preparation for the Apollo lunar missions. When Stanley Kubrick and his collaborator Arthur C. Clarke signed contracts in May 1964, it was for an 82-week project, meaning that the film's completion would coincide with the beginning of the Apollo space program in February 1967 (see Chion 2001: 3). The Apollo 1 mission was cut short on the launch pad on 27 January 1967 when the rocket caught fire during a countdown rehearsal, burning the occupants to death before they could escape from the cockpit. It was to have been a test flight of the lunar rocket, and Apollos 2, 3, 4, 5 and 6 displayed more cautious testing of equipment and procedure in light of the program's inauspicious beginnings. Kubrick's film leapfrogs a period of ardu-

ous research and development (the famous bone-to-spaceship match-cut exscinds thousands of years of technological investment in an instant), offering instead a speculative vision of a future when space travel is another modern banality – the first space traveller we see in the film is sleeping, under-awed by the experience of travelling from the Earth to an orbiting space station.

Kubrick first made contact with Clarke in spring 1964 to discuss his plans for a science fiction film. Clarke's assessment was that they were attempting to 'out-guess the future', (in Bizony 1994: 6) but there was also an effort to define *2001* against other science fiction films. In a press release dated 23 February 1965, Kubrick announced the following:

> Now that the first man-carrying spaceships are actually being built, and the United States is spending over $10,000,000 a day to reach the Moon, and robot probes have already been launched to Mars and Venus, it is time to break away from the clichés of Monsters and Madmen. (Reprinted in Bizony 1994: 10–11)

Accordingly, the only depiction of an alien power (although its origins are never explained) in *2001* is the inscrutable black monolith that appears at key points in humanity's technological development. The juxtaposition of animated models and organic actors in *The Lost World* and *King Kong* were ways of thematising spectacle and portraying otherness, using the human body as a yardstick of scale and movement. Kubrick's focus on the machines of space travel and the dwarfing of their human occupants exploits this principle of special effects to suggest a future where machines have a spectacular dominance and have become the mediators of meaning. The human being is decentred through a lack of dialogue (the first and the last twenty minutes of the film are wordless) and an oblique, uncommunicative narrative that seems to move at machine pace with little in the way of empathic regard for whatever dramas the humans may be enduring.

Inspired by the race for the Moon, Kubrick and Clarke pursued their goal of presenting a scientifically informed view of the future of space travel. Their film assumes an American victory in the space race. By 1961 Russian scientists could launch rockets into a stable orbit of the Earth while the American Mercury rocket program was producing a series of failed attempts at performing the same task. On 12 April 1961, Russian cosmonaut Yuri Gagarin made the first manned space flight and in May of the same year President Kennedy announced his belief that the US should 'commit itself to the goal' of landing astronauts on the lunar surface and returning them safely to Earth. The launch-

ing of rockets and lunar modules was to become a televised spectacle that for the first time allowed a frame of reference, a comparative text for spectators to place beside their own imaginings and previously viewed films. Under the working title *Journey Beyond the Stars*, *2001* was funded to the tune of $6m by MGM in February 1965, but by the time of its premiere in April 1968, it had cost almost twice that amount.

Although many critics felt 'confused, irritated and bored' by the film's enigmatic, elusive nature, it was a great public success, grossing $40,000,000 worldwide on its first run, $25,000,000 of that in the US (see Bizony 1994: 15).[13] It was a talking point and an early 'event movie', perhaps because the public saw it 'as a cinematic experience to be "felt" intuitively, rather than to be picked to pieces scene by scene like most conventional dramas' (Bizony 1994: 18). Kubrick had deliberately denarrativised the film, removing a voice-over commentary and Alex North's emotionally instructive score (see Chion 2001: 1).

A form of realism was essential to achieving Kubrick's idea of how the future might look and how viewers of his film should perceive it. While preparing a treatment for the screenplay, Clarke and Kubrick watched other landmark science fiction films, including *Destination Moon*, *The War of the Worlds*, *Things to Come* and *Forbidden Planet* (Fred M. Wilcox, 1956).[14] Kubrick denigrated 'their lack of absolute realism' (see Bizony 1994: 73); one of the ways in which he hoped to instil a sense of authenticity in his film was by employing technicians who had experience solving and investigating 'real-world' engineering projects, as opposed to just the miniature mimicries required by special effects work. *2001*'s technical advisers included Harry Lange, who had designed space vehicle concepts for NASA as part of their Future Projects Division – his job was to out-guess the future as Kubrick and Clarke were attempting to do, to suggest designs which might be of use once the space program became a full-blown exploratory industry. Frederick Ordway, another technical adviser, had worked with the Army Ballistic Missile Agency in Huntsville, Alabama and in NASA's public relations department, which was concerned with making the complex science of their enterprises sound plausible to the media, corporate sponsors or the public. A 10-minute documentary prologue, made up of interviews with experts in astronautical science, computing and other relevant fields, was intended to begin the film and attach scientific credibility to it, but Kubrick eventually rejected it in his attempts to make *2001* rather more cryptic.[15] By uncoupling the spectacular sequences from narrative purpose, Kubrick provokes appreciation of their merits as illusions even as he claims to be provoking considerations of the futuristic technologies depicted in the film.

The presence of so many expert engineers and technologists in the production might seem like the best way to achieve accurate representations untainted by the idiosyncratic inflections of special effects artists, but they also serve as extra-diegetic branding, a kind of authenticity by association. Similar claims of scientific validity were made for Willis O'Brien's dinosaurs and the rockets of *Destination Moon*. Many companies lent their expertise and research documents to the film project, including NASA, IBM, Honeywell, Boeing, Bell Telephone, RCA, General Dynamics, Chrysler, General Electric and Graumann, and their logos can be seen scattered around the sets and models of the finished film (see Bizony 1994: 90)

The use of a set of distinguished experts to produce special effects, for example Douglas Trumbull, leads to the establishment of 'an increasingly standardised set of optical procedures' (Bizony 1994: 112), which in turn influence our perceptions of how scientific machinery should appear. The film's spacecraft seem resolutely functional, never concerned to adorn a shuttle with romanticised flourishes of fin and spoiler. Its marshalling of 'real-world' specialists seems designed to produce an afilmic authenticity, ensuring that its intertexts are not flying saucer movies or space-opera comic books, but scientific research drawn from the work of technicians more closely connected to making machines that have to function for real, rather than technicians who only have to create the image of such machines.

Aside from its aggrandisement of astronautics, *2001* also turns its attention to the less visually impressive science of artificial intelligence (AI). The concept of AI can be seen as a sub-genre of science fiction, related to but distinct from its actual applications, just as alien invasion or trips into space can be seen as extrapolations of actual scientific endeavours. Identifying what she terms 'cybernetic fiction', Patricia S. Warrick spies a sharp discrepancy between science fiction literature, which is often heavily dystopian, and computer science and its associated writings, which are not. This optimism gradually drains out of science fiction: 'Early optimistic views of man's creative accomplishments are later replaced by destructive metaphors of machines overwhelming and dehumanizing man' (Warrick 1980: xiii–xvi).

On an expedition to Jupiter to investigate the monoliths, HAL, the ship's computer, seems to interpret 'his' orders literally and attempts to kill the crew of the ship in order to best complete the mission, deeming them to be expendable obstacles to his programmed objectives. IBM allegedly asked for their logo to be removed upon their discovery that the film was sceptical about the future of AI, but Arthur C. Clarke has stated that this is a myth that has grown up around the film by those who see it as a dystopian view of the fu-

ture of computerisation (see Clarke 1972). Clarke maintains that HAL stands for 'Heuristic ALgorithmic', a reference to HAL's dual nature, since 'heuristic' implies scientific rules and principles that can be learned and developed autonomously, while algorithms have 'inviolate rules' which the computer must follow to complete a procedure (Minsky in Stork 1997: 28). HAL's inner conflict stems from his strict programming countered by his (paradoxically) emotional reaction to situations. This mirrors the seminal fiction of Isaac Asimov, in which robots find conflicting imperatives in the rules of conduct established by the author in 1941:

> i. A robot may not injure a human being or through action allow a human being to come to harm;
> ii. A robot must obey the orders given it by human beings except when such orders would conflict with the First Law;
> iii. A robot must protect its own existence as long as such protection does not conflict with the First and Second Law. (Reprinted in Asimov 1968: 1)

Whether or not the reference to HAL as a projection of IBM, one step along the alphabet/into the future was deliberate, the parallels are interesting. Until 1985, IBM had a rule which prevented its staff from referring to computers as intelligent in their documentation, retaining a sense of superstitious dread that such a claim would be extreme hubris, although Marvin Minsky's explanation of this is that IBM 'wanted to reassure their potential customers that IBM products would only do what they were programmed to do' (in Stork 1997: 28). If earlier science fiction can be seen as a negotiation of technological discourses around the *physical* prowess of machines (replacing human bodies in automobile factories, for instance), *2001* represents the point at which the computer becomes an emblem of the machine, accompanied by considerations of its *mental* capacities. The film is not simply a showcase for gargantuan achievements in rocket science, but primarily 'a meditation on the evolution of intelligence, from the monolith-inspired development of tools, through HAL's artificial intelligence, up to the ultimate (and deliberately mysterious) stage of the star child' (Stork 1997: 5). These handovers of power are crystallised in the key point of anxiety around HAL's ability to deceive and destroy his human users.

Computers have advantages over humans – they can process data at incredible speeds, have less fallible memory and recall facilities, and do not get bored or distracted performing repetitive tasks. Humans, on the other hand, can respond spontaneously to unforeseen circumstances without requiring

reprogramming. Our depictions of computers and robots rest mainly on fears generated by erasure of these differences: we project images of boredom and humanistic yearnings onto computers, and show them longing to be just like us.

The chess match in *2001* between Frank Poole (Gary Lockwood) and HAL is a decidedly brief and minor moment in the film, but carries much allegorical and scientific significance. Not only does it signal HAL's ability to outwit the crew strategically (he defeats Frank easily, and will later kill him to further his own ambitions), but it is also a projection of the earliest forays into artificial intelligence, when a computer capable of defeating a human at chess was the benchmark for the development of AI, the measurement by which a computer could be assessed as a worthy opponent in games but also in life and in mental processing power.

Murray S. Campbell (1997) sees the chess-playing skills given to computers as emblematic of the limitations of current AI studies. Campbell, with his colleagues Feng-Hsung Hsu and A. Joseph Hoane Jr, developed Deep Blue at IBM's T. J. Watson Research Laboratories, which, in February 1996 became the first computer to beat the human chess world champion Gary Kasparov in a six-game, full-length regulation match sponsored by the Association of Computing Machinery.[16] It was a game which Kasparov had initially touted as 'a defence of the whole human race' (quoted in Campbell 1997: 78). When Kasparov defeated Deep Blue's predecessor, Deep Thought, in 1989, the audience gave him a relieved standing ovation, since 'in recent human-machine matches, the mood has been decidedly pro-human and anti-computer' (Campbell 1997: 77).

The use of chess as an entry point to the potential intelligence of a machine dates back at least as far as Wolfgang von Kempelen's chess-playing automaton (sometimes referred to as 'the Mechanical Turk' due to its Middle Eastern attire), which gave sensational displays of chess-playing from its construction in 1769. Von Kempelen's machine was, of course, a fake, containing a hidden human player and an intricate device for manipulating the pieces from below the board, but it instigated discussions of whether or not a machine could ever replicate the workings of the human brain (see Standage 2002; Wood 2002: 55–104). In 1950, Claude Shannon, a founder of information theory, suggested that a chess machine would be the best way to assess a level of machine intelligence which could be adapted for practical applications. Shannon's work was based on John von Neumann and Oskar Morgernstern's 'minimax' algorithm, which calculates the best move which can be made in a game (its major flaw being that it always assumes that the opponent, human or otherwise, will,

in return, make the best possible move, that is, the one it would predict for itself), and Alan Turing's 1945 program which could generate the basic chess moves and evaluate the advantageousness of various positions on the board (see Campbell 1997: 83).

What limits a computer chess program, and gives its human opponent an indelible advantage, is the computer's reliance on rational process and rejection of emotion. Donald A. Norman describes the differences apparent in our recent understandings of human and machine intelligence: 'Human intelligence means more than intellectual brilliance: it means true depth of understanding, including shared cultural background and knowledge' (1997: 264). Norman sees considerations of emotional intelligence as a neglected area of study in AI science. Suspicion has always surrounded the idea of giving autonomous thought and simulated emotional responses to computers, since their functionality is based on their ability to operate without distraction or mood swings that might impair their judgement. HAL is a fully operational emotional being, evidenced by his ability to lie, since 'lying is at the pinnacle of human intelligence, because it requires not just knowledge, but metaknowledge' – a liar must know what the other person will readily believe, what is plausible in those particular circumstances (Norman 1997: 264).

The notion of emotional computing is such anathema to the public perception of how machines ought to operate that the term 'affective computing' has been adopted, as Rosalind W. Picard says, 'because *emotional computing* tends to connote computers with an undesirable reduction in rationality' (1997: 281; emphasis in original). Picard also believes that emotional capabilities in computers are the key to the failures to produce artificially intelligent computers which can learn from their own mistakes, fearing the consequences of similar failures in the future or yearning to feel the enjoyment of making a good impression on their operators. Pop cultural representations of intelligent machines often imply that to give such capacities to computers will result in their eventual descent into self-serving deviousness and a desire for power.

Reflecting the shift from physically powerful mechanics to the mental nature of computer technologies at the centre of scientific discourse, is a movement towards the use of computers in special effects work, allowing them a visible, if imagistic presence in contemporary cinema. The next chapter will trace the adoption of digital imaging technologies by mainstream cinema, and the thematic and aesthetic baggage which they brought along with them.

CHAPTER 4
The Computer

Industrial Light and Magic

As an institution, George Lucas's effects house, Industrial Light and Magic ILM), has had a profound effect on the development of filmic special effects. More than anything, ILM has advanced the computerisation of the special effects industry. Beginning with the increased adoption of digital processes at ILM, this chapter traces the use of computers as tools of representation, and suggests some ways in which the altered means of achieving visual effects is reflected in the thematic and aesthetic inflections detectable within the films that use them.

ILM was set up in a converted industrial warehouse in Van Nuys, California, in 1975, headed by John Dykstra, for the purpose of producing the special effects and motion control systems for *Star Wars* (George Lucas, 1977). The Van Nuys premises covered 36,000 square feet and incorporated a studio facility, an optical house, a model shop and a design facility, maintaining close links between departments to create a space within which a cohesive and consistent vision of the film's galactic environs could emerge under Lucas's supervision[1] (see Vaz & Duignan 1996: 6). The use of a purpose-built effects house was a dramatic shift of emphasis away from the contemporary state of play within the studio system, which had seen the majors disband their in-house effects facilities and employ freelance effects artists. John Brosnan calculates

that in 1974 there were two hundred such artists in Hollywood and nearly a hundred in the UK (1974: 10), and Thomas G. Smith comments that studios had changed 'from self-contained production centres to mere soundstages controlled by landlords and suites of executive deal-makers' (1985: 2). Financial difficulties for studios had led the majors to rely more on the distribution of independent productions (by the beginning of the 1960s around two thirds of films released by the major studios were independently produced) and effects departments were disbanded in order to reduce massive overheads that had been exacerbated by the increased use of stunts, pyrotechnics and large physical effects performed on location (see Rickitt 2000: 28). The crashing of real aeroplanes, instead of composited miniatures, for *The Great Escape* (John Sturges, 1963), or *The Battle of Britain* (Guy Hamilton, 1969), is emblematic of how a trend for 'live' spectacle had been causing the widespread neglect of post-production special effects facilities. The era of the contemporary blockbuster sparked by *Jaws* (Steven Spielberg, 1975) and *Star Wars* was a lucrative period that saw huge investment in special effects production, research and development, and by the 1980s, multiple effects companies were bidding for work. As Hollywood filmmaking became more capital intensive, formulae for success emerged, which included youth-orientation, action, comedy and visual spectacle.

Smith describes the ILM staff as 'children of the Sixties ... an irregular band of individuals' many of whom 'rebelled against authority figures and traditional work rules' (1985: 2–3). John Dykstra remembers them as 'a bunch of guys working in a garage ... Not a single one of them was an "expert" in the field of special effects, which enabled them to use original approaches to solve the problems that arose' (interviewed in Pinteau 2004: 67–8). George Lucas himself concurs with this characterisation, typifying them as 'more than machines and technical processes', possessing an 'enthusiastic and wild spirit' (in Smith 1985: xi). This image of vigorous frontiersmen resisting the dehumanising properties of the very equipment they work with on a daily basis aims to forestall any preconceptions readers may have had about people who work on the machine side of filmmaking. Whether or not this is an entirely candid presentation (from the 1980s many staff will have witnessed colleagues, offices and hardware being downsized to make way for computer equipment), it seems to summarise an ongoing, ever-shifting consociation between human and machine that can be traced through the history of ILM and the films to which they contribute. In devising ways to mechanise processes of representation, and to situate human actors within them, ILM have built up their own collection of intertexts which feed into an extensive meta-narrative about intercon-

nections of science and nature; whatever their distinct diegetic concerns, films such as *Star Wars* (and all of its sequels and prequels), *Cocoon* (Ron Howard, 1985), *Back to the Future* (Robert Zemeckis, 1985), *Total Recall* (Paul Verhoeven, 1990), *Terminator 2: Judgment Day* (James Cameron, 1991), *Jurassic Park* (Steven Spielberg, 1993), *The Mask* (Chuck Russell, 1994), *Contact* (Robert Zemeckis, 1997), *A.I. Artificial Intelligence* (Steven Spielberg, 2001) and *The Day After Tomorrow* (Roland Emmerich, 2004) all articulate something of the interrelationship between the human and the scientific through the technological imprint left by their association with a company such as ILM. Having made the transition from a practical effects house with an emphasis on model-work and motion control miniatures to a fully-equipped digital effects facility, ILM best illustrates how the particularities of special effects can underpin the narrative content of individual films, and also how the intertexts between those films can be technical as well as star-based or thematic.

From the beginning, computers played a part at ILM. Mechanical motion control techniques were developed by Douglas Trumbull for his directorial debut *Silent Running* (1971) with the assistance of Dykstra, who would develop a computerised system, which he dubbed Dykstraflex, for use on *Star Wars* model shots (see Vaz & Duignan 1996: 7). Dykstra had been working for Berkeley's Institute of Urban and Regional Development in 1973, testing to see if urban development miniatures could be made to appear full-size on screen (an early version of the digitised virtual walk-through displays used by today's architects and estate agents). Using a PDP II (Programmed Data Processor), he and colleagues Al Miller and Jerry Jeffress made computer-controlled movements between miniature buildings on a model layout with a 16mm camera (see Smith 1985: 9). The Dykstraflex system used on *Star Wars* 'allowed a camera unit, consisting of a boom arm at the end of which was a mechanised camera, to be programmed to move itself down a steel track, with the camera executing the desired pan, tilt or roll motion. Motion control allowed numerous separate elements for a composite shot to be programmed, leaving it to the optical department to fit the jigsaw pieces together into one final image' (Vaz & Duignan 1996: 11–12). The major development which it provided was that models would no longer be photographed in motion but would be fixed in place while a computer-controlled camera moved around them in a pattern which could be repeated in multiple passes to allow recording of separate composite components whose movements would match exactly. The precision of the computer would supplement and support the skill of the artist, and a complex relationship between art and electronica was commenced. John T. Caldwell has viewed motion control, as well as associated developments in

video assist, Steadicam, Camrail and robot operation technologies as providing 'disembodied camera fluidity' (2000: 132) which is ultimately destructive of realistic imagery in that it regulates patterned movements which 'automate an inherently omniscient point of view and subjectivise it around a technological rather than a human centre' (2000: 133). Similarly, Vivian Sobchack has argued that science fiction cinema's prioritisation of such technologies converts 'the centred subjectivity of *special affect* (joyous intensities and euphoria) into the decentred subjectification of *special effects* (grand displays of "industrial light and magic")' (1987: 282; emphasis in original). The principles of motion control, along with the patina of authenticity derived from the technique's real-world applications, would be applied extensively to the spacecraft on *Star Wars*. The swooping, diving craft of Lucas's film stand in stark contrast to the comparative indolence of Kubrick's silent, stately space stations. Choreographed like World War Two dogfights, they situate the spectators as passengers on a white-knuckle ride rather than as a disembodied distant observer of intractable machinery.

By forming an institution to achieve effects which were once separate, 'authored' processes, ILM industrialised special effects and assumed, by the sheer scale of their operations, a central role in the production of films, where once they might have occupied a more accessory position. Just as ILM's implementation brought special effects into a more central position within the production process, as it had been within the studio system until the early 1960s, so *Star Wars* sought to return blockbuster filmmaking, in terms of construction and narrative, to earlier modes, displaying a paradoxical urge to regress thematically and aesthetically while using advanced technology to achieve it.

Star Wars takes many influences from earlier films, including the Flash Gordon serials from the 1930s (*Flash Gordon* (1936), *Flash Gordon's Trip to Mars* (1938) and *Flash Gordon Conquers the Universe* (1940), all starring Buster Crabbe and based on the comic strip by Alex Raymond).[2] Lucas has cited as inspiration Akira Kurosawa's *Kakushi Toride No San-Akunin* (*Hidden Fortress*, 1958), mostly for the device of telling an epic story from the point of view of its lowliest participants, but primarily *Star Wars* is a genre hybrid that, with its blend of starships and monsters, outpost taverns and outlaws, borrows motifs from the western as much as from science fiction. It represents a move away from the pseudo-realistic presentation of space travel seen in *2001*, in which all performers were subject to weightlessness. The lack of gravity in the vacuum of space is never a problem during the innumerable sequences of space travel in the *Star Wars* films (nobody experiences weightlessness, and sound carries just fine – stereophonically, in fact) but, after the Apollo mis-

sions, televised worldwide, Lucas does not have the excuse of scientific na-
ivety or innocence. His films refer back to the days when space was a mystery,
open for speculative voyages to other, densely populated and vibrant galaxies,
where every planet's atmosphere could support human life. They prioritise the
heritage of genre cinema over the accumulated knowledge banks of scientific
observation to remember space as the site of frontier myths and pioneering
opportunity unfettered by practicality.

Star Wars spawned two sequels, a set of three prequels and a passionate
fan following that has kept the interlinked stories of the Star Wars universe
expanding through a network of internet sites and fan conventions (see North
2007). The strong visual sense of fantasy in an environment populated by a
vast array of diverse alien species thwarts any attempts at the potentially reac-
tionary political allegory which might normally be expected from a series of
films concerned with a galactic rebellion against a tyrannical, oppressive im-
perial regime. *Star Wars* is set 'a long time ago, in a galaxy far, far away', as the
opening title informs us. This mantra, repeated at the start of each sequel/pre-
quel, offsets comparisons with our own world experience, denying that it has
any relation to the political situation in our galaxy, our time or our species. It is
not a projection of our current era into its logical future state; nor is it a depic-
tion of ancient events which have impacted on our time. It is not an expectant
futuristic vision, but it is not historical revisionism. It is not a projection of
the future of our world, but the past history of another, fictitious one. It might
even be an instance of historical evasion, an attempt to negate the inherent
allegorical component of science fiction narratives. Thus the film becomes an
exercise in spectacular escapism. Robin Wood (1986; 1996) has argued that
Star Wars is one of several Hollywood movies which promotes viewer pas-
sivity, and thereby manages to indulge racist or reactionary fantasies in the
audience, and Ian Grey has referred to the film as a landmark only since it was
'the movie that successfully reconstituted audiences as children', appealing as
it did to 'America's adoration of Really Big Things' (1997: 167–8).

The film's sets, props and spaceships look aged, used and battered – they
carry years of unspecified back-story, which personalises the machinery.
More specifically, the spacecraft used by the Rebel Alliance are battle-worn
and meagre compared to the glistening, pristine arsenals of their fascistic
Imperial enemies, whose machines seem to have been manufactured imme-
diately prior to their appearance onscreen. Further strengthening the image
of ILM technicians as adventurous frontiersmen, they also deployed aged or
modified equipment such as the Anderson optical aerial printer used at ILM
from 1975 until 1993, but originally built for Paramount by Howard Ander-

son in the 1950s (it had been used to produce composite effects shots for *The Ten Commandments* (Cecil B. DeMille, 1956) and *North by Northwest* (Alfred Hitchcock, 1959). The studio sold it to ILM for $11,000, but by the time it was retired in 1993, having been responsible for optical work on most Lucasfilm productions, its market value was estimated at roughly $300,000 (see Vaz & Duignan 1986: 9)).

While science fiction is perceived as progressive, grappling with representations of the future in order to better comprehend the potentialities of the present, *Star Wars* is deeply nostalgic for a time when old value systems and beliefs were contained and human adventurers could triumph over a technocratic regime and enact the creation of a universe free from enslavement by militarised technology. It mixes fantasy, mythology and science fiction in a way that frees each from the burdens of futurism, allegory and social commentary. It also unites the aspects of science fiction so far discussed here. It is structured around binaries of good and evil, the one represented by a rustic alliance of nations, the other by a militaristic fascist regime, but the attention to technical detail inherits the legacy of the space exploration pseudo-documentary. Kubrick's *2001* had been a popular success, but studios found it impossible to capitalise on its success with replications, until George Lucas showed how such transcendental spectacle could be re-narrativised. Instead of foregrounding the special effects for contemplation, *Star Wars* provides a relentlessly linear narrative in which each new planet visited provides an opportunity for a new set of spectacular designs, and each dramatic confrontation a chance for its enactment in careening spacecraft. Its universe is anthropocentric, teeming with alien life but predicated on the heroic or villainous actions of humans and, as David Bordwell has noted, 'in the infinite spaces where Kubrick felt a terrifying silence, Lucas heard the trumpet call of adventure' (2006: 53). After *Star Wars* established it as a centre of research into technologies of illusion, ILM would take its place as a crucial force in the application of digital processes to visual effects over the course of the next three decades. Another point at which this transition can be observed is in the changing depictions of synthetic humanoids.

The study of quantum mechanics, relativity physics, nuclear physics and other 'invisible' sciences has upstaged Newtonian/Classical mechanics to focus on things we cannot see with our eyes, things which we need machines to study (Warrick 1980: 5). Similarly, representations of technology have shifted from concerns with physically powerful machinery, and their abilities to invade, destroy and oppress human civilisation, to the more insidious and viral means of infiltration effected by nano- and bio-technological threats. If the

special effects hardware used to visualise the former was primarily achieved with the hands-on methods of miniature models, then the age of digital effects can be characterised by the intangibility of its attractions – prior to their processing and compositing as cinematic imagery, CGI objects and figures exist only as assemblages of algorithmic data, a fundamentally different kind of modelling. But has this technological change affected the way in which audiences perceive and understand visual illusions, or are these just novel ways to display the same old things?

Before CGI proliferated as a viable tool for visualising the onset of the computer age and anxieties about digital technology and the computerisation of art and industry, the filmic bearer of such allegories was often a cyborg (combining organic and synthetic components) or an android (a machine in human form). These tropes have since given way to representations which reflect the increased invisibility of computer technology. The invulnerable humanoid machine became an iconic metaphor for technological destructiveness, but could also find outlets in the Reagan-era fantasy of inviolable bodies, unmitigated vengeance and technical superiority.

Claudia Springer has argued that the Renaissance and the Industrial Revolution were major turning points in our perceptions of technology as either threat or benevolent ally (1996: 17). After the Renaissance-era interest in science and anatomy made information on the workings of machinery and the human body more accessible, the occult and religious faith were superseded by the visible, the provable, the tangible and the scientifically-tested. Springer also discusses sexualised imaginings of machinery, all pumping pistons and grinding gears, which accompanied the Industrial Revolution's project of supplementing human workers with their mechanical equivalent. Initially this meant the production of machines which could surpass the efficiency of humans by virtue of their sheer power and size, but the twentieth century has seen the emergence of the figure of the humanoid machine, an icon which represents humankind usurped in terms of function and partially replaced in appearance and bodily presence. From this came the cyborg, half-human, half-machine, a combination of electro-mechanical and organic elements. If so much technophobia stems from the possibility of dehumanisation through excessive interface with mechanical or computer technologies, the robot and the cyborg express a similar trepidation that machines are becoming humanised, and that there will come a point where the two are indistinguishable.

RoboCop (Paul Verhoeven, 1987) is a futuristic story of a mechanised police officer and his existential crises. When Alex Murphy (Peter Weller) is shot (many times) by a criminal gang and left for dead, his brain and face are placed

within the reinforced steel body of a robot designed for police duties, rendering him almost completely impervious to attack. Throughout the film and its two sequels, *RoboCop II* (Irvin Kershner, 1990) and *RoboCop III* (Fred Dekker, 1993), Murphy's programmed directives and bodily indestructibility come into conflict with the remnants of his human memories, his own moral values and his emotional fragility. The three films together describe his apotheosis from programmable automaton to fully-fledged superhero (by the end of part three, he can fly with the aid of a jetpack), having finally resolved the duality of his organic and mechanical parts to balance human autonomy with fearsome physical prowess. Just as the films' narratives set up conflicts between the organic and the mechanical, so the special effects enact similarly-themed binary oppositions between real and illusory, miniature and life-size, animation and practical effects, helping to communicate issues of techno-threat and the usurpation of the human (real) by the robotic (illusion).

The films are set in a corporatised future version of Detroit (complete with derelict General Motors factory) where Omni-Consumer Products (OCP) funds, and by extension owns and commands, the Metropolitan Police Department. It also runs the Henry Ford Memorial Hospital, the military and, unofficially, the media. Initially OCP designs a huge, completely robotic police officer, ED-209, which malfunctions and kills a member of the board during a test. ED-209 is designed to replace human beings, who can become fatigued, need rest breaks, salaries and who, of course, are able to refuse orders which do not suit their sense of humanity and virtue. The monstrous robot is rendered on film by one of the last extensive uses of stop-motion animation in commercial cinema (though the same technique is used for the robot's return in the sequels).[3]

The use of an animated character to oppose the increasingly human RoboCop sets up a further binary opposition of old and new technologies. The fearsome otherness provided by the use of stop-motion serves to characterise this monstrous icon of malfunctioning AI. ED-209 is bestialised, roaring and howling unintelligibly when threatened, writhing and gnashing when felled. This is part of the film's discourse around attempts to assimilate the mechanical and organic, which mirrors the attempts of cinema to merge real elements and those simulated by special effects. The *RoboCop* films never openly condemn mechanisation as a force of evil, but instead repeatedly place the blame on corrupt organisations and the unscrupulous programming of those who seek to benefit from its power.

The interest in cyborgs marks a transitional period for the fearsome machine from a powerful, externalised force and physical presence, to the more

abstract embodiment of the computer, whose external shell is of secondary importance to the occult intelligence housed within it. In *2001*, HAL is a spectral presence represented by a red bulb and a monotonous, emotionless voice. Later films would aim to make the computer more spectacular, handing over the responsibilities for rendering filmic illusions to digital effects. It is surely no coincidence that in *Terminator 2: Judgment Day*, Arnold Schwarzenegger's flesh and steel cyborg becomes a heroic figure battling a more advanced, shape-shifting liquid metal robot, whose transformations are achieved with computer-generated morphing effects. The shift in technological focus is reflected in the application of digital special effects, and the message is clear – while the automobiles and factories that were spawned by massive industrialisation in the first half of the twentieth century were spatially and physically disruptive, the next wave of technological development was to be within the computer, where its workings could be rendered invisible. The change in emphasis from miniature model-work to digital animation could be construed as a response to the new kinds of machine that have been absorbed into the 'traditional structure' of the film industry (Bolter & Grusin 2000: 147).

If the issue of human/machine hybridity surfaces in the guise of the cyborg, a semi-organic being containing mechanical or robotic elements, Claudia Springer reminds us that the end of this spate of 'hard-bodied cyborg' movies marks a segue into more abstract concepts such as postmodernity ('disorientation, powerlessness, fragmentation, disintegration') and the 'unsurpassed intimacy' which humans now have with their technologies (1999: 205–6). This is part of a master-narrative of existential angst, where technophobic discourse becomes focused on ambiguities in representations of the 'real' and the artificial, and a conflict between emotional and logical intelligences.

Computers come to power

The computer was initially a 'backstage' tool for filmmakers, ameliorating the repetitive drudgeries of cartoon filmmaking by improving the mechanisms of the cel animation camera stand (Gentleman 1982: 39), or by regulating the movements of motion control systems for special effects shooting where consecutive passes of the same camera moves were required to be composited in a single image. There were isolated experiments with motion control systems such as the Dupy Duplicator, which recorded camera movements onto a phonograph disc but almost without exception, camera position had to be fixed for shots involving optically composited elements (see Rickitt 2000: 118). *2001* used a mechanically controlled camera track to move the camera around a

model spacecraft, shooting one frame at a time, meaning that the same moves could be repeated along the same track time and time again.

The first computer animations were from scientific experiments with the basic analogue computer systems used in anti-aircraft viewfinders in the early 1950s. John Whitney Sr redirected the military focus of computer science and developed computer controls and imaging. Influenced by abstract animation artist Oskar Fischinger, the Whitney brothers (James and John, Jr) had already produced an abstract film, *Five Film Exercises* (1944) using light beams, colour filters and optical printers, but by 1961, working under IBM, James Whitney was using an analogue computer for the generation of abstract imagery in *Catalogue 61*, which 'attempted to combine modernist aesthetics with what was perceived as the liberating and non-elitist new electronic technology' (Noake 1988: 126). In these early days of computer-imaging, the interface was so complicated that making films depended on collaboration between artist and scientist, each assisting the other and creating a forced amalgamation of artistic input and precise mathematical procedure. With the support of major companies such as Boeing and Bell Telephones, CG scientific and technical simulations advanced greatly in the 1960s and 1970s, and artistic uses of the tools were seen as effective ways to test and develop the necessary software that could then be adapted for practical use. In 1962, Ivan Sutherland at MIT's Air Force-sponsored Lincoln Lab produced what may have been the first interactive computer graphics program, 'Sketchpad', 'a man-machine graphical communication system' which could generate simple geometric line drawings for use in engineering and design procedures (Noake 1988: 128; see also Darley 1990: 42). In matching the physical movements of the user's light pen and converting them into designs on the monitor, the programme 'guided the human hand into a conceptual integration with the computer technology' (Hillis 1999: 12).

In the early 1970s experiments into computer animation began in earnest. Late in the Vietnam War, the Mansfield amendment was drafted, restricting DARPA (Defense Advanced Research Projects Agency) funding to weapons-related research, and when many scientists refused to continue working on munitions applications, the development of personal computing received a lot of attention from freed-up scientists. Early 2-D graphical experiments at the New York Institute of Technology focused on making a computer draw 'in-between' frames automatically (O'Rourke 1998: 10). In traditional cel animation, 'key' frames, showing the principal actions of a character, would be drawn by a master animator while the frames in between, linking the most important poses, would be drawn by groups of assistant animators.

The next step was applying these techniques to 3-D animation, and enabling the computer to morph one object into another by generating the frames between two key frame images. All computer animation includes *modelling* (defining the dimensions and co-ordinates of an object in virtual 3-D space), *rendering* (giving the object an appearance, surfaces, textures and colours) and *animation* (making the whole object move) (O'Rourke 1998: 11). In early modelling an actual physical model would be produced and its co-ordinates programmed into the computer, but this was time-consuming, and the existence of physical models defeats the object of being able to produce objects entirely within a virtual realm. In procedural modelling, a number of 3-D figures such as cones, pyramids or cubes are defined and brought together to form a larger object. Fractal geometry can be used to 'grow' an object when the computer is taught that it can make up a larger object by repeatedly adjoining the smaller components. There is also a distinction between surface modelling, where the 3-D object is hollow, and solid modelling, where the object is solid, and has properties such as density and weight defined (O'Rourke 1998: 13). Particle-system modelling animates more diffuse items such as smoke, fire, clouds and mist; anything made of particles without a solid, stable shape.

A polygon is a flat, planar surface between non-dimensional points in space. The interconnection of these to form an object is called polygonal modelling. *Polygonal approximation* is when a curved surface is produced from a number of planar surfaces. The more polygons, the greater the definition of the curve and the higher the resolution of polygonal approximation is said to be. Complex objects are said to have a high polygon count, and a high count will lengthen the render time for the graphical application. In some cases, *polygon thinning* might be used to produce automatically an approximate version of the original model with fewer polygons, or *polygon expansion* if the definition of a model needs to be more precise. These polygons, readily adjustable and with variable resolution, could be seen as the defining units of cinematic realism. The more polygons, the more defined, tangible, verisimilar an object becomes, and the less it resembles a digital construct from geometric and algorithmic templates. Thus we get a perception of the real as an ascending scale where expense is directly proportional to verisimilitude.

Polygonal modelling can approximate the curves in nature, but cannot precisely replicate them – the curve is never entirely smooth. Nature has more curves and irregular objects than it does straight lines, and the polygonised curve is what makes a CG animation look synthetic. When polygons are used to draw a curved line, the computer can perform *linear approxima-*

tion (a *polyline technique*), making what looks like a curved line out of a series of straight lines. *Splines* can be used to generate a curve, where the computer calculates mathematically a curve from the input of a series of *control points* or *control vertices*, which denote the key points and dimensions of the curve (O'Rourke 1998: 21–2). The greater the number of polygons in a curved line, the more 'natural' it will look, so the more natural an object looks, the more it will cost to animate and produce.

Before the 1970s, images were displayed on monitors by continuous vector scanning, until the development of the raster system, whereby the screen is made of coloured squares called pixels. The greater the number of pixels defined in creating an object, the more detail it can be given when rendered on-screen. Therefore, in computer animation, the pixel can be seen as the smallest unit of the image, and is perhaps even a quantifiable unit of realism, or at least of verisimilitude. A CG object constructed from millions of pixels will render its polygonal construction less apparent and give it a closer resemblance to a real object, since its construction from tiny components is less perceptible.

CGI in cinema

An early use of computer-generated imagery within a theatrically released motion picture was in the 'Genesis' sequence in *Star Trek II: The Wrath of Khan* (Nicholas Meyer, 1982), using graphics equipment developed by Lucasfilm Computer Division, formed in the late 1970s, under Ed Catmull (see Smith 1985: 202). The 'Genesis' sequence comes in a tape watched by Captain Kirk (William Shatner); a moment of pure self-reflexivity, it demonstrates the capacities of the fictional Genesis device (which transforms dead moons into habitable environments) at the same time as it asseverates the potential of computer-generated imagery. For 58 seconds (including one brief cutaway to Kirk, Spock and McCoy watching the screen), the viewer is shown a fly-by across the surface of a computer-generated planet morphing into life. It was suited to Lucasfilm's current software research on matting and texture mapping, and was executed by Alvy Ray Smith at the Lucasfilm Computer Graphics Project. Loren Carpenter had been developing fractal techniques, which could produce 'controlled randomness to enrich a synthetic scene' (Smith 1982: 1038). This means allowing pixels to multiply in prescribed directions, thus imitating the intended effect of the Genesis machine, inducing the spontaneous and rapid evolution of a planetary surface without strict boundaries.[4] The sequence is one of the first uses in a film of particle-system animation, used to generate the flames which obliterate the moon's surface before 'fractal'

An onscreen simulation of a world-building technology, demonstrating the potential of Project Genesis, in *Star Trek II: The Wrath of Khan* (1982)

images generate landmass textures – just like the Genesis device itself, the computer-graphics sequence 'grows' its images using basic programs.

ILM was enlisted to work on *Star Trek II* in August 1981, with Ken Ralston and Jim Veilleux in charge, and Paramount committed to a release date of 4 June 1982. Although it was initially a fairly small project, a number of rewrites left a script which needed 150 composite shots to be produced in the last seven months of production, while ILM was already designating resources to *E.T. The Extra-Terrestrial* (Steven Spielberg, 1982) and *Poltergeist* (Tobe Hooper, 1982); the effects were therefore divided up to be delivered by independent artists – Jim Veilleux supervised the 'Genesis' sequence (see Anon 1982: 1030). Veilleux began experimenting with CG early in production to produce graphics for the electronic displays on the viewscreens of the Starship Enterprise, but CG would eventually form some of the visual effects – the 'Genesis' sequence and a computer model of a DNA molecule which had been created by Robert Langridge at the University of California in San Francisco, originally for use in pharmaceutical research (see Veilleux 1982: 1032). The opening main title, most of the star fields and the warp drive effect were produced electronically at Evans and Sutherland in Salt Lake City. Evans and Sutherland, with its 600 employees at that time, was best known for producing digital displays for flight simulators. They had also developed a CG system called 'Digistar 1' which could project moving starfield images onto planetarium domes, comprising as it does a database of 6,719 stars from the solar system based on actual astronomical data (see Veilleux 1982: 1033). The technology used to generate the 'Genesis' sequence was also used by Jim Blinn to produce CG simulations of the Voyager spacecraft flying past Jupiter and Saturn. These simulations, shown frequently on television, were instru-

mental in helping the public to visualise a mission which their tax dollars had part-funded, but of which they would see no other evidence for several years to come.

Steven Lisberger's *Tron* (1982) was intended as a showcase for visual technologies which were to become the predominant force of special effects creation. Superimposing live actors onto computer-generated backgrounds for the first time, and featuring several sequences of entirely computer-generated imagery, *Tron* envisioned the inside of a computer as a vibrant, primary-coloured world where programs are represented by avatars resembling the 'users' who wrote them. Some of these programs express a quasi-religious awe of the users they never see or hear, but whose perceived existence validates their own sense of purpose. Video games designer Kevin Flynn (Jeff Bridges) is molecularised and transported inside a virtual environment where he becomes a gladiatorial defender of the programs confined under the dictatorial superintendence of the Master Control Program (MCP), which has its own ambitions for acquiring power in the outside world by infiltrating military-industrial systems, thus betraying the strategic residue of its origins as a chess program. The MCP governs the programs it has enslaved through fear and capital punishment, and has quelled their theistic attachment to users by restricting access to the Guardian Tower, a church-like structure where programs can interface directly with their human operators. Through this scenario, which is actually a grandiose inflation of an act of data retrieval, the film constructs a battle for the computer's soul, where once there might have been a technophobic aversion or naïve glorification of the machine. By making ontological connections between the electronic and real worlds (most obviously by anthropomorphising the computer's operations), the film shows each space populated by individuated beings with the capacity for corruption or heroism; in concert with the wishes and aims of its user, a computer, through the value system governing its programs, can be an efficient, ethically disinterested corporate slave, or a valuable assistant to free-thinking creative scientists. This theme is reinforced by the film's distinctive appearance, *assimilating* live actors with its computer-generated backgrounds, objects and vehicles in order to harmonise the organic and the synthetic.[5]

Anton Karl Koslovic (2003) has argued that the scientific community, let down by the inefficiency of its public relations mechanisms, has been misrepresented by a kind of 'cyberscepticism' prompted by a reactionary response to computer technologies which paints them as sociopathic deceivers (*2001: A Space Odyssey*), pitiless rapists (*Demon Seed*, Donald Cammell, 1977) or exterminating 'cyber-Nazis' (*The Terminator*, James Cameron, 1984), all exhibit-

ing disregard for human life in ultra-literal enactments of their programming or overstepping the boundaries between master and slave. *Tron* presents a more quixotic vision of computer technologies, and by giving each human user a virtual equivalent, suggests that the actions of the computer are the consequence and responsibility of its operators – technology is an extension of human activity rather than an untethered agent of its own agenda. At the same time, the programs are seen to act intuitively, competing with one another and interpreting their duties in a discriminating manner. Sherry Turkle has argued that this allows the film to engage with efforts by AI scientists to challenge the perception of computers as 'literal-minded' automata (1984: 288). The optimism of this interpretation is enforced by the beautifully crafted aesthetic template of the film's computer-generated imagery, which allows the virtual world to seem ideationally consistent even if it is an expressionistic imagining.

Lisberger storyboarded the entire film with animators Bill Kroyer and Jerry Rees, and its initial development alone cost $500,000. After failing to secure privately their estimated budget of $5m, they took the project to Disney Studios (see Patterson 1982a: 793–4). At this time Disney was trying to break out of a *démodé* image and inadequate success in the live-action feature markets, and *Tron* promised to be an ultra-modern technological experiment that could cash in on a popular fashion for video games. They funded a sequence of test footage,[6] and a CGI test reel was also compiled of footage from MAGI (Mathematic Applications Group, Inc) and Triple I (Information International, Inc.).[7]

MAGI created eight minutes of the film's CG. Triple I produced about six and a half minutes plus the CG backgrounds (see Patterson 1982b: 802). Most of MAGI's scenes come first, and then the Triple I software takes over as Flynn gets closer to the MCP and the environments become more clearly defined. The difference in the graphics techniques were denoted by computer effects supervisor Richard Taylor as thematically significant – MAGI's systems were

Left: the computer-generated light-cycle race from *Tron* (1982); right: integration of live action actors and computer-generated environments in *Tron*

more suited to the fast-moving graphics of the battles with tanks and light cycles, while Triple I could create more organic shapes. The main advantage of CG is the ease with which a third dimension can be rendered, making perspectival shifts and virtual camera movements simpler to generate. The difference between the two types of computer graphics (vector and raster) lies in the way the computer analyses the image. In vector graphics, the computer has to see the image in terms of an arrangement of geometric shapes, while in raster graphics it is reading an image from a collection of pixels. Most of *Tron* was made using raster graphics (which can create more detailed images, but are very slow to render), while vectors were used for the main title sequence and the transition from the real to the virtual world (see Patterson 1982b: 803).

CG techniques are also varied by how the computer's memory constructs the mathematical models of objects and environments. The mathematical model, often referred to as the 'database', had two distinct forms in the making of *Tron*. MAGI were using a system which analyses objects in terms of a set of basic geometric shapes. For instance, the 'light cycle' vehicle was described to the computer in terms of spheres and rectangles existing with certain spatial relationships towards one another. Triple I used a database whereby the object was described to the computer as x, y, and z co-ordinates from a schematic drawing or blueprint and an electronic encoding table. The object is then 'digitised' from this information before being rendered as a graphic object. Once the database information of an object had been input, its action was choreographed. Kroyer and Rees were animators who had never done computer imaging before. They communicated the visual ideas to the programmers with storyboards. Scenes were first drawn as a CG pencil test, a low-resolution vector line representation of the scene which could be viewed in real time on a video monitor. All the companies needed programs for anti-aliasing and anti-rastering, defects which show up the wire-frame origins (through which the outlines are drawn before adding colours or textures to the surface) of a digital object and give it jagged edges. They would also use 'depth cueing', which alters the colour of an object according to how far away it is supposed to be from the viewpoint of the 'camera'. Some of the human characters in the finished film exhibit a minor flickering effect. This was due to the use of Kodaliths (Kodak's trademark name for a high-contrast film stock that renders its subjects in true black and white as opposed to shades of grey) which are produced in individual frames rather than on a film strip. Therefore, the emulsion and consistency of each frame will vary minutely, but detectably when printed for the final compositions. This residual trace of industrial process could be

passed off as glitching computers in Tron's virtual world, and flashing objects were inserted in the air around the characters to hide any severe flickers. In the finished film, every frame of the footage (except that which takes place in the 'real world') was blown up onto a 16-inch by 20-inch Kodalith on a rotoscope camera (which permits animators to trace the action on the film frame by frame) shooting in 65mm, and treated like a traditional animation cel.[8]

The film's virtual spaces are an analogue of the real world in that they contain people, pathways and buildings, but they are also recognisably electronic, with perfectly symmetrical grids of lines extending into vanishing point infinities and suggesting the limitless bounds of the digital age. Their distinctive look comes from the symmetry of their forms, the angular consistency of their environments, and the vivid, retina-searing sharpness of their solid frameworks of colour. The closing shot of the film, after the MCP has been overthrown, allowing greater interfaces between humans and users, cements a symbolic bond between the two worlds with a time-lapse image of a city at night, reducing it to lines of luminous colour that echo the shapes and forms of the virtual world.

Despite heavy marketing and merchandising drives, Tron was a financial disappointment (it grossed just $33m in the US, from a budget of $17m), a costly experiment in predicting a new visual template for popular cinema. Digital effects did not provoke a reinvention of visual style in popular cinema, and they appear in only a few films in the years immediately after Tron's release.

Capitalising on the burgeoning video games craze of the early 1980s,[9] The Last Starfighter (Nick Castle, 1984) is the story of teenage arcade fanatic Alex Rogan (Lance Guest), who finds himself enlisted by an alien species to fly a real spacecraft and save the galaxy from invasion. The video game, which the hero plays repeatedly until he defeats it, is a test machine sent by an air force from another world – the skill displayed in a virtual space is equated with the skills it can teach for use in real space. This is a story which glorifies the video game trend, giving kinetic and physical purpose to what might otherwise be seen as a static and passive virtual pastime.

The digitally-generated graphics of The Last Starfighter (referred to as 'digital scene simulations' in the film's end credits) are of a slightly higher resolution than those seen in Tron, but still use many spacecraft which appear to be constructed from angular blocks of colour. The rudimentary wire-frame graphics of the computer games to which Alex devotes much of his time are contrasted not only with those which the audience sees when 'real' spacecraft invade his space, but also with those seen in Tron, the benchmark for CGI

at that time. Wire-frame graphics define the perimeters and dimensions of a digital object in three-dimensional space prior to the definition of colours and textures on its surfaces, and might be seen as a skeletal, preparatory stage in the building of a fully-realised model. The thematic link (a video games player has to apply virtual skills to an actual environment) between *Tron* and *The Last Starfighter* urges the spectator to draw comparisons not only between the two films, but also between the in-game graphics of the video games which offer the segue into the more expansive digital imagery in the films (see, for example, Poole 2000).

In the 1970s and well into the 1980s, the primary use for computer-generated imagery was in 'commercials, program logos and station identifications' on television (Solomon 1994: 255). It was simply too expensive (by the mid-1980s, US advertisers might pay more than $150,000 for thirty seconds of computer animation), and too constrained by the necessary geometricity of its renderings (see Solomon 1994: 255–6). The early instances of spectacular CGI in mainstream cinema found diegetic excuses for its presence: *Tron* depicted an electronic alternative world; *The Last Starfighter* enfolds its graphics in a tale of video games; *Star Trek II* included a computer-simulation of the Genesis machine; *Young Sherlock Holmes* (Barry Levinson, 1985) featured a digitally-created knight formed from a stained-glass window, which turns out to have been a hallucination; *Terminator 2*'s shape-shifting, liquid-metal villain is born out of an unexplained futuristic technology. In all of these films, CGI is bracketed, to varying degrees, as distinct from real-world spaces. Since the 'electronicness' of the CGI in *Tron* and *The Last Starfighter* coincided with their subject matter, neither film showed how the technology could be useful in unrelated situations. If, as Andrew Darley (1990) has suggested, *Tron* represents the integration of the abstract imagery of early experiments in computer graphics with the narrative feature film, those scientific origins are all too obvious. CGI would not attain its current status as a ubiquitous tool of illusory representation until it became capable of rendering more organic forms. *Tron* was only able to showcase an imagining of a digital world, limited by the rudimentary geometric forms its technology could muster. Lev Manovich has suggested that it was only when the software for adding shading and texture became commercially available that they could approach 'the ideal of photorealism' (2001: 190). It was not until that point that computer graphics would be able to service the narrative needs of mainstream cinema, fitting in smoothly without bringing too much of its own aesthetic baggage to bear on the diegetic space.

Rather than expressing the technological specificities of digital animation and its potential liberation from anthropomorphism and classical spatial rep-

resentation, computers were to be put to work on missions of duplication, imitation and simulation (see Darley 1990: 49–52). Sean Cubitt has argued that this wasted the opportunity for dynamic interaction with computers, forcing them into a position of subservient instrumentality and 'crushing machine perceptions into conformity with a narrow definition of ours' (1998: 35). This suggests a fundamental negation of computers' singular traits, and certainly describes their conceptualisation as machines for refurbishing the same old tricks, so it seems apt that the film that truly set the template for the subsequent deluge of cinematic CGI should return to a very familiar preoccupation.

Digitally reconstructing dinosaurs

In the second chapter, the figure of the prehistoric monster loomed large in the introduction of stop-motion animation techniques to mainstream cinema. We can trace the progression of the dinosaur from its days as the prime subject for stop-motion animators, with its existence as an icon of scientific investigation and disputes over its definitive appearance, to a test bed for computer animation techniques. It is of note that images of dinosaurs have recurred at many of the most important developments in special effects technologies. Winsor McCay's *Gertie the Dinosaur* was a breakthrough in two-dimensional drawn animation characterisation; Willis O'Brien's stop-motion tests and later films all included some kind of prehistoric beast; Ray Harryhausen moved from animating prehistoric monsters as an apprentice to O'Brien, to producing distinctive work as an animator of mythical beasts – he applied the same rigorous attention to plausible motional characteristics in these creatures from Greek and Arabian legends as he and O'Brien had to their exploratory studies in dinosaur locomotion; Steven Spielberg's *Jurassic Park* featured the first sustained integration of computer-generated character animation and live action in a feature film.[10]

The maelstrom of merchandise and promotional franchises attached to *Jurassic Park* (see Balides 2000), as well as its unprecedented financial success, would see dinosaurs inextricably associated with CGI, where once they were associated with mechanical models and stop-motion animation (see *Dinosaur* (Eric Leighton and Ralph Zondag, 2000), and the mock nature documentary *Walking With Dinosaurs* (Tim Haines/Jasper James, 1999)). The production was originally intended as a showcase for model animation and enhanced stop-motion ('go-motion' – Phil Tippett had been employed to deliver about fifty such shots), but early in pre-production it became apparent that CGI had

been made malleable enough to create the dinosaurs, in conjunction with full-scale animatronics. Models made by Stan Winston could be scanned into a computer and animated virtually, and armatured figures with digital encoders at pivot points could record movements on computer. The film had to draw upon the expertise of stop-motion animators to counteract the artifice which inhered with 'the mathematical perfection of the first computer animations' (Winston interviewed in Pinteau 2004: 76), lending the CG dinosaurs a palimpsestic link to their special effects heritage. The resulting film is a supremely self-reflexive distillation of scientific research, popular science and film history, thematising issues of spectacle just as *King Kong* had done sixty years earlier. Based on the book by Michael Crichton (Universal paid him $2m for the film rights and a first-draft screenplay before the novel was even published), the plot is descended principally from Crichton's own *Westworld* (1973). In the earlier film, a Wild West theme park uses anthropomorphic robots in the guise of gunslingers (their appearance based not on historical accuracy, but on western film genre tropes and motifs – the robot villain is played by genre stalwart Yul Brynner, who sports the outfit he wore in *The Magnificent Seven* (John Sturges, 1960)), which duly malfunction and turn violently against the guests who have come to pretend they are part of an environment which usually only exists in films.

In *Jurassic Park*, genetically-engineered dinosaurs escape and attack visitors when an avaricious traitor sabotages the park's computerised security systems. Spielberg's film works as technological morality fable, allowing fear of the story's rampaging technologies to be matched with marvel at the film's own spectacular visualisations – the horror at the idea of genetically-engineered dinosaurs running amok and attacking the anachronisms in their new environment is tempered by the fascination held by the audience for the sight of computer-generated dinosauric attractions. The moral debates presented in the film, often very bluntly in contrived conversational scenes, are contained within a simple linear narrative. The situation is set up, complicated and resolved through a series of encounters with various dinosaurs, as if the viewer is being borne from one enclosure to the next at a zoo. As Umberto Eco once pointed out, zoos offer the visitor an 'oscillation between a promise of uncontaminated nature and a guarantee of negotiated tranquillity' (1986: 51). Invoking the zoo principal of tamed attractions *Jurassic Park*'s structure, guided from one set-piece 'exhibit' to the next, offsets much of the fear and discomfort which could have been created by such a vivid evocation of a scientific marvel refusing its own diegetic containments (cages, fences and so on). In short, one of the most alarming, complex and contentious moral debates in

scientific research is packaged as a thrilling entertainment experience. This digestibility of form and content may be at the expense of the oneiric aspects that characterised earlier types of animation. The computer-generated dinosaurs literalise the act of representation and take much of the burden of imaginative incarnation away from the spectator. As Spielberg himself remarks, presumably suggesting that he was *forced* to convey the dinosaurs naturalistically by public expectation,

> This movie is not *Alien*, where they can take whatever form your imagination suggests and be anything you want them to be because they don't exist in history or physiology. These are dinosaurs that every kid in the world knows. (Quoted in Sears 1993: 78).[11]

Though science fiction of the 1950s was seen as being characterised by a heightened politicisation and reactionary spirit in a time of paranoia and hysteria, the truth is far less simplistic than that. There was a great deal of ambiguity of intent in science fiction of that period, and a variety of viewpoints on show; Brooks Landon (1992) has described an 'aesthetic of ambivalence', where a narrative that warns of the disastrous consequences of technological advance is contradicted by the spectacular deployment of imaging technologies. Spectacular cinema of the 1990s is characterised by these dualities and ambiguities, perhaps because late-twentieth-century technologies are, in the words of Scott Bukatman, 'at once the most liberating and the most repressive in history' (1993: 4), or perhaps because imaging technologies which might safely *represent* dinosaurs onscreen are not correspondingly as hazardous as those which might unleash them (or other genetic miscreations) for real.

In a fascinating discussion of how Spielberg's film achieved unprecedented success at box offices around the globe by appealing to widely recognisable cognitive schemata (the near-universality of a startle reflex, for instance, means that the effect of a sudden, monster-based fright scene is rarely lost in translation), Robert Baird argues that the film's articulation of space is cross-culturally recognisable; it relies upon the spectator's ability to comprehend constructed filmic space in order to perceive the extensive use of offscreen space to suggest imminent threats and dangers. He adds that the special effects are rendered novel by animalising them, removing the abject connotations of monstrousness and 'relying on shared assumptions of animal form, movement and behaviour' (1998: 91). Their movements are mimicked from observations of zoo animals, and enhanced by procedural animation that makes sure that their flesh responds appropriately to environmental factors and muscular re-

flexes. This creates a series of spectacles which refer back comparatively to earlier dinosaur films, but which also refer to real-world characteristics which spectators are expected to recognise. The dinosaurs are rendered as flesh and bone, but their realistic properties are defined by their distance from their machinic origins, whether animatronic or digital.

The special effects technologies on show in *Jurassic Park* may envelop the film in the trappings of novelty, but it could be argued that they rely primarily for their effect upon the recycling of extant techniques and old-fashioned iconographies, meaning that the film's spectacular set-pieces rely as much upon prior knowledge as they do on shocking newness. The film even builds in references to earlier texts which featured the creatures in now antiquated renderings; Ian Malcolm (Jeff Goldblum) comments on the huge, wooden gates at the entrance to the park ('what have you got in there – King Kong?'), and the cartoon demonstration of the process of genetic engineering features a fleeting homage to Winsor McCay's *Gertie the Dinosaur*. Once Spielberg's film had demonstrated the economic and visual power of CGI, there followed a flood of digitally-decorated features, almost all of which exhibit evidence of this same sort of recycling.

For all its surface novelty, the early years of CGI proliferation in Hollywood were almost exclusively devoted to using the technology to rework older, or less 'hi-tech' forms of spectacle. A year after *Jurassic Park*, which remodelled the cinematic depiction of the dinosaur, came *The Mask*, its central character a pastiche of Tex Avery cartoons, and a plethora of others: *The Flintstones* (Brian Levant, 1994), from the Hanna-Barbera cartoon (1966–69); *Casper* (Brad Silberling, 1995), from the Paramount cartoon character first appearing in 1945; *Jumanji* (Joe Johnston, 1995), from Chris Van Allsburg's 1981 illustrated children's book; *Mission: Impossible* (Brian de Palma, 1996), from the television series of the same name (1966–73); *Independence Day* (Roland Emmerich, 1996), a gigantised update of flying saucer movies; *Mars Attacks!* (Tim Burton, 1996), another tribute to the UFO movie, paying particular homage to *Earth vs. the Flying Saucers*, even using CGI to 'mimic' the properties of stop-motion animation; *Lost in Space* (Stephen Hopkins, 1998), based on the television series of the same name (1965–68); *Godzilla* (Roland Emmerich, 1998), relocating Ishirô Honda's 1954 monster from Tokyo to New York; *The Mummy* (Stephen Sommers, 1999), a (very) loose remake of Karl Freund's 1932 original.

Even less obvious choices, such as *Apollo 13* (Ron Howard, 1995), *Twister* (Jan de Bont, 1996), *Starship Troopers* (Paul Verhoeven, 1997), *Armageddon* (Michael Bay, 1998), *Hollow Man* (Paul Verhoeven, 2000), not strictly speak-

ing remakes, are reworkings of earlier, perhaps outmoded sub-genres and cycles (space exploration, natural disaster, alien invasion, invisible man and so on). What this emphasises is the extent to which computer-generated visual effects sequences, even as they trade on their patina of novelty and futurity, explicitly demand comparison with earlier renderings of similar images.

The Mask, based on the Dark Horse Comics character of the same name, relies heavily on digital effects to augment star Jim Carrey's performance. Carrey plays a downtrodden bank clerk who discovers an ancient Norse mask inhabited by the spirit of Loki, god of mischief. When wearing the mask, Carrey is transformed into a being from his id, in this case a whirling, morphing dervish modelled on the characters of cartoonist Tex Avery. His eyes pop out on stalks, he turns into a slavering wolf at the sight of Tina Carlyle (Cameron Diaz), and his suit contains an endless supply of giant mallets, guns, alarm clocks and other accessories. Carrey is therefore invested with the physically and spatially liberated properties of an animated figure; he is indestructible, transmutable. Yet the illusion of his cartoonic alter ego is achieved through extensive use of digital animation mapped onto the actor's body. The character is therefore a walking intertext, embodying a cartoon aesthetic that has been infused with a digital nature – the cartoon is three-dimensional and highly detailed, interacting with 'real' elements.

This mixture of novelty (digital effects) and convention (cartoons) is a frequent trait of special effects of the last twenty years, and can be usefully understood with reference to Jay David Bolter and Richard Grusin's theory of remediation, whereby no medium 'seems to do its cultural work in isolation from other media' (2000: 15). Bolter and Grusin argue that, despite centuries of gestures towards the eventual erasure of all traces of mediation, 'digital media can never reach this state of transcendence, but will instead function in a constant dialectic with earlier media ... what is new about digital media lies in their particular strategies for remediating television, film, photography, and painting' (2000: 50). Nowhere is this more apparent than in those instances where a digital special effect relies for its full appreciation upon the spectator's awareness of what is novel about it, and what is not.

James Cameron's *Titanic* proclaims its own historical authenticity through alignment with earlier types of indexical photographic techniques, even with Bazinian realism. *Titanic* also features a striking moment of self-consciousness about the capabilities of digital simulation. Early in the film, Rose De Witt Bukater, an elderly survivor of the Titanic disaster, is shown a computer reconstruction of what scientists and historians believe happened to the ship as its hull filled with water and eventually split the craft in two. The perfunc-

The continuous 'fly-by' shot from *Titanic* (1997), moving from the bow to the stern

tory coldness with which the tragedy is algorithmically calculated sets up a stark contrast with the dramatised version of events that comprises the film's climax. As Rose says, it is 'a fine, forensic analysis. Of course, the experience of it was somewhat different.' Just as the film disparages the ability of unembellished simulation to capture the meaning and significance of the events it portrays, it simultaneously validates its own use of imaging technologies to authenticate its rendition of the story, by combining footage of the actual shipwreck with miniature models, full-scale reconstruction and CGI. This is how *Titanic* bolsters its romantic plot with a meta-narrative about historical reconstruction.[12]

Digital effects aim to blur the line between real and synthetic elements within the frame through an aesthetic of fluidity that removes jarring boundaries between composited images and allows computer controlled virtual cameras to glide weightlessly through virtual environments (see North 2005). When Jack (Leonardo DiCaprio) perches atop the bow of the great ship, his triumphal cry, 'I'm the King of the World!', is the cue for an extended aerial tracking shot along the length of the ship, achieved through a combination of miniature model-work and computer graphics, but the sustained shot means that the different components of the illusion are not obviously segmented by conspicuous edits or photographic matte processes. Aylish Wood argues that

it is the length of the shot which is significant – by holding the take, Cameron differentiates his film from earlier recreations of the Titanic's voyage such as *A Night to Remember* (Roy Ward Baker, 1958). She states that digital effects can be used to 'lengthen the time that spectacular elements remain convincing before drawing attention to themselves as illusions' (2002: 372). But duration is not the main factor here. Jean Negulesco's 1953 film, *Titanic*, features a 20-second shot of the ship hitting the iceberg, allowing contemplation of the stricken vessel without interruption from cutaways, but in long shot, and with a static framing. The final sinking of the Titanic's stern is shown over fifty seconds with only one cut, again using a miniature model in a water tank. What actually sets Cameron's film apart is the way that the view is depicted as motion through space. The digital effects do not simply allow for the same shot types to be sustained for a greater duration, but instead allow the blending of several elements which might otherwise have required several different set-ups to capture. The fly-by, quasi-aerial shot is a common way to show off what digital technologies provide with great ease – fluid movement and an appearance of total revelation. The movement of the camera between the ship's funnels mark it as a virtual viewpoint – no helicopter could fly so close, no crane rig could be set up so far out to sea.

According to Lev Manovich, while earlier media forms exhibited collage aesthetics where composited elements were clearly delineated as discrete units, digital compositing 'supports a different aesthetic defined by smoothness and continuity' (2001: 142). This should not, however, be mistaken for an aesthetic of concealment – even as the *Titanic* fly-by shot incites amazement at the extrusion of a single 'take', it urges us to draw upon a knowledge of earlier instances of similar effects in order to note the novelty in this latest version. In short, this kind of special effect, at least while it remains novel, depends upon the existence of relatively unsophisticated antecedents for its full effect. But, it is part of the deal that the new effect will itself imminently be upstaged. As Manovich explains:

> Each new technological development ... points out to viewers how 'unrealistic' the previous image was and also reminds them that the present image, even though more realistic, will also be superseded in the future. (2001: 186)

Thus the special effect can be seen as operating to incite wonder at three levels, as outlined in the introduction to this book: *diegetic, intertextual/comparative* and *speculative*. It depicts a fictional event occurring within the story world of

the film (*diegetic*); it invites comparison with other depictions of similar story events (*intertextual/comparative*), in this case portayals of the Titanic disaster; it presents the possibility of even more amazing illusions using the same technology (*speculative*) – it does not confirm a pinnacle of achievement, but instead offers a progress report defining the state of the art by its precedents and its possible successors.

Digital cosmetics

Perhaps the most controversial application of special effects technologies comes when the malleability of digital images is exploited to make tiny cosmetic changes to a film or television broadcast. If films like *Jurassic Park* demonstrated the capability of digital effects to simulate solid objects and moving figures and insert them into the filmic space, then Robert Zemeckis's *Forrest Gump* (1994), an adaptation of the 1986 novel by Winston Groom, announced the same technology's facility with the manipulation of extant imagery. Tom Hanks stars as a man with an IQ far below average, and oblivious to the pivotal role he has played in key moments of American history. The film uses intricate digital compositing techniques to superimpose Hanks within actual newsreel footage. By digitally altering the lip movements of those in the footage, Forrest can appear to interact with John F. Kennedy, Lyndon Johnson, Richard Nixon, John Lennon and Dick Cavett.

Wheeler Winston Dixon has cited *Forrest Gump* as evidence of 'disturbing aspects' inherent in digital effects films which 'do not seem – at first glance – to contain any effects at all' (1998: 23). This stance echoes Paul Willemen's fear of the 'waning of the indexical', as if disclosure of the presence of a visual sleight-of-hand somehow represents unfair conduct on the part of the film's

Forrest Gump (Tom Hanks) meets President John F. Kennedy

makers. Dixon complains that earlier types of special effect announced their presence through the imperfections in their visualisation, offering cues to the audience, such as 'telltale matte lines' around a composited object, which provided accidental assurances that the (almost) realistic images were only innocuous fabrications (1998: 32). Perhaps, though, rather than perniciously seeking to bypass the spectator's critical faculties with its immaculate illusory credentials, *Forrest Gump* seeks to subvert the integrity of photographic history by showing up its very pliability.

The film's thesis is highly ambiguous. It could be seen as a reinforcement of the American dream that anybody can play a key part in society, can step from humble origins to historical prominence. It can be seen as more subversive, though, a parody of the gravity of history, of the austerity and reverence which surrounds moments of historical importance immortalised on film or television. It can also be seen as satirising the supposedly incorruptible veracity of news footage; Forrest pollutes the sacred archival spaces of historical records.

Jennifer Hyland Wang (2000) has shown how the Republican campaign to re-elect George H. W. Bush to the American Presidency in 1994 co-opted the film and sought to impose a fixed meaning upon it. Wang shows that right-wing conservatives, with a desire to return to 'traditional' family values as a key electoral theme, promoted a view of the film as a damning indictment of the counter-culture of the 1960s and seeking a return to the ideal nuclear family epitomised by a 'Golden Age' image of the 1950s. Forrest's sweetheart, Jenny (Robin Wright Penn) is swept up in a string of counter-cultural trends and organisations in order to actively influence important social moments, all to no avail – she is repeatedly shunned and abused, finally conquering her drug problems and settling into marriage and motherhood (before dying from an unspecified virus that we cannot help but presume to be AIDS). Likewise, Gump's platoon leader Lieutenant Dan (Gary Sinise) resents being rescued from his destiny of glorious death in combat. He, similarly, is embittered and tortured by regret until he accepts his new fate, eventually becoming engaged. The film's musings on the nature of fate and predestination, variously embodied by the narrative trajectories of these central characters, are referred to in Forrest's monologue at Jenny's grave, where he notes that: 'I don't know if we each have a destiny or if we're all just floatin' around accidental-like on a breeze, but I think maybe its both.' This ambivalence is, at least in a reading which focuses on the nature of the digital effect, settled by the presence of the feather which dips, twists, rises on the air currents in an unbroken tracking shot over the opening titles, coming to rest at Forrest's feet, drifting away on

the breeze again in the film's closing shot. Ostensibly, this reflects the random nature of Forrest's success, buffeted through life by a series of fortuitous accidents, while Jenny and Dan endeavour to create their own destinies.

The feather's unpredictable delicacy is actually simulated by the digital composition of a feather into the frame to match the camera's apparent tracking shot – in fact, it has been made to move to fit in with the prearranged camera movements. The feather is both free on the breeze, and entirely pre-destined in its path. It is a real, fluttering feather, but it is located, by computer, in a path through the frame of the image that will leave it at a prearranged point. Here the special effect helps to establish meaning, while also possessing ambiguity. The feather has the appearance of freedom, but only because it has been imbued with the *characteristics* of free movement by artists and technicians – its randomness is entirely controlled. Even if the film accommodates the interpretation that it represents the vicissitudes of fate and the randomness of existence, the patina of digitality means that little about the film feels random; when the young Jenny kneels down in a cornfield to pray for God to transform her into a bird, a flock of computer-animated birds flies up into the air, right on cue; looking back on the beautiful moments from his life, Forrest recalls the perfect reflection in a mountain lake, a reflection which was added by digital effects artists; the crowds which attend the college football game, the anti-war rally and the ping-pong game in Mao's China at which Forrest appears, are mostly digitally-composited onlookers – even the ping-pong ball is digitally animated. All of these effects, along with the more blatant blend of Hanks with archival footage, painstakingly rendered, suffuse the film with signs of predestination and directed movement.

'Bring on the computer guys'

Further consideration of the capacities of digital manipulation must include reference to the practice of adjusting previously-released films – though not a common occurrence, these films have attracted considerable attention and indicated the possibility of a new fluidity for certain texts. The *Star Wars* special edition rerelease of 1997 saw many of the original film's special effects glossed over, enhanced or supplemented by digital augmentations, and about four minutes of new footage added. *Star Wars* is already a blend of old and new in terms of genre and iconography – the use of arcane knowledge and chivalrous swordplay in space, a location inextricably linked to futurity, and the combination of advanced special effects with vintage generic traits (westerns, science fiction serials) is a key aspect of the films' intertextual fabric.

The original intention for the special editions of the *Star Wars* trilogy was to pave the way for the prequels, *Star Wars Episode I: The Phantom Menace* (George Lucas, 1999), *Star Wars Episode II: Attack of the Clones* (George Lucas, 2002) and *Star Wars Episode III: Revenge of the Sith* (George Lucas, 2005). Lucas oversaw the digital remastering of all the films' sound and vision, as well as the addition of scenes deleted from the original releases. On top of this, computer-generated objects and lifeforms have been added to the frame to punctuate the films with hi-tech details. The claim is that the intention was to improve upon the originals, to do what technology was incapable of rendering when the films were produced, but it was also a way to experiment with CG animation in the *Star Wars* universe to see if it could be aptly incorporated in the look of the new films. Doing this serves to bridge the technological chasm that would otherwise have existed between the earlier film trilogy and the prequels.

What do we gain in a film that has been digitally augmented years after its original release? It remains to be seen if this will become a trend in mainstream cinema. *Star Wars* and its sequels have made the most high profile uses of the technology for its special edition rereleases in 1997 (*see above*), but a 2002 DVD release of *Star Trek: The Motion Picture* (Robert Wise, 1979) has seen certain shots digitally enhanced, adding computer-generated buildings and objects to supplement the miniature model-work of Douglas Trumbull and John Dykstra. To avoid a commercially noxious NC-17 rating in the US, Warner Bros. inserted computer-generated figures to obscure shots of explicit sex from Stanley Kubrick's *Eyes Wide Shut* (1999), cunningly circumventing their agreement not to cut a single frame from his work (see Guins 2002). The makers of *Zoolander* (Ben Stiller, 2001) had the World Trade Center digitally erased from shots of the New York skyline for its release a month after the terrorist attacks of 11 September 2001, and shots of Oliver Reed, who died before shooting was completed, were digitally captured and inserted into different backgrounds for *Gladiator* (Ridley Scott, 2000). Lucas also added new shots and backgrounds to a DVD reissue of his first feature film, *THX 1138* (1971).

In April 2002, legal proceedings began, brought by Sherwood 48 Associates (a company owning several billboards in Times Square, New York) against Sony/Columbia and their production of *Spider-Man* (Sam Raimi, 2002), though the case was dismissed in August of the same year. In the film, certain billboards, including one for Sony rival Samsung, have been digitally altered to display alternative products. Advertisers using the Times Square billboards have benefited from their advertisements being seen by visitors to

Times Square and by viewers of films, television broadcasts and photographs featuring the famous location. Now that the signs can be easily manipulated in digital media, questions will arise as to whom the *image* of the advertisement belongs and who has the right to alter or conceal it. A similar case brought by Sherwood in 2000, when the CBS network superimposed its logo over an NBD billboard, was settled out of court. The advent of digital media is causing major changes in the way we perceive the ownership, permanence and nature of the image.

In March 2002, Steven Spielberg marked the twentieth anniversary of the original release of his *E.T. The Extra-Terrestrial* by re-issuing it with a 'digital makeover' (Grossberg 2001). A small amount of footage excised from the original version has been restored, most notably a sequence of young Elliot (Henry Thomas) and his alien friend taking a bath. Possibly hampered by its watery setting, the animatronic puppet did not function well and the scene was cut, but now such 'deficiencies' of puppetry can be digitally augmented to give any inaccuracies in mechanised lip-synching a more precise mouth movement or flourish of the hand. The famous line, a catchphrase to millions unperturbed by the peccadilloes of the creature's enunciation, 'E.T. phone home' has now been matched more closely to E.T.'s lip movements by digitally adjusting his face. This is a purely technical adjustment brought about by a desire to judge aged special effects by present-day standards. It recognises the capacity of digital technology to reclaim an image by updating the tell-tale traces of its original moment of manufacture, but the imperfections or flaws in a special effect are what help us to date those images and situate them historically. The desire to correct these effects ignores their involvement in the text's sense of time and place.

The re-issue of *E.T.* demonstrates a more unsettling desire to decontemporise film, to make it perpetually marketable and divorced from its historical moment. Subjective and contingent categories such as taste, decency, political correctness and contemporary sensitivity have converged most perturbingly in the digital removal of shotguns (replaced with computer-generated walkie-talkies) from the final scenes where Elliot and his friends, on bicycles, are pursued by federal agents intent on capturing E.T. for research purposes. Marvin Levy, Spielberg's publicist, has explained that this adjustment was made because 'people were less cognizant of [the impact of guns] in '81 or '82', and justifies the change with the comment that 'most people are not going to notice, except maybe the purists' (quoted in Grossberg 2001).[13] These ideological alterations, made possible by digital technology's ability to infiltrate the composition by being inserted into the virtual three-dimensional space

of the frame, are minor examples but suggest a trend which can only become more frequent. It also undermines the value of film as a gauge of contemporary public sentiment. Spielberg's adjustments are a response to the public mood at a time when it clashed with the long-planned twentieth anniversary rerelease of *E.T.* If representations can be adjusted with such ease, the implications for film as a record of history might be immense, but although it is tempting to presume that this is further evidence of a slide into absolute simulation, I would suggest that this is only another in a long line of manipulations of integral spaces. As has been argued throughout this book, special effects borrow markers of authenticity from various places, whether it is the use of stock footage in *Earth vs. the Flying Saucers*, appeals to scientific expertise in *Destination Moon*, or subversions of faith in theatrical space (and the evidence value of newspaper!) in *L'Escamotage d'une dame au Théâtre Robert-Houdin*. There is always an onus placed upon the media-literate spectator to discern the mechanics of image manipulation and to interpret its composition as an instance of technical contrivance. But does digitalisation make that task of discernment more difficult?

These are not isolated instances, but examples of a proliferation of digital sticking plasters, interfering with the image at the most minute and trivial levels. Rather than allow a 'damaged' or incorrect image to be displayed to audiences, the film image will often be finessed in accordance with predetermined expectations and wishes of the target audience. Ashton Kutcher's Kabbalah bracelet, which he had either forgotten or refused to remove during shooting was erased from *Guess Who?* (Kevin Rodney Sullivan, 2005; see Kilkelly 2005). After conservative test audiences objected to the prominence of Lindsay Lohan's breasts in several scenes from Disney's *Herbie: Fully Loaded* (Angela Robinson, 2005), the studio was allegedly prompted to digitally reduce or conceal the offending flesh.[14] For Lohan, it may have seemed like any young actress's salvation ('Bring on the computer guys!' was her reported response), negating the need for punishing oscillations in body shape to fit into future roles – technicians could just mould her into the appropriate form after the fact. Tales of other manipulations abound, such as Whitney Houston's wasted limbs being plumped up by digital artists for the live television broadcast of a Michael Jackson concert in 2001 (Jackson was also reported to have undergone a live CG makeover). Post-production allowed the flattening of Angelina Jolie's 'loose bosomry' in a stunt sequence from *Mr. & Mrs. Smith* (Doug Liman, 2005; see Harlow 2005). Whether or not these stories are true (some of them seem highly unlikely) is another matter – what is important is the shaken faith in the veracity of the photographic image, and the sense that

anything could seem to have been digitally altered if the spectator is not given the clues necessary to make the distinction.

Are these cosmetic uses of digital technology really a fearful and ultramodern attempt to dislodge the hallowed status of the image? As I have shown, image manipulation has always been a component of image manufacture, and photographs have been altered and touched up for almost as long as they have existed. The famous nude photographs of Marilyn Monroe in the first issue of *Playboy* were also published with black lingerie painted onto her body, though it is arguable that this particular denudement ended up eroticising Monroe's figure alternatively, without reducing the sexuality of the picture. Iconic images in *Playboy* magazine have been airbrushed in order idealise the feminine, removing skin blemishes and the other natural textures which would allude to the fantasy of tangible flesh. Digital technology has assisted with manipulation, erasure and adjustment of images, but has not invented the idea that the image must be controlled and censored on its journey from recording to reception. The next chapter will examine more thoroughly the end product of these excursions into a simulationist aesthetic and its experimental applications to the human body. The virtual actor moves us away from the augmentation of the image towards the construction of photorealistic digital humans. If these examples show that the computer has become a tool with countless diverse uses, the next chapter will explore the mythos of perhaps its most revealing purpose.

CHAPTER 5
The Synthespian

We can undoubtedly produce a machine that satisfies our aesthetic sense ... There are no limits on the physical beauty of such creatures. We may be just the dumb, ugly ducklings that created them. Is there a reason to build such things? Are there reasons not to? It does not matter; they will be built.
Myron W. Krueger (1983: 235–6)

In Andrew Niccol's *S1m0ne* (2002), film director Victor Tarensky (Al Pacino), having lost the services of his petulant, demanding lead actress (Winona Ryder), replaces her performance in his film with a digital synthespian. The public takes her for a charismatic, flesh-and-blood ingénue, and the farcical plot that ensues is driven by Victor's attempts to maintain the façade by manufacturing media appearances by his virtual star. What might have promised to be a biting contemporary satire of acritical celebrity worship, and the imminent arrival of imperceptible illusion (as Victor says, 'our ability to manufacture fraud now exceeds our ability to detect it'), actually ends up reminding us of how distant a prospect its premise really is. The fact that the eponymous digital star has to be played by a real actress (Rachel Roberts) is only one of many indicators that the film is a premonition of something that is not a pressing concern. The software Tarensky uses to drag and drop his star into real-time media bears little relation to any processes currently employed by computer animators (there is no evidence of motion capture or slow render times for

instance) but, more importantly, the film seems to exhibit a perhaps unintentional contempt for the critical faculties of the popular audience. Ray Kurzweil voiced similar criticisms that the film puts forward an incorrect view of the speed at which new technologies emerge:

> By the time the 'perfection' presumably represented by Simone is feasible, the public will be very familiar with the idea of a virtual actress. Technologies such as these never burst on the scene fully formed with no imperfections as is displayed in this film. (2002)

Of course, the fact that none of S1mOne's fans detect flaws in the illusion is the device that sustains this comedy of errors, but its dystopic thesis ignores the role played by spectators in appreciating and interacting with special effects. Niccol's film wants to suggest that all it will take to produce such a deception is a producer unscrupulous enough to break the contract with the spectator which convention dictates will announce the presence of illusions to be deciphered.

S1mOne is far more useful as an indication of the popular belief in the impending advent of virtual actors than it is as a marker of the technological state of play. This chapter examines the anticipated arrival of the synthespian, a photorealistic, potentially autonomous human simulacrum. Brooks Landon notes that 'while numerous Hollywood discussions still centre on the degree of realism that can or cannot be achieved by synthespians, it has become clear that these CGI figures now function as a realisation of technological prowess as much as or more than as a representation of human beings' (2002: 70). The virtual actor has gained currency as a science fictional idea that technology is not yet equipped to deliver, but the possibility of its arrival is as significant as its actual creation could turn out to be. The persistence of the synthespian mythos offers interesting insight into the ways in which special effects operate as machinic performances.

The coming of the virtual actor

Since the late 1980s the word 'synthespian' has been a trademark of the Kleiser-Walczak Construction Co. formed in 1985 by digital animators Jeff Kleiser and Diana Walczak, 'dedicated to exploring the creative applications of computer animation to human figure representation for entertainment projects'.[1] In 1988, their first CG character, Nestor Sextone, a mock presidential candidate, was shown in a short film at the Special Interest Group on Graphics

and Interactive Techniques (SIGGRAPH) conference, and speculations about the acting capabilities of such a synthetic character led them to coin the term 'synthespian'. The following year, Kleiser-Walczak unveiled Dozo, their prototype CG popstar, performing her single 'Don't Touch Me', an appropriate title, given her inherent impalpability.[2] Dozo's dancing is recorded using motion capture, a technique derived from medical research into gait analysis, which involves plotting co-ordinates from numerous reference points ('optical trackers') on a performer's body, off which light from LEDs around the camera lens is bounced back into the camera. The positional data is then used as a basis for full CG animation (see Clipson 1999). This information can be stored in the computer until it is transferred to the digital character, which can be clothed, coloured and characterised according to requirements, retaining the movements memorised from the original performance.

Kleiser-Walczak's work was mostly intended for presentation at industry symposia to showcase future possibilities, but synthespians' early incursions into mainstream cinema saw them performing brief shots of dangerous or impossible stuntwork or expanding crowd scenes.[3] As such, they took on the roles normally occupied by extras or stunt performers, people who appear in films but who are required to remain anonymous. 'Unreal' stunt performers have existed at least since Alfred Clarke of the Edison Kinetoscope Company used a dummy, substituted for his leading actress in a stop-action trick effect, to be decapitated on camera in his film *The Execution of Mary Queen of Scots* (1896). For wide-angle shots of an aerial motorcycle chase scene in *Judge Dredd* (Danny Cannon, 1995), Kleiser-Walczak was employed to replace the film's expensive, frangible leads (Sylvester Stallone and Rob Schneider) with digital doubles (see Pinteau 2002: 122). About twenty actors provided the motion capture material for use on James Cameron's *Titanic*, so that the deck of the ship (a combination of model-work and CGI) could appear to be occupied by hundreds of passengers. However, the virtual performer has achieved much greater prominence in lead roles, and by the start of the twenty-first century it seemed that virtual actors might graduate from their position as background artistes to take centre stage.

Aki Ross, 'CGI goddess'

Final Fantasy: The Spirits Within (Hironobu Sakaguchi, 2001) represents a concerted effort to achieve the synthespian goal. The entire cast, along with all backgrounds, sets and props, is computer-generated, but the film's star is undoubtedly Aki Ross, who was at the time the most detailed computer-gen-

The first sighting of Aki Ross in the opening scene of *Final Fantasy: The Spirits Within* (2001)

erated human visualisation yet rendered.[4] Like her fellow digital characters, Aki is animated from a combination of key frame animation (her movements plotted by an animator) and motion capture (her digital form mapped onto the pre-recorded movements of an actor). The film's plot seems to be only a necessary container for the main attraction of the fascinating textures which are laid out for the viewer's inspection.

One of the enduring thrills of computer animation is seeing everyday objects rendered in CGI – realistic spaces and things transplanted into a medium (animation) which has traditionally been non-realistic. There is no stretch-and-squash in the CG animation world. Just as, in the early cinema period, audiences may have been fascinated by rustling leaves, water and other simple, natural views, now there is a trend for celebrating the CG rendering of simple things; the dust on a shelf (*Toy Story 2*, John Lasseter/Ash Brannon/ Lee Unkrich, 1999) or the fur on a creature (*Monsters, Inc.*, Pete Docter/David Silverman/Lee Unkrich, 2001). An extreme close-up of Aki Ross' eye or a flick of her $2m procedurally-modelled hairdo carry as much spectacular weight as an alien invasion, as long as we are kept aware of precisely how much effort was required for its achievement. Each is an attractive compendium of technologised texture and detail, inviting the eye to inspect closely, to seek out pixilation, jerkiness, or other vestigial traces of its computed origins.

For this reason the pre-publicity for *Final Fantasy: The Spirits Within* incorporated means of showing how fleshily realistic Aki Ross was. Close-ups of her eye, including moisture usually lacking from the eyes of CG characters, were widely published, and shots of Ross wearing only a pink bikini created an astonishing picture of a fully formed CG character. In the actual film, she

is never dressed so sparsely, partly because of the complexities of animating skin, and partly to conceal the metal plate in her chest which is revealed late in the story – her photoshoots are designed to suggest a celebrity life outside the confines of the diegesis. *Empire* magazine in the UK touted her as 'the virtual babe who will change movies forever'.[5] Aki, who also appeared on the cover of the August 2001 edition of *Yahoo!* magazine, had many websites dedicated to her, most of which deliberately mimicked the style of any normal fan site, featuring biography, news, picture galleries and multimedia sections.[6]

From its opening shots, the film holds Aki up to scrutiny with close-ups of her face. Alexander Walker has talked of the close-up as the beginning of the establishment of stars, since 'by isolating and concentrating the player's looks and personality, sometimes unconnected with his or her abilities, it was to be the decisive break with stage convention, the most potent means of establishing an artist's uniqueness and the beginning of the dynamic psychological interplay of the filmgoers' and the film actors' emotions' (1970: 5). Béla Balázs talks of the close-up as leading to 'the discovery of the human face', since facial expressions, with their immense complexity, communicate a great deal of emotional information (1974: 188). However, facial expressions are not a direct revelation of a person's 'soul'. The close-up image is coded cinematically and culturally, especially when all those expressions are digital simulations. Richard Dyer finds value in Balázs' analysis because he articulates a 'belief in the "capturing" of the "unique" "person" of a performer [which is] probably central to the star phenomenon' (1998: 15).

While bodily information is relatively simple to simulate in digital form, Ed Catmull sees the human face as the biggest challenge, simply because that is the part of the body from which we instinctively glean emotional nuance and personality:

> We are genetically programmed to recognise human faces ... It turns out, for instance, that if we make a perfectly symmetrical face, we see it as being wrong. So we want things to be not quite perfect, have a lot of subtlety, but if they're too imperfect, then we think that they're strange. (Quoted in Tyler 2000)

Donald Laming, lecturer in experimental psychology at Cambridge University agrees that, for a synthespian, 'if the face isn't quite right, its not going to work' since 'there is a disproportionate amount of mental capacity used for dealing with faces' (quoted in Mathieson 2001a: 2). The digital construction of a face

delivers an image which is fascinating precisely because it is 'not quite right'. The human face sets off a series of perceptual reflexes in the viewer every time it comes into view. The sophistication of a digital face able to convey facial expressions based on instinctive, even subconscious emotional communication rather than broad mimicry is at present far beyond the scope of any animator, and is likely to remain so for many years. This is not to say that it will never be possible to imbue a digital construct with the ability to communicate emotionally (even if said emoting is merely simulacrous), but we have to factor in the possibility that it might never happen, because it might never be necessary or desirable. At present, though, the state in which the synthespian is made manifest is one of fearful but fascinated mythology, rather than an inevitable path towards a future of artificial entertainers.

The film flopped dismally at the box office, leaving Square Co. with a debt of $113,000,000 (see Williams 2001). As Tom Long in the *Detroit News* put it, 'the only reason to see *Final Fantasy: The Spirits Within* is to gaze in amazement at what the future of film may hold. It's not a particularly good movie, but it's a movie that may change the movies'. Special effects are compensatory attractions in this case, and *Final Fantasy*'s 'stunning [and] revolutionary' animation makes for some 'absolutely jaw-dropping' sequences which compensate for the 'stiff dialogue and standard sci-fi mumbo jumbo' (2001). The critical attacks on Aki and the film went straight for her face, with one reporter complaining that 'anyone hoping to be convinced by the female lead, Aki Ross, is likely to be disappointed ... Her skin and eyes look lifeless, and when she runs, her movements are somehow too smooth' (Mathieson 2001a: 2). Peter Travers' review in *Rolling Stone* is disappointed by the animation of human characters, the one aspect which the producers had hoped would attract no criticism:

> At first it's fun to watch the characters ... but then you notice a coldness in the eyes, a mechanical quality in the movements ... The dark backgrounds leave you with the deadening feeling you get after too many hours of playing cybergames. You miss something. It could be the joystick, the interaction. More likely, it's the human touch from those pesky actors. (2001)

If synthespians create a barrier to identificatory engagement with the audience, there is a potentially crippling flaw in any attempt to make them fulfil the function of human actor. The film's producer, Jun Aida, claimed that 'our goal was not to create photoreal characters. I don't think technically its possible with animation' (quoted in Mathieson 2001a: 2), though most viewers

were inspecting the film as if it was a precursor of the inevitable arrival of photorealistic humans. Roger Ebert found that Aki does not convince us that she is real, but 'we concede she is lifelike, which is the whole point. She has an eerie presence that is at once subtly unreal and yet convincing' (2001). *Box Office Online* critic Michael Tunison corroborated this with his view that *Final Fantasy*'s digital people were 'a little too eerily realistic to be interesting as animation and quite a bit too animated-looking to pass as real – an awkward middle ground that proves endlessly distracting' (2001). Sean Axmaker for the *Seattle Post-Intelligencer* adds that the film is 'rarely involving', citing the fact that 'a brave attempt to express subtle emotions in dramatic scenes is doomed by the limitations of the technology and the animator' (2001). There is a strong consensus amongst popular critics that the technology on display in *Final Fantasy* is not mature enough to engage the viewer without the limits of the technology becoming distracting.

We know from the way audiences have responded emotionally to characters in cel animated features such as those of Walt Disney, that there is no essential reason why emotional responses should be given exclusively to live actors (human or animal). This is not even a problem with computer-animated characters – many films, such as *Toy Story* (John Lasseter, 1995), *Shrek* (Andrew Adamson/Vicky Jenson, 2001) and *Monsters, Inc.* have successfully presented fully-developed, engaging CG characters in completely CG environments. The factors inhibiting the viewer's acceptance of the characters in *Final Fantasy* are, I believe, due to their uncanny humanness; occasionally the movements of the characters are so 'true' that the mind alternates, as in Todorov's conception of the Fantastic, between belief and disbelief in their reality, or rather, their indexicality, and this may not occur at a point of high drama or phantasmagoric implausibility. What was once an essential property of animation (it moves, it appears to live, but it is always distinguishable as a technical illusion) has suddenly become unsettling. The balance between the visibly false and the partially realistic has been upset.

Since the technology of digital imaging is in its infancy, much of the critical work regarding its performance has been speculative, attempting to predict the uses to which the equipment will be put. One suggestion has come from Barbara Creed, who heralds the dawn of the cyberstar or synthespian with a prediction that:

> Although a film, animation aside, has not yet been made with a computer-generated or virtual film star in the main role, this appears to be the future. (2000: 80)

One of the valuable questions Creed asks is how the simultaneous presences of the real and the virtual actor affect the spectator's relation to either one of them (2000: 82). The debate which ensues is indicatively speculative of the possibility of the synthespian, and it has become apparent that theorists are so caught up in the imminence of the arrival of digitised humans and the ontological repercussions that the question is never raised as to why it seems so definite in the first place. Is there any use for synthespians in lead acting roles other than for the technological novelty value, as seen in *Final Fantasy*? Aki Ross is a fictional *character*. She is no more real than Disney's rendition of Snow White, an animated apparition. She will not appear in other films playing a different role. The confusion over the definition of a highly-detailed, verisimilar animation and an autonomous, artificially intelligent animation is tangible in discussions of CG characters, but I would argue that the synthespian represents a contemporary manifestation of the Frankenstein myth, embodying our own fear of replication and obsolescence, our replacement by digital constructs capable of outstripping our every capability and nuance.

If it is to stand comparison with its human referent, our synthespian template can be placed into studies of human stars to test how it performs relatively. According to Richard Dyer, star studies are divisible into the sociological (the film industry needs to have stars with broad appeal) and the semiotic (stars are of significance only because they are in films and are part of the way films signify). He argues that stars must be studied semiotically because they only exist, sociologically speaking, within certain texts (films, magazines, advertising) (see 1998: 1). A synthespian *only* exists in media – there is no personal side of the star to obscure semiotic studies, but it may be the case that the story of a virtual actor's creation can provide a form of biography, with tales of motion capture and texture mapping filling in for the lack of romantic or personal back-story.

Mary Flanagan finds a precedent for virtual stardom with the beginnings of the star system after about 1907, when curiosity about the private lives and extra-filmic activities of picture players grew amongst audiences. Not only did this grant confirmation of audience interest in the 'backstage' areas of film production, but it also proved the bankability of film celebrities and the systems which emerged to promote them by using information from their personal lives to stimulate public interest, facilitating the viewer's simultaneous identification with the performer and the character being portrayed:

> The star system evolved as an important component in the development of
> the information age by blurring distinctions between the personal and the

private. Technology-bound, technologically determined, both digital stars and cinema stars were birthed in an environment of spectacle. (1999: 80)

For Flanagan, Theda Bara's emergence as the first sex symbol 'stems from her construction as a persona without a fixed history. A key factor in her design as a sex symbol was the mystification of her true, "'authentic" identity' (1999: 81). A fictional history was created for her by Fox studios to accompany each film role she played, turning her personal biography, however factitious, into a component of the viewing experience.

Hortense Powdermaker outlines some advantages of the star system:

> The star has tangible features which can be advertised and marketed ... The system provides a formula easy to understand and has made the production of movies seem more like just another business. The use of this formula may serve also to protect executives from talent and having to pay too much attention to such intangibles as the quality of a story or of acting. Here is a standardised product which they can understand, which can be advertised and sold, and which not only they, but also banks and exhibitors, regard as insurance for large profits... (1950: 228–9)

If a star's success is manufactured by a major studio, planting press reports and manipulating sections of the media to promote its interests, we can see a synthespian as the logical extension of an industry that has developed, over decades, the art of manufacturing star images: the replacement of the actual, physical star body with a digital construct is a minor detail because the rest of the manufacturing process is still the same. Edgar Morin, after Carl Laemmle, says that 'the star system is first of all fabrication', and calls the star 'merchandise destined for mass consumption' (1960: 134–5). In assessing the connection between stars and guarantees of a film's financial success, Francesco Alberoni says that the star system does not create a star as such, 'but it proposes the candidate for "election" and helps to retain the favour of the "electors"' (1972: 93). He discounts the suggestion that a human star can be entirely fabricated to ensure success. Studios can only approximate audience desires when constructing a star, leading them to conglomerate those attributes which they feel have carried a level of appeal across a selection of star bodies. The synthespians examined so far are frequently pieced together from attributes gleaned from a variety of human referents – the motion capture data of one performer, the voice of another, facial features based on aggregates of beauty or anatomical studies, for example. Stars are constructed within ideo-

logical boundaries but, says Dyer:

> Because stars have an existence in the world independent of their screen/'fiction' appearances, it is possible to believe (with for instance ideas about the close-up revealing the soul, etc.) that as people they are more real than characters in stories. This means that they serve to disguise the fact that they are just as much produced images, constructed personalities as 'characters' are. Thus the value embodied by a star is as it were harder to reject as 'impossible' or 'false', because the star's existence guarantees the existence of the value s/he embodies. (1998: 20)

Might this mean that the synthespian can readily be dismissed as 'false' because it lacks the depth of personal experience independent of the hard drive from whence it came? Might this go some way towards explaining the criticisms levelled at the 'acting' of Aki Ross?

Describing the value he found in the emotive capabilities of an actor, whose use of facial expressions to denote a particular emotion could produce a corresponding, emotionally imitative effect in the viewer, Sergei Eisenstein noted that 'the whole process of the actor's movement is organised with the aim of facilitating the imitative capacities of the audience' (1997: 27). This stimulus to imitation provided by a performer's expression is not the same as method acting, whereby the emotion of the fictional character arises directly from the emotional state of the performer. Eisenstein stresses that acted movements are purely mechanical, 'achieved by the artificial mechanical setting in motion of the body as a whole' (1997: 30). A performance becomes an articulation of an idea, which can use the human face as a particularly effective tool of attraction to achieve a reaction in the viewer.[7] Can this be compared to the synthespian, where a character can be programmed to produce a performance by imitation of the mechanics of a movement? Can the audience detect when an emotion is not real, when the character has no 'soul' and is just miming the motions associated with that feeling? Possibly not, but it is interesting that critics of synthespian performances display resistance to feeling emotionally involved with a computer-generated human specimen by reaching for abstract terms like 'human touch' or 'soullessness'. The work of Sherry Turkle has consistently been concerned with analysing human interactions with computers, producing fascinating insights into the way humans feel compelled to respond to these electronic devices. She notes that 'discussion about computers becomes charged with feelings about what is special about people: their creativity, their sensuality, their pain and pleasure' (1984: 281). She continues:

Because they stand on the line between mind and not mind, between life and not-life, computers excite reflection about the nature of mind and the nature of life. They provoke us to think about who we are. They challenge our ideas about what it is to be human, to think and feel. They present us with more than a challenge. They present us with an affront, because they hold up a new mirror in which mind is reflected as machine. (1984: 320)

The imagining of computer intelligence, I will argue, has a strong bearing on the creation and circulation of virtual actors.

Synthespians and computer consciousness

Alan Mathison Turing (1912–1954) imagined a 'universal machine' which would perform a range of tasks that might previously have required the construction of several separate specialised machines. We can see this coming to pass in the poly-utilitary personal computer (PC), but in positing the idea that a computer could respond to a variety of requests and adapt its operations accordingly, Turing was beginning to question the possibility and necessity of intelligent machines. A computer interprets symbols in order to understand them, much as a human organism will process environmental information in order to interpret her surroundings. If a human is taking in information which can be represented as tabulated data and fed into a computer, then there is a clear comparison between the computational aspect of the human brain and the interpretative capabilities of a computer.[8]

Turing devised a test for detecting the presence of machine intelligence. For a computer to pass the Turing test, a set of questions is put to both a machine and a human. An examiner should not be able to discern which set of answers was produced by the computer.[9] Turing predicted that computers would have the capacity for a 30 per cent success rate by the year 2000, but so far no computer has passed (Wood 2000: xxiii).

First proposed in the paper 'Computing Machinery and Intelligence' published in *Mind* in 1950, the Turing test was considered a good criterion for defining intelligence because 'if the computer were able to give sufficiently humanlike responses to resist identification in such circumstances, then it would be quite gratuitous to deny that it was behaving intelligently, irrespective of its alleged lack of a soul, an inner perspective, consciousness, or whatever' (Millican 1996: 2).

The test is still a useful point of entry for discussions of machine intelligence, but many computer scientists now question the worth of the test's

potential results, partly because it sets an impossible standard by making idiosyncratic human cognition the benchmark rather than allowing computers a distinctive identity. The article has been treated more as a philosophical conundrum than a technical goal. The basis of the test's effectiveness, says Robert M. French is the belief that 'whatever *acts* sufficiently intelligent *is* sufficiently intelligent' (1996: 12). French takes issue with Hubert L. Dreyfus's claim that the Turing test was the ideal way to create 'thinking machines' and believes that it provides a guarantee 'not of intelligence but of culturally-oriented *human* intelligence', stressing the need not for a test but a *theory* of intelligence (Dreyfus 1972: 73; French 1996: 12). A computer undergoing the test could be extremely intelligent, but would fail if it could not negotiate the kind of subcognitive questioning which humans find so easy to perform, and 'the computer will always be unmasked if it has not experienced the world as a human being has' (French 1996: 26). Nor does the test allow for gradations of intelligence – intelligence is either present or absent.

Turing outlined the bases of artificial intelligence (AI), the science of intelligent machines, in a lecture delivered to the London Mathematical Society on 20 February 1947 (reprinted in Carpenter & Doran 1986). In outlining the need for machines which can learn from experiences, he also argued that 'humanised interfaces are required to enable machines to adapt to people, so as to acquire knowledge tutorially' (see Michie 1996: 28). Turing's test required that a successful computer be able to process experiential data, to learn and develop as a persona rather than simply rearrange input data. Thus we can link the development of synthespians to artificial intelligence, which first attracted massive research funding in the 1950s.[10] At this point, great advances were predicted, and the new research environment attracted specialists in artificial intelligence, computer science, cognitive psychology and cybernetics.

As defined by Nadia Magnenat Thalmann and Daniel Thalmann, the three main requirements, aside from detailed graphical representation, for an autonomous simulated human are 'adaptation, perception and memory' (1994: 2). One reason for their suggested implementation in the entertainment industry is that 'in computer-generated films, the more autonomous behaviour that is built into the virtual humans, the less extra work there is to be done by the designer to create complete scenarios' (1994: 4). Autonomy brings with it a degree of unpredictability – a computer simulation's capacity for autonomous action depends upon its ability to generate responses which result from experientially-formulated thought processes which cannot be exactly predicted by the programmer (the alternative to this might be key frame animation, where all actions are plotted in advance). The virtual actor might therefore be

expected to exhibit randomised movements in order to pass as human, rather than as a pre-directed automaton. But even this is a culturally defined set of rules about how we might perceive the distinctions between human and machine. What would happen, for instance, if we did *not* expect a virtual actor to be mechanical in its movements? Would its ability to 'act' human still be a spectacular attraction (and therefore a commercial viability) once the distinctions between the two categories were erased, or do we need to recognise a special effect as distinct from its real-world referent?

As we examine the synthespian and consider the possibility of intelligent machines, it becomes clear that what is required is a shift in human perceptions of what qualifies as intelligence. Artificial intelligence still clings to many of the parameters laid out by Turing. The Turing test, which N. Katherine Hayles terms 'the inaugural moment of the computer age' is a point at which 'the erasure of embodiment is performed so that "intelligence" becomes a property of the formal manipulation of informational patterns rather than enaction in the human life-world' (1999: 11). She also urges us to think of the test as a magic trick, since it relies on:

> ...getting you to accept at an early stage assumptions that will determine how you interpret what you see later. The important intervention comes not when you try to determine which is the man, the woman, or the machine. Rather, the important intervention comes much earlier, when the test puts you into a cybernetic circuit that splices your will, desire, and perception into a distributed cognitive system in which represented bodies are joined with enacted bodies through mutating and flexible machine interfaces. (1999: 14)

The test implies that the appearance of intelligence, the ability to simulate intelligent responses, is an important step in computer development – it is not so much a question of whether or not the computer can produce truly reasoned responses as it is a test of the computer's ability to manufacture a performance. If we can apply this to a synthespian, a computerised actor (with animators, voice artists, motion capture performers) is attempting to give an approximate sense that it might be human, to create the conditions under which a tester/spectator might be given cause to doubt the synthetic nature of the animated character. Like Todorov's definition of the fantastic, Jentsch's Uncanny or the magician's combination of impossible events and rational methods, the Turing test hinges on a wavering between a belief or disbelief in the humanity of the computer subject—Turing stipulates that a computer can be considered intelligent if it can fool the tester 70 per cent of the time.

Eric Dietrich, in putting forth the question of machine consciousness as 'the most difficult problem in all of science' (2001: 177) has argued that a human being's inherent Cartesian intuition prevents the acceptance of a computer as conscious. Based on Descartes' idea of human duality, which separates human from animal and machine, this intuition 'renders all physical, material explanations of consciousness completely unconvincing' (2001: 178). Cartesian intuition is also that which suggests that our sensory engagement with the world is somehow removed from our physical actuality.

In May 2001, Dietrich was part of a colloquium on machine consciousness which assembled philosophers, neuroscientists, psychologists, AI scientists and engineers to discuss the issue of machine consciousness. He found it inconclusive and by the end they were left with the problem that 'for any suggested physical realisation of consciousness, *P*, it was always possible to imagine *P* occurring in some brain or computer without consciousness thereby occurring' (2001: 177). Dietrich is suggesting that there is always a mental block which prevents us from imagining a machine to be conscious – no wonder then that we grapple with this problem by fetishising the digital image, luxuriating in its simulated surfaces and textures but unable to fully believe in its presence.

In 1950, Turing proclaimed: 'I believe that at the end of the century the use of words and general educated opinion will have altered so much that one will be able to speak of machines thinking without expecting to be contradicted' (Turing quoted in Agar 2001: 126). He had no time for theological arguments against machine intelligence, and deficiencies which he saw in AI were problems stemming from human interpretations of what constituted intelligence. In 1949 Dr G. Jefferson, whose oration 'Mind of Mechanical Man' had been published in the *British Medical Journal*, argued that computers could express simulacra of true feelings, but were just displaying contrived versions of real emotion. For Turing, this could be a solipsistic debate – how do we know that other humans really feel? They could just be a simulacrum of the real world with no real emotions, simply putting up the automated appearances of feeling. CGI is entirely automated appearance. If Aki Ross gives us the appearance of grief (and the story certainly contrives that she is required to endure a series of extreme emotions), we want to believe it is real because this is the basis of cinematic representation and performance – an actor pretends to feel something on the understanding that we, the viewers, will respond accordingly.

Artificial Life (AL) refers to the simulation of biological forms by computer, usually used to recreate 'biological phenomena' which can then be studied in a virtual environment (Thalmann & Thalmann 1994: xi). Behavioural artificial

life (Alife) is the simulation of 'processes which result from consciousness and emotions' (ibid.). Behaviour is a consequence of biological life, a response to one's environment, and can therefore, to an extent, be similarly simulated. Just as giving virtual biological forms the actions which their real-world equivalents would possess enables their accurate replication of biological processes, so the endowment of virtual humans with emotional behavioural reflexes will enable them to simulate emotional processes. The digital human is clearly handicapped by its inability to absorb the same level of real-world experience to inform its future actions as a biological human is able to do. What the virtual human gives is a *performance*, a simulation of emotional response based on the input correlations between bodily and facial expressions and accompanying emotions. We can compare this to method acting, where a performative state is reached by drawing upon emotional memories or perceived emotional memories, but the method actor is expected to actually *feel* the same emotional sensations as the character. There may always be a philosophical debate over whether or not a digital simulation, however accurately it can mimic the external signs of a feeling, can truly feel.

Steven Spielberg's *A.I. Artificial Intelligence* (2001) contributes to this debate by posing questions of subjectivity and spectatorial empathy. The project was initially developed by Stanley Kubrick in the late 1970s (he was alleged to have been envious of the success of *Star Wars*, and wanted to make another science fiction film), inspired by the short story *Super Toys Last All Summer Long* (1969) by Brian Aldiss. Following Kubrick's death in 1999, Spielberg completed the film based on communications and discussions the two of them had been conducting. *A.I.* is a futuristic retelling of the story of Pinocchio – David (Haley Joel Osment), a newly-developed humanoid ('mecha') robot child is given to a couple whose own biological ('orga') son is in a perpetual vegetative state. David has been programmed to love eternally and unconditionally, but when his 'orga' brother makes a sudden recovery and is returned to the family, he suffers in comparison, unable to fit into the family unit. Treated ever more like a faulty household appliance, David is abandoned and left to fend for himself in a society where mecha are treated as second-class citizens, and embarks on a journey to find the mythical blue fairy (he is actually following a trail of clues designed to lead him back to the laboratory where he was created), convinced that he can be made into a 'real boy' and thus deserve his human mother's love again.

The effectiveness of this sentimental subject matter, typical though it is of Spielberg's interest in the plight of outsiders and the impact of otherworldly events on the family unit (as in *Close Encounters of the Third Kind* (1977), *E.T.*,

A 'mecha' reveals her innermost secrets in *A.I. Artificial Intelligence* (2001)

War of the Worlds (2005)), depends entirely on whether or not the viewer can feel any sympathy with a machine, albeit one which professes to feel real emotions (because it has been programmed to say so). David, played by a human actor, is more realistic than other mecha, and is so well developed that his simulacrous appearance is troubling to his foster parents, who find it difficult to treat him as they are accustomed to treating robots ('He just looks so real!'), and when he is brought up for execution at a human supremacist 'flesh fair', where robots are destroyed publicly to reassert the natural order of organisms, the crowd is shocked by his pleas for mercy and calls for his release. Other robots look like robots should, with their visible circuitry (rendered on film using a combination of animatronic models and digitally-augmented actors), but David's emotional and physical resemblance to a real child causes a problematic moment of fantastic hesitation in the spectators at the executions.

After eating some spinach, David's (Haley Joel Osment) face melts out of shape

Similar responses are elicited from viewers of the film in a series of shock moments when human bodies are rendered machinic. A woman's face suddenly splits open to reveal the mechanical workings within; David malfunctions and his face contorts grotesquely out of shape. These effects are achieved in unbroken shots – the lack of cutaways makes it difficult to distinguish between the human and technological performances, a distinction which is always much easier to make when they are separated into discrete shot units. Such tactics mean that the visual effects, rather than merely adorning the narrative in a decorative fashion, strengthen the film's theme of blurred ontologies.

For viewers of the film, it is equally difficult to separate our awareness that David is a machine from our emotional reaction to his protracted torment and, furthermore, from our knowledge that David is a fictional character in a film – there are two levels of performance, each demanding an assessment of the veracity of the other. By keeping David's story within the confines of a linear quest narrative, Spielberg aims to bypass Cartesian intuition to provoke an emotional reaction from a character who, upon deeper consideration, could be seen to be undeserving of such attention; the film makes it difficult to dismiss David as a mere microprocessor, but is only able to do so through emotional appeals delivered by an actor we know to be human.

Scott Bukatman's 'terminal identity' sees subjectivity dissolving to be re-situated within the most postmodern of spaces, the screen. The boundaries between human and machine are similarly eroded, leaving us with a science fiction which explores not only the role of the computer but the place of the body within and without the machine (cyborgs, androids and so on). He argues that the invisibility of computer technologies makes them 'less susceptible to representation', so have we reached a point where we need to see, to visualise, thus resulting in the creation of the synthespian as the ultimate anthropomorphisation of a technology which actually acts only as a rapidly crunched series of binary sequences? (1993: 2). Though the workings of the machinery itself are perceptible to the human eye, computer monitors have been made to communicate pictorially with the user. Bukatman asks 'what relevance can "humanised technology" retain in an era of blurred ontologies? Technology and the human are no longer so dichotomous' (1993: 5).

Using a Graphical User Interface (GUI) such as Microsoft Windows enables the negotiation of various representations of compartmentalised virtual spaces which can be collapsed, stored and overlapped, and these are 'precursive conceptualisations needed for realising VEs [*virtual environments*]' (Hillis 1999: 30). The GUI of the computer screen features a pictorial representation of the inner workings of the machine, rendered more aesthetically pleasing

and semiotically comprehensible to the user. Virtual reality was initially seen as working towards a simulated environment indistinguishable from the physical world, based on the same physical characteristics. As Hillis puts it, 'VR is a technological reproduction of the process of perceiving the real'; cyberspace is information spatialised rather than communicated through a monitor or telephone (1999: xiv).

Hayles sees the encroachment of digital information into our cultural lives (in CGI, for example) as a move towards virtuality, when digital is favoured over analogue. There is less reliance on physical presence, more emphasis on abstract data. Internet users 'engage in virtual experiences enacting a division between the material body that exists on one side of the screen and the computer simulacra that seem to create a space inside the screen' (1999: 20).

Once again, therefore, we find special effects being used as a representational tool for displaying and thematising the concepts behind a popular scientific preoccupation. The computer generated object, endlessly malleable, replicable and indestructible, is tied conceptually to the abstracted image we have of computers as a form of technology too intangible to be knowable, and therefore untrustworthy. The concept of the synthespian embodies fears of usurpation, but, in its current form, its capacities stunted reassuringly by the technological boundaries, it remains the most controllable visualisation of computer intelligence, existing as it does in the form of virtual starlets, computer game sprites and marketing attractions – all forms in which the 'robot' is subjugated by its context, clasped in the stasis of familiar, gendered, humanly-constructed roles.

In keeping with the pseudo-science fictional theme, we can speculate that for the synthespian to be insinuated into the standard arsenal of the Hollywood filmmaker (assuming that this is the industrial base most desirous of such developments), not only will the technology behind the creation and animation of these digital personae have to progress far beyond its current capacities, but there will also need to be a paradigm shift in our perceptions of machine intelligence. Over centuries, machines have gradually become our assistants, our counterparts, saving labour and helping us to industrialise, produce and expand. The granting of autonomy to those who are traditionally servile would represent a major societal shift, and will not come easily. Until computers are granted or attain for themselves a level of intelligence and unpredictability, the synthespian will not transcend its role as digital stand-in or uncanny curiosity, and will remain disruptive, *special* effects. The scientific and philosophical conundrums which have occupied computer scientists and neuroscientists for decades will enter the public domain as celebrity gossip,

rumour and hearsay. Once the digital construct has autonomy, public interest will be sufficiently piqued to inquire about the life of a digital performer outside the film it appears in. Can it really feel? Does it have a partner? Which other celebrities does it most admire? The popularisation of the synthespian is essential to its survival as long as it remains massively expensive to produce, but it is the predictions of its imminence which provide the mythologisation needed to make it desirable.

The contention that a special effect incites wonder at three levels – *diegetic*, *intertextual* and *speculative* – was noted earlier. With this idea in mind this chapter will end by considering some digital characters in their filmic contexts, and how they function to portray diegetic events while simultaneously urging the spectator to consider their artificial make-up.

Digital superheroes

If the synthespian has not gained prominence in a 'pure' form, replacing human actors in normal dramatic roles, this is not to say that virtual performance has not found a cinematic space in which to operate. Perhaps most important of all these spaces has been the one occupied by comic-book adaptations in which the transformed superheroic body is enacted with recourse to digital effects.

In Sam Raimi's *Spider-Man* (2002), *Spider-Man 2* (2004) and *Spider-Man 3* (2007), Tobey Maguire plays Peter Parker, an aspiring photo-journalist whose genetic identity has been radically altered following a bite from a genetically-modified spider. His body becomes preternaturally strong and agile, and he emits webbing from his wrists, enabling him to swing from tall buildings or capture criminals in a super-adhesive binding. Realising that his new powers oblige him to help the less empowered, Parker makes Spider-Man his official alter ego, a costumed emblem of his commitment to fighting crime. The character of Spider-Man was created for Marvel Comics by Stan Lee and Steve Ditko in 1962, and the changes which he has undergone in his transition to the screen can be seen as reflective of the technology employed in that adaptation.

Especially controversial amongst some staunch adherents of the comic-book franchise, was the jettisoning of Spider-Man's mechanical, home-made web-slinging devices; instead, Parker secretes the web fluid from what must be newly opened spinneret glands in his wrists. Initially, this is a quasi-ejaculatory involuntary reflex, but as he matures and masters his redesigned body, the web comes under his control and can be deployed at will and with precision. The organicisation of Spider-Man's weaponry is partly linked to the

demands of perceptual realism, requiring that computer-generated objects be matched by a level of solid plausibility, but it also marks his abilities out as bodily growths rather than exercises in engineering skill. Atomic radiation was a staple excuse for all kinds of otherwise inexplicable mutations in science fiction in the middle decades of the twentieth century – by the time *Spider-Man* makes it to the screen, genetic engineering is the scientific paradigm underpinning the transformation, a site of great potential and, for the lay-viewer, semi-comprehensible specifics. If it seemed unlikely (in the comic book) that a teenage boy could design, without corporate or governmental sponsorship, a cyborgic enhancement of his own body enabling him to swing through metropolitan chasms with great ease and security, it was not impossible within the hyperbolic, framed environs of the comic strip. In making Spider-Man's powers the result of physical developments in his body rather than the mechanical properties of his suit or his equipment, the template is set out for an exploration of the organic constitution of the heroic body.

Batman, by contrast, in all his incarnations, derives his capabilities entirely from gadgets, vehicles and appliances constructed by his billionaire alter ego, Bruce Wayne. For Tim Burton's films *Batman* (1989) and *Batman Returns* (1992), the hero becomes almost like a stage magician, with his dramatic entrances and exits managed with hidden gizmos, tricks and traps, emphasising his spectacular power over his otherwise human physique. Burton uses old-fashioned techniques such as forced perspective miniatures and extensive model-work in displaying Batman's choreographed rescue sequences. For Christopher Nolan's reconfiguration of the franchise, *Batman Begins* (2005), it seems to have been a deliberate decision to minimise the use of CGI, particularly in relation to bodies in motion. Spider-Man's body is affected not by the externally imposed forces of radioactive mutation, but by molecular and genetic twists from within his own person, just as his depiction is allowed not by mechanical apparatus so much as by configurations of pixels. His emergence as a superhero is made analogous to his post-pubescent move into adulthood, and the consolidation of his superheroic identity as a set of practices (that is, those abilities which define him by what he is able to *do* or not do, perhaps in opposition to other superheroes or villains) is matched extra-diegetically by the technologies deployed in his realisation onscreen. Principally, Spider-Man's super-body is achieved through a combination of be-suited stuntwork and computer-generated performance. It is fair to say that a large proportion, perhaps even a majority of Spider-Man's action sequences are performed by a digital double. The result is a spectacular foregrounding of virtual acting, in which Parker's exploration of his abilities, and his struggle to reconcile his

The final shot of *Spider-Man* (2002)

everyday existence as a young man with the duties of a permanently altered *ubermensch*, is complemented by the image of computer technologies facing similar challenges in their task of representing near-impossible heroic deeds in a perceptually realistic manner which approximates a human body to a convincing extent.[11] At the end of *Spider-Man*, even immediately after Peter Parker narrates the traumatic solipsism of being a superhero ('this is my gift. My curse') the image track presents an ecstatic, unbroken 30-second shot of Spider-Man swinging above, over and between the streets and towers of New York. This does not appear to be motivated by the narrative, other than to announce that Parker will continue in his vigilante masquerade, but serves rather as a discrete moment of kinetic spectacle; if he is travelling in a particular direction, on a particular mission, we are not told, permitting us instead to focus on digitised athleticism, both in terms of the acrobatics of the man himself, and in the fluid, vertiginous rendering of computer-augmented urban space. At another level, the seemingly continuous shot (no doubt actually assembled from numerous elements over a period of several weeks) offers a boastful divergence from the character's comic-strip origins – the action is not carved up

into a horizontal sequence of panels, and the comic reader's variable viewing speed is replaced by a dizzying, motion-controlled whirl.

Paul Verhoeven's *Hollow Man* (2000) is a remediation of the 'invisible man' story, stemming from H.G. Wells' 1897 novel. The story inspired James Whale's 1933 film version and a plethora of other films exploring its frightening or comic possibilities.[12] The basic concept of invisibility is a scientific 'possibility' which transforms the diegesis into a place of narrative potential (what will happen? How will the invisible character respond when granted this power?), but equally one of spectacular potential (what will it look like when it happens?). By sharing a premise with all of the other invisible man movies, *Hollow Man* is in intertextual dialogue with them, offering digitised variations on familiar narrative events. The spectator is aided through this terrain by a confederacy of extratextual information as delineated by Barbara Klinger's (1989) idea of 'digressions'. Themed menu screens on the DVD strengthen the connection between the film text and its correlative sub-texts, a gathering of behind-the-scenes promotional material used to market the film and establish expectations for it. The 'equipped' spectator will add the question 'what will *digital effects* make this look like when it happens?'

Verhoeven's film suggests that invisibility is inherently corrupting – an ambitious, self-centred scientist will become a voyeur, a rapist, a murderer when given the facility to do so unseen. Opportunity overrides morality. The concept of invisibility therefore establishes a set of possibilities, some of which are moral or social statements concerning the lengths to which Sebastian (Kevin Bacon) will go in exploring his powers, and others which are visual attractions about how he will interact with his environment. Out of 'invisibility' emerge a range of practical questions: how does an invisible man behave? What might reveal his presence (smoke, water, footprints, blood)? How might he interact with the visible environment in which he is placed? These practical concerns are matched by technical questions: how can the impression be given of a

Drenched in (other people's) blood, Sebastian Caine (Kevin Bacon) becomes partially visible in *Hollow Man* (2000)

character's invisibility? How might an unseen body be rendered spectacular? The conclusion must be that the spectator's interpretation and appreciation of the film text occurs not as a hermetically sealed set of startling images, but as a nexus of information which regulates expectations and aids an oscillatory relationship between diegetic and extra-diegetic material – the spectator can be helped to view the film as a self-contained story and a technological performance simultaneously.

As Norman M. Klein observed, in special effects movies the body can become 'a labyrinth of prosthetics', a playground of augmentation, distortion and mutation (2004: 228). *Hollow Man* sees Kevin Bacon's body transformed into a laboratory specimen, not just for the diegetic invisibility serum, but also for the digital rendering of the human body. As the serum courses through Caine's body, he is disappeared layer by layer. Long takes preserve the fluidity of the transformation, and the lack of cutaways implies its pro-filmic authenticity. Once invisible, Caine can only be seen when he comes into contact with other objects, liquids or gases. He is revealed when he passes through smoke, dives into water, or when one of his victims splashes him with the contents of the laboratory's blood bags. In these cases, the film becomes a playground for testing out the interactions between the body and its environment.

A documentary featurette on the DVD informs us that the animators at Sony Imageworks VFX studio were sent on university anatomy courses and attended autopsies. This information seems to have little bearing upon our comprehension of narrative information, but it certainly helps in the construction of a technological meta-text by enforcing certain connections between the film's visual effects (expertise, history, craft and science) while downplaying others (body-horror, for instance). It may be too early to fully appreciate how completely the DVD viewing context will alter the reception of film texts, except to say that this prescription of intertexts, pre-empting the textual connections which the spectator will make, is not simply in the category of 'added value' sometimes applied, but part of a broader attempt to monitor the consumption of visual illusions. Just as this book has argued that nineteenth-century magicians sought to aggrandise and commercialise their art by situating it in comparative, competitive and artisanal contexts, so the contemporary Hollywood film text uses the centrality of its illusions as a lynchpin through which to control the intertexts to which the film links.

It is rather excessive for Christopher Panzner (2005) to claim that comic-book movies such as *Hulk*, *X-Men*, *Spider-Man* and so on have been 'preparing our collective psyche for the leap to *Ubermensch*'; rather, they are helping the indulgence of fantasies of power in the absence of their imminent occurrence,

Sebastian Caine undertakes the first experiment in human invisibility in *Hollow Man*

with the digital body standing in for our selves as a surrogate corporealisation of such desire. Few films illustrate the co-ordination of special effects and thematised spectacular bodies as clearly as Ang Lee's adaptation of Marvel Comics' character 'The Hulk' (also devised by Stan Lee) for his 2003 film. As with *Spider-Man*, the experimental/accidental origins of the character have been updated, swapping exposure to gamma radiation to a more 'current' technological cocktail of nano-technology and radical genomics as the catalysts for transformation; Ang Lee had hired a scientific consultant, John Underkoffler, to come up with a 'plausible explanation' for the transformation of meek scientist Bruce Banner (Eric Bana) into a huge, green humanoid wrecking ball (see Beaumont 2003).

Hulk is not only a spectacular body by virtue of his being mutated/digital – he is also a detested body, an outcast grappling with the pain of his transformed existence. His questions to the world are ontological ones, just as his digital body always posits semi-subliminal questions about the constitution of a digital body. Indestructible and monosyllabic, Hulk was, according to Geoffrey O'Brien, 'the embodied spirit of comic books' suffering from 'a constant oscillation between intelligence without power and power without intelligence' (2003: 28). He is not a hero in the sense of being a pro-active guardian of particular moral values and codes of justice. He does not select a crime and fight it. Bruce Banner's transformations are prompted by the escalation of his pent-up anger to an uncontrollable degree, and the Hulk manifests this anger in bursts of relatively untrammelled destruction and fury. As such, when Banner becomes Hulk, we are distanced from his human identity by the lack of correspondence between their characters, and the emphasis is shifted from the emotional facets of his nature, and displaced onto the physical exertions of his body.

As with the final shot of *Spider-Man*, *Hulk* authenticates its central digital performance with long takes. Cornered after a rampage in San Francisco, and confronted by his true love Betty (Jennifer Connelly), Hulk transforms from his mighty alter ego back into Bruce Banner in a single shot that blends the divisions between the bodies of the CG character and actor Eric Bana. It plays like a magic trick, simulating the fascinated gaze of the theatrical spectator by

Hulk smashes: CG superhero, digitally modelled on motion capture data of the film's director, Ang Lee

avoiding disruptive cutaways and defying the spectator to discern the point at which Bana is substituted for the digital avatar. The unbroken shot cements an associative ligature between the real and synthetic characters in a succinct but startling manner. As with *Hollow Man*, the film serves up a series of set-piece tests of its lead character's physical properties. As he moves through sprinkler systems, desert sands, explosions and hails of bullets, procedural programming enables his skin to be caked in dust or bombarded with missiles; textures and surfaces, particle clouds and liquids are not drawn or animated pixel by pixel, but generated from algorithms which allow a degree of randomness into the digital elements. The results are at the level of large-scale splendour (explosions, combat) and simultaneous micro-spectacle (rippling skin surfaces).

Discussing the CGI Hulk, O'Brien has to compare it to its antecedents, but takes an unusual route:

> It was perhaps a mistake to show Hulk lifting up Betty in an image clearly derived from *King Kong*, as it underscores how much less emotionally compelling is this basically animated figure than his technically more primitive yet more touching ancestor. It continues to be the paradox of CGI that technical progress diminishes rather than enhances the sense of reality inhering in the image. In today's context *King Kong* looks like cinéma verité. (2003: 30)

Are these failings of emotional communication essential flaws in CGI, or are they dramatic weaknesses that we can pin on the filmmakers and actors? Can these questions be answered definitively, or are they matters of opinion? Certainly, the 'sense of reality' conveyed by *King Kong* was never a monolithic category, as evidenced by the critics who noted its Uncanny, surreal or fantastic qualities. Like those attacking *Final Fantasy*, O'Brien's critique of CGI 'acting' wants to tell us that a synthespian will have to do more than mimeograph the nuances of emotive signals if it is to engage an audience. If digital performers are always inherently unsympathetic, surely it is folly to place serious dramatic burdens onto their frames? The last case study of this chapter might offer more clues as to how and why synthespians might find a place in contemporary cinema.

The Lord of the Rings

Most of the films discussed in this book have based their spectacular attractions around a single brand – whatever else *Jurassic Park* offers, it is sold on the prominence of its dinosaurs; the superhero franchises are sold around the

visual properties of a central iconic figure. Peter Jackson's *Lord of the Rings* trilogy exhibits an aesthetic of surplus characterised by battle scenes extending to vanishing points, minutely detailed production design, and by extravagant juxtapositions of scale. The films constantly switch between panoramic and microscopic foci to achieve a combination of epic and intimate narrational strategies, but also use extended aerial and circling shots to link spaces and characters which might otherwise have been presented in separate shots. After being wounded in an attack by Ring Wraiths, Frodo (Elijah Wood) calls out for Gandalf (Ian McKellen). The next shot takes us to him, in a simulated aerial shot lasting almost a full minute, passing over a fortified wall, following the flight of a moth over Saruman's infernal mines and up the tower where Gandalf is imprisoned, tracking in to a close-up of his face until he grabs the moth in his hand. Most of the shot was achieved with a camera pass over an extensive miniature set augmented with computer-generated extras and moving mining equipment, flames and lighting. As the CG moth approaches Gandalf on the tower, a handover occurs between the digital Gandalf and McKellen himself, the barely-perceptible switch obscured by the flutter of wings. It is the surgical delicacy of these digital joins which helps to connect the spaces of the story as inhabitable locales, blending miniatures and live action into a consistent, spatio-temporal whole. While the close-up of a face traditionally conveys 'real', emotional information, the long shot is more often the domain of a special effects shot's presentation of a fantastic place. The combination of elements within the same frame is not new, but the compositional strategies used have been *intensified* to incorporate camera movements and unbroken shots – even if, in actual fact, the shot has been assembled from disparate sections – which bear the impression of continuous space.

One way in which the films' oscillations in scale can be illustrated is in relation to the array of digital bodies. The films present an amalgamation of effects techniques to show distant shots of enormous crowds and probing close-ups of artificial bodies, centred around the figure of Gollum. The tormented, degenerated alter ego of a hobbit named Sméagol, Gollum is too skeletal, too monstrous a figure to be performed by an actor in make-up (or, at least, his monstrousness offers the potential to exaggerate his Otherness by recreating him synthetically). He appears onscreen as an entirely computer-generated figure, but his performance is mapped onto that of actor Andy Serkis, who provided facial and bodily reference material and motion capture data which informed the movements and mannerisms of the digital Gollum. Various methods were employed to remove Serkis from the frame he shared with other actors, so that the CG body could be inserted in his place. For

some shots, actors would perform to empty spaces into which he could later be composited. At others, he would need to be painstakingly 'painted out' by digital animators. What is more interesting is what remains of Serkis in the finished film, and the lengths taken to ensure that the horrors of a digital character are tempered by an injection of 'humanity'. Serkis maintains prominent input by providing motion capture information, lending Gollum some of his motile inflections, leaving traces of some of his features in the design of the Gollum puppet, but also basing the CG expressions (which were animated using key frame techniques) on recordings of his interpretations of particular scenes, and by involving himself heavily in promotion for the film, iterating himself as a key member of the cast; in 2003 he wrote his own memoir of his work on *The Two Towers* (*The Lord of the Rings: Gollum: How We Made Movie Magic*), and the producers (perhaps with one eye on a marketing opportunity) lobbied for Serkis to receive an Academy Award nomination for Best Supporting Actor, but to no avail (see Askwith 2003).

The focus on the detail of Gollum's face, and on his visualisation as a 'performance' carries a micro-spectacular attraction, but it also plays out like a visual effects Turing test. The character's face, assembled from pixels and programming, forms the visemes that correspond to emotional cues for the spectator to interpret as evidence of emotional states, and even though these are the result of a machinic mimicry of Serkis's own face, the computer's ability to convey those effects is what renders them spectacular. Gollum's presence therefore turns simple dialogue scenes into special effects set-pieces, whereas visual effects might ordinarily be reserved for climactic narrative moments. In many scenes he is in violent conflict with his pro-filmic co-stars, dramatising narrative confrontations as well as intricate interactions between composited elements. For these to become spectacular scenes, rather than simply dramatic events, depends upon the spectator's knowledge that Gollum is a digital effect, putting the spectator into competition with the animators charged with the task of minimising the evidence of joinery between composited elements. Of course, the Turing test stands as a philosophical conundrum concerning machine intelligence and defining it against a human model, with intelligence being found only in machines capable of relating to the tester affectively. Gollum sets up a dynamic between transparent illusion and the technical apparatus behind it – we need to be persuaded that Gollum is alive in order to believe in him as a diegetic presence, but we also need to be aware of the performative aspects of the illusion.

Aside from the breakthrough integration of Gollum amongst live actors, Jackson's *Lord of the Rings* trilogy consolidated another spectacular image

Digital Gollum struggles with his pro-filmic co-stars in *The Lord of the Rings: The Two Towers* (2002)

in the cultural imagination: that of the serried ranks of computer-generated combatants charging into battles stretching from the foreground to the horizon. The CGI battle sequence has become one of the most prevalent visual clichés of the twenty-first century Hollywood blockbuster. The proprietary software attached to these sequences is Massive, which unleashes thousands of digital figures, each one carrying sufficient artificial intelligence to perform individuated actions and to give the impression of a cluttered mass rather than a patterned grid of activity. The software has been used for all three of Jackson's films, but also powers crowd scenes in *I, Robot* (Alex Proyas, 2004) and *The Chronicles of Narnia: The Lion, the Witch and the Wardrobe* (Andrew Adamson, 2005), as well as a series of advertisements, including one for Corona beer in which thousands of mariachis serenade the guards of the Great Wall of China, bearing more than a passing resemblance to the Battle of Helm's Deep from *The Two Towers*. In another advertisement (for Carlton draught), thousands of figures charge together while chanting a modified version of Orff's

Massive CG armies prepare to clash in *The Lord of the Rings: The Two Towers*

'Carmina Burana', again playing off memories of battles in valleys in *The Return of the King*.[13] Whether or not audiences connect these disparately placed scenes through the software which was used to build them all, each instance repeats several characteristics – overhead or aerial shots to emphasise the expanse of the scene, and a dynamic blend of random and co-ordinated action; in the Carlton commercial, the crowds form into a series of animated pictures, while still lacking a machinic level of precise synchronicity.

This software means that crowd scenes need not be staged with thousands of extras, but can be generated automatically on a computer. Each 'agent' in the crowd carries a library of motion capture data that allows it to move with convincing human gait, but those movements are governed by procedures to allow the agent to react to its surroundings, clash with the nearest enemy, avoid collisions or tumble to the ground. It is the addition of elements of chance to the visual effect which seems to offer a shift away from the electronically-inflected 'wonder years' aesthetic attributed by Michele Pierson to those effects which exhibited electronic properties (2002: 131). It seems, though, that rather than shaking off the traces of their electronic origins, Massive sequences simply shift the boundaries of what constitutes 'electronicness'. If the electronic once connoted rigid formalism or straight-edged, chunky graphics, now we need to recognise the abilities of CGI to *perform* the characteristics of organic bodies. The computer's capacity to regulate thousands of individual agents is a property of its electronic nature, a symptom of the multi-functional, procedural prowess of the central processing unit. Its ability to run software capable of organising polygons into anthropomorphic forms that conceal their origins as data constitutes a *performance* of organic imagery, appealing to encultured notions of filmic space to trick the eye into accepting digital and 'real' elements as co-existent, filmed at the same time.

The surfeit of illusions in the *Lord of the Rings* films might seem like the result of necessity, with each effect being required by the episodic demands of an extensive narrative trek, but collectively they comprise an assembly of tricks, each one dynamised by its differentiation from the last, a vaudeville of artifice enhanced by the blend of 'old-fashioned' miniatures, matte paintings and in-camera forced perspectives with contemporary digital effects. It might also seem like narrative is essential to the trilogy anyway, and that such intricacies are only going to be appreciated by the most diligent and connoisseurial of viewers. This is true – any film can be treated with varying degrees of investment on the part of spectators, but Peter Jackson has made connoisseurship an integral part of the viewing experience, fostering what Pierson calls 'cultures of appreciation', engaging with film texts in ways which stretch

beyond simply following prescribed narrative pathways and character arcs (2002: 3).

J. R. R. Tolkien's attention to lexicographic, linguistic, folkloric and ethno-graphic detail in his construction of Middle-Earth, the setting for the *Lord of the Rings* books, is well noted (Foster 1978; Fonstad 1981; Blackham 2006). Jackson paraphrases Tolkien's expansive topography with meticulous design and reiterative establishing shots that survey important spaces or home in on significant details, fetishistically mapping the spaces in which the story is situated. In the labyrinthine spaces of the DVD special editions, compiling 75 hours of audio-visual content and more than five thousand production stills on twelve discs, the films amass a navigable omnibus of intricate information. Surely so much extra-diegetic material should deplete the immersive sense of transparent realism expected of such close attention to detail? (See Gray 2006). It seems that these films exhibit what some nineteenth-century magicians had espoused much earlier – that the fascinated spectator is the involved spectator: the 'wow factor' can only sustain a certain level of interest, and it is the behind-the-scenes information which supplements and reinforces the technological meta-narrative that underpins all spectacular cinema.

CONCLUSION

The scene from *King Kong* which began this book hopefully still stands as a prime example of the themes which have preoccupied this study. The *King Kong* remake inspires spectatorial scrutiny, not just at the level of the shot, but also intertextually. It was always going to be judged in comparison to the original film and its subsequent imitators, but those intertexts connect not just thematically with other monster films, but also with films that share the technological bloodline of Kong. Its dinosaur action could recall *Jurassic Park*, might even aim to upstage it through sheer force of numbers (the literal pile-up of slip-sliding brontosauri must surely be a *reductio ad absurdum* of cinematic saurians), or might refer to the distant relation it shares with Winsor McCay throwing Gertie a pumpkin and interacting with the filmic world.

Most of Kong's motion capture data comes from actor Andy Serkis, and few viewers who had followed the film's pre-publicity trail would have been left unaware of his presence on the set. If they had followed the production diaries posted on the film's official website (www.kongisking.net), they may have accumulated more than five hours of backstage footage; committed fans may even have bought the DVD of the diaries, released before the film as a primer for the main feature, or read some of the books published just in time for the film's premiere (including Weta Workshop's *The World of Kong*, Jenny Wake's *The Making of King Kong* and Christopher Golden's official novelisation). Amidst all of these textual fragments which inform, influence and craft a particular reading of the film, 'readers' would have been likely to encounter

Footage of a motion capture test producing a CG Kong mask from actor Andy Serkis's facial movements, taken from the *King Kong* post-production diaries included on the DVD release

backstage footage of Serkis performing Kong's facial expressions (sometimes called 'facial capture'), with over a hundred markers on his face (in contrast, expressions for Gollum were sculpted by hand, mimicked from footage of the actor). Bill Desowitz (2005b) reports that only about a quarter of Kong's facial animation was performed by Serkis, but the insinuation of human agency is an important factor in selling Kong as creature not computation. Serkis provides an intertextual link to his performance as Gollum in the *Lord of the Rings* films, marking this specialist set of technologies with the cachet of a distinctively authored performance. As a result, Kong's palimpsestic essence, a digital chassis laid over a human undercarriage, benefits from the vestiges of that humanness. In this way, the troubling countenance of machinery, which might otherwise obstruct the affective relationship between character and spectator, is offset. Jackson's film seems like an exercise in emotionalising a digital effect by having it perform a punishing series of challenges before being martyred atop the Empire State Building. The slack-jawed fascination of the ethno-tourists, who fail to acknowledge Kong's soulful individuality in the New York stage show where he is chained, and who gather to ogle his demolished corpse, are contrasted explicitly with Ann Darrow, with whom he has formed a unique empathetic bond high above the streets of rubber-necking crowds.

For all its overt body-spectacle, Jackson's *King Kong* marks a point of convergence between physical performance, visual effects and animation. Whether it constitutes the arrival of a top-billed, fully integrated virtual actor, or whether it relies too heavily on live performance, key frame animation or an insufficiently *human* star to qualify for the title of 'Holy Grail' seems somewhat less than important at this stage. The digital Kong, through its technological and intertextual links to earlier 'rituals of incarnation' excites not because it is a final word, the culmination of various developmental strands, but because it looks back upon its intertextual predecessors to posit itself as a

source of *comparative* wonder, even as it purports to present unprecedented, futuristic visions.

This book has located and demonstrated correlations between science and art in special effects. We can see the regular resurfacing of special effects as a representational strategy for communicating complex (or even invisible) scientific concepts to a popular audience. The Victorian magic show made scientific principles entertaining (rather than mysterious and frightening), and at the same time demanded a kind of inquisitive response to spectacle that required the spectator to scrutinise a scene for the rational means behind amazing appearances. Stop-motion animation could provide moving images of extinct life forms and was an extension of logical (as opposed to fantastic) methods of representing them. Alien invasion and space exploration films of the 1950s were awash with ambiguity and confusion in their special effects displays while public fear of technology (and the institutions controlling it) was at its most hysterical – the highest budgets were spent on aggrandisements of technological development, the Space Race and the military establishment (which stood to gain most from both), while low-budget exploitation films effected a rejection of such associations by presenting diminutions of their cherished machines. CGI developed from a visualisation of mathematical data towards a greater representational familiarity, imitating more organic forms and figures. Synthespians and complex CGI creatures are an extension of forays into artificial life, a fascination with computer consciousness, the usurpation of the analogue by the digital, and the dissolution of an anthropocentric society. The quest for a synthetic actor is not simply the logical outcome of incremental steps towards realist aesthetic goals. It is an experiment with the limits of representation.

Critical assessments, and presumably, assessments made by the general audience, of the quality and substance of particular uses of special effects have tended to be answers to the question 'how realistic are they?' rather than 'what kind of aesthetic sense do they make within the diegesis?' This is not necessarily a problematic reaction. The technologised forgery of real-world referents offers an attraction in itself, and its deployment within fictional media offers a safe containment of those technologies that continually thwarts attempts at total illusionism. The more verisimilar digital effects can become, the more access to backstage information the associated multimedia allows. Digital graphics developments have been matched by viewing technologies which allow ownership of film texts, close inspection, fragmentation and deconstruction. George Lucas's *Star Wars* prequels (1999, 2002, 2005) and Peter Jackson's trilogy of film adaptations of Tolkien's *The Lord of the Rings* (*The*

Fellowship of the Ring (2001), *The Two Towers* (2002), *The Return of the King* (2003)) have been developed with an unprecedented degree of backstage access via officially-sanctioned websites (www.starwars.com/www.lotr.com), displaying production stills, designs, storyboards, interviews with cast and crew, preview footage and news reports. This promotional outlet inscribes the film as a constructed text inseparable from the processes which have effected its visualisation. The inclusion of these and other materials on DVD creates an even greater proximity between the text and its manufacture. The offer of audio commentaries by cast, crew, director or producer directs the spectatorial gaze towards a reading of the text in line with the one favoured by those who created it, but is also a chance to point out flaws, on-set anecdotes and technical details synchronised with a repeat viewing of the film. The clarity of the images on a DVD recording, far superior to VHS tape, enables freeze- frame, slow motion, scene access, zoom functions – a greater opportunity to inspect and scrutinise the structure of scenes and compositions. DVDs frequently include pre-visualisations (basic 3-D, real-time digital storyboards to block out a scene prior to shooting) and rough cuts of scenes. For *Jurassic Park*'s DVD release, this involved two-dimensional storyboards and three-dimensional test versions of key action sequences, identical in composition and construction to the finished scenes, using stop-motion clay dinosaurs and plastic dolls, thus providing a comparative showcase for innovative CGI next to the aged 'handmade' approach to animation. On *Star Wars Episode I: The Phantom Menace*, digital animatics show low-resolution test footage of CG models and animations. Even if the finished products included wholly imperceptible illusions (and they do not), the proliferation of extratextual materials would guide the spectator towards an awareness of their construction.

In this way, the template for illusory aesthetics established in Victorian magic theatre still holds true. The most engaged spectator (and therefore the one who will represent repeat business) is the one who is always aware that she is being tricked, perhaps has partial knowledge of how that trick is being effected, but who wishes to see *how* that trick *looks* when performed. Special effects operate in the same way, requiring an engagement with the technique as well as the appearance of an illusion, and by granting extratextual knowledge to the viewer, the use of specific techniques can come to possess meaning.

Absolute simulation is simply not desirable or economically supportable as long as we live in an anthropocentric world which favours the human as the ultimate example of the real, and the greatest challenge for simulation. What is being moved towards is not a replacement of the human by its simulacrum but a convergence, an interdependence between the human and the

machine, the digital and the analogue, the real and the simulated. The synthespian shows how, in the field of AI, reality itself is under inspection – there are attempts to assess the differences between the real and its representation. The digital image, as opposed to the photochemically-produced indexical image, is closer to our own viewing experience than any other, because it carries with it a need to question the veracity of what is seen, and, consequently, it forces the spectator into a position of interpretation rather than passive acceptance of the photograph's supposedly inherent truths. The digital age is not forcing a new era of disembodied imagery – it is reflecting the fact that information, data and encoded imagery are firmly embedded in media already. As for the plea that the 'waning of the indexical' produces untrustworthy images, simulations which cannot be used as proof of presence, this might finally dissolve the truth claims which have been misplaced on a medium which could always be manipulated to create ideological cues or outright fabrication according to the desire of the filmmakers.

Special effects have, in the cases listed in this work, fulfilled a series of pre-visualisations of promised technological manifestations. By facilitating the magic trick's spectacular narrativisation of scientific mechanisms, by conjuring approximate representations of dinosauric beasts before the techniques of fossil reconstruction were fully developed, by presenting images of space travel and lunar exploration before the full-scale rocketships could match such achievements, by providing a visual lexicon of cyberspace and posthuman virtual embodiment, cinematic visual illusions have supplied visions of popular science's 'forthcoming attractions'. In doing so, they may have contributed to a belief that future technological developments are a foregone conclusion. Like all futurologies, though, the predictions must be seen as extrapolations of the current 'state-of-the-art', and therefore need to be acknowledged as malleable in favour of certain ideological or cultural expectations.

In certain cases, such as the regressive spectacles of the flying saucer B-movie or the anti-realistic, oneiric qualities of Willis O'Brien's stop-motion animation, withdrawal from the expected aggrandisement of the technologised future provide the spectator with alternatives to deterministic conceptions of technology. In the case of the synthespian, whose perfection is unattainable but presented in the form of convincing digital puppetry, we can see such mythologised futurological imagery in its most uncanny format, but we need not be fooled by its attractive surface once we understand the enduring illusionistic concepts at work behind the scenes. Being firmly situated in the transitional phase between a technology's initial development and its popular adoption and proliferation, special effects are bound by a need to be appar-

ently innovative (while actually being more like a public relations division of, for instance, independently developed computer graphics applications) and the requirement that they remain visible. The unwritten codes of realistic illusionism might brand hyperreality and indetectibility as transgressions, disavowing as they do the spectator's ability to discern the trick. The need for special effects to have a history of 'inferior' precedents and future goals shows how visual illusions can be situated in the space similarly occupied by new or partial technologies (AI, genetic engineering, cybernetics) which are at a stage where they are unfamiliar enough to appear magically spectacular before their assimilation with all that is ordinarily visible.

Most importantly, special effects perform. They do not just sustain and facilitate the narrative journeys that films routinely make. They do not sit quietly and await our inspection. Instead, they push to the front of the stage, instilling those narratives with their own spectacular agenda. Appreciating this aspect of cinema requires us to understand the nature of these performances, to remain active participants in the interplay of trickery and discernment between the spectator and the screen

NOTES

1 A good example of blue screen work can be found in certain flying sequences of *Superman* (Richard Donner, 1978). The eponymous superhero wears a red and blue outfit. The blue screen is placed behind a subject that is then filmed, isolated and superimposed onto a different background – in this case, Superman flies through the air and is thus presented against a backdrop of passing skyscrapers or other scenery. On *Superman*, the complex 'blue-screen colour difference process' was used for some shots (see Rickitt 2000: 51–4), and a precise shade of turquoise suit had to be found for actor Christopher Reeve to wear, which could be used to produce a matte against a blue screen (and which met with the approval of DC Comics, owners of the Superman franchise and protective of the character's image and appearance) and lit so as to minimise the green tinge that might be visible on the character. Filming a subject in front of a blue screen yields, after optical rephotography, one film of the subject against a black background, and another of the subject's silhouette against a white background. The rephotography involves reprinting the footage through a filter which turns the blue of the screen to black without altering the subject, and a second reprinting which turns the blue to white and blocks out all other colours, leaving the subject silhouetted. The silhouette is then used to create a space in a separately shot film of the required background, a space into which the subjects can be inserted. The blue screen is strongly illuminated, but care must be taken that none of the blue light 'spills' onto the subject, and, conversely, that none of the light from the subject is deflected onto the screen.

Areas of the film suffering from this 'blue spill' may become transparent during the matte process of superimposure. The special lighting arrangements which are required to avoid such occurrences are another factor which give superimposed elements a distinctive artificiality. Colour film stock has three levels of silver halides, each sensitive to one of the three primary colours – red, green or blue – and objects photographed in front of a screen of one of these colours can be isolated with an optical printer to generate mattes and colour separations. The printer can deliver a 'male matte' (also known as a 'black centre matte' or 'hold-out matte'), consisting of a black silhouette of the element against the blue screen, and a 'female matte', a clear silhouette of the element on a black background (see Vaz & Duignan 1996: 20). Blue is used most frequently because it is the colour least present in skin tones. Today's special effects technicians have the option of using a green screen, which operates in the same way but which permits the photographing of blue subjects, and which reacts differently under certain lighting arrangements.

2 See, for example: Raymond Fielding, *The Technique of Special-Effects Cinematography* (1965); Richard Pettigrew, *The Stop Motion Filmography* (1998); Richard Parent, *Computer Animation* (2001); Mark Cotta Vaz *et al.*, *The Invisible Art* (2002).

3 See, for example: Jerome Agel, *The Making of Kubrick's 2001* (1970); Orville Goldner and George E. Turner, *The Making of King Kong: The Story Behind a Film Classic* (1975); Don Shay and Jody Duncan, *The Making of Jurassic Park* (1993). Some texts are linked specifically to particular effects houses: Thomas G. Smith, *Industrial Light and Magic: The Art of Special Effects* (1985); Mark Cotta Vaz and Patricia Rose Duignan, *Industrial Light and Magic: Into the Digital Realm* (1996); Piers Bizony, *Digital Domain* (2001).

4 See, for example: Frank P. Clark, *Special Effects in Motion Pictures* (1966); John Brosnan, *Movie Magic: The Story of Special Effects in the Cinema* (1974); Christopher Finch, *Special Effects: Creating Movie Magic* (1984); Jack Imes Jr, *Special Visual Effects* (1984); Richard Rickitt, *Special Effects: The History and Technique* (2000).

5 Salt's standpoint is a 'Scientific Realism' which relies on causal attributes of technology. He insists that film is an art which relies so heavily on technologies, which are produced by application of causal and experimental thinking, that a purely philosophical approach is inadequate. He rejects psychoanalysis, linguistics, structural anthropology and Marxism as tools of study, preferring to rely on rational thinking and scientific investigation. He sees deficiencies in French teaching of natural sciences and mathematics as the causes of the pseudo-scientific philosophical work of the French film theorists.

CHAPTER 1

1 The Cinématographe was demonstrated to the Société d'Encouragement à l'Industrie Nationale in Paris, 22 March 1895, and at the Sorbonne, 17 April of the

same year. The first public show (invitation only), was not until 28 December 1895. See Herbert (1994).

2 See Bottomore (1999). The original train film was *L'Arrivée d'un Train à la Ciotat* (1895), from which some spectators were reputed to have run away. The rumour was dramatised for comic effect in Robert W. Paul's *The Countryman and the Cinematograph* (1901), in which a rural peasant stands alongside a screen showing a series of films, struggling to distinguish the images from real objects, people and spaces.

3 A different approach to Spiritualism was taken by Daniel Douglas Home, for instance, who never gave public séances, but offered himself as a guest at private dinner parties. He never promised to be able to summon spirits on every occasion, but could only perform under very specific conditions (usually in total darkness). By not claiming to deliver on demand, he could evade close scrutiny and give the impression that his abilities were actually reliant upon the whims of unpredictable spirits. He was therefore never publicly exposed as a charlatan and became a popular addition to society soirées. See Lamb (1976: 57). The most complete account of Home's career is to be found in Lamont & Wiseman (2005).

4 Undated programme for a show at the Egyptian Hall, London. Held at The Bill Douglas Centre for the History of Cinema and Popular Culture, University of Exeter. Item no. EXE BD 18563.

5 Ibid.

6 From a programme for 'Messrs. Maskelyne and Cooke's Entertainment', 1896. Held at The Bill Douglas Centre for Cinema and Popular Culture, University of Exeter. Item no. EXE BD 18564.

7 The 'Ghost Illusion' as Pepper called it at the time, was not blessed with an inherent longevity. Although it thrived in fairgrounds, it was finally usurped, like many other entertainment attractions, by the arrival of the Bioscope on the fairground circuit. The illusion was restricted by the narrow scope it offered for narrative integration. And its popularity waned as the possibilities for its exploitation came to be narrowed by the technical necessities of its presentation. The glass pane was obstructive to performers' dialogue, and the rigid choreography required to enable them to interact with an invisible co-star was stifling to spontaneity. The stories in which it was incorporated were brief and repetitive, designed only to present the special effect, but the illusion's repetition led the audience to discern which renditions were technically proficient, and which were the work of 'duffers'. Pepper's Ghost found some success in fairgrounds and travelling shows as practiced by Randall Williams (1846–1898) (See Toulmin 1998).

8 Devant's advice on performance may have been influenced by Henry Dean's *The Whole Art of Legerdemain: or, Hocus Pocus in Perfection* (1727; I have only been able to consult the second edition), where the author lists the qualities required of a conjuror: '1. He must be one of a bold and undaunted Resolution, so as to set a good face upon the Matter. 2. He must have strange Terms, and emphatical Words,

to grace and adorn his Actions; and the more to amaze and astonish the Beholders. 3. And Lastly, He must use such Gestures of Body, as may take off the Spectators Eyes, from a strict and diligent beholding your Manner of Performance' (1727: 8).

9 Devant reiterates this yet again in the book he wrote with Nevil Maskelyne (the son of John Nevil), which begins with a most unequivocal disclaimer: 'So far from feeling any reluctance towards letting the general public into the secrets of our procedure, we are most anxious to educate the public in such matters, in order that a proper understanding of our art may be disseminated among its votaries and patrons ... Tricks and dodges are of comparatively small importance in the art of magic. At the utmost, they display inventive ability, but nothing more. The effect – and the effect alone – produced by the use of such inventions, is the consideration of real importance' (1911: vi). Nevil Maskelyne worked on producing film cameras, and patented his Mutagraph in 1897. He also experimented with high-speed photography and produced a camera capable of capturing the motion of artillery shells in flight.

10 Devant's seven forms of magic are:
 1. A production or creation.
 2. A disappearance.
 3. A transformation.
 4. A transposition.
 5. An apparent defiance of natural laws.
 6. An exhibition of secret motive power.
 7. Apparent mental phenomena.
 (1931: 105)

11 Other books include George P. Moon, *How to Give a Conjuring Entertainment* (c.1890); A. Anderson, *How to do Forty Tricks with Cards* (1894); Professor Haffner, *How to do Tricks with Cards* (1894); Anonymous, *The Black Art, or, Magic Made Easy* (1893); Charles J. Carter, *Magic and Magicians – A Full Exposé of Modern Miracles* (1903).

12 Sobchack's statement is part of an argument that science fiction is an interaction between science, magic and religion, and can be distinguished from horror only in the sense that the two genres (so often confused and overlapped) represent two ends of a spectrum, with science fiction only able to maintain absolute generic purity by avoiding recourse to 'elements that are not empirically based, elements of superstition, mysticism, or religion (the magical and the miraculous) most often associated with the horror film' (1993: 55).

13 David Robinson suggests that there was an afternoon preview for press and guests, to which Méliès, as proprietor of a nearby theatre, would almost certainly have been invited (1993: 12).

14 Many of the Theatrographs which Paul sold were presented under different names, perhaps with slight modifications. Imitations of the Cinématographe and Kinetoscope appeared rapidly, including the Electrograph, Eknetographe, Eidoloscope,

Actograph, Ikonographe, Biactographe, Polyscope, Scenematographe, Andersono-scopographe and the Photo-Motoscope, to name but a few.

15 Hertz was particularly instrumental in spreading knowledge of film shows around the world. He bought his Theatrograph on 27 March 1896, and, having embarked on a voyage to South Africa the next day, was showing films on the ship, the S.S. Norman, within days of his purchase. On his arrival in Johannesburg, he found the shows were highly successful there, but he only had five films, each of 55-feet, which did not leave him much opportunity for a varied programme. He managed to purchase ten Kinetoscope films in a local rubber shop, and had to make his own sprocket holes in the filmstrips to make the rolls of film compatible with his machine (see Hertz 1924: 144–5). Regarding his South African shows in July 1896, Hertz notes in his autobiography that 'the theatre was so packed that I was sum-moned and fined on three different occasions for permitting overcrowding' (1924: 151). Hertz also presented the first film shows, as part of his magic act, in Aus-tralia (Melbourne Opera House, 22 August 1896, followed by shows in Sydney and Adelaide), New Zealand and Queensland. He then toured extensively in Western Australia before giving shows in Colombo and Kandy. In Bombay, amidst an epi-demic of bubonic plague, Hertz was the first to show films in India, to a capacity crowd of 1500 at the Novelty Theatre. He toured other Indian cities, notably Poona, Allahabad and Calcutta, before moving on to Rangoon and Mandelay in Burma, then Singapore and Manila, a few weeks after the American seizure of the Filipino capital led by General Merrett. Before reaching Shanghai, Hertz had played shows in Java, Borneo, Saigon and Hong Kong. Hertz's Japanese tour took in Nagasaki, Kobe, Kyoto, Osaka Yokohama and Tokyo, before he travelled to London via Fiji, Honolulu and San Francisco, rounding off a series of international performances that had lasted for two and a half years. Audiences in all of these places would have witnessed moving pictures for the first time in the context of a magic show.

16 Egg-conjuring was the first trick Devant ever learned. He had bought the necessary props from a magic shop on Oxford Street, London, for a shilling, and progressed his act by buying more and more tricks and adapting them to his own performance style.

17 These were: a 15-part serial for Pathé entitled *The Master Mystery* (Harry Gross-man/Burton L. King, 1919), *The Grim Game* (Irvin Willat, 1919), *Terror Island* (James Cruze, 1920), *The Soul of Bronze* (Unknown, 1921), *The Man From Beyond* (Burton L. King, 1922), *Haldane of the Secret Service* (Harry Houdini, 1923). In 1901, reports Barnouw, Houdini appeared in a short film for Pathé in which he escapes from a prison cell (1981: 79). All that remains of it today is a photograph in the Houdini Collection at the US Library of Congress.

18 Witness, for instance, the ease with which Tony Curtis appears to perform Houd-ini's escapes in the biographical film *Houdini* (George Marshall, 1953). Curtis was himself an amateur conjuror, but by no means capable of genuinely imitating Houdini. Paul Michael Glaser also played Houdini in a 1976 film *The Great Houd-*

ini (directed by Melville Shavelson and co-written by Peter Benchley). Another biography, *Houdini*, was made for television in 1998, directed by Pen Densham and starring Johnathon Schaech. This focused principally on the romance between the performer and his wife, Bess.

19 Charles Musser has pointed out the importance of exhibition contexts and contemporary issues in constructions of intertextual and extratextual narratives. Musser discusses the role played by exhibitors who would edit short pieces of film, or 'views' into a programme with varying degrees of meaning established by juxtaposing individual works. See Musser (1994).

20 Other Lumière trick films include *La Charcuterie mécanique* (*The Mechanical Butcher*) directed by Louis in 1895, which features a machine which turns live pigs into sausages and pork chops in a clean, struggle-free instant, by use of a simple conjuring trick whereby the pig is concealed inside a box which also contains the pre-cut meat. This is an example of a recording of a trick rather than an in-camera effect. One of the earliest Lumière shorts was Louis' *Assiettes Tournantes* which features a showman spinning plates on poles, a well-known stage act which could be transferred to film with the knowledge that it had already proven to be a popular spectacle before it was used a piece of cinema. Louis also produced a film called *Le Prestidigitateur au Café* (c.1896), showing a street magician demonstrating sleight-of-hand tricks. The 1905 Lumière catalogue of views includes 14 films under the heading 'Vues fantasmagoriques (Scènes de Genre et à Transformations)'. See, for example, the reprinted catalogue in Chardère (1995).

21 Some sources attribute many more films than this to Méliès. According to Cherchi Usai (1991: 175, footnote 35), Méliès made about 510 films, but since he numbered his films in the Star-Film Catalogue according to their length (giving a new number for every twenty metres of film), some confusion arises over the number of individual films he made. Sadoul (1947) lists 1,539 catalogue entries within Méliès' oeuvre.

22 Although Méliès has become associated principally with fantasy films, Elizabeth Ezra attributes this partly to the selection of films shown at a 1929 gala in his honour at the Salle Pleyel, composed of the recently rediscovered films commissioned by the Dufayel Department Store, which were commissioned for child audiences, and which therefore featured a predominance of faeries and fantasy. He also made actualities, historical reconstructions and other types of views (2000: 50).

23 Christian Metz makes such a distinction (see 1974: 44); Katherine Singer Kovács also uses it (1983: 244), and Georges Sadoul makes the same assumption (see 1949: 31).

24 See Fischer (1983) and Williams (1986) for interesting interpretations of the underlying meanings behind these tricks which depict a patriarchal mastery of the female body.

25 It could be argued that spirit photography prefigures the technique of the stop-motion substitution. One way to achieve the effect of a transparent figure in a pho-

tographed scene was to shut the camera's aperture and remove the figure partway through a prolonged exposure, leaving an incomplete imprint on a fully-exposed scene. As with stop-motion, the technique involves a spatio-temporal manipulation which intercepts the camera's standard operations.

26 Ezra provides an insightful analysis of Méliès' Place de l'Opéra story, arguing that it indicates all of his later concerns – the omnibus changes into a hearse, men change into women – thus Méliès comes to challenge death and produce reanimations and gender confusions and transformations (2000: 29).

27 Michael Chanan refutes the idea of special effects being discovered by happy accidents, but sees them as emerging from the reapplication of earlier photographic or lantern-based processes, such as the use of double exposures to create moving spirit photographs, including G.A. Smith's *Photographing a Ghost* (1897) (see Chanan 1996: 117).

28 American photographer Birt Acres (born 23 July 1854 in Richmond, Virginia) shot Britain's first ever film, *The Oxford and Cambridge University Boat Race*, 30 March 1895, using the machine he and Paul had developed to be compatible with the Kinetoscope. They were both aware of the advantages of sharing such compatibility with other equipment, since this would help to begin standardisation of exhibition facilities. Paul and Acres fell out during arguments over who was more greatly responsible for the Theatrograph designs, but Acres continued working in films until 1900.

29 French director Jean Durand (1882–1946) used the character of Onésime, played by Ernest Bourbon, in several other films, including *Onésime* (1912), *Onésime sur le sentier de guerre* (1913) and *Onésime et le coeur de tzigane* (*Onésime and the Heart of the Gypsy*, 1913).

30 Around the time of Vitagraph's *Liquid Electricity* (1907), and certainly before *Onésime Horloger*, under-cranking was being used to speed up chase scenes and slapstick in film comedies. The aforementioned films used extreme under-cranking as a technical trick and a part of the diegetic sense of the film (Salt 1983: 130).

CHAPTER 2

1 From 1892, Emile Reynaud was projecting animations, hand-drawn on celluloid, onto a screen for his Théâtre Optique shows. Reynaud's praxinoscope cartoons (hand-drawn), shown in the Théâtre Optique, were not cyclic actions like zoetrope reels, but could last for several minutes. They can still be shown, photographed onto modern film stock. Donald Crafton argues that it is unlikely to have been Reynaud who inspired early animators, since 'direct iconographic links to pre-cinematic optical traditions are still hard to find', and he cites Méliès and the magic tradition of trick effects as far more likely sources of inspiration (1982: 7).

2 The same technique was applied for *The Birth and Adventures of a Fountain Pen* (1909). In 1908, Arthur Melbourne Cooper's *Dreams of Toyland* featured dolls

animated by stop-motion techniques, as did his *Noah's Ark* of the same year (see Holman 1975: 21). Emile Cohl made several stop-motion films, including *Mobelier Fidèle* (1910), in which furniture moves itself into a van and then repositions itself in its new home. In the same year he completed *Le Petit Faust*, a retelling of the Faust story with animated puppets.

3 McCay had featured a similar framing narrative in *Little Nemo* (released 8 April 1911, and first included in the vaudeville act 12 April 1911 (Canemaker 1975: 45)), in which he makes a bet with friends that he can produce moving drawings, and in which we see McCay engaged in the process of animating the drawings.

4 Edison was forced to sell the company, and, unhappy with his new employers, O'Brien resigned to take up an offer from Herbert M. Dawley to produce stop-motion dinosaur sequences for insertion in *The Ghost of Slumber Mountain* (released in June 1919), for $3000, for which he collaborated with Dr Barnum Brown, vertebrate palaeontologist at the American Museum of Natural History. The sequences, somewhat tangential to the surrounding story, were acclaimed enough to bring stop-motion techniques to popular attention for the first time, but Dawley claimed sole credit for the animation, even releasing his own film, *Along the Moon Beam Trail* (1920), pieced together from O'Brien's test footage and out-takes. Dawley patented stop-motion animation techniques (which O'Brien had neglected to do), and later, when he heard that O'Brien was contributing to a production of *The Lost World*, he sued for $100,000 for breach of copyright. His lawsuit was overturned when the court was shown O'Brien's work made prior to Dawley's patent application (see Rovin 1977: 12).

5 D. W. Griffith's *Man's Genesis* (1912), about cavemen, was incorporated in a later release, *Of Primal Tribes/In Prehistoric Days* (1912–13), where the second half of the film featured a large moveable model ceratosaurus. Max Fleischer's 1923 production *Evolution* borrowed O'Brien's dinosaur animations from *Ghost of Slumber Mountain* (1918). Dinosaurs appeared prominently in cartoons and comedies – John Bray created a swift remake of Winsor McCay's *Gertie the Dinosaur* (released in December 1914), and then produced *A Stone Age Adventure* (L.M. Glackens, 1915), an animated short. Famous cartoon stars had adventures including the giant creatures, for example *Felix the Cat Trifles in Time* (1925), *Betty Boop's Museum* (Dave Fleischer, 1932, in which Ms Boop is trapped overnight in a museum where the dinosaur skeletons come to life) and *Daffy Duck and the Dinosaur* (Chuck Jones, 1939). Live-action stars also capitalised on the craze for prehistory, particularly in comic contexts. One of Charlie Chaplin's early shorts for Keystone (released by Mutual) was *His Prehistoric Past* (1914), a parody of D. W. Griffith's *Man's Genesis*, with the anachronistic sight gag of his trademark bowler hat worn with his caveman's animal skins in a dream sequence. Laurel and Hardy played cavemen in *Flying Elephants* (Frank Butler, 1927), in which a triceratops (two men in a rubber suit) makes a brief appearance. In the 'prehistory' segment of *The Three Ages* (Buster Keaton/Eddie Kline, 1923), Buster Keaton rides an animated bronto-

saurus. Howard Hawks' *Fig Leaves* (1926) includes a prologue set in the Garden of Eden featuring a large brontosaurus model on wheels, projecting the prehistoric anomaly into the Biblical account of Creation. Disney's *Fantasia* (1940) includes a passage during the 'Rites of spring' section depicting the Creation, the reign and destruction of the dinosaurs. An edited version, with music removed and narration added, was subsequently released to US schools and libraries under the title *A World is Born*.

6 Roy Field, optical effects technician, records Frank Williams' experiments with travelling mattes in 1918 with Keystone Cops films. He exploited it fully in *Beyond the Rocks* (Sam Wood, 1922), starring Rudolph Valentino and Gloria Swanson, *The Lost World* (Harry O. Hoyt, 1925) and *Ben Hur* (Fred Niblo, 1925). One incentive for the development of travelling matte and back projection processes such as these (whereby two separate elements in motion could be combined in the same frame) was to enable greater control over sound recording and other factors simplified by their containment within a studio set.

7 This is how Williams described the process later, but Salt believes it is more likely that a rotoscope was used to paint the counter-silhouettes around the moving figures in the foreground action frame by frame. In the original description of the process, the photographic matte was often not dense enough to produce an unexposed background, so the two elements would blur together like a double exposure. Early examples of this expensive, time-consuming process include Cecil B. DeMille's *Manslaughter* (1922).

8 *The Invisible Man Returns* (Joe May, 1940), *The Invisible Woman* (A. Edward Sutherland, 1941), *Invisible Agent* (Edwin L. Marin, 1942), *The Invisible Man's Revenge* (Ford Beebe, 1944).

9 For a full description of the process, which involves the use of colour filters and a production camera in which the panchromatic negative raw film stock is combined with a bleached and orange-dyed master positive background plate, see Fielding (1965: 191–6); Rickitt (2000: 47–8).

10 In 1945, The Rank Film Research Department (RFRD) employed David Rawnsley to come up with a system for reducing the costs of building sets. Rawnsley designed large, low-wheeled platforms which could be easily moved in and out of position as shooting required; the next scene could be prepared without waiting for the previous set to be dismantled. Multiple back projection screens were used to give an illusion of space, distance, and whatever environment was selected for use as a backdrop to the scene. The technique, called 'the Independent Frame', fulfilled all of the requirements requested by the RFRD, but created new technical difficulties in the process. Each scene would have to be carefully planned in advance of shooting to establish a frame in which actors could perform. Camera movements and lighting effects were also problematised and compromised by the projection screens. One proposed use for Independent Frame was its packaging and export; it was suggested that films using the system could package the props, backdrops,

plates and storyboards and export them, allowing foreign buyers to produce their own versions of the film following the explicit directions in the screenplay. The Dunning-Pomeroy process was used to produce several foreign language versions of *The Big Trail* (Raoul Walsh, 1930), with each cast performing before the same backgrounds. More information on Independent Frame can be found in Dixon (1994), and in the series of articles by Tony Iles published in *Image Technology* in 2001.

11 The first screening was at New York City's Astor Theater on 8 July, 1929. First National arranged with Kodascope libraries to make a 16mm, five-reel abridgement of the film (approximately 55 minutes) for distribution to schools. This kept all of the dinosaur footage and some of the narrative. By this point the film had been withdrawn from release, leaving only one complete domestic negative, pending a remake. For a more complete account of the loss of the film and its subsequent restoration to the version now readily available (and the version discussed in this chapter, released in the UK on DVD from Eureka! Video), see Edward Summer's article *Save the Lost World!* (actually a plea for donations for further preservation of the film) <http://users.rcn.com/dinosaur.interport//lostworld.htm>.

12 This information is from Roy Pilot's commentary on the Eureka DVD release of the film (2001). This version is a restoration and digital mastering of what is believed to be the most complete print available, running 93 minutes, still short of the 9200ft (approximately 104 minutes) original length.

13 According to Rovin, two London streets, totalling 600 feet in length, were built at the studio and adorned with 2000 extras, 200 prop cars and six buses (1977: 20). While the sets appear impressively large, these figures are exaggerations of scale claimed by contemporary press handouts.

14 Born in Jacksonville, Florida, Cooper worked with only one other director in his career – John Ford. He was first a military pilot, then a journalist before meeting Ernest B. Schoedsack, with whom he collaborated on *Grass* (1926), *Chang* (1927) and *Rango* (1931). Cooper was the one who added the entrepreneurial aspects of the films to complement Schoedsack's relatively objective ethnographic interests. For *Grass* Cooper and Schoedsack, with correspondent Marguerite Harrison, filmed a nomadic tribe in Persia, in a film planned for exhibition on lecture circuits, but which Paramount put on general theatrical release having recognised its popular potential. At the New York premiere of *Chang*, the Magnascope trick was used, in which the screen was enlarged during spectacular moments such as the elephant stampede.

15 Wladislaw Starewicz (1882–1965) has spoken of how he first began animating puppets while trying to force two stag beetles to fight for a nature film he had been commissioned to make for the Museum of Natural History at Kovno, Russia. The reluctance of these unpredictable organisms to fight for the cameras prompted him to model his own creatures and animate them himself (see Holman 1975: 22). In the work of Willis O'Brien, animated models were essential in enabling him to

16 Model-maker Delgado would also make miniatures for Cooper and Schoedsack's *The Last Days of Pompeii* (1935), Schoedsack's *Mighty Joe Young* (1949), *The War of the Worlds* (Byron Haskin, 1953), *20,000 Leagues Under the Sea* (Richard Fleischer, 1954) and *Fantastic Voyage* (Richard Fleischer, 1966).

17 The film was released nationally in the USA on 10 April 1933, produced and distributed by Radio Pictures, following an unprecedented New York preview at both the New Roxy and Radio City Music Hall on 2 March 1933. Schoedsack made budgetary savings by filming *The Most Dangerous Game* (Irving Pichel/Ernest B. Schoedsack, 1932) and *King Kong* on many of the same jungle sets. The two films even shared Fay Wray as the female lead. Schoedsack has a small cameo in the film as the machine gunner who fires the shots which finally topple Kong from the top of the Empire State Building. Merian C. Cooper plays his pilot. The success of the film may have saved the troubled RKO studios from bankruptcy.

18 From the original RKO promotional programme for *King Kong* (1933) in The Bill Douglas Centre for the History of Cinema and Popular Culture, University of Exeter. Item No. 17153.

19 Like dinosaurs, giant apes abound in cinema prior to the release of *King Kong*. *The Missing Link* (Charles F. Reisner, 1926), features an ape-man played by Bull Montana, reprising the similar role he played in *The Lost World* (1925). *The King of the Kongo* (Richard Thorpe, 1929) was a ten-part serial about the discovery of an ancient temple in an African jungle, where the eponymous giant ape resides. *King Klunk* (Walter Lantz and William Nolan, 1933) is a cartoon parody of Cooper and Schoedsack's film of the same year.

20 Ray Harryhausen is often linked directly to O'Brien, as if to preserve the authored nature of the technique of stop-motion – many accounts suggest a mentor/student relationship between the two. Harryhausen himself claims to have been inspired to start making 16mm stop-motion films after seeing *King Kong* in 1933 and learning the process for himself. Ray's father, Fred Harryhausen, was a machinist who helped him to construct the metal armatures for his earliest models, and later made some of the aluminium spacecraft in *Earth vs. the Flying Saucers* (Fred F. Sears, 1956).

CHAPTER 3

1 After the financially disappointing performance of *Mighty Joe Young*, O'Brien's apprentice, Ray Harryhausen, was one of very few mainstream proponents of stop-motion, and though he would later achieve international renown for his application of the technique in a series of classical fantasy adventure films, he had to begin by plying his trade in the increasingly popular science fiction genre, where miniature models were routinely required to depict gigantic machines, but where animation would become increasingly side-lined. Harryhausen's science fiction films include

The Beast from Twenty Thousand Fathoms (Eugène Lourié, 1953), *It Came From Beneath the Sea* (Robert Gordon, 1955), *Earth Versus the Flying Saucers* (Fred F. Sears, 1956) and *20 Million Miles to Earth* (Nathan Juran, 1957).

2 For an excellent account of Hollywood's conversion to sound, see Crafton (1999).

3 In optical printing, whereby one layer of an image is projected onto another, the content of the frame can be manipulated *during* the copying process (for instance, adjusting the size of the figure composited into a background plate), as opposed to in-camera. Optical printers first became widespread in the late 1920s: prior to this, 'contact printing' sandwiched together film of elements to be combined, and a copy was made onto another strip of film.

4 Vivian Sobchack has argued that science fiction cinema was not a critically recognised genre until after the atomic attacks on Hiroshima and Nagasaki in 1945, when 'logic itself became suspect' and the destructive potential of machines and computers took up a central position in popular discourse (1993: 21). The era between the world wars has been seen as a Golden Age of science fiction literature, with flurries of stories filling magazines such as Hugo Gernsback's *Amazing Stories* and *Science Wonder Stories*, and John W. Campbell's *Astounding*. Science fiction in the first half of the twentieth century was a largely denigrated form in America, confined principally to pulp magazines. In 1946 the prestigious publisher Random House of New York published a science fiction anthology, *Adventures in Time and Space*, which lent a new level of credibility to the genre. It was in part the massive popularity of such publications, and news events such as flying saucer sightings that convinced studios that it was a genre with a large enough fan base to make it worthy of exploitation.

5 In his published diaries, Kenneth Tynan remarks upon the opportunity for dual interpretations of *Invasion of the Body Snatchers*: 'What is fascinating is the ambivalence of the message. To Siegel, one suspects, the doctor-hero represents the last radical non-conformist in a world of Eisenhower, post-McCarthyite capitalism. To the producers, however, he must have represented the last Eisenhower, post-McCarthyite capitalist in a world about to be conquered by creeping Communism. In this way, the mass media reconcile Marx and Mammon. (I don't suggest, by the way, that Siegel is a Marxist or even a liberal. It may be that he deliberately made the film ambiguous in order to appeal to conservatives and dissenters alike.)' From the entry of 22 January 1971 (Tynan 2002: 22–3).

6 F. W. Taylor (1856–1915) implemented financial incentives, and time-and-motion studies in the American workplace. The principle of performance-based pay threatened to undermine the solidarity of trade unions and set workers in competition with each other, thus forcing them to work harder than their peers or be relegated to the lowest levels of the company hierarchies. Taylor reasoned that rates of pay should be adjusted to reward the most productive workers, to prevent the most efficient people from slowing down to the rate of their slovenly counterparts. Taylor sought the complete segregation of work and leisure, whilst aiming

to combine man and machine to create the most efficient systems of production. Similar segregations were suggested between management and machine operatives, the former making the important decisions while the other carried out the practicalities of the manufacturing process. This was Taylor's system of 'Scientific Management', urging managers to tighten control of the methods of production and granting responsibilities and choices only to those at the higher levels of the company ladder. After the Depression of the 1930s, Fordist policies (which idealised mass production, job loyalty and production line systems, with human labour as co-workers alongside increasingly swift and effective production machinery) had led to a weakening of the status of the individual in working life. The Ford Motor Company was established in 1903, and began production of the Ford Model T automobile in 1908. It was designed as a mass production vehicle, neither cheap nor luxurious, an all-purpose mode of transport aiming to conform to all consumer tastes. This meant a lack of ornamentation and variety – *all* Model Ts were black. As its production began, Ford discontinued all other models to concentrate on the mass production of the Model T. By 1913, Ford's Highland Park plant was using an assembly line of conveyor belts and advanced machinery to manufacture the vehicles with remarkable efficiency. 15,000,000 Model Ts had been rolled off Ford's production lines by the time of its discontinuation on 26 May 1927, stubbornly working to the same design for almost twenty years and finally usurped by General Motors and Chevrolet (see Sheldrake 1995: 86).

7 Reproduced at *Project 1947*'s (less than sceptical) website: <http://www.project1947. com/fig/gallup.htm> (accessed 7 December 2004).

8 Susan Sontag previously identified a formula in science fiction (though she appears to be talking exclusively about alien invasion narratives), in which a five-phase narrative structure emerges, beginning with the arrival of a 'thing' (1); then a major act of destruction to corroborate the account given by the original lone witness and including the massacre of local law enforcement officers (2); national emergency declared, scientists discuss how to destroy the monster (3); big battle, military pyrotechnics all unsuccessful in thwarting the invader (4); the hero's plan to exploit the invader's weakness is put into action and disaster averted (5). Sontag also outlines a low-budget version of this script, of which Lucanio's version is a refinement. (Sontag 2001: 209–11).

9 Carl Jung argues that the reason the mandala emerges as reports of half-glimpsed circles in the sky, blurred Polaroids or as dazzling lights in the night is that the vision of the mandala cannot be fully-formed in so secularised a society: 'no one is deeply rooted enough in the tradition of earlier centuries to consider an intervention from heaven as a matter of course' (1959: 22). Hence the vagueness and ambiguity of so many (imagined) sightings. The mandala thus appears in the form of a mythical machine, an archetypal manifestation of a technology superior to our own, bearing connotations of wisdom and enlightenment.

10 This poorly received musical comedy was a satirical vision of the future in which

all of the automobiles have Jewish names, apparently a reference to Henry Ford's alleged anti-Semitism.

11 Oberth (1894–1989) had, along with Willy Ley (1906–1969), acted in a similar capacity on Fritz Lang's *Die Frau im Mond* (*The Woman in the Moon*, 1929; released in the US in 1931 as *By Rocket to the Moon*). Lang wanted the film to have a kind of documentary realism to support the story of an industrially-sponsored lunar mission. The film was famously withdrawn from distribution by the Nazis, who feared that it might reveal secrets about the ongoing development of the V1 and V2 rockets. The spaceship model used in the film was also destroyed by the Gestapo. Willy Ley had been a friend of Lang and his wife, Thea von Harbou, and was the respected author of *Möglichkeit der Weltraumfahrt* (*The Possibility of Space Travel*, 1928) and founding member of the Society for Space Travel in Germany. Ley introduced Lang to Oberth, who had been a designer of rocket artillery for the Austrian army in World War One and was author of the highly influential *Die Rakete zu den Planetenräumen* (*By Rocket to Interplanetary Space*, 1923). He would later perform scientific research for the Nazis, while Willy Ley fled to the US. One of the film's many accurate predictions was the countdown as part of launch protocol, something which is communicated by title cards (the film was silent), and which Lang invented for dramatic effect in the film. An extensive account of the making of this film can be found in McGilligan (1997: 140–4). See also Christaan Strange's brief biography 'Hermann Oberth: Father of Space Travel', <http://www.kiosek.com/oberth/> (accessed 2 August 2005).

12 For more information on the art of Chesley Bonestell, see *Bonestell Space Art* <http://www.bonestell.org/> (accessed 2 August 2005).

13 Despite Arthur C. Clarke's assertion that *2001* had made no 'concession to popular taste' (quoted in Agel 1970: 93), between the critics' negative criticisms and the public's reception of the film, Kubrick had shortened the film by 19 minutes, excising material mainly from the lengthy, lingering sequences of special effects work. The film premiered in Washington, on 2 April 1968, and was re-edited by Kubrick between 4–5 April before the final cut was shown in New York, on 6 April 1968.

14 Believing that screenplays were unsuited to communicating the overall sense of a film, Kubrick had instructed Clarke to write a novel, which they could then adapt for the screen. The starting point was Clarke's 4,000-word short story, 'The Sentinel' (1948), about a lunar landing which unwittingly activates the signalling device of a machine which informs an alien race that Earthlings have begun exploring environments outside those of their own planet. Clarke had written the story for a BBC Christmas writing competition, from which it was rejected, remaining unpublished until it appeared in the magazine *10 Story Fantasy* in 1951.

15 Portions of this documentary are transcribed in Agel 1970: 27–57.

16 Deep Blue works principally by processing at incredible speed the moves which it can play next and which would be most advantageous to its game. Its memory contains a database of 600,000 games and their check-mate combinations, a library

from which it can plunder experience of previous matches as if it had played them itself, and its VLSI (Very Large-Scale Integration, whereby a single chip houses many transistor circuits) chip can process two million chess positions per second. When it played Kasparov in February 1996, the IBM SP2 supercomputer through which Deep Blue was operating was running over two hundred such chips in parallel. Kasparov was defeated in a game of speed chess in 1995 by a computer program called GENIUS3. Speed chess gives each player 25 minutes to complete the game, as opposed to the regulation chess rules which allow two hours in which to complete forty moves.

CHAPTER 4

1 In keeping with this drive for in-house facilities, Skywalker Ranch is Lucas's ongoing, Hearstian project of self-containment, gathering up all sections of Lucasfilm's empire. It includes Skywalker Sound's eight mixing stages, housed in 150,000 square feet of post-production studio space, and the Lucas Archive, which opened in November 1991. Archivist David Craig began photographing and documenting models, storyboards, costumes, props and other ephemera from Lucas's films in 1983, and by 1999 it contained over 10,000 objects (see Baxter 2000: 4–5). By 1996 Skywalker Ranch occupied 2500 acres in Marin County, its growth contained only by protests from local farmers, who blocked his plans to transfer ILM to the premises in 1988, which would have provided a complete production facility on the site.

2 Lucas was prevented from making a direct remake of *Flash Gordon*, since Dino de Laurentiis had bought the rights to the characters, having planned a new film version to be directed by Federico Fellini. Fellini never committed to the project, and it was finally directed by Mike Hodges in 1980.

3 More specifically, the process is 'go-motion', as designed by Phil Tippett at ILM for *Dragonslayer* (Matthew Robbins, 1981). Stop-motion techniques had changed little since the basic principles were applied by Willis O'Brien (see previous chapter), and its lack of motion blur was its 'major stylistic drawback, a generic flaw' (Smith 1985: 92), making it seem essentially unrealistic, separate from the physical laws to which the real-world elements of the frame (for example, live actors) were subject. With a figure animated by stop-motion processes, the character is always in focus in each exposed frame, since it is a static object which is being shot to appear as if it is in motion. The pristine, focused look of the creature serves as a reminder that it exists in a separate time zone from other elements. In go-motion, blue rods are attached to the major body parts of a puppet, which is then animated, frame-by-frame as usual. Instead of shooting the character at this point, the rods' movements are recorded by a computer which can then repeat the motions described to it by the animator, allowing the figure to be shot, in front of a blue screen while the shutter is open, which captures motion blur. The imitation of what is, effectively, a

limitation of photographic process to which we have grown accustomed, lends the image the sort of realism which is based on our understanding of how photography operates.

4 In August 1981 Smith, Carpenter and Ed Catmull had done a CG test for ILM using Carpenter's 'Reyes' (Renders Everything You Ever Saw) 3-D rendering program to create a 3-D model of the Starship Enterprise in pursuit of a Klingon craft (Smith 1982: 1038).

5 Although the backgrounds are computer-generated, much of *Tron*'s distinctive look comes from the backlighting effects, which Lisberger had been using already in his commercials produced in Boston with Lisberger studios. The process uses mattes composited with coloured lights shone directly at the camera lens, using theatrical gels to saturate those colours. It was originally an animation effect used to make glowing, pseudo-neon logos for television and advertisements. 'Tron' first appeared as a backlit animated line character sold as a promotional logo for WCOZ radio in Boston, though it was probably sold to several stations with the name on the logo altered. The character therefore became a trademark which could be re-positioned in various contexts.

6 This was initially filmed with frisbee champion Sam Schatz in a white suit against a white background (the actual film would be shot against black backgrounds to reduce the amount of lighting required), battling actors in costumes left over from *The Black Hole* (Gary Nelson, 1979).

7 Four CG firms were responsible for *Tron*'s graphics: Abel Associates produced the sequence of a first person point-of-view shot of a transition from the real to the virtual world; Digital Effects in New York created the opening logo and the character 'Bit'; MAGI Synthevision modelled the tanks and light cycles; Triple I produced other models and backgrounds. 'Bit' may have been one of the insistences of Disney's involvement in the film – he is a comic sidekick, who can only communicate with a monotonous 'yes' or 'no', like the positive and negative values of a computer bit. The obscure in-joke for computer scientists may have been wasted on most viewers.

8 Triple I developed a programme for lighting effects which could create up to three light sources for any frame. Computers offer the viewpoint of a virtual camera, which can be positioned anywhere in the defined three-dimensional environment and which has an infinitely variable focal length of its 'lens'. Triple I used a film recorder which transfers the digital image to film with a point line scanner, a video tube, exposing each frame in VistaVision format in three passes with a red, green or blue filter on each pass. A single frame could take five minutes to expose, though the time varied according to the complexity of the image, which therefore had to be limited to meet production schedules. When CG backgrounds were being composited with the live-action principal photography, Richard Taylor devised a technique of using 'witness points' on the set, whose position on the set could be described to the computer, and used as references when working out how to move

the backgrounds to correspond with live-action camera moves. This is a kind of early version of the use of reference points in motion studies. 'Once the computer knew where the witness points were on the set and where they appeared on the screen in the shot, it could deduce the camera position and the focal length of the lens' (Patterson 1982b: 822). Most composite shots kept the camera locked off to simplify what was anticipated as being a complex post-production process.

9 Throughout 1970 Nolan Bushnell worked on a programme for his computer game 'Computer Space'. 1,500 copies of the game were produced for the coin-operated arcade games market, and subsequently Bushnell and partner Ted Dabney decided to form their own games manufacture/distribution company instead of licensing their games out to other companies. This was Syzygy Engineering/Atari Inc. and in 1972, only a few months after it was registered (on 27 June 1972), Atari produced the coin-operated arcade game 'Pong', beginning the era of video games. 'Space Invaders' was first delivered to video games arcades in 1978, and was the first coin-operated arcade game to achieve worldwide success on the scale that might usually only have been seen by blockbuster films such as *Star Wars*. In 1980, a home version of the game was released for the Atari 2600 games console system, contemporaneous with other hit games such as 'Asteroids' and 'Missile Command'.

10 Constant revisions of dinosaur visualisations could be seen in the films of Ray Harryhausen, and a series of remakes or alternative versions of *The Lost World* (Irwin Allen, 1960), *One Million Years BC* (Don Chaffey, 1966), its sequel *When Dinosaurs Ruled the Earth* (Val Guest, 1969, with a screenplay expanded from a treatment by J. G. Ballard), *Creatures the World Forgot* (Don Chaffey, 1971), *The Land that Time Forgot* (Kevin Connor, 1974, based on the novel by Edgar Rice Burroughs), with various ways of creating the dinosaurs, sometimes using real lizards in miniature sets or blown up to (apparently) giant proportions in background plates. See Irwin Allen's 1960 version of *The Lost World* for particularly extensive use of this approach. The first film to do this was probably the short *On Moonshine Mountain* (Lubin Manufacturing Company, 1914), and real lizards were similarly photographically enlarged to double as dinosaurs for *Darkest Africa* (B. Reeves Eason and Joseph Kane, 1936) and *One Million BC* (Hal Roach, Hal Roach Jr, D. W. Griffith, 1940).

11 Spielberg does not mention the velociraptors, whose scale of approximately 5–6 feet in their fossil records left them somewhat unspectacular as the *Jurassic Park*'s most deadly creatures – they were doubled in size for the film.

12 Director James Cameron has maintained a public profile as a maritime historian, adding further authority to *Titanic*'s appeals to historical authenticity. This interest has been demonstrated most prominently in Cameron's three undersea documentaries, *Expedition: Bismarck* (co-directed with Gary Johstone, 2002) *Ghosts of the Abyss* (2003), which explores the wreck of the Titanic, and *Aliens of the Deep* (co-directed with Steven Quale, 2005).

13 *E. T.* has also been released on DVD in two different versions, with or without dig-

ital augmentation. In a sequence where Elliot and his siblings get dressed for Halloween celebrations, Elliot's mother (Dee Wallace), forbids her son from dressing as 'a terrorist'. In the re-release, the word 'terrorist' has been replaced with a prohibition on a 'hippie' costume. The dubbing of 'terrorist' was originally performed for television broadcasts of the film in the late 1980s.

14 See *Hollywood.com*, 30 May 2005: <http://www.hollywood.com/news/detail/article/2440957> (accessed 17 August 2005).

CHAPTER 5

1 A quotation from the company's website <http://www.kwcc.com/>.

2 Dozo's performance can be viewed ononline <http://www.kwcc.com/works/sp/index_3frames.html>.

3 Another branch of the synthespian mythos is the belief in the resurrection of dead stars in imagistic form. California's Senate Bill 209 (sometimes referred to as the Astaire Bill), passed in August 1999, was drawn up to restrict the use of celebrity images without the consent of their heirs. Fred Astaire's image, digitally manipulated from stock footage, had been used to advertise dance instruction videos, contraceptives and vacuum cleaners (see Logan 1999). Astaire's widow, Robyn, campaigned for the legislation to be pushed through, and though the US Screen Actors Guild supported her cause, the MPAA opposed it, and managed to prevent the passing of the portion of the bill which would have prevented the digitisation of images of deceased performers. This is permitted for 'non-commercial' purposes. Virtual Celebrity Productions has secured the rights to synthetic digital versions of George Burns, Sammy Davis Jr, Clark Gable and Vincent Price. Marlene Dietrich's grandson has licensed the digitisation of her image and he hopes that she will eventually become a fully functioning film star again before 2010, albeit only as an image. Brian Logan quotes 'a recent poll' as showing that 80 per cent of cinemagoers in the US are 'keen to see dead icons reanimated in new films'.

4 The Square digital animation studio at Harbor Court, Honolulu, Hawaii, where *Final Fantasy* was processed, houses two super-computers named Nereus and Okeanus, containing around two thousand CPUs between them (see Kennedy 2001: 87). Aki Ross's face has one hundred separate controls for facial movements, and her hair consists of 80,000 separately animated strands, all of them deep black (due to the different light reflection factors, blonde hair is still far more difficult to animate). Once again, the film has its origins in a video game, in this case the 'Final Fantasy' series, first launched on the Nintendo NES console in 1987. Atypically, the series of (to date) 13 games features a different set of characters and environments in each incarnation – they are linked principally by the ambitious animation effects of their original creator, Hironobu Sakaguchi, who also directed the film. 1997 saw the games' seventh instalment launched on the Sony Playstation, a console far more proficient at 3-D animation than the NES. It sold 6,500,000

copies worldwide. At this point Sakaguchi set in motion his long-held ambition to produce digital humans, selecting a studio for Square Co. Ltd. to produce the film approximately halfway between Tokyo and Hollywood – Hawaii. In a large, open studio space at Diamond Head, 16 motion capture cameras were employed to store almost two thousand shots of human performers. No scanning of human faces was involved; all facial information was 'painted' by CG artists. In November 2002, *National Geographic* published images from graphics demonstrations by Dr Henrik wann Jensen of the computer graphics laboratory at Stanford University, showing a digital skin generated from a 13,000,000 polygon scan of a model's photograph. The aim was to produce a still image of human skin with accurate simulations of light reflections – when light enters skin, it is scattered by the translucent cells beneath its surface. The technique is being developed to assist in the production of surgical simulations, but Jensen predicts that such detailed skin will also adorn future generations of virtual actor (see Swerdlow 2001).

5 From the front cover of *Empire* 147, September 2001.

6 See, for example, 'Aki Ross – CGI Goddess' <www.angelfire.com/movies/akiross/>, or the 'Aki Ross Shrine' at <http:/temoto.co.uk/aki/>.

7 In *The Film Sense*, Eisenstein answers the possible question that an actor's continuous, consistent performance must clash with the principle of montage as a series of separate actions compiled to produce a new meaning which they do not possess inherently until placed into an order by the director. He instructs us to look for montage within the actor's performance itself. He urges the actor to acknowledge facts about the character in order to assess how that character would react in a particular situation, constructing a performance from fragments of necessary information rather than by full immersion in the inner life of the person he is portraying. The actor forces himself to imagine pictures and images, for instance emerging from the possible consequences of his character's actions, which will produce a corresponding emotion in him – for example, a man about to commit a murder picturing his arrest and execution will mime a considerable level of apprehension. The actor's response to his own imaginings reflects the imitative response in the audience (see 1986: 37–43).

8 On 28 May 1936, Turing submitted his paper 'On Computable Numbers with an Application to the *Entschiedungsproblem*', published the following year. In it, he defined his own system of 'computable' numbers comprising rational (those numbers expressible by a fraction) and irrational numbers. He was trying to find 'whether there was a mechanical method that could be applied that would generate the decimal digits' of a particular number (Agar 2001: 86–7). The square root of 2, for instance, is a computable number because there is a method which can be applied to generate its infinite decimal representation (1.4142...). Turing went on to imagine a machine that could be used to generate and work with computable numbers. Since 1927, the Government Code and Cypher School, based at Bletchley Park, has guarded its secrets very closely, so the aspects of British computing

which benefited from its resources are somewhat hidden from history. When the plans for a stored-program computer called EDVAC were unveiled at a summer school in 1946, it is possible that the proposals (published under the name of John von Neumann but principally authored by J. Presper Eckert and John Mauchly) had been similarly mooted at Bletchley Park during World War Two, but could not be acknowledged officially (Agar 2001: 116).

9 The test is an imitative exercise, suggesting that the best way to develop computers is to model them on human capabilities. But it also has the air of magic about it. The computer is hidden, answering questions as a spiritualist would ask of a 'ghost' to ascertain its identity – an interrogator/spectator attempts to discern where the trick is taking place, where he is being deceived.

10 IBM was able to expand to an enormous commercial company (by 1965, their series of compatible systems, from militarily-focused supercomputers to small office machines, was generating about $5,000,000,000,000 a year), partly due to US military investment in computers expanded by the Cold War. As Agar remarks, 'the Cold War produced computers, while the computer also became a guiding metaphor for the Cold War' (2001: 136). When the US Navy and Air Force jointly co-funded the prototype Whirlwind computer at MIT in 1951, it was 'to form the centre of the United States' real-time command and control system, SAGE, that collected together the data from radar stations surrounding the country, displayed incoming bombers, and controlled the response' (Agar 2001: 137). SAGE was a technologised system which represented the computerisation of borders and their automated protection devices. IBM built 56 computers for it, and was paid $30m for each.

11 By far the greatest single segment of the production budget for *Spider-Man 2* went on visual effects, with approximately $65m of the total $200m (though more than that may have been spent on global marketing and merchandising (see Thomas 2004).

12 See, for example, *The Invisible Man Returns* (Joe May, 1940), *The Invisible Woman* (A. Edward Sutherland, 1940), *Invisible Agent* (Edwin L. Marin, 1942), *Abbott and Costello Meet the Invisible Man* (Charles Lamont, 1951), *The Amazing Transparent Man* (Edgar G. Ulmer, 1960), *Memoirs of an Invisible Man* (John Carpenter, 1992), *Invisible Mom* (Fred Olen Ray, 1995).

13 Both advertisements can be viewed at Massive's official website: <http://www.massivesoftware.com/>.

BIBLIOGRAPHY

Abel, R. (2000) 'The Cinema of Attractions in France, 1896–1904', in L. Grieveson and P. Krämer (eds) *The Silent Cinema Reader*. London and New York: Routledge, 63–75.

_____ (2005) 'Introduction', in *Encyclopedia of Early Cinema*. London: Routledge, xxix–xxx.

_____ (ed.) (2005) *Encyclopedia of Early Cinema*. London: Routledge.

Adorno, T. (1991) 'The Schema of Mass Culture', in J. M. Bernstein (ed.) *The Culture Industry: Selected Essays on Mass Culture*. London: Routledge, 54–5.

Adorno, T. and M. Horkheimer (1986 [1944]) *Dialectic of Enlightenment*, trans. J. Cumming. London: Verso.

Agar, J. (2001) *Turing and the Universal Machine*. Duxford, Cambridge: Icon.

Agel, J. (1970) *The Making of Kubrick's 2001*. New York: New American Library.

Alberoni, F. (1972) 'The Powerless Elite: Theory and Sociological Research on the Phenomenon of the Stars', in D. McQuail (ed.) *Sociology of Mass Communications*. London: Penguin, 75–98.

Aldiss, B. (2001) *Supertoys Last All Summer Long and Other Stories of Future Time*. London: Orbit.

Allen, D. (1976) 'Dramatic Principles in Stop Motion', in H. Geduld and R. Gottesman (eds) *The Girl in the Hairy Paw: King Kong as Myth, Movie and Monster*. New York: Avon, 185–7.

Allen, J. (1980) 'The Industrial Context of Film Technology: Standardisation and Patents', in T. de Lauretis and S. Heath (eds) *The Cinematic Apparatus*. London and Basingstoke: MacMillan, 26–36.

Allen, R. (1995) *Projecting Illusion: Film Spectatorship and the Impression of Reality.* Cambridge/New York: Cambridge University Press.

Anderson, A. (1894) *How to do Forty Tricks with Cards.* New York: Frank Tousey.

Anon. (1853) 'Untitled Column', *Chambers's Edinburgh Journal*, January, 26.

____ (1861) 'Magic and Science', *All the Year Round*, 23 March, 561–6.

____ (1880) *The Secrets of Ancient and Modern Magic: or The Art of Conjuring Unveilled.* New York: M. Young.

____ (1882) 'Conjuring Contretemps', *Chambers's Journal*, 16 December, 800–4.

____ (1893) *The Black Art, or, Magic Made Easy.* New York: De Witt.

____ (1897) 'Side Shows IV', *The Strand*, June, 774–80.

____ (1982) 'Special Effects for *Star Trek II: The Wrath of Khan*', *American Cinematographer*, 63, 10, 1030.

Anthony, B. (2001) 'Introduction to "Natural Magic"', *Living Pictures*, 1, 1, 85–98.

Appignanesi, R. (ed.) (2002) *Postmodernism and Big Science.* Cambridge: Icon.

Archer, S. (1993) *Willis O'Brien: Special Effects Genius.* Jefferson NC and London: McFarland.

Armes, R. (1978) *A Critical History of British Cinema.* London: Secker and Warburg.

Arnheim, R. (1958) *Film as Art.* London: Faber and Faber.

Asimov, I. (1952) *I, Robot.* London: Grayson and Grayson.

____ (1968) *The Rest of the Robots.* St. Albans: Panther.

Askwith, I. (2003) 'Gollum: Dissed by the Oscars?', *Salon*, 18 February. <http://dir.salon.com/story/tech/feature/2003/02/18/gollum/index.html> (accessed 8 September 2006).

Astheimer, P., E. Dai, M. Gobel, R. Knase, S. Miller and G. Zachmann (1994) 'Realism in Virtual Reality', in N. M. Thalmann and D. Thalmann (eds) *Artificial Life and Virtual Reality.* Chichester/New York/Brisbane/Toronto/Singapore: John Wiley and Sons, 189–210.

Axmaker, S. (2001) 'Final Fantasy is a Blast Visually but Fizzles Emotionally', *The Seattle Post-Intelliencer*, 11 July. <http://seattlepi.nwsource.com/movies/30747_fantasyq.shtml> (accessed 1 September 2006).

Bacon, G. (1902) 'The Story of the Egyptian Hall', *The English Illustrated Magazine*, 28, 231, 298–308.

Baird, R. (1998) 'Animalizing *Jurassic Park*'s Dinosaurs: Blockbuster Schemata and Cross-Cultural Cognition in the Threat Scene', *Cinema Journal*, 37, 4, 82–103.

Baker, R. (1993) 'Computer Technology and Special Effects in Contemporary Cinema', in P. Hayward and T. Wollen (eds) *Future Visions: New Technologies of the Screen.* London: British Film Institute, 31–45.

Balázs, B. (1974) 'The Face of Man', in G. Mast and M. Cohen (eds) *Film Theory and Criticism: Introductory Readings.* New York: Oxford University Press, 187–94.

Balides, C. (2000) 'Jurassic Post-Fordism: Tall Tales of Economics in the Theme Park', *Screen*, 41, 2, 139–60.

Barker, M. and T. Austin (2000) *From Antz to Titanic: Reinventing Film Analysis.* London: Pluto.

Barnouw, E. (1981) *The Magician and the Cinema*. New York: Oxford University Press.

Barsacq, L. (1976) *Caligari's Cabinet and Other Grand Illusions: A History of Film Design*. Boston: New York Graphic Society.

_____ (1985) *Le Décor de Film: 1895–1969*. Paris: Henri Veyrier.

Barthes, R. (1982) *Camera Lucida: Reflections on Photography*, trans. R. Howard. London: Cape.

Batory, R. D. and W. A. S. Sarjeant (1989) 'Sussex Iguanadon Footprints and the Writing of *The Lost World*', in D. D. Gillette and M. G. Lockley (eds) *Dinosaur Tracks and Traces*. Cambridge: Cambridge University Press, 13–18.

Baudrillard, J. (1983) *Simulations*. New York: Semiotext.

_____ (1995) *The Gulf War Did Not Take Place*, trans. P. Patton. Bloomington: Indiana University Press.

Baxter, J. (2000) *George Lucas: A Biography*. London: HarperCollins.

Baylis, P. (2003) 'Weekend Beat: In Quest of the "Holy Grail" of the Truly Lifelike Digital Actor', *The Asahi Shimbun*, 7 June. <http://www.asahi.com/english/weekend/K2003060700271.html> (accessed 12 August 2003).

Bazin, A. (1967) *What is Cinema?: Volume I*, trans. H. Gray. Berkeley: University of California Press.

_____ (1971) 'An Aesthetic of Reality: Neorealism' in *What is Cinema?: Volume II*, trans. H. Gray. Berkeley: University of California Press, 16–40.

_____ (1996) *Bazin at Work: Major Essays and Reviews from the Forties and Fifties*, ed. B. Cardullo, trans. A. Piette and B. Cardullo. New York: Routledge.

Beaumont, K. (2003) 'The Man Behind the Monster', *Technology Review*, 1 November. <http://www.technologyreview.com/BioTech/13348/> (accessed 4 September 2005).

Belton, J. (1993) *Widescreen Cinema*. Cambridge, MA: Harvard University Press.

_____ (ed.) (1996) *Movies and Mass Culture*. New Brunswick: Rutgers University Press.

Bendazzi, G. (1994) *Cartoons: One Hundred Years of Cinema Animation*. London: John Libbey.

Bender, A. K. (1963) *Flying Saucers and the Three Men in Black*. London: Neville Spearman.

Benjamin, M. (2003) *Rocket Dreams: How the Space Age Shaped our Vision of a World Beyond*. London: Chatto and Windus.

Benjamin, W. (1970) *Illuminations*, ed. H. Arendt. London: Jonathan Cape.

Bentley, P. J. (2001) *Digital Biology: The Creation of Life Inside Computers and How it will Affect Us*. London: Headline.

Bergman, A. (1991) *We're in the Money: Depression America and its Films*. New York: New York University Press.

Biocca, F. and M. R. Levy (1995) *Communication in the Age of Virtual Reality*. Hillside, NJ: L.Erlbaum Associates.

Biskind, P. (1983) *Seeing is Believing: How Hollywood Taught us to Stop Worrying and Love the Fifties*. London: Pluto.

_____ (1999) *Easy Riders, Raging Bulls: How the Sex 'n' Drugs 'n' Rock 'n' Roll Generation Saved Hollywood*. London: Bloomsbury.

Bizony, P. (1994) *2001: Filming the Future*. London: Aurum.

_____ (2001) *Digital Domain*. London: Aurum.

Blackham, R. (2006) *The Roots of Tolkien's Middle-earth*. Stroud: Tempus.

Bolter, J. D. and R. Grusin (2000) *Remediation: Understanding New Media*. Cambridge, MA: MIT Press.

Booth, M. R. (1981) *Victorian Spectacular Theatre 1850–1910*. London: Routledge and Kegan Paul.

_____ (1991) *Theatre in the Victorian Age*. Cambridge: Cambridge University Press.

Bordwell, D. (2006) *The Way Hollywood Tells It: Story and Style in Modern Movies*. Berkeley: University of California Press.

Bordwell, D., J. Staiger and K. Thompson (1985) *The Classical Hollywood Cinema: Film Style and Mode of Production to 1960*. London: Routledge and Kegan Paul.

Borger, J. (2002) 'Wake-up call', *The Guardian: G2*, 6 September, 2–3.

Bottomore, S. (1999) 'The Panicking Audience?: Early Cinema and the "Train Effect"', *Historical Journal of Film, Radio and Television*, 19, 2, 177–216.

Boullet, J. (1976) 'Willis O'Brien, or the Birth of a Film from Design to Still', in H. Geduld and R. Gottesman (eds) *The Girl in the Hairy Paw*. New York: Avon, 107–10.

Brecht, B. (1974 [1938]) 'Against Georg Lukács', *New Left Review*, 84, March/April, 39–53.

Brewster, B. and L. Jacobs (1997) *Theatre to Cinema: Stage Pictorialism and the Early Feature Film*. Oxford: Oxford University Press.

Brooks, R. A. (2002) *Robot: The Future of Flesh and Machines*. London: Penguin.

Brosnan, J. (1974) *Movie Magic: The Story of Special Effects in the Cinema*. London: MacDonald and Jane's.

_____ (1991) *The Primal Screen: A History of Science Fiction Film*. London: Orbit.

Bukatman, S. (1993) *Terminal Identity: The Virtual Subject in Postmodern Science Fiction*. Durham, NC, and London: Duke University Press.

_____ (2003) *Matters of Gravity: Special Effects and Supermen in the 20th Century*. Durham, NC and London: Duke University Press.

Burch, N. (1990) *Life to Those Shadows*, trans. B. Brewster. London: British Film Institute.

Burnett, T. (2005) *Who Really Won the Space Race?: Uncovering the Conspiracy That Kept America Second to the Russians*. London: Collins and Brown.

Burns, E. (1972) *Theatricality*. London: Longman.

Butler, S. (1970) *Erewhon*. Harmondsworth: Penguin.

Cadbury, D. (2001) *The Dinosaur Hunters*. London: Fourth Estate.

_____ (2006) *Space Race: The Battle to Rule the Heavens*. London: Harper Perennial.

Caldwell, J. T. (2000 [1995]) 'Modes of Production: The Televisual Apparatus', in R. Stam and T. Miller (eds) *Film Theory: An Anthology*. Oxford: Blackwell, 125–43.

Campbell, J. (1953) *The Hero with a Thousand Faces*. New York: Pantheon.

Campbell, M. S. (1997) ' "An Enjoyable Game": How HAL Plays Chess', in D. G. Stork (ed.) *Hal's Legacy: 2001's Computer as Dream and Reality*. London and Cambridge, MA: MIT Press, 74–99.

Canemaker, J. (1975) 'Winsor McCay', *Film Comment*, 11, 1, 44–7.

Cannel, J. C. (1931) *The Secrets of Houdini*. London: Hutchinson.

Capa, C. and R. Whelan (eds) (1985) *Robert Capa: Photographs*. New York: Alfred A Knopf.

Capek, K. (1969) *R.U.R.: Rossum's Universal Robots*, trans. P. Selver. Oxford: Oxford University Press.

Carpenter, B. E. and R. W. Doran (eds) (1986) *A. M. Turing's ACE Report and Other Papers*. Cambridge, MA: MIT Press.

Carroll, N. (1988) *Philosophical Problems of Classical Film Theory*. Princeton, NJ: Princeton University Press.

____ (1996) *Theorizing the Moving Image*. Cambridge: Cambridge University Press.

____ (1998) *Interpreting the Moving Image*. Cambridge: Cambridge University Press.

Carter, C. J. (1903) *Magic and Magicians – A Full Exposé of Modern Miracles*. New York and Chicago: Will Rossiter.

Cartwright, L. (1998) 'Science and the Cinema', in N. Mirzoeff (ed.) *The Visual Culture Reader*. London: Routledge, 199–213.

Casetti, F. (1999) *Theories of Cinema, 1945–1995*, trans. F. Chiostri, E. G. Bartolini-Salimbeni and T. Kelso. Austin: University of Texas Press.

Ceram, C. W. (1965) *Archaeology of the Cinema*, trans. R. Winston. London: Thames and Hudson.

Chalfont, A. (1985) *Star Wars: Suicide or Survival*. London: Weidenfeld and Nicolson.

Chanan, M. (1996) 'The Treats of Trickery', in C. Williams (ed.) *Cinema: The Beginnings and the Future*. London: University of Westminster Press, 117–22.

Chardère, B. (1995) *Les Images des Lumière*. Paris: Gallimard.

Chion, M. (2001) *2001: Kubrick's Cinema Odyssey*, trans. C. Gorbman. London: British Film Institute.

Cholodenko, A. (1991) 'Introduction', in *The Illusion of Life: Essays on Animation*. Sydney: Power Publications, 9–36.

____ (ed.) (1991) *The Illusion of Life: Essays on Animation*. Sydney: Power Publications.

Chomette, H. (1988 [1925]) 'Second Stage', in R. Abel (ed.) *French Film Theory and Criticism: A History/Anthology Volume 1: 1907–1929*. Princeton, NJ: Princeton University Press, 371–2.

Christie, I. (1994) *The Last Machine: Early Cinema and the Birth of the Modern World*. London: BBC Educational Developments/British Film Institute.

____ (2004) 'Forms 1890–1930: The Shifting Boundaries of Art and Industry', in M. Temple and M. Witt (eds) *The French Cinema Book*. London: Routledge, 50–64.

Clark, F. P. (1966) *Special Effects in Motion Pictures*. New York: Society of Motion Picture and Television Engineers.

Clarke, A. C. (1972) 'The Birth of HAL', in A. C. Clarke (ed.) *The Lost Worlds of 2001*. London: Sedgwick and Jackson, 76–9.

Clarke, D. and A. Roberts (2002) *Out of the Shadows: UFOs, The Establishment and the Official Cover-Up*. London: Piatkus.

Clipson, R. (1999) 'Capturing the Motion', *Image Technology*, 81, 1, 5.

Cohen, K. F. (2002) 'Winsor McCay's Animation Lesson Number One, 1919', *Animation World Magazine*. <http://mag.awn.com/index.php?article_no=1557> (accessed 7 January 2006).

Comolli, J.-L. (1980) 'Machines of the Visible', in T. de Lauretis and S. Heath (eds) *The Cinematic Apparatus*. London and Basingstoke: MacMillan, 121–42.

Connor, S. (1997) *Postmodernist Culture: An Introduction to Theories of the Contemporary*. Oxford: Blackwell.

Corman, R. (1990) *How I Made a Hundred Movies in Hollywood and Never Lost a Dime*. London: Muller.

Cosandey, R. (1991) 'Georges Méliès as L'Inescamotable Escamoteur: A Study in Recognition', in P. Cherchi Usai (ed.) *Lo Schermo Incantato: Georges Méliès (1861–1938)*. Gemona: Le Giornate del Cinema Muto/International Museum of Photography at George Eastman House/Edizioni Biblioteca dell'Immagine, 57–111.

Cotton, B. and R. Oliver (1994) *The Cyberspace Lexicon: An Illustrated Dictionary of Terms from Multimedia to Virtual Reality*. London: Phaidon.

Cowling, M. (ed.) (1998) *The Communist Manifesto: New Interpretations*. Edinburgh: Edinburgh University Press.

Crafton, D. (1982) *Before Mickey: The Animated Film 1898–1928*. Cambridge, MA: MIT Press.

____ (1999) *The Talkies: American Cinema's Transition to Sound, 1926–31*. Berkeley and London: University of California Press.

Creed, B. (2000) 'The Cyberstar: Digital Pleasures and the End of the Unconscious', *Screen*, 41, 1, 79–86.

Cubitt, S. (1998) *Digital Aesthetics*. London: Sage Publications.

____ (1999) 'Phalke, Méliès, and Special Effects Today', *Wide Angle*, 21, 1, 114–30.

____ (2003) *The Cinema Effect*. Cambridge, MA and London: MIT Press.

Cumings, B. (1994) 'The Politics of Television in the Gulf War', in J. O'Loughlin, T. Mayer and E. S. Greenberg (eds) *War and its Consequences: Lessons from the Persian Gulf Conflict*. New York: HarperCollins College Publishers, 137–54.

Curtis, D. (1971) *Experimental Cinema: A Fifty Year Evolution*. London: Studio Vista.

Dale, R. C. (1976) 'Narrative, Fable and Dream in *King Kong*', in H. Geduld and R. Gottesman (eds) *The Girl in the Hairy Paw*. New York: Avon, 117–21.

Darley, A. (1990) 'From Abstraction to Simulation: Notes on the History of Computer Imaging', in P. Hayward (ed.) *Culture, Technology and Creativity in the Late Twentieth Century*. London: John Libbey, 39–64.

____ (2000) *Visual Digital Culture: Surface Play and Spectacle in New Media Genres*. London and New York: Routledge.

____ (2003) 'Simulating Natural History: *Walking With Dinosaurs* as Hyper-Real Edutainment', *Science as Culture*, 12, 2, 228–56.

Darwin, C. (1985) *The Origin of Species*. London: Penguin.

Dawes, E. A. (1979) *The Great Illusionists*. Secaucus, NJ: Chartwell.

Dean, H. (1727) *The Whole Art of Legerdemain: or, Hocus Pocus in Perfection*, second edition. London: A. Bettesworth.

Debord, G. (1983) *The Society of the Spectacle*. Detroit: Black and Red.

____ (1990) *Comments on the Society of the Spectacle*. London: Verso.

Desowitz, B. (2005a) 'Oscar Nominees Discuss *Azkaban*, *I Robot* and *Spider-Man 2*', *VFX-World*, 24 February. <http://vfxworld.com/index.php?atype=articles&id=2406> (accessed 10 March 2005).

____ (2005b) '*King Kong*: Part 1 – The Creatures of Skull Island', *VFXWorld*, 14 December. <http://vfxworld.com/?atype=articles&id=2724> (accessed 22 December 2005).

Deutelbaum, M. (1979) 'Structural Planning in the Lumière Films', *Wide Angle*, 3, 1, 28–37.

Devant, D. (1915) *Tricks for Everyone: Clever Conjuring with Common Objects*. London: C. Arthur Pearson.

____ (1931) *My Magic Life*. London: Hutchinson and Co.

____ (1935) 'Illusion and Disillusion', *The Windsor Magazine*, 492, 117–25.

Devant, D. and N. Maskelyne (1911) *Our Magic: The Art in Magic, the Theory of Magic, the Practice of Magic*. London: G. Routledge.

Dietrich, E. (2001) 'Banbury Bound or Can a Machine be Conscious?', *Journal of Experimental and Theoretical Artificial Intelligence*, 13, 3, 177–80.

Dinsmore-Tully, U. (2000) 'The Pleasures of "Home Cinema", or Watching Movies on Telly: An Audience Study in Cinephiliac VCR Use', *Screen* 41, 3, 315–27.

Diprose, R. and C. Vasseleu (1991) 'Animation-AIDS in Science/Fiction', in A. Cholodenko (ed.) *The Illusion of Life: Essays on Animation*. Sydney: Power Publications, 145–60.

Dircks, H. (1864) *The Ghost! As Produced in the Spectre Drama: Popularly Illustrating the Marvellous Optical Illusions Obtained by the Apparatus Called the Dircksian Phantasmagoria*. London: Spon.

Dixon, W. W. (1994) 'The Doubled Image: Montgomery Tully's Boys in Brown and the Independent Frame process', in W. W. Dixon (ed.) *Reviewing British Cinema, 1900–1992*. New York: State University of New York Press, 18–32.

____ (1998) *The Transparency of Spectacle: Meditations on the Moving Image*. Albany: State University of New York Press.

Donelan, J. (2000) 'Designed to Please: Ananova', *Computer Graphics World*, 23, 6, 27–9.

Doyle, A. C. (1995) *The Lost World and Other Stories*. London: Wordsworth Editions.

Doyle, A. (2000) 'Lip Service', *Computer Graphics World*, 23, 8, 51–8.

Dreyfus, H. L. (1972) *What Computers Can't Do: A Critique of Artificial Reason*. New York: Harper and Row.

Duncan, J. (2000) 'Hitchcock Homage', *Cinefex*, 83, 57–66, 154.

____ (2002) 'Love and War', *Cinefex*, 90, 60–119.

____ (ed.) (2005) 'State of the Art: A *Cinefex* 25th Anniversary Forum', *Cinefex*, 100, 17–107.

During, S. (2002) *Modern Enchantments: The Cultural Power of Secular Magic*. Cambridge, MA and London: Harvard University Press.

Dyer, R. (1998) *Stars*. London: British Film Institute.

Ebert, R. (2001) 'Final Fantasy: The Spirits Within', *The Chicago Sun-Times*, 11 July. <http://www.suntimes.com/ebert/ebert_reviews/2001/07/071101.html> (accessed 1 September 2003).

Eco, U. (1982) 'Critique of the Image', in V. Burgin (ed.) *Thinking Photography*. London: MacMillan, 32–8.

____ (1986) *Faith in Fakes*, trans. W. Weaver. London: Secker and Warburg.

Eisenstein, S. M. (1986) *The Film Sense*, trans. J. Leyda. London: Faber and Faber.

____ (1997 [1924]) 'The Montage of Film Attractions', in P. Lehman (ed.) *Defining Cinema*. London: The Athlone Press, 17–36.

Elsaesser, T. (2000) *Metropolis*. London: British Film Institute.

Everett, R. (1902) 'The Best Tricks of Famous Magicians', *The Cosmopolitan*, December, 142–50.

Ezra, E. (2000) *Georges Méliès: The Birth of the Auteur*. Manchester: Manchester University Press.

Ferrell, R. (1991) 'Life-Threatening Life: Angela Carter and the Uncanny', in A. Cholodenko (ed.) *The Illusion of Life: Essays on Animation*. Sydney: Power Publications, 131–44.

Field, R. (2002) 'Getting the pictures together for the movies!', in *Image Technology*, 84, 6, 33–7.

Fielding, R. (1965) *The Technique of Special-Effects Cinematography*. London:Focal.

Finch, C. (1984) *Special Effects: Creating Movie Magic*. New York: Abbeville Press.

Fischer, L. (1983) 'The Lady Vanishes: Women, Magic and the Movies', in J. L. Fell (ed.), *Film Before Griffith*. Berkeley: University of California Press, 339–54.

Fitzsimons, R. (1980) *Death and the Magician: The Mystery of Houdini*. London: Hamish Hamilton.

Flanagan, M. (1999) 'Mobile Identities, Digital Stars and Post-Cinematic Selves', *Wide Angle*, 21, 1, 76–93.

Flynn, T. (1995a) 'Beyond Belief: The Curse of Clarity', *CSICOP* Online, 1 March. <http://www.csicop.org/sb/9503/curse.html> (accessed 13 September 2006).

____ (1995b) 'Beyond Belief: The Curse of Clarity Returns', *CSICOP* Online, 1 June. <http://www.csicop.org/sb/9506/clarity.html> (accessed 13 September 2006).

Fonstad, K. W. (1981) *The Atlas of Middle-earth*. Boston: Houghton Mifflin.

Fordham, J. (2002) 'Spin City', *Cinefex*, 90, 14–54, 123–30.

Foster, R. (1978) *The Complete Guide to Middle-earth: From the Hobbit to the Silmarillion*. London: Allen and Unwin.

French, R. M. (1996) 'Subcognition and the Turing Test', in P. J. R. Millican and A. Clark (eds) *Machines and Thought: The Legacy of Alan Turing Vol.1*. Oxford: Clarendon Press, 11–26.

Freud, S. (2003 [1919]) *The Uncanny*, trans. D. McLintock. London: Penguin.

Galbraith IV, S. (1998) *Monsters are Attacking Tokyo! The Incredible World of Japanese Fantasy Films*. Venice, CA: Feral House.

Garenne, H. (c.1879) *The Art of Modern Conjuring, Magic, and Illusions*. London: Ward, Lock and Co.

Gentleman, W. (1982) 'Visual Effects as a Cinematic Art Form', *American Cinematographer*, 63, 1, 32–3, 80–1, 87–9.

Gettings, F. (1978) *Ghosts in Photographs: The Extraordinary Story of Spirit Photography*. New York: Harmony Books.

Geuens, J. (1996) 'Through the Looking Glass: From the Camera Obscura to Video Assist', *Film Quarterly*, 49, 3, 16–25.

Gibson, W. (1995) *Neuromancer*. London: HarperCollins.

____ (1997) *Idoru*. London: Penguin.

____ (2001) 'Modern Boys and Mobile Girls', *The Observer Magazine*, 1 April, 8-11.

Gilfillan, S. C. (1935) *The Sociology of Invention*. Chicago: Follett.

Gillette, D. D. and M. G. Lockley (1989) *Dinosaur Tracks and Traces*. Cambridge: Cambridge University Press.

Girgus, S. B. (1998) *Hollywood Renaissance: The Cinema of Democracy in the Era of Ford, Capra and Kazan*. Cambridge: Cambridge University Press.

Godwin, J. (1979) *Athanasius Kircher*. London: Thames and Hudson.

Golden, J. (2005) *King Kong: The Official Novelisation*. London: Pocket Books.

Goldner, O. and G. E. Turner (1975) *The Making of King Kong: The Story Behind a Film Classic*. London: The Tantivy Press.

Goleman, D. (1995) *Emotional Intelligence*. New York: Bantam.

Graham, E. L. (2002) *Representations of the Post/Human: Monsters, Aliens and Others in Popular Culture*. Manchester: Manchester University Press.

Grau, O. (2003) *Virtual Art: From Illusion to Immersion*, trans. G. Custance. Cambridge, MA: MIT Press.

Gray, J. (2006) 'Bonus Material: The DVD Layering of *The Lord of the Rings*', in E. Mathijs (ed.) *The Lord of the Rings: Popular Culture in Global Context*. London: Wallflower Press, 238–53.

Grey, I. (1997) *Sex, Stupidity and Greed*. New York: Juno.

Grey, R. (1994) *Nightmare of Ecstasy: The Life and Art of Edward D. Wood, Jnr*. London: Faber and Faber.

Grieveson, L. and P. Krämer (2004) *The Silent Cinema Reader*. London and New York: Routledge.

Grindon, L. (1994) 'The Role of Spectacle and Excess in the Critique of Illusion', *Postscript*, 13, 2, 35–43.

Groom, W. (1994) *Forrest Gump*. London: Black Swan.

Grossberg, J. (2001) 'Revamped *E.T.* Courts Controversy', *E! Online*, 2 November. <http://www.eonline.com/News/Items/0,1,9065,00.html> (accessed 2 August 2005).

Grundberg, A. (1990) *Crisis of the Real: Writings on Photography, 1974–1989*. New York: Aperture.

Guins, R. (2002) 'From Senseless Acts of Violence to Seamless Acts of Visibility: "Film Censorship" in the Age of Digital Compositing', *New Formations*, 46, Spring, 23–33.

Gunning, T. (1983) 'An Unseen Energy Swallows Space: The Space in Early Film and Its Relation to American Avant-Garde Film', in J. L. Fell (ed.) *Film Before Griffith.* Berkeley and London: University of California Press, 355–66.

_____ (1990) 'The Cinema of Attractions: Early Film, Its Spectator and the Avant-Garde', in T. Elsaesser (ed.) *Early Cinema: Space Frame Narrative.* London: British Film Institute, 56–62.

_____ (1995) 'An Aesthetic of Astonishment: Early Film and the (In)credulous Spectator', in L. Williams (ed.) *Viewing Positions: Ways of Seeing Film.* New Brunswick, NJ: Rutgers University Press, 114–33.

_____ (2000) '"Now You See It, Now You Don't": The Temporality of the Cinema of Attractions', in L. Grieveson and P. Krämer (eds) *The Silent Cinema Reader.* London and New York: Routledge, 41–50.

_____ (2001) 'The Ghost in the Machine: Animated Pictures at the Haunted Hotel of Early Cinema', *Living Pictures*, 1, 1, 3–17.

Prof. Haffner (1894) *How to do Tricks with Cards.* New York: Frank Tousey.

Haraway, D. (1991) *Simians, Cyborgs and Women: The Reinvention of Nature.* London: Free Association Books.

Hardy, P. (ed.) (1984) *The Aurum Film Encyclopedia: Science Fiction.* London: Aurum.

Hark, I. R. (2001) '"Daddy, Where's the FBI Warning?": Constructing the Video Spectator', in M. Tinkcom and A. Villarejo (eds) *Keyframes: Popular Cinema and Cultural Studies.* London: Routledge, 72–81.

Harlow, J. (2005) 'Prim Hollywood's "Digital Boob Jobs"', *The Times* Online, 29 May. <http://www.timesonline.co.uk/article/0,,2089-1632031,00.html> (accessed 17 August 2005).

Harryhausen, R. and T. Dalton (2003) *Ray Harryhausen: An Animated Life.* London: Aurum.

Haskell, M. (1974) *From Reverence to Rape.* New York: Holt Rinehart and Winston.

Hayles, N. K. (1999) *How we Became Posthuman: Virtual Bodies in Cybernetics, Literature, and Informatics.* Chicago and London: University of Chicago Press.

Hayward, P. and Wollen, T. (1993) 'Introduction: Surpassing the Real', in *Future Visions: New Technologies of the Screen.* London: British Film Institute, 1–9.

_____ (eds) *Future Visions: New Technologies of the Screen.* London: British Film Institute.

Hayward, S. (2002) *Cinema Studies: The Key Concepts*, second edition. London: Routledge.

Healy, R. J. and J. F. McComas (eds) (1946) *Adventures in Time and Space.* New York: Random House.

Heath, S. (1976) 'Narrative Space', *Screen*, 17, 3, 68–112.

_____ (1980) 'The Cinematic Apparatus: Technology as Historical and Cultural Form', in T. de Lauretis and S. Heath (eds) *The Cinematic Apparatus.* London and Basingstoke: MacMillan, 1–13.

Heidegger, M. (1977 [1954]) 'The Question Concerning Technology', in D. F. Krell (ed.) *Martin Heidegger: Basic Writings.* San Francisco: Harper Collins, 283–317.

Heinlein , R. A. (1972) 'Shooting Destination Moon', in Johnson, W. (ed.) *Focus on the Science Fiction Film*. Englewood Cliffs, NJ: Prentice Hall, 52–65.

Henry, J. (2002) *Knowledge is Power: How Magic, the Government and an Apocalyptic Vision Inspired Francis Bacon to Create Modern Science*. Cambridge: Icon.

Hepworth, C. M. (1957) *Came the Dawn: Memories of a Film Pioneer*. London: Phoenix House.

Herbert, S. (ed.) (1994) *When the Movies Began...: A Chronology of the World's Film Productions and Film Shows Before May 1896*. London: The Projection Box.

____ (ed.) (1996) *Victorian Film Catalogues*. London: The Projection Box.

____ (ed.) (1999) *A History of Early Film*. London: Routledge.

____ (ed.) (2004) *Eadweard Muybridge: the Kingston Museum Bequest*. London: The Projection Box.

Herbert, S. and L. McKernan (eds) (1996) *Who's Who of Victorian Cinema: A Worldwide Survey*. London: British Film Institute.

Herrmann, A. (1892) 'Light on the Black Art', *The Cosmopolitan*, December, 208–14.

Hertz, C. (1924) *A Modern Mystery Merchant*. London: Hutchinson.

Higson, A. (2002) 'Cecil Hepworth, Alice in Wonderland and the Development of the Narrative Film', in A. Higson (ed.) *Young and Innocent? The Cinema in Britain 1896–1930*. Exeter: Exeter University Press, 42–64.

Higuinen, E. and C. Tesson (2002) 'Jeux Vidéo: La Nouvelle Alliance du Film et du Jeu', *Cahiers du Cinéma*, 565, 10–17.

Hillis, K. (1999) *Digital Sensations: Space, Identity and Embodiment in Virtual Reality*. Minneapolis, MN: University of Minnesota Press.

Hoberman, J. (2000) 'Burn, Blast, Bomb, Cut', *Sight and Sound*, 10, 2, 18.

Hodges, A. (1983) *Alan Turing: The Enigma*. London: Burnett.

Holman, L. B. (1975) *Puppet Animation in the Cinema: History and Technique*. London: The Tantivy Press.

Hopkins, A. (ed.) (1977) *Magic: Stage Illusions and Scientific Diversions*. New York: Arno.

Hughes, J. (2002) *The Manhattan Project: Big Science and the Atom Bomb*. Cambridge: Icon.

Hunningher, J. (1996) 'Premiere on Regent Street', in C. Williams (ed.) *Cinema: The Beginnings and the Future*. London: University of Westminster Press, 41–54.

Iles, T. (2001a) 'Independent Frame: The Forgotten Revolution', *Image Technology*, 83, 5, 17–25.

____ (2001b) 'Independent Frame: The Forgotten Revolution Part 2', *Image Technology*, 83, 6, 23–9.

____ (2001c) 'The New Information: Independent Frame Part 3', *Image Technology*, 83, 7, 34–7.

____ (2001d) 'The Project Begins: Independent Frame Part 4', *Image Technology*, 83, 8, 34–7.

____ (2001e) 'Equipment Information: Independent Frame: The Forgotten Revolution Part 5', *Image Technology*, 83, 9, 33–7.

____ (2001f) 'Tying Up Loose Ends: Independent Frame Part 6', *Image Technology*, 83, 10, 34–7.

Imes, J. (1984) *Special Visual Effects*. New York: Van Nostrand Reinhold Company.

James, G. (2002) 'Out of their Minds', *Red Herring*, 116, 23 August, 50–4.

Jancovich, M. (1992) *Horror*. London: Batsford.

____ (1996) *Rational Fears: American Horror in the 1950s*. Manchester: Manchester University Press.

Jenks, T. (1901) 'A Modern Magician', *St. Nicholas Magazine*, April, 512–20.

Jenness, G. A. (1967) *Maskelyne and Cooke, Egyptian Hall, London, 1873–1904*. Enfield, Middlesex.

Jentsch, E. (1995) 'On the Psychology of the Uncanny', trans. R. Sellars, *Angelaki* 2, 7–16.

Johnson, W. (ed.) (1972) *Focus on the Science Fiction Film*. Englewood Cliffs, NJ: Prentice Hall.

Jung, C. G. (1959) *Flying Saucers: A Modern Myth of Things Seen in the Sky*. London: Routledge and Kegan Paul.

Kelly, K. (1995) *Out of Control: The New Biology of Machines*. London: Fourth Estate.

Kennedy, C. (2001) 'Electric Dreams', *Empire*, 12, 9, 86–90.

Kennedy, X. J. (1972) 'Who Killed King Kong?', in R. Huss and T. J. Ross (eds) *Focus on the Horror Film*. Englewood Cliffs, NJ: Prentice Hall, 106–9.

Kessler, F. (2005) 'Trick Films', in R. Abel (ed.) *Encyclopedia of Early Cinema*. London: Routledge, 643–5.

Kilkelly, D. (2005) 'Kutcher's Kabbalah Bracelet Removed', *Digital Spy*, 16 April. <http://www.digitalspy.co.uk/article/ds20692.html > (accessed 1 November 2006).

Killheffer, R. K. J. (1991) 'Living Illusions', *Omni*, 13, 1, 50–3.

King, G. (2000) *Spectacular Narratives: Hollywood in the Age of the Blockbuster*. London: I. B. Tauris.

____ (2002) *New Hollywood Cinema: An Introduction*. London: I. B. Tauris.

King, G. and T. Krzywinska (2000) *Science Fiction Cinema: From Outerspace to Cyberspace*. London: Wallflower Press.

Klein, N. M. (2000) 'Animation and Animorphs: A Brief Disappearing Act', in V. Sobchack (ed.) *Meta-Morphing: Visual Transformation and the Culture of Quick Change*. Minneapolis, MN: University of Minnesota Press, 21–39.

____ (2004) *The Vatican to Vegas: A History of Special Effects*. New York and London: The New Press.

De Klerk, N. (1999) 'A Few Remaining Hours: News Films and the Interest in Technology in Amsterdam Film Shows, 1896–1910', *Film History*, 11, 3, 5–17.

Klevan, A. (2005) *Film Performance: From Achievement to Appreciation*. London: Wallflower Press.

Klinger, B. (1989) 'Digressions at the Cinema: Reception and Mass Culture', *Cinema Journal*, 28, 4, Summer, 3–19.

Knight, G. (1896) '"Professor Hoffmann" and Conjuring', *Windsor Magazine*, September, 362–4.

Kolker, R. (1983) *The Altering Eye: Contemporary International Cinema*. New York: Oxford University Press.

Koslovic, A. K. (2003) 'Technophobic Themes in Pre-1990 Computer Films', *Science as Culture*, 12, 3, 341–73.

Kovács, K. S. (1983) 'Georges Méliès and the Féerie', in J. L. Fell (ed.) *Film Before Griffith*. Berkeley and London: University of California Press, 244–57.

Kracauer, S. (1997) 'Basic Concepts', in P. Lehman (ed.) *Defining Cinema*. London: Athlone Press, 97–110.

Krueger, M. W. (1983) *Artificial Reality*. Reading, MA: Addison-Wesley.

Kuhn, A. (ed.) (1990) *Alien Zone: Cultural Theory and Contemporary Science Fiction Cinema*. London: Verso.

_____ (1999) 'Introduction', in *Alien Zone II: The Spaces of Science Fiction Cinema*. London and New York: Verso, 1–8.

_____ (ed.) (1999) *Alien Zone II: The Spaces of Science Fiction Cinema*. London and New York: Verso.

Kurzweil, R. (2000) 'Merging Human and Machine', *Computer Graphics World*, 23, 8, 23–4.

_____ (2002) 'Reflections on *S1m0ne*', *Kurzweilai.net*. No date. <http://www.kurzweilai.net/meme/frame.html?main=/articles/art0514.html> (accessed 24 June 2003).

Lamb, G. (1976) *Victorian Magic*. London: Routledge and Kegan Paul.

Lamont, P. and R. Wiseman (2005) *Magic in Theory: An Introduction to the Theoretical and Psychological Elements of Conjuring*. Hatfield: Hertfordshire University Press.

Landon, B. (1992) *The Aesthetics of Ambivalence: Rethinking Science Fiction Film in the Age of Electronic (Re)Production*. Westport, CT and London: Greenwood Press.

_____ (2002) 'Synthespians, Virtual Humans, and Hypermedia: Emerging Contours of Post-SF Film', in V. Hollinger and J. Gordon (eds) *Edging into the Future: Science Fiction and Contemporary Cultural Transformation*. Philadelphia: University of Pennsylvania Press, 55–72.

Langton, C. (ed.) (1989) *Artificial Life*. Redwood City, CA: Addison-Wesley.

Lauria, R. and H. M. White (1995) 'Mythic Analogues of the Space and the Cyberspace: A Critical Analysis of U.S. Policy for the Space and the Information Age', *Journal of Communication Inquiry*, 19, 2, 64–87.

La Valley, A. J. (1985) 'Traditions of Trickery: The Role of Special Effects in the Science Fiction Film', in G. Slusser and E. S. Rabkin (eds) *Shadows of the Magic Lamp: Fantasy and Science Fiction in the Film*. Carbondale: Southern Illinois University Press.

Lenning, A. (1969) *The Silent Voice: A Text*. Albany, NY: Lane Press.

Lévy, J. (1988 [1933]) 'Review of *King Kong*', trans. P. Hammond, in R. Abel (ed.) *French Film Theory and Criticism: A History/Anthology Volume II, 1929–1939*. Princeton, NJ: Princeton University Press, 137–40.

Lewis, J. (ed.) (2002) *The End of Cinema As We Know It: American Film in the Nineties*. London: Pluto.

Lewis, T. H. (1895) 'The Great Wizard of the West: Mr J. N. Maskelyne at the Egyptian Hall', *English Illustrated Magazine*, 12, 1, 75–83.

Libreri, K. (2004) '12 Predictions on the Future of VFX', *VFXWorld*, 7 December. <http://vfxworld.com/?atype=articles&id=2319> (accessed 9 December 2004).

Linker, M. (2003) 'Why Should Ideal Reasoners Become Evil Computers', *Science as Culture*, 12, 4, 547–55.

LoBrutto, V. (1998) *Stanley Kubrick*. London: Faber and Faber.

Logan, B. (1999) 'Things to do in Hollywood when You're Dead', *Guardian*, 17 September. <http://www.guardian.co.uk/Archive/Article/0,4273,3902644,00.html> (accessed 9 December 2004).

Long, T. (2001) '*Final Fantasy* Shatters Mold for Animation', *The Detroit News*, July, <http://www.rottentomatoes.com/click/movie-1108683/reviews.php?critic=columns&sortby=default&page=1&rid=235673> (accessed 20 August 2004).

Low, R. (1971) *The History of the British Film, 1918–1929*. London: George Allen and Unwin.

Lowenthal, L. (1961) *Literature, Popular Culture and Society*. Englewood Cliffs, NJ: Prentice Hall.

Lucanio, P. (1987) *Them or Us: Archetypal Interpretations of Fifties Alien Invasion Films*. Bloomington: Indiana University Press.

Lynn, H. S. (1878) *The Adventures of the Strange Man, with a Supplement Showing 'How It's Done!'*. Leicester: Edward Lamb.

MacCabe, C. (1974) 'Realism and the Cinema: Notes on Some Brechtian Theses', *Screen*, 15, 2, 7–27.

Machray, R. (1899) 'How the Eye is Tricked', *Cassell's Magazine*, February, 334–8.

Maltby, Richard (2003) *Hollywood Cinema*, second edition. Oxford: Blackwell.

Mannoni, L. (2000) *The Great Art of Light and Shadow*, trans. R. Crangle. Exeter: Exeter University Press.

Manovich, L. (2001) *The Language of New Media*. Cambridge, MA and London: MIT Press.

March, J. (1998) *Cassell's Dictionary of Classical Mythology*. London: Cassell.

Marriott, W. (c.1890) 'Spirit Photographs', *Pearson's Magazine*, 30, 12, 162–73.

Marvin, C. (1987) 'Information and History', in J. D. Slack and F. Fejes (eds) *The Ideology of the Information Age*. Norwood, NJ: Ablex, 49–62.

Maskelyne, J. (1936) *White Magic: The Story of the Maskelynes*. London: Stanley Paul.

Maskelyne, J. N. (1875) *Modern Spiritualism: A Short Account of its Rise and Progress, with some Exposures of So-Called Spirit-Media*. London: Frederick Warne.

____ (1880) 'Conjurer's Properties', *Leisure Hour*, 150–2, 189–91.

____ (c. 1891) 'The Magnetic Lady or A Human Magnet De-Magnetised', Appendix to *The Supernatual*. Bristol: J. Arrowsmith.

____ (2001 [1878]) 'Natural Magic', *Living Pictures*, 1, 1, 85–98.

Mast, G. (1971) *A Short History of the Movies*. New York: Pegasus.

Mast, G. and M. Cohen (eds) (1974) *Film Theory and Criticism: Introductory Readings*. New York: Oxford University Press.

Mathieson, S.A. (2001a) 'Let Me be your Fantasy', *The Guardian*: Online, 26 April, 2–3.

_____ (2001b) 'Don't Believe your Eyes', *The Guardian*: Online, 26 April, 2–3.

Mauss, M. (1975) *A General Theory of Magic*, trans. R. Brain. New York: W. W. Norton.

McGilligan, P. (1997) *Fritz Lang: The Nature of the Beast*. London: Faber and Faber.

McGrath, R. (1996) 'Natural Magic and Science Fiction: Instruction, Amusement and the Popular Show 1795–1895', in C. Williams (ed.) *Cinema: The Beginnings and the Future*. London: University of Westminster Press, 13–23.

Méliès, G. (1938) 'The Silver Lining', *Sight and Sound*, 7, 25, 7–9.

_____ (1988 [1907]) 'Cinematographic Views', trans. S. Liebman, in R. Abel (ed.) *French Film Theory and Criticism: A History/Anthology Volume 1: 1907–1929*. Princeton, NJ: Princeton University Press, 35–47.

Melton, J. (1620) *Astrologaster, or, The Figure-Caster*. London: Edward Blackmore.

Metz, C. (1974) *Film Language: A Semiotics of the Cinema*, trans. M. Taylor. New York: Oxford University Press.

_____ (1982) *Psychoanalysis and Cinema: The Imaginary Signifier*, trans. C. Britton, A. Williams, B. Brewster and A. Guzzetti. London: Macmillan.

Michelson, A. (1968) 'Review of *What is Cinema?*', *Artforum*, 6, 10, 66–71.

Michie, D. (1996) 'Turing's Test and Conscious Thought', in P. J. R. Millican and A. Clark (eds) *Machines and Thought: The Legacy of Alan Turing Vol.1*. Oxford: Clarendon, 27–51.

Millican, P. J. R. (1996) 'Introduction', in P. J. R. Millican and A. Clark (eds) *Machines and Thought: The Legacy of Alan Turing Vol.1*. Oxford: Clarendon, 1–10.

Moltenbrey, K. (2001) 'No Bones About It', *Computer Graphics World*, 24, 2, 24–30.

Moon, G. (c.1890) *How to Give a Conjuring Entertainment*. London: James Henderson.

Moore, B. (1997) *The Magician's Wife*. London: Bloomsbury.

Moore, R. (2000) *Savage Theory: Cinema as Modern Magic*. Durham and London: Duke University Press.

Morin, E. (1960) *The Stars*, trans. R. Howard. New York: Grove.

Morse, J. J. (1909) *A History of Spirit Photography*. Manchester: The Two Worlds Publishing Co.

Mulvey, L. (2006) *Death 24x a Second: Stillness and the Moving Image*. London: Reaktion Books.

Musser, C. (1994) 'Rethinking Early Cinema: Cinema of Attractions and Narrativity', *Yale Journal of Criticism*, 7, 2, 203–33.

_____ (2000) 'At the Beginning: Motion Picture Production, Representation and Ideology at the Edison and Lumière Companies', in L. Grieveson and P. Krämer (eds) *The Silent Cinema Reader*. London and New York: Routledge, 15–30.

Naughton, John (2000) *A Brief History of the Future: The Origins of the Internet*. London: Pheonix.

Ndalianis, A. (2000) 'Special Effects, Morphing Magic, and the 1990s Cinema of Attractions', in V. Sobchack (ed.) *Meta-Morphing: Visual Transformation and the Culture of Quick Change*. Minneapolis, MN: University of Minnesota Press, 251–71.

Netzley, P. D. (2000) *Encyclopedia of Movie Special Effects*. Phoenix, AZ: Oryx.

Neupert, R. (2001) 'Trouble in Watermelon Land: George Pal and the Little Jasper Cartoons', *Film Quarterly*, 55, 1, 14–26.

Newman, K. (1999) *Millennium Movies: End of the World Cinema*. London: Titan.

Nickell, J. (2005) *Camera Clues: A Handbook for Photographic Investigation*. Lexington, KY: University of Kentucky Press.

Nilsen, V. (1959) *The Cinema as a Graphic Art*, trans. S. Garry. New York: Hill and Wang.

Noake, R. (1988) *Animation: A Guide to Animated Film Techniques*. London: MacDonald.

Norman, D. A. (1997) 'Living in Space: Working with the Machines of the Future', in D. G. Stork (ed.) *Hal's Legacy: 2001's Computer as Dream and Reality*. London and Cambridge, MA: MIT Press, 262–77.

North, D. (2005) 'Virtual Actors, Spectacle and Special Effects: Kung Fu Meets "All That CGI Bullshit"', in S. Gillis (ed.) *The Matrix Trilogy: Cyberpunk Reloaded*. London: Wallflower Press, 48–61.

____ (2007) 'Kill Binks: Why the World Hated its First Virtual Actor', *Revising the Force: Critical Engagements with the Star Wars Trilogies*. NC: McFarland, 155–74.

O'Brien, G. (2003) 'Something's Gotta Give', *Film Comment*, 39, 4, 28–30.

O'Brien, W. (1976) 'Miniature Effects Shots', in H. Geduld and R. Gottesman (eds) *The Girl in the Hairy Paw: King Kong as Myth, Movie and Monster*. New York: Avon, 183–4.

Ollier, C. (1972) 'A King in New York', in R. Huss (ed.) *Focus on the Horror Film*. Englewood Cliffs, NJ: Prentice Hall, 110–20.

O'Rourke, M. (1998) *Principles of Three-Dimensional Computer Animation: Modelling, Rendering, and Animating with 3D Computer Graphics*. New York and London: W. W. Norton.

Overbey, D. (1978) *Springtime in Italy: A Reader on Neo-Realism*. Hamden, CT: Archon.

Panzner, C. (2005) 'Magic vs. Science: Is it Live or Animation?', *VFXWorld*, 23 March. <http://vfxworld.com/?atype=articles&id=2434> (accessed 24 April 2005).

Parent, R. (2001) *Computer Animation*. San Francisco: Morgan Kaufmann.

Partridge, D. and Y. Wilks (eds) (1990) *The Foundations of Artificial Intelligence: A Sourcebook*. Cambridge: Cambridge University Press.

Patterson, R. (1982a) 'The Making of Tron', *American Cinematographer*, 63, 8, 792–5, 813–19.

____ (1982b) 'Computer Imagery for Tron', *American Cinematographer*, 63, 8, 802–5, 820–3.

Pearson, R. E. (1996) 'The Attractions of Cinema, or, How I Learned to Start Worrying about Loving Early Film', in C. Williams (ed.) *Cinema: The Beginnings and the Future*. London: University of Westminster Press, 150–7.

Pepper, J. H. (1996 [1890]) *The True History of Pepper's Ghost*. London: The Projection Box.

Pettigrew, N. (1999) *The Stop Motion Filmography*. London: McFarland.

Pettigrew, T. (1986) *Raising Hell: The Rebel in the Movies*. London: Columbus.

Picard, R. W. (1997) 'Does HAL Cry Digital Tears? Emotion and Computers', in D. G. Stork (ed.) *Hal's Legacy: 2001's Computer as Dream and Reality*. London and Cambridge, MA: MIT Press, 278–303.

Pierson, M. (2002) *Special Effects: Still in Search of Wonder*. New York: Columbia University Press.

Pigott, R. H. (1867) 'An Old Trick', *Once a Week*, 8 June, 674–5.

Pinteau, P. (ed.) (2004) *Special Effects: An Oral History*, trans. L. Hirsch. New York: Abrams.

Plantec, P. (2005) 'The Convergence of Digital Acting and VFX', *VFXWorld*, 20 December. <http://vfxworld.com/?atype=articles&id=2732> (accessed 3 September 2006).

Pollock, D. (1983) *Skywalking: The Life and Films of George Lucas*. London: Elm Tree Books/Hamish Hamilton.

Poole, S. (2000) *Trigger Happy: The Inner Life of Videogames*. London: Fourth Estate.

Powdermaker, H. (1950) *Hollywood, the Dream Factory*. Boston: Little, Brown and Co.

Price, H. (1935) 'Ghost Hunting with a Ciné Camera: Using the Film in Psychical Research', *Sight and Sound*, 4, 15, 109–10.

Priest, C. (2004) *The Prestige*. London: Gollancz.

Prince, S. (1996) 'True Lies: Perceptual Realism, Digital Images and Film Theory', *Film Quarterly*, 49, 3, 27–37.

Punt, M. (2000a) *Early Cinema and the Technological Imaginary*. Amsterdam: Post-digital Press.

_____ (2000b) 'Parallel Histories: Early Cinema and Digital Media', *Convergence*, 6, 2, 62–76.

Rabin, S. (ed.) (2000) *A.I. Game Programming Wisdom*. Higham, MA: Charles River Media.

Rawnsley, D. (1948) 'The Independent Frame', *The Cine-Technician*, March–April, 50–6.

Ray, T. S. (1993/4) 'An Evolutionary Approach to Synthetic Biology: Zen and the Art of Creating Life', *Artificial Life*, 1, 1/2, 195–226.

Richard, S. (1991) 'A Beginner's Guide to the Art of Georges Méliès', in P. Cherchi Usai (ed.) *Lo Schermo Incantato: Georges Méliès (1861–1938)*. Gemona: Le Giornate del Cinema Muto/International Museum of Photography at George Eastman House/Edizioni Biblioteca dell'Immagine, 39–55.

Richards, J. (2000) 'Preface', in G. King *Spectacular Narratives: Hollywood in the Age of the Blockbuster*. London: I.B. Tauris, vii–viii.

Rickitt, R. (2000) *Special Effects: The History and Technique*. London: Virgin.

Ridgely-Evans, H. (1932) *A Master of Modern Magic: The Life and Adventures of Robert-Houdin*. New York: Macoy Publishing.

Robert-Houdin, J. E. (1859) *The Life of Robert-Houdin, the King of Conjurors*, trans. R. S. Mackenzie. Philadelphia: Porter and Coates.

Robinson, D. (1993) *Georges Méliès: Father of Film Fantasy*. London: British Film Institute.

Rony, F. T. (1996) *The Third Eye: Race, Cinema and Ethnographic Spectacle*. Durham, NC and London: Duke University Press.

____ (2000) 'King Kong and the Monster in Ethnographic Cinema', in K. Gelder (ed.) *The Horror Reader*. London and New York: Routledge, 242–50.

Rovin, J. (1977) *From the Land Beyond Beyond: The Making of the Movie Monsters You've Known and Loved*. New York: Berkley Windhover.

Ryan, D. (1868) 'The Conjuror at Home', *Belgravia*, 6, 576–84.

Sadoul, G. (1947) *An Index to the Creative Work of Georges Méliès [1896–1912]: Special Supplement to Sight and Sound, INDEX SERIES No.11*. London: British Film Institute.

____ (1949) *Histoire d'un Art: Le Cinéma: des Origines à nos Jours*. Paris: Flammarion.

Salt, B. (1983) *Film Style and Technology: History and Analysis*. London: Starword.

____ (1996) 'Cut and Shuffle', in C. Williams (ed.) *Cinema: The Beginnings and the Future*. London: University of Westminster Press, 171–83.

Schatz, T. (1998) *The Genius of the System: Hollywood Film-making in the Studio Era*. London: Faber and Faber.

Sconce, J. (2000) *Haunted Media: Electronic Presence from Telgraphy to Television*. Durham, NC and London: Duke University Press.

Scott, B. (2002) 'The Illusion of Intelligence', in S. Rabin (ed.) *A.I. Game Programming Wisdom*. Higham, MA: Charles River Media, 16–20.

Sears, R. (1993) 'It's Big!', *Empire*, 4, 8, 72–84.

Serkis, A. (2003) *The Lord of the Rings: Gollum: How We Made Movie Magic*. London: Collins.

Shannon, C. (1950) 'Programming a Computer for Playing Chess', *Philosophical Magazine*, 41, 256–75.

Shay, D. and J. Duncan (1993) *The Making of Jurassic Park*. London: Boxtree.

Sheldrake, J. (1995) *Management Theory*. London: International Thompson Business Press.

Shelley, M. W. (1994) *Frankenstein, or, The Modern Prometheus: the 1818 Text*. London: Penguin.

Singer, I. (1998) *Reality Transformed: Film as Meaning and Technique*. London and Cambridge, MA: MIT Press.

Skinner, W. E. (1892) *Wehman's Wizards' Manual: A Practical Treatise on Mind Reading, Ventriloquism, Sleight of Hand*. New York: Henry J. Wehman.

Skweres, M. A. (2004) 'Getting Respect for Invisible VFX', *VFXWorld*, 28 December 2004. <http://vfxworld.com/?atype=articles&id=2339> (accessed 4 January 2005).

Smith, A. E. and P. A. Koury (1952) *Two Reels and a Crank*. New York: Doubleday.

Smith, A. R. (1982) 'The Genesis Demo: Instant Evolution with Computer Graphics', in *American Cinematographer*, 63, 10, 1038–9, 1048–50.

Smith, T. G. (1985) *Industrial Light and Magic: The Art of Special Effects*. London: Columbus.

Snead, J. (1994) 'Spectatorship and Capture in *King Kong*: The Guilty Look', in C. Mac-Cabe and C. West (eds) *White Screens Black Images: Hollywood from the Dark Side*. London: Routledge.

Sobchack, V. (1976) 'The Alien Landscapes of the Planet Earth: Science Fiction in the 1950s', in T. R. Atkins (ed.) *Science Fiction Films*. New York: Monarch, 48–61.

____ (1987) *Screening Space: The American Science Fiction Film*. New York: Ungar.

____ (1993) *Screening Space*. New York: Ungar.

Solomon, C. (1994) *Enchanted Drawings: The History of Animation*. New York: Wings.

Sontag, S. (2001) 'The Imagination of Disaster', in *Against Interpretation and Other Essays*. New York: Picador, 209–25.

Springer, C. (1996) *Electronic Eros: Bodies and Desire in the Post-industrial Age*. London: Athlone.

____ (1999) 'Psycho-Cybernetics in Films of the 1990s', in A. Kuhn (ed.) *Alien Zone II: The Spaces of Science Fiction Cinema*. London and New York: Verso, 203–18.

Stam, R. (2000) 'The Question of Realism', in R. Stam and T. Miller (eds) *Film Theory: An Anthology*. Oxford: Blackwell, 223–8.

Stam, R. and T. Miller (eds) (2000) *Film Theory: An Anthology*. Oxford: Blackwell.

Standage, T. (2002) *The Mechanical Turk: The True Story of the Chess-Playing Automaton that Fooled the World*. London: Allen Lane/Penguin.

Steinmeyer, J. (2004) *Hiding the Elephant: How Magicians Invented the Impossible*. London: William Heinemann.

Stephenson, R. (1967) *Animation in the Cinema*. London: Zwemmer/Barnes.

Stern, M. (2004) '*Jurassic Park* and the Moveable Feast of Science', *Science as Culture*, 13, 3, 347–72.

Stolker, G. (1996) 'Memesis', in *Ars Electronica Festival* 96: *Memesis*. New York: Springer Wien, 26–7.

Stork, D. G. (1997) '"The Best-Informed Dream": HAL and the Vision of *2001*', in *Hal's Legacy: 2001's Computer as Dream and Reality*. London and Cambridge, MA: MIT Press, 1–14.

____ (1997) 'Scientist on the Set: An Interview with Marvin Minsky', in *Hal's Legacy: 2001's Computer as Dream and Reality*. London and Cambridge, MA: MIT Press, 15–32.

____ (ed.) (1997) *Hal's Legacy: 2001's Computer as Dream and Reality*. London and Cambridge, MA: MIT Press.

Strange, C. (2000) 'Hermann Oberth: Father of Space Travel', <http://www.kiosek.com/oberth/> (accessed 2 August 2005).

Strong, R. (1973) *Splendour at Court: Renaissance Spectacle and Illusion*. London: Weidenfeld and Nicolson.

Sutton, D. (2004) 'The DreamWorks Effect: The Case for Studying the Ideology of Production Design', *Screen*, 45, 4, 383–90.

Swerdlow, J. L. (2001) 'Unmasking Skin', *National Geographic*, 202, 5, 36–63.

Tafler, D. I. (1999) 'When Analog Cinema Becomes Digital Memory', *Wide Angle*, 21, 1, 181–204.

Talbot, F. A. (1912) *Moving Pictures: How they are Made and Worked*. London: William Heinemann.

Telotte, J. P. (1995) *Replications: A Robotic History of the Science Fiction Film*. Urbana and Chicago: University of Illinois Press.

_____ (1999) *A Distant Technology: Science Fiction and the Machine Age*. Hanover and London: University Press of New England.

Thalmann, N. M. and D. Thalmann (eds) (1994) *Artificial Life and Virtual Reality*. Chichester/New York/Brisbane/Toronto/Singapore: John Wiley and Sons.

Thomas, A. (2004) 'Anatomy of a Blockbuster', *Guardian Unlimited*, 11 June. <http://film.guardian.co.uk/features/featurepages/0,4120,1235576,00.html> (accessed 4 September 2005).

Thomas, F. and O. Johnston (1981) *Disney Animation: The Illusion of Life*. New York: Abbeville.

Thomas, G. (2006) 'Getting it Right the Second Time: Adapting *Ben-Hur* for the Screen', *Bright Lights Film Journal*, 52. <http://www.brightlightsfilm.com/52/benhur.htm> (accessed 3 September 2006).

Thomas, K. (1971) *Religion and the Decline of Magic*. New York: Scribner's.

Thompson, K. (1980) 'Implications of the Cel Animation Technique', in T. de Lauretis and S. Heath (eds) *The Cinematic Apparatus*. London and Basingstoke: MacMillan, 106–20.

Thomson, D. (1994) *A Biographical Dictionary of Film*. London: André Deutsch.

Todorov, T. (2000) 'Definition of the Fantastic', in K. Gelder (ed.) *The Horror Reader*. London and New York: Routledge, 14–19.

Toulmin, V. (1998) *Randall Williams: King of Showmen*. London: The Projection Box.

Travers, P. (2001) 'Review of Final Fantasy', *Rolling Stone*, 2 August. <http://www.rollingstone.com/mv_reviews/review.asp?mid=2042272&afl=imdb> (accessed 1 September 2003).

Troy, W. (1972 [1933]) 'Beauty and the Beast', in R. Huss and T. J. Ross (eds) *Focus on the Horror Film*. Englewood Cliffs, NJ: Prentice Hall, 104–5.

Tunison, M. (2001) 'Review of *Final Fantasy: The Spirits Within*', *Box Office* Online. 13 July. <http://www.boxoffice.com/boxoffice_scr/movie_reviews_result.asp?terms=5463> (accessed 1 September 2003).

Turkle, S. (1984) *The Second Self: Computers and the Human Spirit*. London: Granada.

Turner, G. E. (1982) 'A Hollywood Saga: Karl Brown', *American Cinematographer*, 63, 10, 1014–18, 1084–8.

Tyler, K. (2000) 'Virtual Humans', *Nova* Online, 1 November. <http://pbs.org/wgbh/nova/specialfx2/humans.html> (accessed 7 September 2006).

Tynan, K. (2002) *The Diaries of Kenneth Tynan*, ed. J. Lahr. London: Bloomsbury.

Usai, P. C. (ed.) (1991) *Lo Schermo Incantato: Georges Méliès (1861–1938)*. Gemona: Le Giornate del Cinema Muto/International Museum of Photography at George Eastman House/Edizioni Biblioteca dell'Immagine.

_____ (2000) *Silent Cinema: An Introduction*, second edition. London: British Film Institute.

Usher, A. P. (1929) *A History of Mechanical Inventions*. New York: MacGraw-Hill.

Vardac, A. N. (1987) *Stage to Screen: Theatrical Origins of Early Film: David Garrick to D. W. Griffith*. New York and London: Da Capo.

Vaz, M. C. (2000) 'Engendered Species', *Cinefex*, 82, 68–89.

Vaz, M. C., C. Barron and G. Lucas (2002) *The Invisible Art*. London: Thames and Hudson.

Vaz, M. C. and P. R. Duignan (1996) *Industrial Light and Magic: Into the Digital Realm*. London: Virgin.

Veilleux, J. (1982) 'Warp Speed and Beyond', *American Cinematographer*, 63, 10, 1032–4, 1054–8.

Vertov, D. (1988 [1922]) 'We. A Version of a Manifesto' in R. Taylor and I. Christie (eds) *The Film Factory: Russian and Soviet Cinema in Documents, 1896–1939*, trans. R. Taylor. London: Routledge and Kegan Paul, 69–72.

Virilio, P. (1989) *War and Cinema*. London: Verso.

Vyse, S. A. (1997) *Believing in Magic: The Psychology of Superstition*. New York: Oxford University Press.

Wake, J. (2005) *The Making of King Kong: The Official Guide to the Motion Picture*. London: Pocket Books.

Walker, A. (1970) *Stardom, the Hollywood Phenomenon*. London: Michael Joseph.

Wang, J. H. (2000) 'A Struggle of Contending Stories: Race, Gender and Political Memory in *Forrest Gump*', *Cinema Journal*, 39, 3, 92–115.

Ward, K. and D. Coupland. (1998) *Lara's Book: Lara Croft and the Tomb Raider Phenomenon*. Rocklin, CA: Prima.

Ward, P. (2000) 'Defining "Animation": The Animated Film and the Emergence of the Film Bill', *Scope: An Online Journal of Film Studies*, 1 December. <http://www.nottingham.ac.uk/film/scopearchive/articles/defining-animation.htm> (accessed 3 September 2006).

Warrick, P. S. (1980) *The Cybernetic Imagination in Science Fiction*. Cambridge, MA and London: MIT Press.

Weizenbaum, J. (1976) *Computer Power and Human Reason*. London: Freeman.

Wells, P. (2002a) *Animation and America*. Edinburgh: Edinburgh University Press.

____ (2002b) *Understanding Animation*. London and New York: Routledge.

WETA Workshop (2005) *The World of Kong: A Natural History of Skull Island*. London: Pocket Books.

Weynants, T. (1997) 'The Fantasmagoria', in D. Crompton, R. Franklin and S. Herbert (eds) *Servants of Light: The Book of the Lantern*. Ripon: Magic Lantern Society.

Wiedemann, J. (2002) *Digital Beauties: 2D and 3D Computer-Generated Digital Models, Virtual Idols and Characters*. Köln: Taschen.

Willemen, P. (2000) 'Of Mice and Men: Reflections on Digital Imagery', *292: Essays in Visual Culture*, 1, 1, 5–20.

Williams, A. (1983) 'The Lumière Organization and Documentary Realism', in J. Fell (ed.) *Film Before Griffith*. Berkely and Los Angeles: University of California Press, 153–61.

Williams, C. (1980) *Realism and the Cinema*. London: Routledge and Kegan Paul.

____ (ed.) (1996) *Cinema: The Beginnings and the Future*. London: University of Westminster Press.

Williams, L. (1986) 'Film Body: An Implantation of Perversions', in P. Rosen (ed.) *Narrative, Apparatus, Ideology: A Film Theory Reader*. New York: Columbia University Press, 507–34.

Williams, M. (2001) 'CG Idols Mean No Human is Required', *CNN.Com: Sci-Tech*, 29 November. <http://archives.cnn.com/2001/TECH/ptech/11/29/idols.no.human.idg/index.html> (accessed 1 November 2006).

Wilton, H.B. (1870) *The Somatic Conjuror: A Treatise on Natural and Scientific Magic, including the Latest Novelties, Supernatural Vision, or, Second Sight*. Melbourne: Clarson, Massina and Co.

Winston, B. (1995) *Claiming the Real: Documentary Film Revisited*. London: British Film Institute.

____ (1996) *Technologies of Seeing*. London: British Film Institute.

Wittgenstein, L. (1981) *Tractatus Logico-Philosophicus*, trans. D. F. Pears and B. F. McGuinness. London: Routledge and Kegan Paul.

Wood, A. (2002) 'Timespaces in Spectacular Cinema: Crossing the Great Divide of Spectacle Versus Narrative', *Screen*, 43, 4, 370–86.

Wood, G. (2000) *Living Dolls: A Magical History of the Quest for Mechanical Life*. London: Faber and Faber.

Wood, R. (1986) *Hollywood from Vietnam to Reagan*. New York: Columbia University Press.

____ (1996) 'Papering the Cracks: Fantasy and Ideology in the Reagan Era', in J. Belton (ed.) *Movies and Mass Culture*. New Brunswick: Rutgers University Press, 204–25.

INDEX